THE SUN STALKER

THE SUN STALKER

A NOVEL BY

Gordon Parks

BASED ON THE LIFE OF

Joseph Mallord William Turner

RUDER FINN PRESS

Acknowledgements

Harry Craig, the Scottish poet, lies deepest in my memory when I acknowledge inspiration for writing this book. A photograph of mine at an exhibition in London had caught his eye. To him, it strongly resembled Turner's nineteenth century painting of a storm at sea. Turner was not only Craig's favorite artist, he was also the foremost inspiration for his verse. With help from Shana Alexander, the journalist and mutual friend of ours, Harry knocked on my door with an offer. It was an intriguing one—to accompany him to Hollywood to meet a producer who had shown unusual interest in making a film on Turner's life. Harry felt I would be a suitable director for the project. I accepted.

But disaster awaited us on the West Coast. Mr. Z, the producer, spoke rather candidly at our first meeting. "You know fellows, I just read a script on Turner that Bill Styron wrote, and I told him frankly that it's not the time for a picture on slavery." His was a melancholy language for our ears. Mr. Z was referring to Nat Turner, the slave.

Harry left Hollywood broken and filled with bitterness. Before taking a plane for London, he asked a favor. "Should anything happen to me, keep my dream for Turner alive and moving." It was a strange request—especially when coming from a man nearly half my age.

"I promise, Harry. I'll do that."

A year later Harry Craig was gone. Death had been waiting for him. The promise I made was there to be kept. And Shana Alexander was there to make sure that I kept it.

After that I remember days in London, Venice and Wales, where I went to inhale the memory of Turner's existence. His spirit was still moving in the shadows of places where his soul had been. And there were times particularly fragrant with friends whose hearts overflowed with concern for what I was doing. Margot Pharr, a dear friend, sent books, articles and research that emerged from Turner's past. Dee Dee Moore, my faithful secretary, examined my motives and constantly questioned the route I took in one direction or another. Anna Winand, an admirable and learned friend, kept the air round me thick with questions. Arthur and Jeanne Ashe blessed me with an edition of the artist's work they had found in England. And always there to urge me on was Renate Haarhoff, a wise woman for whom I have infinitely pure love. But the extravagant power that rescued me from an antiquated typewriter came with the arrival of a lovely young lady who became my cherished assistant—and certainly one of my closest friends. Without the computer knowledge Johanna Fiore blessed me with, work on this book would have gone on for a thousand years. For her, and all of those aforementioned, my heart could not hold greater appreciation.

Gordon Parks

The Sun Stalker

He was born to the tempest—

his father the roaring wind,

his mother the angry sea,

his God, the baffling sun.

He, the self-willed child,

was condemned to taste the salt

that would ravage his dearest dreams.

Yet, he was to know best

and always love best—

the turbulence of unbridled storms.

Gordon Parks

Book One

CHAPTER ONE

London, 1778

A southeasterly wind rippled the Thames. The sun burned orange into the water. It was a Sabbath morning so peaceful that a Pope might have blessed it. A hundred yards off the watersides a small green boat with three people in it drifted with the tide.

A woman, her aquiline nose as rigidly set as the prow, sat in the stern gazing into the sun. Her lower lip quivered and her skin glistened with sweat. One hand toyed with a strand of frizzled hair curling from under the flappers of her white linen cap and the other clutched a black shawl draped over her shoulders.

A man, fishing from the center of the boat, wore a frock coat and stovepipe hat. He was spare and muscular, with small beady eyes and a long hooked nose. The fish were not biting and he stared into the water as he struggled to maintain his patience.

A boy, with crayons and a pad of paper, lay sprawled on his stomach, drawing. The sun was flaring into a bend in the Thames, and he was frowning at it. Reddish brown hair curled to his shoulders and he wore a blue cotton shirt tucked into the knee-length corduroy britches that clung tightly to his thighs and backside. A gull's cry jarred the silence. The man looked up to watch it glide off, then glanced at the woman. She was pulling an oar to her side. What sense enabled the man to perceive her intention he would never know. Something, however, made his arm shoot up to deflect the downward swish of the oar as it smacked the boat's side just inches from the boy's head. The man lurched forward and grabbed her, and she slumped into his arms. "Mary, why in God's name did you do that?" Still smiling she didn't answer. The boy sat upright and was now quivering with fright, sure that his mother had suddenly gone mad.

"Billy, row us to shore."

Everyone except his parents called Billy by his first name, Joseph.

Avoiding his mother's eyes, the boy did as his father had asked. Then he trudged behind them with his sketch pad under one arm and fishing gear under the other. As they crossed a field beside the river, Mary lifted her skirt above her shoe tops. "This infernal soot's all over the place!"

"Coal smoke, Mary."

She glared at her husband. "You've no need to tell me that, William. I've not lost my sight."

They stopped at Cavendish Square, where William bought gooseberries and a buttonhook. They walked on into streams of Sabbath strollers headed toward Covent Garden's teahouses and taverns. Sedan chairs were being readied outside the White Perruke. Stagecoaches rumbled by.

"Trollops, beggars, mud, slop. I'm coming to hate this place."

"Yes, Mary."

They reached home on Maiden Lane showing hardly any signs of the violent outburst that had occurred on the river. Mary's frizzled hair was in some disarray, but William appeared calm. Only the most discerning eye could have detected the despair boiling inside Joseph.

"Change this door, William. It has the looks of a coffin lid."

"In time, Mary. In time." He took a key from his pocket and opened the door and took the gear from Joseph. "I suppose you're to wait here for Gully?"

"Yessir."

Home was a two-story brick house coated with dust, soot and smoke. A rusty smokestack topped the tile roof that jutted out between two windowed gables. William's hairdressing shop was on the bottom floor. At the entrance, four white-wigged dummies smiled through the grime on a glass showcase. Joseph disliked them, except the one he called Hedges. When he was troubled, Hedges observed him with understanding; and this morning that was what he needed.

The smack of the oar was still resounding in his thoughts when Gully Cooke stepped to his side. "How was the boat ride this mornin', Joseph?"

"Went well."

"Much sketchin' or drawing?"

"A bit. Still having trouble with the sun. Just can't find colors to match it."

"I've no patience with it. Never did have. Your Mum go along this time?"

"Nope. She's ailin'. Do any sketches this week?"

"Nothin' to buzz about—a couple of haystacks and a turnstile on Osnaburg Road."

"Sorry. Can't spend time with you today, Gully."

"Why? What's on?"

"Chores to do for Mum."

They traded doubtful looks. Gully shrugged. "Okay. It's sugar with me. See you Wednesday."

Joseph sighed as they parted. He needed to be alone after what had happened this crazy morning, but he felt bad for having dropped the lid on his best friend. He entered the house and climbed the stairs to his room.

It was small with a low ceiling and it appeared disordered, although things were arranged with purpose. Sketches and drawings were neatly stacked in corners and beneath the bed. An old easel standing amid the confusion made everything else seem of small importance. A window overlooked Maiden Lane and parts of the Thames. A full-length mirror to the left of the bed was the boy's fervent observer. For most of his thirteen years it had been telling him that his hair was too long, that his face was too pimpled, and that his age expected someone a bit taller. This morning it was harshly explicit. "You're lucky your skull's not bashed in," it seemed to say.

He would have liked it to answer a couple of questions he found insoluble. Had Mary Ann's death done something to his mother's head? Would she rather have seen him in that wooden coffin? He remembered his mother sitting beside it that night before the funeral, knitting a black shawl to put about his dead sister's shoulders. He remembered her clipping off two of Mary Ann's braids and lacing them with pink ribbon, then later standing in the rain at the grave, staring blankly, until his father had pulled her away.

The mirror offered no answers. Joseph went to the window, pushed it open and glanced toward the Thames. Except for a patch of sun sparkling on its surface, the river flowed darkly. His eyes were focused on that patch

when a boat plowed through it. What had shimmered like stars moments before was left rumpled in the boat's wake.

Mary Turner slept through supper. Joseph and his father ate in silence. Nervously chewing at fish and chips, William was leaving Mary's behavior solely to the Lord. "Only he'd know why your mum'd do such a thing, Billy. I don't understand. One day she's calm as can be; then the next day she's flyin' apart. Your sister's passin' has a lot to do with it, I'm afraid." A fly buzzed his nose and he slapped at it. "She loved that child." He smiled weakly and patted his son's hand. "And surely she loves you."

Joseph nodded in agreement, but after their boat ride he was beginning to have his doubts. "Why'd Mary Ann die, Daddy?"

"Weak lungs. Hardly more than five at the time." His head shook sadly. "'Twas the Lord's will." He attempted to lift the gloom. "I'm to go dress Squire Tompkinson's hair in the mornin'. Like comin' along?"

"For sure I would."

At half past eleven, veiled moonlight glowed through Joseph's window. Sleep had finally overtaken him when he heard the creaking of his door. His eyes snapped open. Quietly, almost like a ghost, his mother was entering his room. As she moved through the moon's glow he could see her frizzed hair standing up like coiled springs. Quickly he shut his eyes; feigning sleep as she came toward him. Again the smack of the oar flashed through his mind. Terror seized him as she sat on the bed. Not until her hand softly caressed his forehead did his fear begin to subside.

"Billy."

"Yes, Mum?"

"I've come to wish you good night." She kissed his hair. "I'm doing things I don't mean to do sometimes. Do you understand?"

"Yes, Mum."

He felt the sheet being pulled off and her hand gently rubbing his stomach. He lay still holding his breath as her lips again touched his hair. "Put your arms around me, Billy." Cautiously, his arms moved forward, then pulled back. "Do as you're told, Billy!" Fear raced through him; forced his arms to hers. Then abruptly her arms fell from him as though they had been

cut away. She rose to move again through the glow of moonlight, and from what seemed to be some unearthly space he heard her ask, "Why did crazy old Ebenezer have to sneeze at a time like that?"

As she left, the tension that had been coursing through him departed with her, but her presence lingered in the shadows. Certainly he remembered Ebenezer, the old gravedigger who, while lowering his sister's coffin, had begun sneezing so violently that his father had had to help him with the lowering ropes. He had just shut his eyes when he heard a soft purring at his side. Toby, his cat, had leapt onto the bed. He pulled it close, and then fell asleep.

The following day, William and Joseph walked through a thick fog to the Squire's stone mansion on Carburton Street. Covered with ivy, it loomed like a castle in the grayness. Joseph carried his father's tools of trade: three powder puffs, curling irons, scissors and two razors. William knocked. "You're to remember, Billy, the squire's a most important man."

"Yessir," the boy replied. He had been made aware of the squire's prominence a thousand times over.

A sour-mannered servant opened the door and looked at them as though they were unwelcome termites. "Yes?"

"I'm Mr. Turner and—"

"I know. The master is in his chamber. Follow me." His cold arrogance cut William like a knife.

The servant led them up a magnificent circular stairway, which seemed to William like an ascent to heaven. The collection of paintings on the chamber's outer walls stunned Joseph. Their theme was the explicitly erotic: the copulatory adventures of satyrs and nymphs.

Tompkinson, a portly man with florid cheeks entered the chamber and sent William's spirits soaring with a gracious bow. "Ah, Turner, delighted that you came. And who is this remarkable-looking lad?"

Proudly, William put his back to the servant. "My son, sir. Hope you don't mind my bringin' him along."

"Why, I'm delighted that you did." Immediately he sat down on a

plushly padded stool and William placed a towel around his neck. "I want to look exquisite, Turner, I'm expecting a very special luncheon guest."

"You'll be handsome as ever, sir." William motioned to his son. "Billy, set yourself down in that corner."

"Oh, no." Tompkinson pointed to a scarlet chaise longue. "That's more befitting to you, lad." Nervously Joseph obeyed. "Now, Turner, let us get down to making me presentable." He twirled his forefinger. "My hair's to look like newly fallen snow and I've three wigs to be curled; those you can take with you." He turned back to Joseph. "What is your given name, lad?"

William cut in. "Joseph, sir. His Mum and I've always called him Billy and he's to be a painter someday—and a good one."

"Indeed?" The squire threw Joseph a wink. "You're to outdo Reynolds and Gainsborough—providing you give it a grand enough try." Joseph grinned sheepishly. A silver salver engraved with Tompkinson's coat of arms had caught his eye. Crested across it was a powerfully flanked lion with long claws. He had never seen an authentic salver before. But by the time his father had finished beautifying the squire, this one was firmly embedded in his mind. He was studying it when the squire got up to face the mirror. "Congratulations, Turner. I look magnificent." He dug a generous helping of silver pieces from his dressing gown and slapped them into William's hand.

"Ah, thank you, sir. Very generous of you."

"My pleasure, and I will be awaiting the wigs."

"In about three days, sir."

"Fine. Adieu, Turner—and to you, Billy, I look forward to your work gracing my walls someday." He departed as flamboyantly as he had entered.

As they left the house, they saw a striking young woman stepping from a hansom. The very special guest had arrived.

Joseph came to supper with a drawing of Tompkinson's lion. He handed it to his father. William smiled. Mary, who was filling their plates with stew, glanced at him. "What is it you're grinning at, William?" He handed it to her. "It's wonderful, don't you think?"

After taking a close look she drew back as if the animal were about to attack her. "It's awfully strange. What on earth would bring you to draw such a thing as that, Billy?"

Billy frowned. William responded for him, "I don't find it strange, Mary. Squire Tompkinson's to see it, and you'd be proud of the praise he had for Billy."

"The man's a foul windbag."

"I disagree with you, Mary. I find him a kind and upright man."

"Nothing kind or upright about him. He's a devil and you are foolish for not knowing it, William."

Joseph sat staring at her. She stared back. "Why do you look at me in such a dumb way, Billy?"

He had no answer, and again William sprang to the defense. "Mary, Mary, the child means no harm by just lookin' at you."

"You're disgusting, William." She jumped to her feet. "I'm off to bed."

Joseph stared at the table as William patted his shoulder. "It's a fine drawin', Billy. You're to be proud of it, and I'm hangin' it in the shop tomorrow."

Joseph went to bed regretting the drawing, and his trip to Squire Tompkinson's house.

Since the age of four, he had shown little interest in anything other than sketching or painting with watercolors. While others his age rolled hoops or played at hopscotch he could be found in his room with his fingers, face and clothes smeared with chalk or paint. William no longer considered favorable comments about his talent as just gracious gestures; pridefully he boasted about it. Mary had been more concerned about his lungs rotting from Covent Garden's soot and smoke. "This place's bound to kill the child sooner or later."

Joseph had turned six by the time she convinced her brother in Brentford to take him for a couple of years. There, away from the gloom of the city, were vast green meadows and forests, and the clean air of the upper Thames. Brentford had opened his eyes to the glories of nature.

At the end of his first year a letter had come to William from Mr. John White, Joseph's schoolmaster, that more than delighted him. It wasn't

exactly a flattering letter, but one sentence upped William's pulse. "Your lad has absolutely no head for studying, but he is sure to become a gifted painter, and he should be encouraged to the limit." William's instincts had been confirmed, and from then on he gave no thought to the possibility of Joseph's ever becoming anything but a painter—and a great one.

Joseph remembered Brentford well. He remembered Mr. White and the old grump's cane smacking his backside; the senseless Latin grammar; those dull passages of Horace, Caesar and Virgil no brain should have been expected to retain. Old pruneface, the students had called the schoolmaster. In his bushy wig, blue stockings and long, smelly camlet coat, he had herded them on tiring Sabbath strolls—all of them decked out in stiff-skirted coats in every color of the rainbow.

Mary had read Mr. White's remark with a doubtful eye. She considered painting a "mighty skinny way to put bread on the table." She had married a wigmaker knowing that her life would be relegated to ordinariness, yet after Joseph was born she began pushing the family toward a more luxurious existence. With Mary Ann's arrival, she had conjured up a world so privileged it would have taken miracles to fulfill it. Stubbornly, she had overridden William's objections to her indulgences. "Our children are not to go about like ragmuffins. They're not to be laughed at on the street."

"But that dress you bought Mary Ann amounts to a week's work of wig cleanin', Mary."

"Ask more for your labors. Make yourself more respected around these parts," had been her reply.

William had swallowed his desperation while she held her high ground and ignored the fact that the neighbors had dubbed her the "Duchess of Wigdom." Until Mary Ann's death she had worn the title well. Then abruptly she had changed. No longer did she seem to care about appearance, or much else. Whereas she once walked Covent Garden proudly, she now possessed the look of a beaten woman. She was oddly dressed and seldom spoke to anyone. A puzzlement to both her husband and her son, she seemed to be split in half—one part love; the other part disruption.

Joseph had another thorny problem. The airy freedom of his earlier draw-
ings was being stifled by Tom Malton, his art instructor. Malton was stuffing
discipline down his throat until he choked on it. Lines. Lines. Lines!
Architecturally correct lines. Straight lines. Slanting and circular lines. He
had become insufferably adept at penciling them into bridges, houses,
churches and barns—all the while feeling sure that a dumb goose could do
the same. In addition, there was Malton's carping about perspective, over
which he was being forced to agonize. "I'm bein' pounded into doing things
I don't like." He was tired of having his imagination shackled by a hard-arse
who kept at him like a hungry woodpecker.

His weekend watercolor assignment was finished; he looked at it and
groaned. Covent Garden church appeared flat as a sheet cake. The dull
clouds curled like dough and the road looked like a slab of tripe. It was
something Malton would probably like, but Joseph was sour on the results.
"Well Malton can go dump in the sea!" he thought. Furiously, he began
daubing the entire picture with explosive color. "For sure Malton'll have a
say about this."

For sure Malton did. "Joseph, obviously you're losing your sight or your
mind. This is the most outlandish thing I've ever seen. What's happening to
your senses? The trees are closer to orange spinach, and those clouds—if
that's what they're supposed to be—look to be dripping with red gravy."

"That's the way I saw it, sir."

"Then I'd say you're in need of spectacles."

A dung fork for you, Malton. That, of course, is what he wanted to say,
but he settled for a curt bow, took his creation and went home. "I'm not to
get the sads about Malton's gibberish. He's a bunghole." This he did say—
after he was well out the door.

William's eyes widened when he saw the work in question. "What'd
Malton think of it?"

"He hated it and said so."

William rubbed his chin. "Well—I'll go and have a talk with him."

"I'm not turnin' tail. I'm lookin' to do things my own way."

William admired his son's resolve, but secretly, he too thought the
painting was a sorry jumble of something he failed to understand.

CHAPTER TWO

Squire Tompkinson's wigs were ready. William gave them a proud smile. They suited the likeness of their owner. Joseph was summoned. "Billy, I've a awful busy day ahead and the Squire needs his wigs. You're to be a good lad and take them to him." Delighted with such an important chore, Joseph took the wigs and set off for Carburton Street.

Knocking on the door, he expected to be confronted by the grouchy servant he had met on his previous visit. Well, he'd just hand him the wigs and be off. But things didn't work out that way. A large lady, naked from the waist up and holding a champagne bottle, opened the door. Shocked, he held out the wigs to her. "For Mr. Tompkinson." She grabbed his wrist, pulled him inside and slammed the door. The wigs dropped to the floor and with horror he watched her kick them. "Nicole. Look what I've found!" Even more shocked, Joseph struggled to free himself. A dozen or more half-naked ladies and gentlemen were doing things that would have made Satan blush. Nicole, with a woman nibbling at her bosom, beckoned to him. "Come here, cherub." He couldn't. His captor had now torn open his fly, and was dousing his genitals with the champagne. When he tried to pull away her hand tightened about them. He yelped and fell backward onto the floor.

Squire Tompkinson's voice from the top of the stairwell saved him further abuse. "Friends! Friends! A revelation!" The Squire wore a red dressing gown. The girl he held about the waist had long black hair. Smiling, she stood with a silk robe flung about her shoulders. Suddenly, with the flair of a magician, the Squire snatched away the robe, revealing that she was very much a gentleman. It was the "special guest" that Joseph had seen on his earlier visit. This was Joseph's moment of deliverance. Scrambling to his feet he fled out the door and into Carburton Street, buttoning his fly as he ran. Slowing to a walk, he went on dazedly, feeling as if all of Covent Garden was snarling and laughing at him at the same time.

Peculiar sounds were coming from his mother's bedroom when he climbed the stairs. He stopped to looked through her door. She was on her knees, leaning against the bed.

"Are you alright, Mum?"

"I'm praying, Billy." He saw that she was holding Mary Ann's braids in her hand. "Sorry, Mum."

"The squire got his wigs alright, Billy?" William asked during supper.

Joseph held back for a moment. A lewd pastiche of the afternoon's events was streaking through his thoughts.

"That snooty servant of his didn't give you trouble?"

"No, sir—not a bit."

"Guess he's learned good manners by watching his master."

"Suppose he did." All of Joseph's memories of the experience were contained in the answer. That night, those images chased him in his dreams. No matter how fast he ran, he could not escape them.

He awoke to a glorious day. Except for a few rifted clouds the sky was clear and blue. Starlings and sparrows flitted about chirped in the trees along Maiden Lane. He pulled on a blue shirt, wriggled into his corduroy britches and buttoned them on with red suspenders. After some tea and a hunk of bread smeared with marmalade he started work on a new watercolor.

A pan of water, a jumble of brushes and pencils, withered sponges, and chunks of Prussian blue, burnt sienna, and red and yellow lake sat to his right. An old baker's board served as a palette. After a few bold pencil strokes a man-of-war began taking shape on the paper. Deftly he began laying on a wash of ultramarine. He was off to a good start.

His father's day was beginning differently. He had paid a call on Tom Malton, who came straight to the point. "I'm afraid your son's not going to be a painter, Mr. Turner. I'm now convinced he'd make a better tinker or cobbler."

"I didn't come here to listen to such tripe."

"It's my singular opinion, Mr. Turner."

"Your opinion be damned, Malton. My son will become a painter, and a good one."

"Your son lacks discipline and imagination, and he's hopelessly bull-headed. I can no longer put up with his nonsense."

"Why, Joseph's got more imagination in his little toe than you've got in your thick skull."

"But my dear man, he can hardly paint with his toe, now can he?"

"You'll come to eat your words one day, mind you." William put his trembling finger before Malton's nose.

"Unless there's a drastic change in your son's attitude I've no fear of that." I'm truly sorry about all this. A good day to you."

"Your sorrow's to be met down the road. Good day." William was out the door before Malton could answer.

Joseph was penciling in the sails when a flurry of rain suddenly struck his window. The sky had darkened; the weather gone bad. He stroked in a shadow to heighten the billowing of the mainsail. He was brushing a mixture of gamboge and green into the watersides when William came through the door.

"Hullo, Billy."

"Hullo, Daddy. You're drenched."

"Billy, you're not to darken Tom Malton's door again. We're going to find another instructor." He observed the watercolor in progress. "That looks fine—just fine," he muttered. Then he left for his shop.

Joseph went on painting. The water lacked something; he didn't know exactly what. It was time for a closer look at the Thames. It had a way of solving problems. The storm clouds had rolled back when he stopped at half past noon. His mother was mopping the floor as he passed her on the way out. "Hullo, Mum." There was no answer.

At the corner of Hand Street an old woman slouched on the curb with a gunnysack at her side.

"Hullo, Miss Kilbrew."

She spat and wiped her nose on a rag. "Git along, scalawag. You're up to no good."

He snickered and walked on. Luck met him at Frampton's Dock. Gig Pipes, his favorite waterman, was about to set sail, and he was able to scrounge a ride with him. Gig had a willing ear and a gruff tongue that he used unsparingly. The prow of his boat—the parlor—was never without a jug of ale. He took a huge swig then hoisted the mainsail. "Readies me for up fer a good day's labor, lad. An how's that freckled arse sidekick of your'n?"

"Gully?"

"Yup."

"Meetin' him tomorrow."

"'Ee's a load on his mind, lately. Not hisself a'tall. Somethin' off with 'im?"

"Don't know."

Few watermen could ease a sail into the wind like Gig Pipes, and quickly they were moving downstream. The slap of the waves against the prow was music to Joseph's ears. They came alongside a blue barge. "Look's to be new, Gig. Never seen it before."

"'Tis new, jus off the rafters—and with a greasy old prick for a cap'n. A bloody jabber 'ee is. An 'ows the paintin' goin', lad? Ole Malton still knockin' on your 'ead?"

"He's booted me out."

"Fer what?"

"Thinks I'm a mulehead. Hate's my doin' things my own way."

"Right you are for that, lad. Nothin' to gain by bein' a copycat. Take me word fer it. Don't be a'feared of nothin'. If you've got good thoughts of yer own, glue 'em to yer bones. You've gotta learn to piss square into the wind—even if its blowin' a'gin ya."

Joseph smiled. "I'll remember that, Gig."

"An fer shore ya must, lad, else you're a dead duck."

After two hours the boat nosed into Sotheby's Landing. Gig dropped anchor and Joseph leapt ashore to tie the rope. Gig flung it and Joseph knotted it around a wooden anchor pin.

"Ah, a fine tar you'd make, lad—a fine tar."

From Gig, such a compliment was a golden moment. "Thank you, Gig. Thank you."

"I'm 'ere fer 'bout an hour, then headin' back."

"I'll be waitin'." Admiringly he watched Gig leap to the embankment then with his sketch pad he sat down to study the Thames. It had its own rules and it never seemed to be wrong.

When they sailed back toward Frampton's Dock, a crimson sun was sinking beneath the waterline, wrinkling it into a miraculous orange. The river had spoken.

CHAPTER THREE

Gully wore a Friday face when Joseph approached him at Cavendish Square on Wednesday. He sat with his back to a stone wall with his head between his knees, fingering the frayed bill of his cap. He looked up at Joseph through puffed eyelids. Tears seemed to have dried on his freckled cheeks.

Joseph spoke cautiously. "Ready for sketchin', Gully?"

"I've no pads or pencils with me."

"I've plenty. Come on."

"Where to?"

"How about the meadows? Nice day for that."

"Well—"

"Good turnstiles and hayricks 'round the Capper place."

Slowly Gully got to his feet; then they headed toward the countryside. At a bend of the Thames they reached a field adjoining the Capper property, sat down in the weeds and began sketching a turnstile.

After about ten minutes of work, Gully abruptly stopped, "I feel like a shitbag, Joseph."

"Want to call it off?"

"Ah, I don't want to muff your day.

"Not so. Come on, let's chuck it in."

Gully was in need of unburdening himself, and at Kennington Common they turned toward his house. The squalid two-story hovel Gully and his father lived in was crusted with gull droppings, dirt and soot. The front door needed repairing and was nailed shut. They both got a start when they reached the back of the house: A few feet from them, a huge man with a red bushy beard was stumbling out of the thickets. His sailor's garb was matted with mud. He stopped for a moment, shot them a hard look, then limped off into the woods.

"Criminy, Gully, who was that?"

"Never seen him before. Probably a docksider."

"A mean looker he was."

They entered the house through the back door. A dank foulness met them in the kitchen and stayed with them until they reached Gully's room on the second floor.

"Since Mum's gone everything's turned to rot."

Joseph responded to this with silence.

The room was small and dimly lit. Half of the broken windowpane was stuffed with gunnysacking. Gully's bed was a straw mattress on the floor, his cover, a ragged horse blanket. The furniture was a box with a board on top that he had rigged up for sketching, and a wooden stool, held together with bailing wire, that sat beside it. What few clothes he had were bunched together like rags in a corner. Home for Gully Cooke had become a motherless shack reeking with the stench of decay.

After they had sat in silence on the floor for a few moments, Gully asked, "Like to see a few of my sketches?"

"Sure."

Gully pulled six from a pasteboard box and laid them on the floor. They were hardly visible in the dim light. Joseph moved them closer to the window and studied them for a few moments. "They're all bloody well good, I'd say."

Gully shrugged. "Don't much care anymore. Pa don't give a tinker's dam about them. Mum was a noggin-thumper and yelled a lot, but she show'd some interest."

"Tell me, Gully, what's wrong?"

" Nothin' more to say about the sketches?"

"They're all good. This hayrick's better'n most I've seen. Should bring in five shillings, I'd say."

"Ha. I could use five shillings about now."

"Are you hungry, Gully?"

"Why'd you ask?"

"Somethin's wrong, and I'm your friend with a right to ask."

"I hate flogg'n the cat, but Pa's at his worst. Always jugged up with ale

and I've not seen him for three days. Don't know where he's holed up. The food's run out."

"Three days?"

Gully nodded.

Joseph touched his arm. "Come on, you'll come to our house for supper."

"Your Mum and Pa won't mind?"

"They'd be put off if you didn't come."

"Promise not to tell them about Pa."

" I promise."

Mutton and dumplings made a princely meal for an empty stomach, and Gully's spirit lifted with every mouthful. He was sensing the first familial attention since his mother had died, but Joseph was suffering from the promise he had made. Gully couldn't go back to that house; the very thought of it chilled him. He was verging on betrayal when a solution swept into his head. He glanced at his father. "Could Gully spend the night with us?"

"'Twould be fine with me, but I'd think his father would want a say about it."

William looked to Gully; Gully looked to Joseph, who made an acceptable suggestion. "We'll go ask him."

They planned not to re-enter the house, only to walk there, turn about, and come back, but this plan was not in keeping with what they witnessed upon their arrival. In the light of two lanterns, Constable Cleary, with two of his deputies, was there banging on the front door. "Gully. Gully Cooke, are you inside? Open up!"

Nervously, Gully stepped into the light. "I'm here, Mr. Cleary."

The constable lifted his lantern higher, squinting. "Ah, 'tis you lad. And where've you been at this hour?"

"At Joseph's house."

Ratlon Swaine and Dave Picklow, the hangmen at Kennington Common, stepped to Cleary's side. He cleared his throat. "When'd you last see your pa, lad?"

"Not for three days. Why? Did ya find him?"

Cleary scratched his nose. "Not sure of that. Maybe we have, then maybe not. You're to come along with me and help decide."

"Come where?"

Cleary hesitated for a moment. "To the charnel house."

Surely Cleary had made a mistake. "You mean the gaol?" Joseph asked.

"No, lad, the charnel house." His hand touched Gully's shoulder. "You'd better come along." The five of them started off.

Black, windowless, with one crooked chimney, the charnel house resembled a monster lurking in the darkness. Trembling from fright, Gully and Joseph followed the men through a wooden door. With lanterns lighting the way, they continued through a narrow passageway; then Cleary stopped at another door. "Now, lad, you'll have to prove yourself a man. Won't be easy for you, but we've got to know if your Pa's here or not. Understand?"

Gully nodded.

"For your sake I hope he's not. You know his clothes of course?"

Gully nodded and again Cleary touched his shoulder. "Won't be show'n you his face. Now steady yourself, lad." Cleary opened the door; and they stepped into the darkness. The lanterns lifted. A black tarpaulin covered the corpse and Cleary pulled it back to reveal all but the head. The body had been taken from the Thames an hour before and the clothing was damp, the old cutaway coat caked with mud. The bootless feet had turned gray and leaned in opposite directions.

Both boys gasped. Gully snapped his eyes shut and turned away. "It's him."

"You're sure, lad?"

"I'm sure," Gully moaned.

Cleary motioned for Ratlon Swain to cover the corpse again; then he turned to Gully. "I'm sorry for you, lad. Now tell me, do you have any kin about? Uncle or aunt, maybe? Somebody such as that."

"My aunt, Belle Prescott. She's his sister."

"And where can I find her?"

"She's workin' for Mr. Harrison at Leicester Square."

"You know the street number?"

"Sixteen—number sixteen."

Cleary took a pad from his waistcoat pocket and jotted down the number.

"Sorry, lad. The Holy Father be with you. I'll find quarters to put you up for the night."

Joseph cut in. "He's to stay the night with us."

"Ah, good. I'll find your aunty in the morning so don't worry yourself, lad."

"What happened to my pa?"

"That I don't know but I'm going to find out."

Silently they went from the dark of the charnel house to the street. Cleary and his men turned toward the river. Gully and Joseph crossed to Maiden Lane.

"God Almighty," Gully cried. "God Almighty!"

The next day, five people stood with Gully at the pauper's grave on the outskirts of Covent Garden—Joseph, his parents, Belle Prescott and an unidentified woman who William thought smelled of hard spirits. Five hours later Gully left Covent Garden to live in the outskirts of London with his aunt. As they waved their goodbyes, Joseph wondered if they would ever see each other again. Despairing, he watched the coach disappear into the dusk. The companionship he had assumed they would always share had suddenly been taken away.

CHAPTER FOUR

The following week, Joseph tacked a drawing of William on the wall of his father's shop—a rendering of a skinny little man with a slight paunch and bandy legs. A long crooked nose jutted out over an equally long chin. "It's good, don't you think?" William asked all of his customers. "Billy's a hard worker he is, and hard work puts steel in the blood." The motto had become his catechism. True to it, William labored hard to please his customers, most of whom kept at least three wigs to be powdered and curled every week. Then there were the shavings, frizzings, and trimmings of hair, beards and muttonchops. Some of Joseph's drawings were selling for as much as five shillings apiece, and William's place of business was becoming sort of a wig shop-gallery, where common gossip was giving way to discussions about art.

On one particular Monday, William sensed beatification. Had the Pope himself wandered in he would have been only mildly surprised. "Indeed I felt promise floating about," he would confess later, "not for myself but for Billy. Something spiritual was taking over. I could feel it in the crispin' irons, in my head and toes."

Spiritually charged as he was, William nearly missed the true moment of salvation. After seventeen frizzings and grooming a dozen wigs, he was tired. Then too, the divine savior didn't arrive in the personage of a Pope or a cardinal, but in the shape of an elderly clergyman named Robert Nixon. Since he only wanted his muttonchops trimmed, Nixon's arrival seemed unremarkable. But then after the trimming, he decided he wanted a frizzing.

"For that, sir, you'll have to wait. I've another customer."

William wanted him to leave. It was past seven. He was tired and wanted to close out the day. But Nixon had waited. Meanwhile, he took a good look at Joseph's work. After thirty minutes he got his frizzing.

"Turner," he said before leaving, "Your son should submit his work to the Royal Academy. I've a feeling they'd take him on as a probationer."

William gasped. "Why, Billy's only fourteen, sir. Are you serious?"

"Most certainly I am, and if you'd like, I'll take him to meet Monsieur Rigaud next week. He's a friend and an academician in his own right."

William was transfixed. "Oh, indeed that would be a blessing, sir. My son at England's academy for her greatest painters? Oh, what a Godsend that would be."

"Your lad deserves a chance."

"Which of the drawings caught your fancy?"

Nixon's eyes swept the wall. "Without a doubt the personality sketches. And the architectural renderings are superior." He smiled. "But then, all of them are superior."

"Billy's bent on landscape."

"I'd discourage that. Richard Wilson's the best in that field and he's all but reduced to porridge these days. No, I, for one, feel landscape's a thankless journey."

William was thrilled to have his own feelings confirmed, and he had to restrain himself from embracing the old clergyman. When Nixon took out money to pay, he refused it. Taking his money at such a moment seemed sacrilegious.

A wry smile crossed Nixon's face. "No, thanks. I'll pay. Rather see you at church now and then. Good day, Turner. I'll come for the lad next week."

William began sweeping the floor while mulling over possibilities for Joseph's future. In his mind were a luxurious studio, Leicester Square, fashionable ladies and elegant men, all waiting to be immortalized—and by his son. He imagined guineas flowing like flour from hopper-spouts. But Leicester Square and its pretensions were a long distance away from those rugged elements of nature tugging at his son's heart. Painting the elegance of fashionable ladies and gentlemen never crossed his mind.

William would not forget Nixon's promise, nor would he ignore the clergyman's hint about his irregular attendance at church. His presence with Joseph in a forward pew that following Sabbath was an expression of gratitude, but he was shocked by Nixon's sermon on immorality, and by his condemnation of the British Empire's sins: "Why, for a few paltry pounds, renowned Englishmen are enjoying carnal pleasures with boys and girls.

Brothels outnumber the churches. The Royal Prince's behavior is beyond belief. Naked harlots are being glorified by sculptors and painters and most literature is unfit to print." This tongue-lashing of the Empire caught William off balance, shocked him. Nixon devoted the final minutes of prayer to saving the wayward souls of England, a task that would try the patience of Job.

"Mr. Nixon's a God-fearing man," William said as they walked toward home.

Joseph was silent. The sermon had had no effect whatsoever on him. His interests were a long way from the King or the Empire's carnal pleasures.

William pressed on. "'Twould be good for us to be seen in church more often."

That suggestion was also lost on Joseph. His religion was art. Had William been able to read his son's thoughts he might have entertained fears of having sired a budding atheist.

CHAPTER FIVE

Joseph's heart was beating uncontrollably when, with Nixon, he found himself outside Monsieur Rigaud's door a week later. It was opened by a tall, thin old woman servant. "A fine morning to you, pastor. The master's waiting for you in his study."

They entered to find Rigaud seated on the floor opposite a boy about Joseph's age. Sketches and watercolors lay scattered between them. Abruptly they stood, shook hands with Nixon, and introduced themselves to Joseph. Whereas Joseph's response was barely audible, Tom Girtin spoke his name as though it were a princely title. Monsieur Rigaud, a tall, slender, elegantly attired man with flowing white hair, threw Joseph a lordly glance. "So—the esteemed young artist arrives. Are those samples of your work you're clutching there?"

"Only brought twenty, sir."

"One would have been sufficient, providing it was good enough." To Joseph's relief, he smiled. "Let me have a look?" With trembling hands, Joseph gave him the drawings. "Why don't you and Tom get acquainted in that outer room. Mr. Nixon and I have some private matters to talk over." Nixon gave Joseph a reassuring pat on the shoulder as Tom led him away.

The outer room was a rich brown tinged with gold, and reeking with intimidation. The walls, like Squire Tompkinson's, were weighted with paintings, but of a far different nature. Joseph stood for a moment staring in disbelief. Here were works by Gainsborough, Reynolds, Wilson, Fuseli, Lorraine, Correggio, and Hogarth.

"All academicians, except for Correggio, of course," Girtin said with a soft chuckle. Then he pointed at the Gainsborough, a portrait of an elegant lady with two small children clinging to her satin gown. "Do you like that, Turner—honestly like it?" Astonishment held Joseph in silence, so Tom Girtin answered his own question. "A graveyard with three stones. All's lacking is a tray of sweets and a nanny to wipe their arses. Big money, that's

what he's all about." Tom's face matched his manner—bold, open and frank. Curly black hair fell wildly over his forehead. He sat down at a huge table and opened his collar. Joseph sat down beside him. There was a plate of cookies on the table. Tom took one, bit into it, and then lifted the plate toward Joseph, who politely refused. Rain suddenly spattered against the windows. Pointing to it, Girtin observed that friendships made during rain were lasting. He laughed. "So says my mother, who lays no claim to a single friend." He looked Joseph dead in the eye. "So you're after a bone?"

"A bone?"

"Admission to the Academy."

"I'd say you're right."

"I've big ears and I'd wager your chances are good." He leaned back in the chair as though it belonged to him. "You'd be bloody lucky to make it at your age. Nobody has, you know, but there's a first for everything. It's a good place to be swallowed up by straightfingers who want to run your mind. I'd flop there. Too much my own man."

Joseph's eyes shifted to the painting by Richard Wilson. "That's a fine one, I'd say."

"The Wilson? You're right. It's by far the finest of the lot. He'll have tongues wagging when the others are forgotten. They tried filling his belly with stale water, but he refused to drink." He paused for a moment. "How much meat a bone would add to your table is a wild guess. I'm copying prints and washing in skies for a tyrant named Dayes. Doing the same for old Doc Monro, but he's cheery and sets a good table. Take you to meet him, if you like."

"I'd like that."

"Then it's done. Only Girtin can save Tom Girtin's arse from mediocrity. Should be the same with you, Turner."

Joseph's answer was a noncommittal smile. His thoughts had become occupied with the appraisal Monsieur Rigaud was giving his work.

Half an hour passed before Rigaud summoned them. He smiled stiffly, thanked Joseph for coming but said nothing about his drawings or sketches. Joseph felt disappointment. He had hoped for an opinion of some sort, some indication of his chances one way or the other.

He had keened to Tom, in spite of his cockiness. But he had his own views and wasn't afraid to express them. Nothing wrong with that, he thought, not a bad trait at all.

Tom took Joseph to his lodging above a butcher's shop in St. Martin's-Le-Grand to see his paintings. En route, he let Joseph know that he was the sole provider for his mother and younger brother, and that five years before his father had been killed while hunting. As for Dayes, the draughtsman he worked for: "We hate each other, but since he supplies most of the family's bread I have to put up with him."

At the top of the stairs he stopped abruptly. "Now, I don't give a snip about what you think of my work. It matters little if you hate the whole lot. I'm out to please Tom Girtin." His room was in complete disorder. Spaciousness was the best thing that could be said for it. Clothes, shoes, sketches, discarded paper, paint pots and brushes were scrambled together like eggs. The only semblance of neatness was a wooden shelf that held Girtin's paintings.

Joseph had settled himself on a stool when a knock came on the door. "Tom."

"Yes, Mum?"

"Dayes was here looking for you. He seemed anxious."

"The sham-legger's always anxious."

"Just thought I'd tell you."

"Thanks, Mum." Tom took four paintings from the shelf and put them on the floor before Joseph. "Nobody's seen these, and nobody will 'till I'm bloody well ready to show them—and that might be a long time off."

"I'm honored."

"No need to be. Not sure I keen to them myself."

Joseph's face lit up. His attention was immediately drawn to a small landscape, handsomely composed of greens, indigo and sienna that faded delicately into a Prussian blue. "You're good, Tom."

Girtin's reply was somewhat less swaggering. "Getting there slowly. How did Rigaud strike you?"

"Haven't thought about him yet."

"He's a queer duck. Not one to let you know what's on his mind. Like's to keep your thoughts tangled."

"I'm not to worry about it," Joseph said with a casualness that belied his true feelings.

They spent the rest of the afternoon together, then walked along the watersides until nightfall. As they parted, Tom slapped Joseph's shoulder. "Takin' you to see Monro in a couple of days."

"Lookin' forward to it." Joseph's thoughts had returned to Monsieur Rigaud and Reverend Nixon. Neither of them had offered him the faintest clue. He would have to wait and see, and so would his father, who was bubbling with anxiety.

It was solidly dark and raining when he reached Maiden Lane. He was approaching home when, from a recessed doorway, a large hairy hand reached out toward him. The muddied brute he and Gully had seen stumbling from the thicket confronted him. He shuddered, ducked and scrambled away. "You'll keep your trap shut, lad, or I'll shut it for ya!"

Before entering his door Joseph glanced back to see him limping off into the darkness. Inside, he stood with his back to the door breathing heavily, his entire body quaking with terror.

"Just some drunkard," Mary concluded at supper later that night. But at the gaol, where William took him the following morning, Joseph heeded Constable Cleary's warning, "If you see him, keep your distance."

Doctor Monro, Tom's other employer, led a double life, one half devoted to art and the other to the enigmas of dementia.

"He's like a fat-arse terrier chasing between the Academy, the hospital and our royal daffiness, the King," Tom quipped after rapping on the door.

Monro, short, thickset and balding, gave them a cheerful greeting and ushered them into his parlor, where Joseph took a seat next to Tom on a divan. "Welcome, Joseph. Tom told me he was bringing you along and I'm glad you came."

A thin pinched-faced woman with a gray shawl flung about her shoulders entered and hurried across the room toward another door. "My dear, this is Tom's friend, Joseph," Monro called out to her.

"Good evening," she mumbled, and without looking back walked on.

Tom grinned. He was used to such a greeting from the doctor's wife. He was no favorite of hers.

Monro plumped his bearish frame into an armchair and lit his pipe. "We'll have a bite to eat in a few minutes." He blew a cloud of smoke. "Tell me, Joseph, what are you up to?"

"Trying for a bone to the Academy, sir." He had spoken the word "bone" with such assurance one might have thought he invented it.

Tom smiled. "I was hoping you'd take him on to work with me."

"'That's possible," Monro answered after a burst of coughing. "Think you'd like that, lad?"

"I'm sure I would, sir."

"Good," Tom exclaimed. "Your pay'll be three meals a week plus half a crown a night."

After a meal of beefsteak, roasted potatoes and plum pudding, Tom took Joseph on a tour of Monro's gallery. Again, Joseph's eyes were drinking in genius. There were drawings and sketches by Rosa, Van Lint, Zuccarelli, Snyders, Rembrandt, Canaletto, Morland, Cozens—even one of Malton's oils. Suddenly, Monro was calling from the outer hallway. "Sorry, lads. I have to be off to the hospital. Cozens is on a rampage." The door slammed and he was gone.

Joseph shot Tom a quizzical glance. "Cozens?"

"Chasing purple elephants out of his room every night."

"Daft, is he?"

"Not if you believe in purple elephants. Come. Time to earn our beef-steak." For the next two hours they copied watercolors and drawings of the masters.

Tom had supplied Monro with a substantial supply of reproductions; Joseph was puzzled. "Can't tell some of the originals from your copies," he said.

Tom chuckled. "I've more than earned my half crown and beefsteak this past year."

Joseph reached home around eleven o'clock, and found William asleep at the bottom of the stairs with a knotted walking stick at this side. When Joseph entered he jumped awake. "A bit worried I was. How did things go at Monro's?"

"Just fine, Daddy. I'm to work at copyin' drawings and paintings for him."

"Ah, then things did go well." He started up the stairs then turned back. "No word from Nixon or Rigaud yet?"

"Haven't heard a word, Daddy."

"You're not to worry, Billy—not to worry." Then, ignoring his own advice, he sighed and went off to bed.

Two weeks later Joseph received his bone.

Nixon himself brought the word at two in the afternoon. Overwhelmed, William closed shop for the remainder of the day. He was so filled with excitement it would have been dangerous for him to use a razor on someone's face. Joseph, returning from another trip down the Thames with Gig Pipes, arrived to a rare event. Smiling broadly, Joseph and Mary Turner were sharing a bottle of red wine.

She was granted the moment of revelation. "Son—your Mum's got something to tell you."

Joseph turned to look at his mother. And during that moment he saw a happiness that had been absent for a long time. Suddenly it had blossomed in her face, in the tears welling as she gently pulled him into her arms.

"Billy. Oh, Billy."

"Yes, Mum."

"We're so happy for you. So proud. You—" Crying now, she stopped, turned from him and went to sit on the divan.

William, caught between Mary's emotion and happiness, spoke for her. "Billy—you've been accepted at the Royal Academy. Your Mum and I are proud as can be."

Joseph stood for a few moments smiling in joyful silence. The worry that had hung on him like a bag of stones left him little by little. Going to his mother, he said only what he could bring himself to say, "Mum, I'll do my best for you and Daddy." Actually he hadn't realized that she attached so much importance to the Academy; he had doubted that the place even crossed her mind.

The visit to Monsieur Rigaud had paid off. A month had passed and the Academy auditorium was filled to capacity. Joseph sat between his father and Tom Girtin, perspiring from head to toe. For reasons of her own, Mary had decided not to attend. William was flushed with excitement; Tom appeared as calm as a cat. A slight stirring came as Sir Joshua Reynolds took the keeper's chair and rapped three times with a gavel. The white-stockinged custodian stepped forward and laid the names of the six probationers before him. Though nearly blind by now, Reynolds glanced at them. "Fellow academicians, I will now proceed with the induction. Would the candidates please stand."

Nervously, Joseph stood along with five others—all seven years and more beyond his age.

"Congratulations, probationers, and welcome to this prestigious body. You may be seated." The custodian whispered into Reynolds' ear. He nodded. "It has been brought to my attention that at fourteen, Joseph Mallord Turner is the youngest ever to be admitted here. Congratulations, young man. Please stand."

Joseph stood up and quickly sat back down amidst thundering applause. William beamed. From the expression on his face, one might have thought that Joseph had been granted a knighthood.

Reynolds cleared his throat and began his discourse. "We have lately lost Mr. Gainsborough, one of our great ornaments. It is not our business here to make panegyrics on the living, or even on the dead, who were of our body. Praise of the former might bear the appearance of adulation; and in the latter, of untimely justice. My object is not so much to praise or to blame him—"

"But to castrate him," Girtin mumbled.

Reynolds rambled on for nearly an hour, mostly about Gainsborough's deficiencies, which he granted no apologies for. He concluded, "And if any little jealousies subsisted between us they are forgotten."

"Bull," Girtin muttered.

The ceremony had ended; Reynolds' mumbling had passed over Joseph like clouds of smoke, and he felt exalted. Later, when he stood smiling between Tom and his father, both Nixon and Rigaud congratulated him.

"Thank you; thank you," he said over and over again to the compliments that rained on him from the other academicians.

"Well, Joseph," Tom said, "You got your bone. Tell me, how do you feel?"

"Like I'm going to distinguish myself."

"Stand up to this bunch of back-patters. Let 'em know you're sticking to your guns."

Gig Pipe's words spilled out of Joseph. "I'm to piss square into the wind, even if it's blowin' against me."

He had ascended to this fine moment unequaled by anyone his age— practical, tight-lipped and unpredictable. Now, on the afternoon of this turn in his fortunes, he sensed two powers lording over him—as though he was being moved with primal persuasion by one and with some generative force by the other. Desire boiled inside him, but even on this exceptional day he wasn't puffed up about himself. Besides painting, the things he liked most were still hoisting sails and rowing skiffs. Nothing else had changed. The earth, seas and sun had kept at their elemental duties. That night, snow fell on the soot and grime of Covent Garden, and England was about to enjoy its whitest Christmas in ten years.

Joseph awoke the following morning in a sweat, troubled by a dream in which he had been nailed to a wall in the Academy. His arms had been stretched to the thinness of thread, and one of his legs had been shorn from his body. He had felt like a human cross with blood gushing down his sides. Haltingly his hand touched the wet sheet. "Cripes!" He had urinated all over the bed.

He glanced out the window as he dressed. It had stopped snowing and the big oaks stood stiff and black, bare of their leaves under the snow. A large towering cloud in the shape of a bear hovered over the distant horizon, and for a fleeting moment a thin line of pinkish-violet sun wavered through its belly. He thought back to the ceremony and a warm feeling flowed through him. Then suddenly he was mumbling "Gully. Poor Gully. What's to become of him?"

The odor of urine struck his nose, and he was pulling the sheet off the bed when he heard the yelping of a dog, then the screaming of his mother from the backyard. He bolted down the stairs and through the kitchen to

the yard. His cat, Toby, lay dead with a broken spine, and his mother was whacking at the assassin with a broomstick. With fangs bared, the cornered dog lunged toward her as she swung, missed and fell to her knees. Quickly Joseph rushed in with a kick to the animal's belly, and yelping, it escaped through a hole in the fence.

Joseph dug a grave in the corner of the yard as Mary tied a pink ribbon into a bow around Toby's neck. Snow was falling when they buried him; for a while afterward Joseph stood at the kitchen window, watching until the grave was completely white.

Later, the two of them sat at the table having tea with snips of ribbon lying between them. After a long silence, Mary sighed, "Poor thing. 'Twas a horrible death she came to." Joseph glanced at her. Had she forgotten that Toby was a male? She sipped her tea, took a small piece of ribbon in her hands and studied it for several seconds. "Pink was best for her and she always looked pretty in this color. Death's choosey about colors you put on loved ones. Pink, blue, yellow for the young—black, purple, gray for the old. That's the way death wants it." Then, to his astonishment, she jumped up from the table, poured warm water from a teakettle into a wash pan, broke a bar of soap in half and motioned to him. "Come here, Billy, I'm to do something about that hair of yours."

Herr Fechner, a gaunt, stony-headed, masterful man, was in charge of probationers, and his fierce eyes and gruffness usually reduced them to dust. He had been born in England but brought up in Stuttgart, where his father taught sculpture, and he frequently lapsed into German. The first session of the Academy's plaister classes department had begun, and all six probationers stood nervously awaiting Fechner's first words. Slowly he scanned his charges, stopping beside each for an instant to let them appreciate the fury in his eyes. He took a sip of water. "All of you look eager and bright, with your pockets full of dreams. Good, but listen to me. Stuff the dreams in a bag, tie them up and forget them, and not until you're ready for them do you pull them out again."

When someone snickered, Fechner's left eyebrow arched to a peak. "Ah, one is amongst us who takes such advice lightly. Tighten your britches,

young man; you're in for a rough ride." The probationers stood at attention like sticks, their faces bathed in solemnity. "Now take your seats and take out your sketchbooks." He turned and pointed to a row of life-size plaister figures. "You're to pick one of your own liking and bring life to it." He looked sternly at the group for a moment. "Any questions?" Silence. "Good. Now get to your work."

Joseph arrived at Fechner's desk with his first assignment in very little time, and after he waited for a long excruciating moment, Fechner said, "Ah, already you are finished?"

Joseph cleared his throat and held forth his sketch. "I am, sir." He watched as Fechner observed it without the slightest sign of emotion, and squirmed a bit as the silence lengthened—feeling like every eye in the room was piercing his back.

Finally Fechner spoke—but to himself. "*Es ist nicht so gut.*" He handed the sketch back.

Anxiety submitted Joseph to a mistake. "Come to think of it, sir, I might have done better with that right leg."

Fechner's brow darkened and his eyes blazed. "It never occurred to me to ask you what you thought—nor does it matter."

"Yessir."

"But I this agree with you. It is the leg of an elephant—not a woman." Snickering filled the room. Joseph was about to return to his seat when Fechner hailed him. "You are here to study, learn and listen. Inquiry is fine, but unsolicited comment to your instructors is not." He made a small motion at the sketch Joseph held. "Put blood in the veins. Make the flesh touchable and give the mouth some reality, such that it would not surprise if it spoke." He turned away to make notes, leaving Joseph to digest his words and give further study to the subjects. Joseph felt demeaned. Herr Fechner had humiliated him in front of the entire class.

The master's irritable remarks were still ringing in his ears at suppertime. Later in his room he launched a counter-attack against Fechner—spending two hours putting blood into veins and making flesh touchable. At half past twelve he snuffed out the candles and climbed into bed.

It was a Saturday morning when Joseph looked from his window to see Gully Cooke, his aunt and constable Cleary crossing Maiden Lane toward the house. He ran down the stairs, upturning a chair as he went. Mary whirled about. "Billy!" What in God's name's wrong with you?" Clutching her apron she followed him to the front door.

Joseph and Gully grabbed one another and began jabbering. Nearly a year had gone by since they had seen each other. Mary acknowledged Belle with a quick bob of her head, then stared at Cleary. "What's going on here, Constable?" she asked.

"I need your boy over at the gaol, Madam. Won't take long. I'll send him right back."

"The gaol—for what?"

"It's to do with the culprit I've got locked up."

Mary's confusion deepened. "Billy, go fetch your father."

After a few moments William came to the door clutching a wig. After giving Belle Prescott a quick hello and a handshake to Gully he turned to the Constable. What's the trouble, Cleary?"

"I think we've got the murderer of this lad's father. Fact is, I'm sure of it, but I'm needing your boy to help identify him. Come along, if you like."

"By all means I'll come with you." William ran back to his shop, dropped the wig and apologized to his customer, then with the others he set out for the gaol. Confused, Mary shook her head and went back inside.

The gaol, just a block off Maiden Lane, was properly called "the dungeon." Cleary rammed a big key into the lock, twisted it, and the gate swung open. Once they were inside he relocked the gate and motioned for the others to follow. They walked about twenty feet through a dark tunnel and emerged at a small square of light, beyond which were three cells where prisoners stared at the group from behind iron bars. The odor brought Belle's handkerchief to her nose. At the last cell, Cleary picked up a lantern, lit it and held it above his head. Alone and sitting against the stone wall with his feet chained together was the suspect. Belle cringed at the sight of him. William stared angrily. Gully and Joseph seemed paralyzed.

"On your feet, Brogan," Cleary snapped.

The man rose slowly, with an ugly bruise showing on his forehead and stared menacingly at Joseph and Gully. Cleary pointed at him. "Tell me, lads, is this the one you saw outside Mr. Cooke's house the week he met his death?"

The reply was in unison. "That's him."

"And the same one who came at you outside your house, lad?"

"It's him," Joseph responded.

Cleary took a silver watch from his waistcoat and handed it to Gully. "You ever see this before?"

Gully's hand trembled as he studied it. "It's Pa's."

Cleary nodded his head confidently. "You just put the rope 'round his neck, lads." Then from a dark corner he took a brown jug. "This," he said, glaring at Brogan, "was the property he stole off Gig Pipes' boat."

"You're all bloody liars!" Brogan roared. His voice seemed to shake the place.

Cleary ignored his rage. "You lads 'ave done the Crown a big service. I'm proud as can be of you."

"What's to become of that devil?" Belle asked as they left.

"He'll be judged for killing your brother, found guilty, and for that he'll git his due."

Jules Brogan's trial lasted five days. He was found guilty and sentenced to hang for murdering Timothy Cooke with a dockman's hammer. Belle Prescott was invited to the hanging, but she failed to show up. Early on the morning of the execution she took Gully off in a coach, without giving Joseph the chance to bid him goodbye.

William was at Newgate Prison to see justice done. The morning was cold and wet. Brogan stood waiting. And there were those who considered him lucky for escaping the Press Yard, where the condemned were pressed to death. It had been a busy morning for Cleary. Since dawn three others had been hanged outside the Debtor's Door. His order to Brogan was blunt. "Step forward. You've the right to a last word."

Brogan stared at Cleary then exercised his right. "Boil yer pecker for supper, bufflehead."

"That's it?"

"That's it."

Cleary motioned with his hand and Ratlon Swaine stepped over to place a black hood on Brogan's head. "Wipe your bung with it, nip," Brogan scoffed. "I won't be needin' it."

Cleary signaled for action and Ratlon secured the noose, stepped back then flung the other end of the rope over the gallows arm. Brogan only grunted when they strung him up, then for several minutes he swayed back and forth before being dropped to the platform. Blood trickled from his mouth and he was turning blue when Cleary turned him over on his back. With one last gasp Brogan spit blood into Cleary's face and died.

CHAPTER SIX

As Jules Brogan's sentence was being carried out, Mary Turner sat in bed propped against two pillows. After dozing off a couple of times she fell asleep. She awoke thinking she had slept for only a few minutes. Two hours had passed.

As he was leaving for the Academy, Joseph looked in on her. She smiled at him so oddly that he paused to stare at her. "You alright, Mum?"

She motioned for him to sit on the bed. "I've just left Mary Ann." Joseph sat down beside her, listening. "We went to a valley where a lot of angels were waiting. They took us to a man with a beard and a wrinkled face. They said he was a thousand years old. He kissed Mary Ann and asked her to stay with him forever and put her on a throne made of beautiful pink flowers. Then we all lay down and went to sleep. It was so quiet you could hear stars moving and the sky turned red with flocks of black swans flying right through it. 'Twas a sight I'll not forget."

It had become painful to him. He spoke gently, attempting to stop her. "Mum—"

She went on. "When we woke up, everybody had gone. Only the throne was left and Mary Ann climbed into it. She looked so happy there, waving goodbye to me. We're not to worry one bit, Billy. They'll take good care of her." She paused for a moment. "I rode home on a white horse with wings and fire in its eyes. When I got off its back it went plunging over a cliff and broke up into little pieces on the rocks." She was sobbing now. "All shattered and bloody it was. I hated seeing it die like that." Suddenly, as if awakened, she stopped and dug her face into a pillow.

"'Twas a strange dream, Mum—very strange."

She screamed as though he had struck her. "It was not a dream! You should know that!"

"I'm sorry, Mum." He got up slowly and continued down the stairs mumbling to himself. "Poor Mum, poor Mum."

At the close of that same day, the plaister class experienced a most unusual event: Herr Fechner smiled. With Brogan's execution it had amounted to an odd day for Joseph, yet nowhere in the offing had promise seemed so full. He was learning a lot at Dr. Monro's and becoming more fluid in his sketching and watercoloring under Fechner's tutelage. After the other probationers left, he remained for a few moments to complete a drawing. With one final, graceful stroke he blended the line of a neck into that of a shoulder, then sat back and carefully observed the portrait of his mother. He liked it.

Herr Fechner was pulling on his coat when Joseph approached him with the drawing. Fechner studied it for several moments. "It is good—very good. You are familiar with the subject, *ja?*"

"For sure I am, sir."

"It shows."

"Ah, thank you, sir."

"The line's thin between life and art. Do you agree?"

"Sounds right, sir. But could you answer just one question for me before you go?"

"I'll try, Josef."

"Pardon me, sir, but why's the sun so bloody hard to paint?"

"So—you too are having problems with it?"

"Yessir—and for a long time."

Fechner rubbed his chin, pondering. "That's a good question, and a difficult one, Josef. Its glare has always burned like salt into these frail eyes of mine. Once, after looking directly into its orbit, I turned away quickly, a little bewildered and not knowing what I'd been looking at, or what I'd been looking for. I could only remember it as a ghostly moon shimmering in a pale sea of heat." He smiled. "I'm afraid anyone who tries painting such puzzling imagery is asking for trouble." He touched Joseph's shoulder. "But that's not to keep you from trying."

"No, sir, afraid not."

"Good. Obviously the challenge is there waiting for you. Well, it's heavy with obligation, Josef, and you'll need a lot of patience. But I'm quite sure

of one thing. In case the sun ever decides to divulge its secrets to you, those eyes of yours will be wide open and listening."

"Well thank you—and a good evenin', sir."

Fechner put on his leather cap. "*Aufwiedersehen*, Josef." Then very slowly he made his way out of the room.

Fechner's compliments had sent him home in a buoyant mood. His mother was asleep on the divan and his father was setting the table for supper when Joseph handed him the portrait. After studying it for a few moments William broke into a generous smile. The aquiline nose, the frizzed hair sticking from beneath the flappers of her cap, and the somberness were all there. "Son, your mother will be pleased to the depths."

William seemed to be right. When at supper Mary was shown her portrait she gave it an admiring glance and smiled. Then, to Joseph and William's astonishment, she casually tore the drawing in half and thrust it into the candle flame. It flared, burned her hand, wafted to the table and set the cloth afire. The scorched hand triggered fury. She grabbed a bowl of cabbage and flung it against the wall. William grabbed her as the flames spread. Joseph snatched the burning cloth from the table, threw it to the floor then stomped out the flames. Biting, scratching and kicking, Mary seemed bent on destruction.

"Billy, you'd better go get Dr. Monro. Hurry."

Smoke curled out the door and over Joseph's head as he left the house running. The day that had begun with a hanging and promise had now erupted into madness.

Exhausted, quivering, her eyes tightly shut, Mary lay on the floor beneath a quilt when Doctor Monro arrived. William lay beside her, his cheek smeared with blood where her fingernails had dug in. Monro doused a wad of cotton with camphor and waved it beneath Mary's nose. She stirred, shook her head as her eyes opened she stared blankly at Monro. "What are you doing here in my house?"

Monro spoke softly. "It would be best if you took to your bed, Mary."

"I'm to stay right where I am, and I want you to vacate these premises right away!" Snatching the end of the quilt, she pulled it over her head.

Monro removed his spectacles then took William aside. "Best you send her to Bethlehem Royal Hospital. She'll get good care there. I'll be looking in on her every day."

William shook his head sadly. "She'd never stand for that."

"You're to make the decision, Turner. She's incapable of doing so. Try explaining it to her tonight. She might understand."

"I'll try."

"Good. I'll send two attendants first off tomorrow morning. Sorry, Turner."

The mention of Bethlehem Hospital had sent Joseph into despair. He had heard that it was a lunatic asylum where inmates were kept in cells like caged animals for visitors to gawk at, some chained to walls by the ankle. The violent ones were either whipped or ducked into cold water. The thought of his mother in such a place devastated him, although he was certain Dr. Monro would never allow her to suffer such a fate.

The attendants arrived, but the straitjacket they brought wasn't needed. Mary shook William's hand as though it belonged to a stranger then went peacefully to Bethlehem Hospital. Joseph had remained in his room, feigning sleep, avoiding her departure, holding his drawing of her to blame for starting all the trouble.

With his father, he went to visit her twice every week. "Your mother will come home good as new," Monro promised six months later. Inevitably he would make the same promise after another six months had passed. Once she stared at Joseph curiously. "Who is that standing by my bed, William?"

"Why—why that's your son, Mary."

"I've no son. Never had one. Don't lie to me, William."

Joseph went sleepless for two nights after seeing her strapped to a bed with a rag pulled between her teeth and knotted at the back of her head. Monro explained that it was to keep her from biting her tongue. After that, William thought it best to visit Mary alone.

Joseph was slowly learning to live with the rage of his mother's illness. He tried blotting out the madness, but it was too complex, too baffling. He could only stare at it from a distance and accept it. The contorted face, the

terrible railings, forced him toward resignation. Monro's prediction of eventual recovery had no doubt been sincere, but now even he would have to admit to being wrong. On his final round of the day he entered Mary's room to find her staring at the ceiling. He didn't speak, but she sensed his presence. "When will they hang me, Doctor?"

Monro was startled. "Hang you? Why'd you ask such a question?"

"Murderers hang, don't they?"

"But you're not a murderer. Never say that again."

He felt somewhat confused. Just what relationship did her hallucinations have with reality? He rubbed his brow wearily and with good cause. Mary Turner lay anticipating the hangman's noose. Just down the hall, Cozens was chasing purple elephants from his room. Back at the palace, King George III had taken to crawling beneath his bed, trying to make peace with a plum tree.

Fechner's confidential report on Joseph to the Academy board, noted: "More than any student I have taught, young Turner shows an inner understanding of himself and his aspirations. At times, he works too quickly and carelessly, but he is capable of applying himself and continues to make progress. He is a stubborn sort, but he has a willingness to learn. His mind is keen and intense, but not necessarily profound, and his love for work is an asset. He is hypersensitive, prideful and shy at times, and one senses considerable goodness in him. He admits to faults when they are pointed out, accepts advice reluctantly, but heeds it with favorable results. Most importantly, he seems to have a mind of his own with a determination to express it. I find this good. He's not the type to be buttoned down, and should be allowed a controlled freedom. In this, I feel he will best steady his present achievements. He has traits that tend to hold him unpopular with his class brothers, and he is sometimes secretive and withdrawn and pretty much keeps to himself—and for that he cannot be faulted."

Fechner was right about Joseph's unpopularity with the other probationers. To them he was a strange mixture—unfriendly and secretive, without hardly ever a word outside of a curt "hullo." They respected his talent, even envied it, but thought his sketches, drawings and colors were

too wild. Jimmy Hinton, a somewhat gregarious type, had tried breaking through Joseph's reserve, but with no success. However, when Jimmy was missing for several days, it was Joseph who asked Fechner about his absence.

"I fear his mother's dying," Fechner had replied.

"Is there help to lend him, sir?"

"None, I'm afraid, but it is thoughtful of you to inquire, Josef."

Hand-picked wildflowers found their way to the coffin when Jimmy's mother was buried two weeks later. A rather scruffy card came with them. "Sorry, Jim," it read. Signed Joseph. Certainly Jimmy Hinton might have expected a softening of his attitude after that. It didn't happen. Joseph's greetings remained as Spartan as ever. "Hullo, Jim." "See you later, Jim." Silence seemed to obsess him when he was in the presence of his fellow probationers.

CHAPTER SEVEN

Two years had passed. With Gully gone, the plaister class about to suspend
for three months and Tom Girtin off in the highlands sketching for Lord
Sussex, Joseph faced a dull summer. Bluntly, Fechner offered advice. "Go,
find the right place and put yourself to work."

John Narraway's estate at Broadmead, Bristol, with its sculptured
gardens, grand oaks and secretive groves, seemed to be the right place. Fish
and the manufacture of glue had lifted Narraway above the masses, but his
friendship for William Turner the wigmaker was a long and loyal one.
Narraway was tall and portly with curly black hair that fell to his shoulders.
Given to moments of self-exaltation, he seemed to prance with each step.
Madam Narraway, whom he referred to as "Lady," was a buxom woman
with a soothing tongue. She mothered Beatrice, her daughter, and her two
nieces, Ann and Elizabeth Dart, with unbridled affection.

Broadmead was a beautiful house, where everything glowed in candle-
light. Fine paintings covered the walls and a life-size portrait of Narraway
looked down upon the dining table. On Joseph's first evening there, dinner
was wild boar with apple dumplings. Later, in the drawing room, Narraway
read from Milton and Langthorn, then, after an enormous intake of brandy,
he fell asleep in his great chair. Lady Narraway and the girls went to their
beds, and Joseph to a four-poster in a bedroom at the end of the hall.

Officially spring had arrived, but winter still hung in the air. With a wool
scarf tied about his face, a traveling box and his pockets bulging with cheese
and bread, Joseph reached the peak of the moors the following morning.
The River Avon, the gorge and the vast wild countryside, reduced him to a
speck on the universe. Fog drifted the lowlands. Swiftly moving cumulus
floated over the upper reaches, shadowing them with patches of darkness.
The sun burst through, giving shape to everything it touched—the cliffs,
the earth and the river. Fringed with yellow and floating over the opposite

shore was a huge dusty-blue cloud. A cloud-finger of copper pointed toward it. Joseph gasped. It was poetry. He worked on, stopping only to blow warmth into his fingers. He was uncomfortably cold and the sun had slipped beneath the horizon when he finally headed back to the warmth of the Narraway House.

He found poetry, too, in the well-formed breasts and curvaceous buttocks of Elizabeth Dart. And he sensed that she was not exactly unaware of that. The sudden shift in her wearing apparel had become rather suggestive—showing her voluptuousness in the right places. Spring finally arrived and the moors bloomed. Sissle leaves sprouted from heather stems, ivy climbed the rocks and the scent of jasmine floated in the air. On his sixteenth birthday, Joseph invited Elizabeth to accompany him on a trip to the moors. She accepted.

They climbed silently, she with a picnic basket and blanket, and he with his sketching, his thoughts on those pleasures beneath the tightly bodiced dress. Midway to the summit they stopped at a shaded spot beneath a copse of low elms. His heart thumped when she stood for a moment and allowed the breeze to flatten the dress against her body. Her hair blew wildly and her breasts heaved from the climb. "I've never seen the river from here." She was lying of course. The blanket was spread and they sat down on it. "This should be a very special day for you, Joseph. It was the day you were born."

His cheeks reddened. "'Twas nice of you to say that, and it is very special—because you're here."

"Oh?"

"You're about the most beautiful girl I've ever met."

Her smile oozed with innocence. "And how many have you met?"

"Ah—so many 'twould be hard to remember."

Seeming amused, she pulled back her hair and knotted it at the nape of her neck. "It is indeed a personal question, I know—but have you ever made love to a woman?"

"Ah, yes. Surely I'd confess to that."

"So, you are betrothed, Joseph."

"Oh, no—of course not."

She turned to stare at him angrily for a moment. "Then quite obviously you're a culprit with dishonorable intentions. I shouldn't have come here with you. Heavens, you are a cur!" Denying him further explanation, she jumped to her feet and fled down the path, leaving him alone to feel like a wounded animal. So quickly the beautiful day he had anticipated was over.

At supper, John Narraway led the birthday song. Everyone joined in, except Elizabeth. The cake for Joseph was cut and everyone ate a slice, except Elizabeth. Narraway's wineglass shot upward. "To Joseph, the prince of the rocks. May he paint the Kingdom to glory!" All glasses raised, except Elizabeth's.

Joseph's voice was repentant when he saw her for a moment in the hallway. "I'm sorry for what I said this morning. 'Twas a sort of joke, all of it and—"

"I'm not one to be joked with in such a fashion. Good night Joseph." With a flounce of her calico skirt, she marched off to her room. For the rest of the week she did not speak one word to him.

A carriage waited at the front steps when he left for the moors the following Monday. He had crossed the King's Road when voices turned him about. The cook was helping Elizabeth out with her bags. If she saw him she didn't let on. He watched as the carriage disappeared around the bend of the road, shrugged, then went on. Reaching the peak, he forced his thoughts toward the imagery that he hoped would soothe Elizabeth's departure—Avon Gorge and those unmatchable uplands. She had knifed deeper into his heart than he cared to admit. The following morning he suffered from indigestion; a severe case of loose bowels on the next. For three days he failed to sketch or paint. But gradually his concern for her begin to vanish, and before long his heart felt no further need to mourn her absence. He had just experienced his first love-thirsty spring.

During the rest of the summer he made sketching trips to Wiltshire and Malmesbury on a pony Narraway lent him. In late September, he arrived

back at Narraway's with a lame pony and a bad case of laryngitis. With October only a fortnight away, he began packing for home. Just before his departure, a letter came from William informing him that his mother was home from Bethlehem. William wasn't sure of how long she would be allowed to stay. "With God's blessing she might be home for good. My fingers are crossed, Billy. I just don't know what to expect. My love and thanks to the Narraways for putting you up. We're both looking forward to seeing you."

The stagecoach carrying Joseph homeward was four hours from London when he was struck with a violent croup. By the time he reached there he burned with fever, and blood colored his spittle.

"Pneumonia," Dr. Monro gravely pronounced later that evening. He had returned unhinged and dangerously ill from the exhausting journeys into the highlands. Unexpectedly, Mary Turner's behavior during the perilous hours was a model of motherly concern. Seldom did she leave he son's room. She bathed his brow constantly, fed him, and watched over him day and night.

He plunged deeper into delirium. Mother, father, doctor, walls, ceiling—all silent formless ghosts swimming silently in and out of his subconscious. The solitary candle flame—a ball of fire flickering in unfathomable darkness. For a few moments of the third night the delirium thinned. He was looking into the mask of a face moving over him. He stirred, his eyes focusing through the dimness. The black sockets were slowly dissolving into eyes. He tried to sit up. His strength failed him.

"Mum . . . "

"Yes, Billy."

"Where's Toby?"

"Why—Toby's with Mary Ann, Billy. Didn't you know? She'll take good care of him. You're not to worry."

"I'm glad you're here, Mum. I . . . " His eyes closed wearily. His thoughts were curling into blackness again.

She was cooling his brow with a damp towel when William entered the room. "Mary, please, you're to go to bed and get some rest. It's four in the mornin'."

"I'm to stay right here, William. Billy's my son and he's in need of me." The resolve in her voice put an end to further conversation. William went on hoping that she was getting better, but still he kept his fingers crossed. Monro also remained cautious. They could awaken any given morning to find their hopes wrapped in disappointment.

Mid-October found Joseph still weak but satisfactorily recovered. He was back at the Academy and earning his half guinea at Monro's again. It was a work night and Tom Girtin was two hours late. Monro was worried. "It's not like him. Something's happened, I'm afraid." Another hour had passed when Monro answered a knock on the door. Girtin's mother had arrived with tears in her eyes. "Tom's in the gaol at Bridewell."

"Bridewell? Come in—come in, dear lady."

"Dayes had him gaoled and I'm needing your help to get him out."

"Dayes? Why'd he do such a thing?"

"I don't know, but he did it, nevertheless, and you've got to help. Tom's all we've got to keep us going."

"To be sure I'll help, dear lady. You're not to worry."

After Monro's assuring pat on the shoulder she left, then he and Joseph hurried off to Bridewell.

They were approaching Tom's cell with Constable Cleary when Monro's eyes narrowed and he gasped. Working by candlelight, Tom was chalking a mural onto the cell wall, complete with the London Bridge, the Thames, people, boats, gulls and billowing clouds.

"Tom."

He whirled about to Monro's voice, his hair tangled and matted, his face and arms filthy with dirt. "Ah, at last you've come." He pointed at the mural. "And what would you say to that?"

"You do look a mess, lad. What on earth are you doing here?"

"I'm a guest of that leather-head, Dayes."

"What happened between the two of you?"

"He got on me about a bloody sketch. Says the sky was wrong. Well, I'd already had a'nough of his niggling that morning, so I said, 'hold your jaw, nip.' The blighter starts bellowing and puts his dirty finger in my face. And

for that I did him a mean smack in the eye and walked out. Next thing I know, Cleary's at my door. Then he throws me in this stinking clink."

"How long have you been here?"

"Three days of it I've had."

"Monstrous. I'm to be getting you out of here right away."

"Jolly good news. It's vomit they feed you here." Cleary was unlocking the cell door. "Ah, so old whale belly's about to let me out."

"A'nough of your lip," Cleary growled, and as Tom walked out he shot him a warning. "If you're in here again I'll put me belt buckle to your arse."

"Go pump yourself, Cleary."

"Quiet, Tom," Monro said, hustling him out to the corridor.

An hour later Tom was washed and enjoying roast beef at the doctor's table. Monro eyed him with curiosity as he hungrily chewed the meat. "You'd best be careful with Dayes," he warned. "He's got kin in high places."

Tom took another slice of beef then cut into it. "Not one bit sorry for what I did. That fusspot's too high in the belly. He needed a smack in the eye."

Tom was heating up again, and Monro quickly turned the conversation toward a more amicable subject. "I'm considering taking the Grand Tour soon as possible. It's far too late to go into details now. I'll get into that next week." He then canceled work for the evening, and as they ate the horrors of Bridewell gradually fell away.

The Grand Tour. Joseph thought it a coincidence that Fechner was closing his lecture the following afternoon on its importance. "Switzerland, Italy, Germany and France—all necessary to a painter." Fechner shrugged. "But chances for getting to France soon are no better than your getting to the moon, what with those heathens chopping off royal heads all over the place. Now England's muddled into the mess, and art suffers. I am afraid we are headed back toward the Middle Ages." He closed his sheaf of notes. "That is all. You are dismissed."

Joseph confronted the cold January evening with a cup of hot chocolate on his mind. He was taking a shortcut through a field of fresh snow when he saw a great plume of smoke billowing into the sky. Something huge was

afire. Hurrying toward it, he soon reached Oxford Street, where he saw the Athenaeum belching smoke and flame. He pushed his way through lines of spectators, stopped precariously close to the burning structure and began sketching. Firemen were pumping water into the blaze. Several clerks from the building stood helpless among the spectators. A stairwell broke loose from a wall, exploded in a ball of flame and plummeted downward. Then with a roar an entire ceiling crashed into the inferno. The fire raged on and Joseph sketched until it burned itself out around midnight.

Four days later he presented his painting of the catastrophe to Fechner. After scanning every inch of the watercolor Fechner mumbled to himself, *"Das Feuer ist kalt."*

"Pardon, sir?"

"The fire, it is cold."

Joseph frowned. "Cold?"

Fechner's fingers touched the painting. "The flames should burn at the touch." He pursed his lips. "It is good, but now you put heat into it."

Joseph pushed on. "Hardly good, sir, if it's needing work. Would you agree, sir?"

"I do not make a profession of being in doubt. The fire is cold. Rework it."

Joseph took the painting and went back to his seat feeling charred to the bone.

Nearly a month had passed when Fechner questioned him about the painting. "And how did the reworking go, Josef? You never brought it back to me."

Suppressing a smile, Joseph replied, "Very well, sir. It's been accepted for the Academy show this spring."

"Ah—then I have reason to congratulate you . . . "

"I'm much obliged, sir. I—"

" . . . but in the future allow the courtesy of approval of your instructor before submitting to the exhibition panel. You are still the probationer. I hope not to find it necessary to remind you again." His eyes dropped to a stack of papers and he began reading. The day was over and the probationers filed out. Crushed, Joseph also turned to leave.

"Josef?"

"Yes—sir."

"A word with you." Fechner twisted around to face the window, and suddenly he looked pale and crumpled in the gray winter light. "Josef, yours is the kind of imagination that escapes most of us—something that as a young painter I wanted but didn't have." Joseph's brow wrinkled as Fechner went on. "With hard work, and faith in yourself, you could dismiss yourself from the ordinary lot. God, or maybe the devil, blessed you." He turned to observe the puzzlement on Joseph's face. "You don't know what I'm talking about?"

"No, sir."

Fechner turned to look out the window. "You are a rare talent."

"I'm very flattered, sir."

"I don't stoop to flattery, Josef, and I think you are more aware of yourself than you are willing to admit. You live in the center of Josef. I find no wrong in that." He took a pipe from his pocket. "That's not to bother the likes of you. What's important is that you've got the gift—and you're not to let a soul botch it up, not even yourself. Better you shut your soul to most of the rot you'll hear and go on your own. You'll be beaten down by all sorts of devils, but you'll learn to survive. Your stubbornness might help you there." He packed tobacco into his pipe and lit it. "It's unforgivable to fail at something you are meant to do well." Suddenly, his head dropped. For a moment he looked as though pain had struck him.

Nervously, Joseph asked, "Are you alright, sir?"

"*Das ist alles.*" He waved Joseph away.

Joseph returned to his desk and scribbled a note to himself: Need ocher, cobalt blue and a batch of vermilion. Fechner sat dozing in his chair when he looked up. Joseph left the room quietly so as not to awaken him.

Dayes and Monro had been Tom Girtin's mainstays, but eventually important engravers and publishers had begun sending him on sketching tours. With Joseph, he had taken a week's trip to Yorkshire. Here, Henry Lascelles, the Earl of Harewood, had brought them to capture the splendor of Harewood House and its spacious surroundings. Between them they had

completed ten sketches of the magnificent buildings rising under the Yorkshire clouds that rolled eastward above Almscliff Craig.

Now Joseph, through Tom's help and the Academy's consent, had accepted several commissions. The ensuing twelve months suited his account ledger nicely. M. Cadell, a publisher who kept topographical demands to a minimum, was giving him lots of work. Joseph did pretty much as he liked—seas, storms, wrecked vessels and landscapes. But Cadell did pinch a guinea. Even when Joseph rode mail coaches to cut down traveling expenses he failed to show appreciation. Before leaving on another tour, Joseph complained. " I gave you nine mills and a couple of kilns not even on your list, sir, but you don't offer me one guinea extra."

"I promise to make it up to you, Joseph."

"And I promise to remind of your promise."

It was uncommonly hot as he worked his way through the countryside of Kent countryside on foot. He traveled light, carrying only a tiny sketchbook, watercolors, a makeshift easel and a small box of tools. Morning was over and the sun was still under the clouds. After a meal of sausage, cheese and bread he found a grassy knoll and stretched out flat on his back. A few minutes later he was sound asleep, his mind swimming within a dream—an improbable dream, the color of lightning and shrouded in smoke. A wave of heat suddenly touched his face and his forehead opened like a door. At least he thought it opened. Blue stars glided in. A crescent moon drifted in. Smoke poured in. He was closing the door when the moon pointed upward. He looked. There, white on even whiter white with its flaming mane surrounding it, was the sun—its powerful presence dominated by a solitary white eye glowing at its center. Fiercely it held him in its glare—filling his entire body with heat. Such a wonder demanded painting. Hastily he tried mixing suitable colors. All were too light or too dark! Troubled, he ran from cloud to cloud sweating, impatiently searching for colors that might blend with the circling whiteness.

He was still running hard when a school of starlings flew over and awakened him. Confused, perspiring heavily, he lay for several minutes in a daze, gazing directly up into the sun's orbit. And burning down, the sun's aura

wavered him into a hypnotic trance that lasted for hours. The sun was still challenging him, declaring its deity.

Back home during supper he quietly said, "If there's a God, I think it is the sun."

William shot him a curious glance, but Mary frowned. "Those are sinful words, Billy. You shouldn't say such things."

"I've good reason to believe it, Mum."

"No matter what you believe they're sinful words."

The subject was dropped.

Herr Fechner had a somber smile on his face when Joseph met him in the entrance to the Academy on the first of December. "Well, Josef, I've good news. This year's landscape award is yours. I'm proud of you."

Joseph beamed. In all honesty he could have said, "I bloody well deserved it." But he allowed his eyes to register surprise. "Oh? Thank you, sir. Grateful to you for pushing me. Couldn't have done it without your help."

"Spare me the sugar, Josef. I've done only what I'm here to do." He pulled out his watch and glanced at it hurriedly. " Have you seen this year's assignment board?"

"On my way there now, sir."

"You're in for another surprise." Fechner turned and walked away without further explanation.

Joseph found the assignment board surrounded by probationers. He shouldered his way through them, and took a close look. Joseph Mallord Turner had been assigned to Mr. Beauford Partridge's life class. It was a lift upward, but the unpleasant thought struck him like a brick. No longer would he answer to Fechner, whom he had grown to respect and like. Well, Fechner would still be around. Nothing to keep him from calling on him now and then.

A light snow was falling when Joseph went to see him. Collapsed into his chair, the old instructor looked to be far beyond his age. His hair was graying, his face ashen, blotched and more gaunt. Thick veins lined his forehead and his hands were like pale goat skin. Gently, Joseph touched his

shoulder. As if awakening from a trance, Fechner turned and looked up "Ah, Josef, it is you. What have you on that mind of yours?"

"I've come to wish you a good New Year, sir. And I'm sorry not to be in your class anymore. I want to thank you for all you've done for me."

Fechner was silent for a few moments before answering, "I wish you the same, Josef. I, too, confess sorrow for not having you to boot around. I ask no more than that you continue as you have in the past."

"I'll do my best, sir."

"Good." Fechner turned back into the wintry light sifting through the window. As one hand took a pipe from his pocket, the other searched for a match. He lit the pipe and blew out a stream of smoke. "You've got yourself a fancy award and some newsprint to feel grand about." He smiled weakly. "Stuff them together, put them in a closet and forget they exist. But I have one thing to say of great importance."

"Yes sir."

"You're at your best with nature. Stay with it. Don't trudge another fool's path. Remember that, Josef. Go your own way."

"I will, sir."

Fechner turned slowly, pushed himself up from the chair. Then, as if to honor him, he walked his favorite student to the door. "*Aufwiedersehen*, Josef. Have a splendid year."

Wisps of pipe smoke drifted behind them, and—for no reason he could have explained—Joseph felt with mounting anxiety that perhaps he would never see the old man again. "Goodbye, Mr. Fechner."

"Goodbye"—the wrong word. Suddenly, the very meaning of it seemed to confirm his premonition.

The gravity of the voices of the two men passing him in the Academy's foyer a week later whetted Joseph's curiosity. "Too bad—but to be expected I'd say."

"Ah, but a shame. Terrible. Terrible."

His curiosity heightened when he noticed several instructors gathered in hushed conversation. Mr. Partridge was sitting at his desk leaning on his elbows and rubbing his forehead when Joseph entered the classroom.

Normally a jolly, high-spirited man, Mr. Partridge was far from that now.

"Good mornin', sir."

Partridge lifted his head. "Hello, Joseph, but it's hardly a good morning. Mr. Fechner collapsed about an hour ago."

"How is he, sir?"

"Dead, I'm sorry to say."

Several moments went by before Joseph fully grasped the meaning of Partridge's words. "Dead? Mr. Fechner is dead?" For several moments he stood staring at the floor. Then he went slowly to Fechner's classroom and stared at the empty chair. The plaister figures, the entire enclosure, seemed to be draped in blackness. It troubled him suddenly that he had never apologized to Fechner for presenting his painting to the board without his approval. He would have been astonished to know that it was Fechner who had chosen the painting of the burning building in the show.

Joseph stood in the doorway of Fechner's classroom for a few moments, recalling the old man's gaunt frame, his sour gentleness, his butchered English and his furious eyes. He had been hard to understand; he would be harder to forget. After a final look, Joseph shut the door to the room where, in three years, he had learned things that would last him for a lifetime.

Hans Fechner's final request was for cremation. "*Keine Blumen. Keine Worte. Keine Trauer.*" No flowers. No words. No mourning.

CHAPTER EIGHT

Not a soul in Covent Garden loved grog more than Tom Girtin. Joseph had accompanied him to the White Perruke to drink in the New Year. Having downed two mugs, Tom raised the third high above his head. "Drink to me, friend. I'm to take on a wife this spring!"

Joseph had heard this from him two days before, but he feigned surprise and raised his mug. "I say, congratulations are in order. A prosperous mate you'll be takin' on."

"Ah, queen's silk she is, but I'm not to hold that against her, now am I?"

They drank to Tom's rich bride-to-be, to the coming year, to just about everything—until Tom's voice outgrew the room and they were kicked out. The quiet atmosphere at the Red Parrot had small effect on Tom's previous behavior; a slap on the barmaid's rump got them tossed out before they finished their grog. Tom's unpaid debts barred their entrance to the Green Mole. Dr. Monro was awakened at two o'clock in the morning and apprised of the forthcoming marriage. After a whiff of Tom's breath, Monro insisted that the two of them sleep out the old year on his living room floor.

It was a foggy, April day when Tom took Evelyn Boritte as his bride. As their carriage pulled away, loneliness overtook Joseph. He was a young man, feeling alone, and suddenly in need of a woman himself. Without clear purpose he walked in the direction of the Thames, reached its banks and leaned against a large oak. He thought of Gully Cooke. Where was he now? Two close friends had gone off to live different lives. Joseph felt deserted. A huge trawler was moving toward him, its sails billowing. For a magical moment, fog completely obscured the hull and only the sails floated in the grayness. It came closer, sailed by and entered another fog bank, leaving only the aft section in sight. On the hull, printed in large white letters was the legend: MARGATE. As the trawler disappeared, Joseph watched until fog swirled into the void, then took the path toward Maiden Lane. "An old

man of eighteen trompin' the woods and feelin' sorry for hisself. Bloody stupid." Walking faster, he went on toward the Academy. Midwinter classes were about to end. His desk was to be cleared and he needed sketch pads. "Have ta stop thinkin' backward. It's bloody well dangerous."

The spring showing at the Academy had opened to a full house. "*The Rising Squall*'s a magnificent painting, wouldn't you say, Mr. Turner?"

William turned toward the voice of the clergyman, Mr. Nixon.

"Thank you, sir. Surely I'd say it is. And I'm just as proud of Billy's other entries."

"You should be. He's growing splendidly into his talent."

"And you're to be praised for your help."

Nixon accepted the acknowledgment with a modest toss of his head. "Where is Joseph? Certainly he's here this afternoon."

William's eyes darted about the crowd. "He must be here somewhere."

Before them hung his son's other entries—*The Fire*, *The River Avon* and *Hotwells*.

Joseph should have been there, but he wasn't. He was attending his mother. She had dropped an iron skillet on her foot, and her screams had at last faded into a constant moan. "I'll go for Dr. Monro."

"No! I wouldn't have that, Billy. Oh, the fool I am for having done such a crazy thing."

"'Twas accident, Mum. You're not to blame yourself."

"No one else to blame. Go fetch the camphor. I feel I'm about to faint. Your father, where's he at a time such as this? Where is he?"

"He's gone to the Academy, Mum."

"For what?"

"It's the year's showings and I've some works hanging in it."

The moaning stopped. "Oh, it is so. It left my mind altogether, Billy, and indeed I'm sorry. Now hurry, you're to go join your father right away."

He went instead to look for the camphor bottle and, after a long search, found it on a closet shelf. When he returned, his mother was asleep, but still moaning. Refusing either to awaken or to leave her, he sat in a corner staring

at her. The drawn face, sunken cheeks and twitching fingers clearly meant that she was edging back toward Bethlehem. He was still staring at her when drowsiness overtook him.

Two hours had passed when William returned to find both of them asleep. He went quietly to the kitchen, wondering why, of all times, Billy had not shown up at the Academy. The heavy odor of camphor suggested something unusual had taken place. He found out later when Mary awoke and hollered for a pan of cold water to lessen the pain.

Although Joseph was being celebrated neither in London's artistic circles nor in Covent Garden, wealthy patrons, publishers and engravers were sending him on sketching tours. Ephram Bell, the engraver, had asked to join him on a trip. Reluctantly, Joseph had agreed.

The night before, they had crossed Spithead Channel to the Isle of Wight. Now a storm had sent them to shelter in an old boathouse. Confronted by a tempestuous sea, Ephram was having second thoughts. "Hardly a place for a velvet-belly like me. I'd be better off by a hearth swigging hot rum."

Joseph chuckled. "You wanted to see firsthand what you spent your guineas for. Plenty of hot rum back at Newport."

Ephram smiled grimly. "If we get back to Newport. I'm a bloody poor swimmer."

"I'll get you back to your hot rum. No Ephram; no guineas."

"Ah, you're only worried about the silver."

"That's not so."

Ephram smiled wanly. "If it's not money that drives you what is it, a need for fame?"

"Certainly not that." Joseph laughed softly. " When I was six at Brentford, I plucked a daisy to send to my mum, but I found it dead the next mornin'. But I'd made a drawin' of it, and the drawing was still fresh as ever, so I sent that to her instead. I'd put life into something with my hands, and I've been doin' that ever since."

"That's all well and good, but—"

"The sun!" It was blazing through the overcast sky.

They stepped out into the open. The clouds were rolling back and the sea was taking on a calm. A few minutes later they pushed off in the skiff Ephram had borrowed from the harbormaster. Soon the Isle of Wight lay behind. Ephram rowed as Joseph sketched. A big trawler was splitting the waves. Small fishing boats with white, green and blue sails were moving through the mist.

Suddenly, the sky blackened again, and off the Needles stormed the gale. Moments later the boats were being tossed about by giant waves. Frightened, Ephram began rowing toward shore. Joseph went on sketching. The storm grew more violent. The skiff's prow shot upward, slammed down and smacked the water. Ephram's strength was ebbing. "Take to the oars, Joseph! I'm tuckered!"

"Keep rowin'. Keep rowin'!"

"Damn your bloody sketching. Grab the oars or we're finished!"

The sky exploded with a deafening thunderclap. Walls of rain swept in. Lightning flashed. Joseph finally took the oars and started pulling desperately. But the skiff, trapped inside a powerful undercurrent, whirled aimlessly. Water was inching up in the hull, reaching their shoe tops before Joseph dropped the oars. They were bailing with their hands when Ephram looked up. "Oh, Lord!" The swell was sweeping them headlong into a barge. The skiff struck and broke apart. Clinging to the debris, they yelled for help and kept yelling. With another crack of thunder came the shrilling of a bos'n's whistle. As the barge slowed to a stop Joseph looked up to see three boatmen peering down at them. He glanced at Ephram whose face was frozen with fear. He was giving up.

"Hang on, Ephram. They see us!"

Ephram was clawing air, going under when Joseph grabbed his collar. A small raft splashed down beside them and Joseph grasped it. Then a young boatman was in the water securing a rope beneath Ephram's arms.

"Alright, lad, let's heave him on."

Joseph helped Ephram onto the raft, then climbed atop of it himself. After they were lifted over the sides he lay at last on the deck, breathing heavily. Ephram, exhausted and half drowned, lay at his side.

An hour later the storm quieted, the rain stopped, and the sky opened to a full moon as the barge sailed pass the Needles toward Newport. Ephram sat on the deck, wet and shivering, amazed at Joseph's calm. Joseph stood at the railing, sketching on a piece of sailcloth, admiring the water's sabled surface. "Such color," he was thinking, "begged for oil paint."

A week later, he reached home at noon to find his mother in black mourning clothes sitting at the kitchen's bare oaken table with her head bowed.

"Mornin', Mum."

She smiled and crossed herself. "Mary Ann looks wonderful, don't you think, Billy?"

He reached out and touched her. "Mum, I think you should take to your bed."

She pushed his hand away. "No, Billy. I'm staying here with your sister. She's not to be left alone." He sighed, turned and went up the stairs, certain now that her mind was hopelessly beyond repair.

For five days he had mulled over his experience on the Isle of Wight. At half past seven in the morning, he made up his mind. The remainder of the day was spent gathering materials for painting with oil. At eight the next morning he put the first brushstroke to the canvas. The burnt-yellow under-coating he laid on took the good part of an hour; then he went to the kitchen for bread and jam. Truth had seized him; working in oil wasn't going to be easy. It was one thing to remember the colors of a sabled sea, another thing to render them in oil on the stubborn surface of canvas.

William entered. "Mornin', Billy. Up bright and early I see." He noticed the paint on Joseph's fingers. "You're workin' already?"

"Tryin' my first oil, Daddy."

"And how does it feel?"

"Very hard, but I'm going to give it a decent try." He bit into a chunk of bread. "Mum's turnin' for the worse."

"I know."

"Bethlehem again?"

"Afraid so."

"Nothin' we can do?"

"Nothin', Billy." They were silent for a several moments. "And what are you up to this summer, son?"

"I'm off to Margate. Fechner used to say it's a good place to work."

"And I agree with him. I've an old friend there who'll put you up. Name's Maude and she does a lot of talking, but a fine woman she is."

"Sounds fine, Daddy."

Gradually the seascape settled into the canvas. Brooding clouds drifted across a full moon. Cold yellow light flared on a restless sea. Three gulls hovered above a small fishing boat wallowing in the swells, a confirmation of an experience neither he nor Ephram could forget. After two weeks it was finished, and then turned to the wall. Three days later Joseph turned it around, appraised it then scribbled a title on its back—*Fisherman At Sea*. As he lay in bed that night it dawned on him that he was approaching full manhood. He looked back through the years and they glared back with the hard sharpness of nail points. It was hard to believe they were the years that he had lived through so far. What he once had thought impossible seemed now to be possible. He dozed off with his thoughts on Margate.

CHAPTER NINE

Built like a butcher's block, overburdened with cargo and seasick passengers, the old hoy had sailed sluggishly toward Margate. But during its rough voyage, Joseph felt no urgency for the feel of land. Under the sapphire sky was a choice between encumbrance and freedom. The creaking of the hull had been music, the mesmerizing fall and rise of the horizon a reaffirmation of peace. Now Margate was just ahead.

The chalky cliffs of Thanet Isle were climbing through the haze when the macabre tableau caught his eye. There on the marshy flats just off shore were seven malefactors chained to wooden uprights. Puzzled, he stood looking at them.

"Mighty strange way to punish a bloke, wouldn't you think?" The voice had interrupted his silence.

"You're right about that."

"Well, they've committed crimes and they're paying for it. Hope I'm not intruding. I'm Reginald Forsyth."

Joseph turned to acknowledge the tall, handsome young man. "Name's Turner, Joseph Turner."

"You've been sketching a lot during the trip. Are you an artist?"

"Workin' at it. In Margate for the summer. And you?"

"Importer. Just getting started. Taking over my father's business here."

"Like the place?"

"Lived here all my life. A bit dull, but pleasant enough but—oh, sorry, my mother's a poor sailor." Taking a paper sack from his pocket he went quickly to the woman's side. Hurriedly she seized the sack, put it to her mouth and relieved herself.

Thirty minutes later the gangplank dropped. In the crowd of passengers moving toward the dock Joseph saw Reginald Forsyth carrying his mother ashore.

The cottage Joseph came to sat on the crest of a rocky slope above the north shore of the village. Uncommonly small, and with a thatched roof, its appearance might have caused one to hesitate before entering. But trusting his father's words, he knocked. After a few moments the door swung open to a fat woman with a big smile on her face.

"Would you be the Turner lad?"

"Yes, ma'am. You're Mrs. Clougherty?"

"I am for sure. Collect yourself and come in."

The warmth of her voice put him at ease, and he gathered up his belongings and entered.

Both Maude and her cosh—as she called her home—resembled leftovers from another century. She herself weighed close to two hundred pounds, and her straggly hair flopped about like a wet mop, but she radiated charm. Joseph found his room deceptively large and comfortable, with a view of the waterfront. In one corner was a small brick hearth with logs stacked beside it.

"You'll like it here, lad," she said, opening the window. The sea air's good, but no help to my gout, and that hearth draws well as any." She gave him a maternal glance. "Your father wrote that you're a painter. Well, plenty ta paint 'round these parts. 'Ere for the first time?"

"Brought here once as a child. Never been back."

"A good man, yer father." She plumped up two pillows. "Saw the first light of day 'ere I did. I never gave one thrip about ever leaving. All this talk about London and such places—not for me. Happy to be right 'ere on these rocks where I was born." With a sweep of her hands she smoothed out the coverlet. "Mighty good bed this is. Sleep's like you're on a cloud." Then standing with her hands flattened against her immense hips, she gave the room a final inspection. "Everything's in proper place. If you're needin' somethin' just make yerself heard."

"Thanks, Mrs. Clougherty."

"Maude's me name, lad, and I don't mind answering to it. Would you be hungry?"

"I am for sure."

"Good. I'm a outstanding cook." She smiled. "No bumpy meals comin'

out'a my kitchen. Now you jes' settle in. The table's ta be set with things that'll make your belly smile." The floor trembled as she waddled out of the room.

Joseph had finished his third helping when Maude looked at his plate and giggled. "So, it's true you see. I'm a dandy cook."

He nodded in agreement.

"Wilder, that late husband of mine, always said I was the best cook of his five wives, and about that 'ee was straight-fingered. Ah, 'ee 'ad faults a'plenty but about that 'ee'd not lie." A touch of sadness had entered her voice. "For that I admired 'im."

"How long is he dead?"

"Dead?" The bugger's alive as can be."

"Sorry. Thought you said you'd lost him."

"And that I did—to a poplolly who struts about the village in a tittup fashion. Ah, me mind was fumbled for a spell, but I've the sense to know that nothin's worth worryin' yourself to a grave." She shook her head. "A bad one 'ee is—skippin' out on me for the likes of 'er. 'Ee was nothin' when I took 'im in—a crook called Hasper Mullison. Now 'ee's back to nothin' a'gin."

Joseph changed the subject. "Would there be a nice park somewhere 'round here?"

"Ah, to be sure—and a fine one it is. At the foot of the path you'll note a stand of big oaks. Follow your nose right through 'em, a quick right and you're aimed for Chatham Park. A stream winds through it from one end to the other." She got up to clear the table. "A wake for 'ole Liam Conaire after midday. 'Ave to be there. Don't want the 'ole gooper hauntin' my sleep for not showin' up."

"Thanks for the food, Maude—and would there be a key to the door?"

"That door's not seen a key since I remember. Just give the knob a twist and let yerself in."

Joseph started out at eleven. Sunday had turned into a beautiful day. Sunlight sprayed the earth and a soft breeze stirred over the countryside. A moorhen, startled by his approach, squawked, splashed across the stream

and scampered into the woods. To his left lay fields of virgin wheat; to his right, hedges of thorn and alder. Nature was at its best. Beyond a small clearing he saw a forest of black-plumed trees. He scrambled up through a clump of bushes and entered Chatham Park. It was alive with villagers wandering in the blue shade. His eyes finally came to rest on a young couple who sat silently gazing into a stream, and he took out a pad and pencil.

He had been sketching for a while when a small boy came to his side. "Could I see what you're doing, sir?"

"If you like."

"Turn it about if you would. It's upside down."

"Oh? To me it's right side up."

The boy gave it a closer look. "Just splotches, I'd say."

Smiling, Joseph handed him a blank sketch pad. "Like to try your hand?"

The boy sat down, looked about then chose orange and blue chalk. "You're not supposed to watch."

Joseph turned away, delighted at such innocent brashness.

The result was handed back to him after a few minutes. "How do you like that?"

Before Joseph could answer, a woman appeared. "Peter! Where have you been? I've looked all over for you." She yanked the boy to his feet, took him by the ear and marched him off.

His efforts pleased Joseph. An orange girl and the blue man sitting under a tree. "Not bad." The light was shifting. He got up and moved off to follow it.

"Joseph!" The blue man was on his feet beckoning toward him. "Reginald Forsyth. We met briefly on the boat a couple of days ago."

"Ah, yes to be sure."

Reginald turned to the orange girl who sat on a blanket removing food from a picnic basket. "My sister, Katherine. Joseph—Joseph—"

"Turner. Glad to meet you, Katherine."

"And I you, Joseph."

"Come," Reginald urged, "we're about to have lunch."

"Ah, thanks but I couldn't."

"But please do. We have plenty." Katherine patted the blanket. "Come, sit down."

Instantly, Katherine's beautiful face was spreading through his thoughts, the warmth of her voice drawing him to her. "You're sure?"

"Of course. Please, sit down."

"Joseph is a painter and he's here to work for the summer."

"Oh, and is Margate up to your expectations, Joseph?"

"Servin' my purpose very well, I'd say."

"Katherine's all music and poetry, and she's good at both."

"An amateur at both, I'm afraid."

"I'd very much like to read some of your poetry."

"Perhaps, providing you allow me the pleasure of seeing your paintings."

"Only if you agree to my doin' a portrait of you."

"A very worthy compromise," Reginald said cheerily. "It must be arranged."

The remainder of Joseph's afternoon bathed in Katherine's light. Conversation moved easily among the three of them, flowing with music, paint and poetry, missing nothing—not even the most inconsequential things. Eventually he was promised an invitation to the Forsyth home for dinner.

The day was drawing to a rapturous close when he took the path up to Maude's cottage. That parting smile Katherine Forsyth had given him left him wanting to say things impossible to say. His heart was in controversy with his reason, so quickly he had been taken with her.

CHAPTER TEN

Five distressful days had gone by and no invitation had arrived from Katherine. Now, in the quiet of morning, Joseph's thoughts flowed toward her as he worked at his easel. He had been up since seven and Maude was changing his bed linen. Eventually her curiosity got the best of her and she came to look over his shoulder.

"Ah, to the gaol dock you've been. The place gives me the squeaks—those bumsters hanging in chains like rotted meat."

"An ugly sight, Maude."

She took a close look at one of the malefactors. "Seems to be Johnny Haverk. 'Ee throttled his wife with a fish line." She stepped closer and squinted. "And that one looks to be Rake Towser. Ran a crooked tablehouse and stole guineas right and left 'till they caught up to 'im."

"A sorry lot."

"I've no pity for 'em. Every blasted one got what was comin' to 'em. My late husband'll end up there. ,'Twould fit him right."

Joseph thickened Johnny Haverk's shoulder with a blunt pencil point, stepped back, observed it and yawned.

"You stay hard at it, lad. Always got a pencil in your hand."

"It's my life, Maude. Have to stay at it." He smeared a shadow under the neck with his thumb.

"And what would you be thinkin' of Margate by now?"

His thoughts vaulted over the Channel, the teeming docks, the roads, fields and white cliffs, then came to the giant elm where he had met Katherine Forsyth. "Could spend the rest of my life right here, Maude."

"Now you're joshing with me, lad. You, a Londoner, sayin' such a thing?"

"For sure it's a place to my likin'."

"Good as any, I suppose. Too many poplollys breakin' up homes. Ah, but you'll find 'em everywhere." With that, she started out the door.

"Would you be knowin' a family with the name of Forsyth who live across from Chatham Park."

"I do for sure. Old Ertha's into everybody's business. A fine son she's got, and a pretty adopted daughter. The girl plays at funerals and weddings. Trained on the piano. The boy's doin' well for hisself—in spite of the mother. Why'd you ask?"

"For no special reason. Met him on the boat from London."

"Well, I've known the old witch for ages. She worried her poor husband to 'is death. Good man 'ee was too. The girl she took in a year or so before 'ee passed. Always a pretty little thing. The boy's of her own birthright, though you'd never guess it. They're different as sugar and salt. You'll keep your business to yourself 'round her. Full of 'ate she is." Maude started out the door then turned back. "And while I'm at it. Careful who you take up with 'round here. There's drossells in this place who turn young bucks like you to rot. Well, I'm off to shop."

A knock came at the door a few minutes after she left. He went to answer it. A postman stood there. "Joseph Turner?"

"That's me." He took the letter, ripped off the envelope and read the message three times before shutting the door.

> Dear Joseph,
> Please join us for dinner
> next Thursday at seven o'clock.
> I do hope the time is convenient.
> If not we can arrange another
> day to your liking. I look
> forward to seeing you.
>> Katherine Forsyth
>> 23 Halburton Road

Thursday! Five agonizing days away. He shut the door, went to his easel, penciled in shadows under Johnny Haverk's eyes, and then returned to his dreaming.

Normally swift, and modestly attentive to her appearance, Katherine was longer than usual with her toilette that Thursday evening. Boating in the sun had left her handsomely browned, and her dark hair blended gently into her complexion. The dress she finally chose, soft pink organdy with a modestly low neckline, allowed a mere suggestion of the cleavage between her breasts.

No less meticulous in his own preparation, Joseph was scrubbed clean, his hair washed to a flaxen softness. Having purchased a beige cravat for the occasion, he tucked the ends of it into his waistcoat and hurried off to Halburton Road.

When he knocked, Katherine came swiftly to open the door. "I'm so delighted that you could come."

"And I'm happy for the invitation."

The parlor was dimly lit and starkly furnished. Everything, the chairs, tables, even the lamps, seemed zealously upright, outright stiff. Katherine's delicacy seemed somehow misplaced—like an orchid in a patch of thorns. Radiant, faintly scented with lilac water, she motioned him to a divan, then sat down beside him. "Reginald will be down shortly. Well, how is your work going?"

"Keepin' my hand at it. And your poetry, is it keepin' you busy?"

"Not really. I volunteered to help at the orphanage. They are short-handed for the summer. Must say I enjoy it, and the children are wonderful to be with."

He glanced up at a large portrait hanging above her. "A fine lookin' gentleman."

"My father. He was indeed a handsome man." She glanced up at the painting. "I regret not getting to know him better. I was only four when he died."

"Ah, too bad." The resemblance of father and daughter was remarkable. "Certainly you seemed to have taken after him. The nose, the mouth, the eyes—"

She laughed softly. "So everyone says. However, I was adopted when I was barely two years old."

Maude had said as much. How stupid of him not to remember. "Shall I meet your mother this evening?"

"Indeed. At the moment she is in the cellar feeding her cats. She insists on keeping them down there."

"And for good reason, Katherine." The sharp, winterish voice coming from the doorway behind them gave Joseph a start. Jumping to his feet he gave Ertha Forsyth two quick bows.

"Mother, this is Joseph Turner."

"How do you do, madam. I'm very happy to make your acquaintance."

In return, Joseph received a bleached, penetrating glare. If Ertha Forsyth shared his happiness she failed to show it. "Hello," she answered icily. "Katherine, where is your brother?"

"He should be down momentarily, Mother."

"Well, he's to hurry. Supper is ready." She eyed Joseph grimly. He was still standing at attention. "Take your seat, young man." He obeyed the command as she went to the dining room. Indeed, an inauspicious beginning.

Katherine laughed softly. "Mother's always at her jolliest just before dinner." He returned her smile, remembering suddenly the sight of Ertha heaving into that paper sack.

Reginald arrived clutching a work sheet. "So glad you could make it, Joseph. Sorry to be late."

"And indeed you are late," Ertha informed him from the dining room. "Come along. I refuse to eat cold food."

Ertha had already seated herself at the head of the table when they entered. Reginald sat at the opposite end; Katherine and Joseph faced each other across the table. Dinner was a leg of mutton with roasted potatoes. As they ate, Ertha, eyes studiously avoiding Joseph, launched her inquisition.

"And what is your business in Margate?"

"I'm here to paint landscapes."

"How long do you intend staying?"

"Oh, for a good part of the summer."

"What part of London do you come from?"

"Covent Garden. I live—"

"And your father—what is his profession?"

"He's in the wig business."

"A hairdresser?"

"In a way. He—"

"Are you studying anywhere?"

"Well . . . I was accepted at the Royal Academy when I was fourteen. So I —"

"The Royal Academy? I find it hard to believe that anyone has been accepted at the Academy at the age of fourteen."

"But, Mother—"

"Your guest can speak for himself, Katherine."

"Madam Forsyth, I—"

"Mrs., if you don't mind."

"Oh—sorry, Mrs. Forsyth. The Academy took me in as a probationer. I've hopes of becoming an associate someday."

Attempting to ease the tension, Katherine only intensified it. "Joseph's to do a portrait of me."

Ertha bristled. "When and where?"

"That must be left to Joseph."

Ertha frowned. "You have no time for that. You promised yourself to the orphanage."

"I will find the time, Mother."

Ertha had no answer. Following apple cobbler she rose and cleared the table. Joseph and Reginald retired to the parlor with Katherine. After a glass of brandy, Reginald returned to his work, but Joseph and Katherine were not allowed to enjoy a moment of privacy. Ertha joined them with knitting needles and a basket of yarn, and there she stayed until Joseph got up to leave.

"Thanks, Mrs. Forsyth. I enjoyed the dinner."

"Good evening."

"Katherine went with him to the door. "Perhaps Sunday would be a good day, Joseph?"

Unhesitating, he agreed, then walked happily into the night.

"I don't trust that fellow."

"Reginald and I find him delightful."

"Neither of you are judges of character."

"Good night, Mother."

"Quite frankly, I don't like him."

"Good night, Mother."

Nobly, Joseph had withstood the assault. As he walked along the quay, the scent of Katherine's lilac water intermingled with that of jasmine and honeysuckle floating in the air. Joy was erupting inside him. The entire world was in order. He was, for the first time, in love.

The next morning a letter came from William, filled with bad news. Mary was tottering at the brink of insanity. William had awakened one night to find her gone. After a long search she had been found asleep next to Mary Ann's grave. Then, a vendor wanted her gaoled for upsetting his fruit cart. William had paid handsomely to prevent that. What was more, his trade was being undermined by a powder tax imposed by the Tories.

It looked as though he would have to close his shop; that was the stark reality. Like all of England, his father was caught up in the machine of change. The scope of his problems stayed with Joseph for hours, spinning around him, dizzying him. Night arrived to harass him with its gloomy geography. Unable to sleep, he got up at two o'clock in the morning, lit a candle and accepted the weight of obligation.

> Dear Daddy,
> Sorry to hear such things about Mum.
>
> We'll just have to keep faith. You are not to worry about money. I have savings and there are lots of commissions at Wales where I go next. If you need money, go to Ephram Bell. He is in my debt. I will write him. Someday I will put you and Mum in a good country house where you will have no concern about your welfare. My work's going well, and I am getting control of the sea, but the sun stays a problem. It refuses to be conquered. I often think about our trips on the Thames. We will do it again someday. You were right about Maude. She's wonderful, and so is Margate. You will

be surprised to hear that I am in love. Katherine is her name and she's very gifted and beautiful.

You are not to worry, Daddy. Things will work out. If you see Tom, give him my good wishes. That is about all for now.

My love to you and Mum.

<div style="text-align: center">

Billy

May 12, 1796

Margate, Kent

</div>

'That must be left to Joseph.'

Katherine's rather impetuous response at the dinner table amounted to polite rebellion against the tyranny of her mother. Ertha's wave of despotism had swept in during the second year after Katherine's adoption. Invariably, friends had noticed a strong resemblance between Edward Forsyth and his newly adopted daughter. According to village gossip, Edward's housekeeper had committed suicide after giving birth to his child. Life for him became hell when Ertha got wind of this tale. Mercilessly and endlessly she accused him of adultery. His repeated denials were of no avail, and his constant intake of grog to feed his despair brought on two heart attacks. On one Christmas morning, he quietly expired.

Misery and distrust gradually seeped into Ertha's behavior. She became cruelly strict, running her household with an iron hand. Dust was blasphemous. Noise was a sacrilege. Falsehoods were cleansed from her daughter's mouth with soap. By the time Katherine was fourteen she was subjected to a watchfulness far beyond normal concern. Now, at nineteen, she was in a mild state of mutiny.

Joseph had chosen Sunday afternoon as the time. The place was a cove above the village, thickly bedded with clover and hidden beneath a copse of sheltering trees. Katherine appeared at her best in a pink summer dress, lying at ease on a blanket, her dark hair loose and falling to her shoulders.

As Joseph sketched, she let her eyes roam beyond him for several moments. "It is so peaceful here."

Silently he worked on. After half an hour he put his sketch pad down and pushed it aside. "There's a promise you're to keep, Katherine."

"And what might that be?"

"Your poetry. You said you would bring some along."

"Well…I admit to that, but perhaps we should wait until it's finished."

"You promised."

"Well…if you insist."

He watched as her fingers lifted a slip of paper from inside the dress just above her breast. After looking at it for a few seconds she began to read:

Now begins the struggle inside the heart

and close by doubt hovers, trembles,

ready to have its enlightened say.

And I, betwixt its riven thoughts,

seek a binding harmony to assure

no false joy for frustration to prepare.

She stopped. "That is as far as I have gone."

"Such beautiful words, I'm lookin' forward to your finishin' it."

"In time. No rush. The rest will fall in place."

She settled back into the bed of clover and he resumed his sketching. Another twenty minutes passed before he stopped.

"Can I see what you've done, Joseph?"

He smiled. "In time. No rush. The rest will fall in place."

"So, you choose to torment me."

They had indulged in small talk without risking a solid look at one another. She rose and went to stand near the edge of the clearing. Far below, the Channel was orange in the late sun. She gazed at it. "Oh, to be a painter."

He came to stand beside her. "But you paint with words."

She shook her head. "It is hardly the same. Words are so easily forgotten."

"Not yours. I remember everything you've said to me."

"But I haven't had that much to say."

And neither of them had much to say as they went down the path toward the quay.

Three Sunday afternoons of rendezvous had passed. Both the sketching and the poetry had continued, but both remained unfinished. Evening was approaching on the fourth Sunday when suddenly Katherine turned toward him and looked deeply into his eyes. Finally, he took courage and lifted her hand to his lips; modesty and propriety were gently exiled together. With passionate desire they kissed and fell into each other's arms. Then abruptly she pulled away. "I think we should leave, Joseph."

"But why?"

"There are many reasons. Please, let's go."

Not until they reached the bottom of the path did he speak. "Katherine . . ."

"Yes?"

"I'm in love with you."

"Remember, Joseph, no false joys."

The village clock showed twelve minutes past six when they reached Katherine's house. The touch of her body still flamed through him, "And when can I see you again?"

"Sunday afternoon, if you are free."

"I'll be free." He watched her enter the door before leaving.

Ertha stared at Katherine when they met at the top of the stairs. She stared back. "Good evening, Mother."

Without a word, Ertha went down the stairs. The breach had widened. She didn't join Katherine and Reginald for supper, but she came to the dining room to confront them. "I will not tolerate the presence of that Turner fellow in this house." As she left, Katherine and Reginald exchanged smiles.

Morning found Ertha's mood changed—considerably so. She even had a smile for Katherine at breakfast. Pleasantly, she turned to Reginald. Roger Becket's to arrive today, isn't he?"

"Why, yes, Mother. Our meeting is set for ten o'clock."

"I hope you get your father's business matters straightened out with him to our satisfaction."

"I don't anticipate any problems. He's proven to be quite reasonable so far." Reginald finished his coffee and got up to leave.

"You're welcome to ask him for dinner."

"Thanks, Mother. I will. He returns to London tomorrow."

"Seven o'clock would be fine."

Ertha broke the uncomfortable silence that followed Reginald's departure. "Katherine, it would be nice if you are here to help make things pleasant for Roger this evening. As you well know, he's quite fond of you."

"And I of him, but the children have their little concert at the orphanage tonight, and I must be there."

"Roger will be disappointed."

"Sorry."

"And indeed I am also sorry." She paused as Katherine got up and began clearing the table. "Frankly, I fail to understand why you give him so little attention."

"And why do you say that, Mother?"

"Because it is fact. Most young ladies must find him very attractive. What is more, he is intelligent and comes from an extremely well-fixed family."

"I'm quite aware of all that, Mother. I also find him attractive and intelligent, but I'm not concerned in the least about his wealth."

Silence abruptly returned to the room.

It was closing time and only five customers had come to William's shop all day. Wig powdering days were all but over. Joseph's drawings had been stripped from the walls and sold. The celebrative atmosphere they had once created had vanished with them. It was a bad time.

William mentioned Joseph's letter to Mary that evening as she put a bowl of barley soup on the table. "His work's going well—and of all things, he thinks he's falling in love." He sat down to the table. She ladled soup into his bowl and sat down opposite him.

"In love? I must say that explains him. That's why he shows me none anymore."

"Why, he loves you, Mary, and he's going to buy us a nice house in the country after his tour in Wales."

"I want no house from him. And I don't want this horrible soup!"

"Now, Mary you must eat. You've not had food for two days."

"It's full of maggots. Look! They're crawling all through it!" Springing to her feet she grabbed her bowl and hurled it against the wall. It shattered and the soup dripped to the floor. Screaming, she upended the table and ran toward the door. "Maggots. Maggots! I'm to get out of here!"

She never reached the door. Swaying for an instant, she lost consciousness, sagged against the wall and dropped to the floor.

Only for a few moments did she open her eyes the next morning, just long enough to recognize the cracked ceiling of her old cell at Bethlehem Hospital.

William felt betrayed—by time, the Tories, even God. Everything was moving backward. He was alone again in a house where everything seemed to be weeping. The soup stains on the wall mocked him. The furniture sat around like lame animals and rugs rotted under his feet. He was beginning to talk to himself and his own voice startled him in the silence. Unhappiness had become an intruder in his house, and he could not bring himself to make peace with it.

Since he was unwelcome at the Forsyth house, Joseph and Katherine had spent the summer enjoying strolls along the waterfront and occasional picnics at Chatham Park. Of course they also went often to their cove above Margate. Here now, on this final Sunday before he was to depart for Wales, they sat in silence. Both had grown afraid of words; it was no longer a time for trivial conversation. Within a few hours their blissful summer would end.

He moved close to her. She rested her head on his shoulders and then read the words of her finished poem:

> Now through the shadowed peace
> how beautiful the vision
> before my eyes—a blessed summer
> so joyous to my heart.
> Doubt lies vanquished, atoned
> by a love serene and assured.

"Beautiful. So beautiful." Then, from the pages of his sketch pad, he took out the drawing and handed it to her. She lifted it, smiling warmly at the finished portrait. Dark, luminous eyes gleamed in the paleness of the enchanting face. Raven hair flowed down to the gentle swell of the breasts—all so reflective of that afternoon when they first met.

"It's lovely, Joseph."

"You'll wait for me?"

"Am I expected to?"

He took the portrait from her and laid it aside, then took her into his arms. "Indeed so, but as my future wife." His lips touched her cheeks. "I'm askin' you to marry me, Katherine."

A long silence fell between them. She turned from him, her thoughts racing, pondering the consequences of her answer. His thoughts raced alongside hers, weighing the meaning of her silence. Finally she turned back to face him. "Joseph—is this a serious proposal."

"I surely mean it to be."

"Then I must be frankly honest. Mother would never approve."

"And I know that. But I hope she's not to say who you're to love, or spend the rest of your life with." He took her hand in his. "Your future belongs to you, Katherine—not your mother."

Fostered by desperation, his words had sabotaged the deepest roots of Ertha Forsyth's despotism. Turning back to him she gently eased herself into his arms. "I would be most happy to be your wife, Joseph."

The answer left him quivering. "Katherine, dear Katherine." Such joy left little more to say. Dusk finally dropped. Chastity was cast aside. There, in the darkness of their secret cove, their bodies touched as they had never touched before. They were still love-bound when the pale light of a full moon rose over Margate.

Silence at the Forsyth breakfast table had grown tedious, and the care with which Katherine peeled an apple was putting Ertha Forsyth on edge.

"Mother."

"Yes."

Reginald, sensing something unusual in his sister's mood, glanced toward her. She pushed the apple aside then spoke with calm. "I have just become betrothed to Joseph Turner."

Ertha took a deep breath, then met Katherine's calmness with her own. "Without my permission?"

"You would not have consented, Mother."

"And I never shall." She shot a glance at her son. "And what do you think of this foolhardiness, Reginald?"

"A bit taken back, I must say, but not really surprised. Quite frankly I'm delighted. I find him decent, talented and quite resourceful."

"Resourceful? A lowly wigmaker's son?"

"I find nothing dishonorable about that, Mother. He is as well a fine artist—and a gentleman whom I have come to love and respect."

In spite of her inner rage, Ertha Forsyth remained calm. "We shall see, Katherine." The hardness of her voice could be matched only by the stare she gave her daughter as she abruptly left the table.

Maude Clougherty handed Joseph a paper sack filled with fish and chips she had prepared for his journey. "I'm 'appy fer ya, lad. She's a fairhead if there ever was one. You're to be good to her and no foolin' a'roun'."

"You've no need to worry." He picked up his bags and walked to the door. "Goin' to miss you, Maude, but I'll be coming back—and you're to be at the wedding."

"I'll squawk like a rooster if I'm not." She stood watching until he disappeared from the path. "A fine lad," she remarked.

The coach was waiting on the quay when he reached there, and Katherine stood beside it. Dropping his belongings, he rushed to take her into his arms. "Never did I expect you'd be here."

"I couldn't bear to have you go without saying goodbye."

"It's not goodbye. I'll be returnin' before too long."

"A year. Much too long."

The stage driver was showing impatience. "You're to board, lad. It's past leaving time!"

"Do write often, Joseph."

"You'll be pressed to read all the letters I send." He kissed her quickly and climbed into the stage. It was moving from her sight when he glanced back. She was still there waving. Moved by the sight of her, he spoke to himself. "Wait for me, Katherine. Wait for me."

CHAPTER ELEVEN

Sprawling westward from County Cheshire to the Irish Sea, Wales awaited Joseph. At Monmouthshire, he found a room on the second floor above a furniture shop. It was spacious, with a bed, a table, stove and two chairs. The northern light he loved brightened the walls, but the place was dirty as a pigsty. He spent the morning throwing out trash and scrubbing the floor. In the afternoon, he posted his first letter to Katherine. Now, her face glowed in everything he put his hand to—the sea, the moon, the mountains, the sun. She roamed his solitude. The memory of their last hours together filled his mind every day.

Fog curled through the ruins of Tintern Abbey the next morning as he stood before it, sketching. Several beggars sat with their backs against the outer walls. A young girl was sleeping out the morning against a stone abutment. Beside her was a small child wrapped in a horse blanket.

"Blessed light this morning, lad, but you'll have to keep up with it. It keeps moving all the time." The voice had come from behind him, phlegmatic and aged. Joseph remained silent, hoping to cut off any further conversation. Suddenly the sun filtered through the fog. "Ah, there it is, changing things right before your eyes. The foliage was black only a jot ago. Now it's blazing green."

Joseph was becoming annoyed.

"Might you spare a few farthing, lad. I'd so appreciate it."

Without looking back, Joseph took a coin from his pocket and held it out.

"Ah, thank you, lad. Heraclitus will bless you." Curiosity turned Joseph around. The old man had long hair the color of barley; beard flowed to his chest and he wore a tattered monk's habit. Smiling, he placed the coins in a leather pouch beneath his right armpit. Then for a moment the two men stood staring at each other. "You're a stranger to these parts, lad."

"I am."

"You've come to look for secrets like all the others."

"Secrets?"

"Things left behind centuries ago. The old abbey's thick with them, in every crack and shadow. You'll have to work hard to get a hold of them. I gave up trying a long time ago." He took a look at the sketch on the easel. "Ah, a fine hand you've got, lad."

"Thanks."

"I had a hand like that once. Far back it was. Far back."

"Were you a painter?"

The old man pulled back the right sleeve of his robe. There was only a nub. "Until this happened."

"Too bad, especially for a painter."

"'Twas a part of the universal plan." He was walking away. "You've been kind, lad. We should meet again."

Joseph turned back to his work. The light was moving southward, creeping through the ruins, leaving black and gray shadows between the ceilingless stone arches. Cloud puffs drifted across a sapphire sky. Then for a moment, fog whirled in again. The old man was right; the hand had to keep moving to catch the changing moods.

Dusk had settled in when he approached his lodging place. He hardly noticed the old woman until she stopped him and thrust a fold of paper into his hand. "It's important," she said before moving off into the shadows. After a quick glance at the paper he tossed it away. He had reached the entrance to the building when suddenly he turned back to pick the paper up. In his room he lit a candle and placed it on the table. When he opened the paper a leaf fluttered to the floor. The message had been written in a beautiful hand:

> This leaf holds infinite wisdom.
> You are to sleep upon it this
> coming darkness. On awaking
> carry it close to the heart.
> On the third darkness Hikkon
> will appear with the knowledge

of which it is bless'd. Listen

to the word he bears.

To heed not is wisdom wasted.

He tossed it aside. "Such nonsense. Who the deuce is Hikkon?"

Several times he dreamt the leaf was crawling over him. The night was half gone when he got up, relit the candle and found it on the floor. "Such nonsense." Reluctantly he placed it under his pillow—and slept peacefully. The next morning he smiled at himself in the mirror after putting the leaf in a pocket next to his heart.

Three nights later a knock came at his door. He opened it—to the old man who had approached him at the abbey.

"You're Hikkon?"

"May I enter?"

"Come in. I've been waitin' for you."

"Then you take the message to be meaningful." The old man pushed back a cowl from his head, refused a chair and sat on the floor.

"The leaf, it is still with you?"

With a trace of sarcasm Joseph answered. "It is."

"And you have followed the instructions?"

"I have."

"Might I see it?"

Joseph hesitated, then took the leaf from his pocket and handed it to him. "It's in poor shape I'm afraid."

"It is good enough." Silence fell over the room as Hikkon held the leaf against the candle's glow and began scanning it. Twice a faint smile crossed his face. Twice he frowned as Joseph watched him uneasily. Finally he spoke. "You move under the constellation Orion, and with a destiny far beyond the ordinary. In all my eighty-five years I've never seen such markings." He and studied them further. "Are you not aware of your dimension?"

Joseph's face was impassive. He wasn't to be taken in by any tomfoolery. "Nope. I'm not."

"Then take unto yourself the wisdom of which you are bless'd." He got up, placed the leaf on the table, then moved to the window. "Come, lad. I'm sent to reveal the stars that guide you." Joseph went to the window where

Hikkon stood gazing into the sky. His eyes followed the crooked finger as he pointed toward the brightest star. "There it is. Now look carefully. The four bright quadrangles of stars are Orion's shoulders and feet. Do you see them?"

Joseph squinted then lied. "Yep."

"Now follow closely. Had your eyes the power you would see the fiery red Betelgeuse at the right shoulder, then lower, the brilliance of Rigel at the left foot. Surrounding it are the twenty-five brightest stars. The Saiph at the right foot is of the second magnitude. Just a bit lower three bright second-magnitude stars form a belt along the celestial equator. Do you understand?"

Joseph nodded affirmatively.

"Hanging from the belt is a sword made up of dimmer stars. Those are the stars that guide you." He turned slowly from the window, his face glistening with sweat.

Joseph had not really recognized the different formations, nor did he understand such difficult astronomical descriptions. To him all of it was so much hogwash. "Who are you, old man?"

Hikkon smiled wanly. "A philosopher of the road, one might say. A disciple of Heraclitus."

"And who's Heracles—or whatever you call him?"

"He is revered for his limitless wisdom. You have not heard of him?"

"Afraid not."

"To him you owe everything."

"All you see in that leaf?"

"And much more."

"And it will cost me to know what you see?"

"No, lad. I'm blessed for having been chosen to bring his knowledge to you." Hikkon looked deeply into Joseph's eyes. "There are a number of things bothering you."

Joseph thought for a moment then decided to ensnare the old man. "To be sure there is. First off I'd like to know when my mother'll return to England from the continent."

A long silence ensued as the old man's eyes continued to bore into Joseph's. "You do not have faith in me, lad."

"And why'd you say that?"

"We both know your mother is not where you would have me believe her to be."

Joseph was stunned. As Hikkon moved toward the door he stopped him. "Then where would you place her?"

An even longer silence. "I will say no more than that your mother is in great mental distress—and that you feel the deepest sorrow for her."

"Well, I must admit you're right. And I'm findin' it hard to accept her condition."

The old man stood for several moments rubbing his brow. "There is no permanent reality to attach to anything save that of change. All else is an illusion of the senses. Your mother is in the state of becoming whatever it is she is to become. All things have opposites. Joy—sorrow. Life—death. Being and not being are part of everyday life. Try remembering that, and her affliction will be easier for you to accept."

"This Heracles, what's the connection between him and me?"

"Heraclitus. As he struggled with creation and destruction so will you struggle. As he understood fire to be the substance of the universe, and all other elements of it, so will you come to understand fire."

"Then the two of us are of one soul. Is that what you're sayin'?"

"In a way, yes. You share soul fire. No man has a soul all to himself." He pulled the cowl over his head.

"Now I must go. Perhaps we will meet again."

"But I would like . . . sorry . . . it's nothin'."

The old man gave Joseph another piercing look as he opened the door. "Your betrothed sits lonely by the sea with evil hovering about her."

"Wait. Wait!"

Hikkon moved on out the door. Baffled, Joseph went back to gaze once more into the sky. Somewhere up there hidden from view was the Orion nebula. He remained there for several minutes pondering that parting remark about his betrothed. He was still brooding over it when he climbed into bed.

Joseph spent the next day at the abbey filled with apprehension. He was not taking Hikkon's words lightly. Heavy fog drifted through the dusk as he started homeward. He had walked but a short distance when he

stopped abruptly. On the road before him two men were stomping on a man who was lying on the ground. As he approached the scene the attackers fled. Drawing closer he recognized the victim and knelt beside him. From his pocket he took a cloth and wiped blood from the man's mouth and forehead.

"Hikkon, it's me—Joseph."

The old man's left eye opened, then closed again. Joseph shook him gently, "Who were those men? Why were they attackin' you?"

"Because they're the devil's henchmen," replied a woman's voice behind him. It was the old woman who had thrust the paper into Joseph's hands. "Brother," she said to Hikkon, "It's me, Straca." Hikkon did not answer. "Ach, the monsters will pay with their souls," Straca said.

"You must get help. He's in bad shape."

"There's none to help. They all wish him dead."

"I'll help. You have to get him home."

"Then wait." She hurried off. After a few minutes she returned with a pushcart. "Hurry, before that ornery butcher misses this."

After lifting him into the cart they pushed it through an alley, then down a long winding path that ended in the countryside. After another hundred yards the woman stopped at a wooden door. Joseph was astonished. It was the entrance to a cave dug into the hillside. She unlocked the door, and they carried him inside and placed him on a sack of straw that lay on the floor. Hurriedly, Straca lit two candles, and again Joseph's eyes widened with amazement. The interior was somewhat larger than a normal room, and seemed to have been shaped by a sculptor's hand. The ledges held small, carved wooden figures—some of monks, standing, kneeling or lying as if in death; a goat with two legs, another with eight, two with three heads; a snake with forked tongues; a fish with a dog's head. The floor was of earth. The ceiling was also earth, shored up by roughly hewn beams.

Straca took a lump of damp clay from a bowl and gently rubbed it into Hikkon's wounds. He groaned.

Joseph looked at him several seconds. "I'm afraid he's finished."

"He will outlast his enemies. For years they've tried to do away with him."

"But why?"

"They accuse him of witchery because he dares to speak the truth."

The nub of Hikkon's right arm lay bare in the candle glow.

"How did that happen?"

"A wicked Lord had his lackeys chop his hand off after Hikkon's word proved him to be the garrotter of his dead wife. Would you like seeing it?"

"You still have it?"

She reached for an oblong wooden box and lifted off the top. Inside lay the skeletal remains of Hikkon's right hand, the finger still pointing as if to accuse the murderer.

"This is his?"

"For sure it is."

When she replaced the lid Joseph read the words carved into the surface:

> Death is potential in life
>
> Heraclitus

Hikkon groaned.

"Is he to be alright? I must be on my way."

"Thanks, lad. You will be blessed."

Joseph took several coins from his pocket and placed them on a ledge. Leaving, he saw another inscription carved in wood above the entrance. He paused to read it:

> You never step into the same river twice.
>
> When you step in the second time
>
> the water in the river is different
>
> and you yourself are changed by time.
>
> He stepped out into the darkness, feeling as though he
>
> had glimpsed another world.

The next morning he journeyed to Caernarvon Castle. There, with a chunk of lamb and a bottle of ale at his side, he experimented solely with watercolors, applying first a subdued blue wash. After heightening the image of the castle with white body color, he laid on thick yellow, ocher and golden brown. He was breaking rules, going his own way—pissing against the wind.

Gig Pipes, Tom Girtin and Fechner sat there beside him, urging him on. Three hours later, Caernarvon Castle was finished, shot through with the hot glow of an orange sunset.

A week later he moved even deeper into virgin territory. Kilgarran Castle emerged from rounded blobs of paint flattened with a palette knife. After splashing it with a wet brush he blotted it with paper. With his thoughts wheeling back through the years to Tom Malton, he laughed. Malton would have sworn he had lost his wits.

CHAPTER TWELVE

A month had passed when Joseph departed for the lowlands. On foot with an umbrella and traveling box he covered up to thirty miles some days. In the sweep of vistas cattle roamed and castles loomed. In six weeks he reached the rise of the hills in the northwest, then followed the River Wye into the Plynlimon heights. A month later, from Cambria, he was sketching the River Usk flowing toward Bristol.

Sitting in the quiet of the riverside, he wrote Katherine for the twenty-first time. His longing, his loneliness, his intentions of building a home for her at Brentford had been written in every letter. On Christmas Eve he arrived in Glamorganshire. Here, he would embrace the present of all presents—his first letter from her. This was where he had asked her to write him. He hurried to the post station. The aged postmaster handed him a packet. Eagerly, he tore off the string. There was a letter from his father, several others from publishers and engravers, one in a dirty brown envelope—and nothing from Katherine. Disappointment churned inside him. He stuck the letters into his pocket then asked for directions to Boarshead Lodge.

"Straight ahead. Far corner on your left. You can't miss it."

The Boarshead turned out to be small, clean and comfortable. Neath Galsworth, the proprietor and a friend of Tom Girtin's, invited him for dinner with his family. Joseph politely refused. He was in no mood for conversation. What was more, the long journey had left him in need of sleep.

His father's letter was short and cheerless. Things were no better at home. Mary was still at Bethlehem and growing worse. The only favorable news was that Ephram Bell had advanced the money for Mary's hospitalization, for which William was most thankful. The dirty brown envelope aroused his curiosity. It had been forwarded from Covent Garden, and its very first sentence jolted him:

Dear Joseph,

I'm now a sailor on the *Vanguard*, but not of my own doing. Three months ago I was press-ganged by six cutthroats, beaten and thrown on to this stinking ship. I sneaked this letter off to you with the help of a midshipman. It maybe be my last for a long time. It's awful. The officers live like kings. They eat goat meat and we eat hard salty beef with worms in it. I sleep on the gun deck. No air and it smells of bilge slop. This is Nelson's flagship and I'm doing dirty work on the quarterdeck so I never see him. There's word we're to fight the French fleet and I'm bloody scared. I know you don't like praying but try saying one for me. I'm writing this in a hurry. Have to stop. Think about you a lot, Joseph. I'll write when I can. Hello to your Mum and Dad.

Gully

Gully Cooke—kidnapped into the navy. Unbelievable! First no word from Katherine, and now this. His depression deepened. It was still gnawing at him when he got into bed. "Don't know who I'm prayin' to, but whoever you are keep Gully Cooke safe," he muttered. He had done what Gully had asked of him. Nightmarish dreams invaded his sleep, he saw Katherine sitting naked and weeping on a storm-torn beach and Gully Cooke struggling to free himself from layers of rotting beef. He sprang awake when a broken meteor had sailed in, slicing him in half.

Christmas morning found him still in low spirits. He opened his mail. Ephram Bell, Dr. Monro, the Earl of Wessex, Sir Henry Mildmay, the Marquis of Lorne and a Mr. Lascelles were offering commissions that would require another three months' work. He moved to the window and looked into the sky. Pale, starless now, it seemed to be echoing Hikkon's warning: "Your betrothed sits lonely by the sea with evil hovering about her . . ." He would return to Margate. The commissions could wait. For the rest of the day he thought it over. No. Katherine would wait; that he believed from the depths of his heart.

The winter in Wales was the coldest in a decade. The Cambrian peaks blazed with snow. Bitter winds swept in from the Irish Sea making the passes

impossible to travel. Wrapped to his nose in woolen scarves, Joseph worked on. Frigid temperatures forced him to work inside Llandaff Cathedral, and even there he worked with a horse blanket draped around his greatcoat.

The shop he entered one afternoon was small and the goldsmith was so tall that his head nearly touched the ceiling. He smiled solicitously as he handed Joseph the wedding band for his inspection. Joseph gazed at it, imagining it on Katherine's finger.

"It's costly, but a deserving bride's not to be denied the very best, providing one can afford it."

Barely noticing the goldsmith's words, Joseph tore a page from his sketch pad, wrote on it and placed it on the counter. "It's to be inscribed," he said.

The goldsmith smiled. "For Katherine from Joseph. Ah, lovely indeed."

"And when can I to pick it up?"

"In one week, lad. And the engraving will be to your liking."

"I'll need a chain to hang it about my neck for safekeepin'."

"You shall have one—and as a wedding gift from me."

"Kind of you," Joseph said, feeling sure that the purchase price had already taken care of that.

When he entered the Ewenny Priory a couple of hours later, the sun's rays were entering the windows, cutting into the gloom of the transept. He was jarred by what he saw. A few yards away, in solemn grandeur, the full-length effigy of Sir Roger de Remi lay above his tomb. On his stone chest perched a turkey. Joseph smiled as the bird stared at him. Just a few yards away a burly man was chasing a pig past a woman feeding a flock of chickens. It was his final day in Glamorganshire, and he was allowing the priory to impress itself deep into his memory. He remained there sketching until the daylight had gone.

He left by coach the next morning. He traveled to Cardiff, took the crooked road to Swansea, and stopped for a fortnight. Then, for the next six months by foot and rented horses, he worked through Kidwelly, Laughharne and Tenby. By the time he reached Pembrokeshire, eight months had gone by—and with still no word from Katherine, he was thoroughly disheartened. His last letter had asked her to write him here.

The village of St. David's was dark and silent when he reached Snowden Lodge. He banged on the door for ten minutes before a surly innkeeper let him in. After the long journey sleep came easily.

He awoke early, dressed, and daring to let his hopes soar, hurried to the post station. There was nothing. Surely something beyond her control had taken over. Disheartened, he strode slowly back to the lodge. There was no question now; he must return to Margate, and as quickly as possible.

CHAPTER THIRTEEN

The ancient carriage creaked down the mountain road, then rumbled through a corridor of ivy and out into the clearing. For the third time, Joseph rapped the coachman's seat. "How long to Melincourt, driver?"

The aged man spat and mumbled to himself, "Sananach MiFhoigideach."

Joseph raised his voice. "Are you deaf? I made a simple inquiry of you."

"Thrice I've placed your arriving time half beyond an hour." The man's voice leaned toward anger.

"Well, press on; I'm countin' on my connection there!"

"Doin' our best, me 'orse and I. Shan't kill the poor beast for the pittance of a fare. 'Ee's a soul too, ya know."

They reached Melincourt with only a few minutes to spare. The Welshman looked like a man betrayed when Joseph handed him a few extra shillings. Only with a scratch of his beard did he express thanks.

For short distances Joseph shared coaches with a dullard of a bootmaker from Abergarnedd; a sailor from Bath who constantly complained of nausea; and a plump, debauched woman from Brecknockshire who entertained him with accounts of her nocturnal affairs.

It was a happenstance between Merthyr and Aberdare that enlivened the third leg of his journey. Driving this particular afternoon was a big Flintshireman with a long face and shaggy eyebrows who had introduced himself as Pilkington. A middle-aged woman sat stiffly beside him in the driver's seat, not speaking a word. Around three o'clock, rain suddenly swept in over the moors. Lightning flashed; then came a volley of thunderclaps. The squall struck swiftly. Hailstones pounded the driver, the woman and the horses. At a juncture where a trail curved off the road, Pilkington reined his horses in beneath a large stand of oak trees. He lifted the woman down and helped her into the seat opposite Joseph. Water dripped off her

hat into her face and lap. Lightning flashed. The animals reared, nearly overturning the stage. Only the strength of Pilkington held them under control. The full force of the squall hit and hail pounded like rocks. Joseph cracked the window. "Come inside, driver!"

Pilkington refused with a wave of the hand, and remained under the pounding, gently calming his animals. The woman sat motionless, seeming to ignore the noise. Joseph shouted, "Terrible storm, madam!"

Without answering, she gazed past him. Lowering his voice he leaned forward. "My name's Turner." Her lips parted slightly but she remained silent.

After thirty minutes the squall blew itself out. Before parting at Aberdare, Pilkington stooped over and whispered into Joseph's ear. "Sorry about the wife, sir. She's without sound or speech. I had no time to tell you."

"Quite alright, Pilkington. Quite alright."

That night he dreamed that Mrs. Pilkington came with candle in hand to stand beside his bed, swathed in black with her hair curled into ringlets, pointing at him. "Your Mum's mad, Joseph, just like me. And you're going mad, Joseph!"

"Joseph. Joseph!" He sprang awake, screaming his own name. He then lay for several moments wiping away sweat, shaking off the nightmare. Strange woman, unusual man. Pilkington's actions had placed him beyond those of an ordinary man. He was so different from the shepherds and forest dwellers he had met in Wales.

Cardiff's waterfront was charged with a carnivalesque atmosphere when he reached there on a Saturday afternoon. Three British frigates wallowed in high tide alongside the quay, their crews searching out the petticoat-mongers. After months at sea they were eager to shed their loneliness. The sight of the frigates turned Joseph's mind toward Gully. Where was he now? He hoped his prayer had done some good. Two old patriots performed, one with a drum, the other with a fife; a clown dressed in a star-spangled outfit danced on stilts. An organ grinder with a monkey on his shoulder sold hot chestnuts, while a barefoot Hindu danced on hot coals while juggling three

balls. Joseph waded through the crowds and came to Fawke's Shop for Seamen. In the window was a dummy clothed in a sailor's outfit; his fascination for nautical paraphernalia took over. He entered the store, and for a pound sixpence he came out with the outfit.

By Sunday noon, Joseph's boat to Bristol was well out into the channel. It was a perfect day for the crossing and the deck was filled with travelers. He languished beside a gunwale, watching the sun play on the waves.

"Joseph. Joseph, lad!"

The voice snapped his head around and he jumped to his feet. "Ah, Mr. Narraway. A pleasant surprise you are."

"And where are you bound for, lad?"

"Margate, sir. And how's your wife and daughter?"

"Both fine. Had a note from your father several days ago."

"Oh?"

"As you must know, he's terribly concerned about your Mum. She seems to have taken a turn for the worse. He also tells me you've fallen in love. Is that so?"

"Yessir. It is for sure. "

"And who, might I ask, is the fortunate young lady?"

"Her name's Katherine—Katherine Forsyth. And I'm the fortunate one."

"Forsyth. That name sounds familiar." He closed his eyes for a few seconds, thinking. "Ah, yes. Does she have a brother who answers to the name of Reginald?"

"That's right, sir."

"Bright lad. I've done business with his father. Oh, I must say his sister is a beauty. You *are* indeed fortunate, lad."

"Thank you, sir."

Narraway drew a handkerchief from his waistcoat and wiped at his brow. "We will expect a visit from the two of you at Bristol."

"That's very kind of you, sir."

He gave Joseph a pat on the back. "Well, I've urgent business with the ship's captain. Have a glorious wedding, Joseph. And my best to your bride." He turned and started making his way through the passengers.

Joseph exited Bristol by coach through the kind of countryside he loved most—abundantly green, misty and quiet.

For a short distance a woman with two small children were passengers. The girl was rose-cheeked and wore braids; the boy was ruddy and strong. As they left the coach Joseph was thinking of fathering two such children, who, he hoped, would resemble Katherine in manner and looks. Good news awaited him at Southampton. The R.M.S. *Suffolk,* on which he booked passage to Margate, was about to sail, and he scrambled aboard.

With its long bowsprit and heavy boom, the ship, to him, seemed unbearably slow. But now with a full wind in her sails, Katherine was only a gull's flight away. His heart thumped wildly as the ship's prow finally nosed into Margate's docks. With impatience he waited until the gangplank lowered, and it had hardly touched down before he was rushing off the ship.

Laden with his belongings he hurried toward Maude's cottage. The sight of the thatched roof warmed him. The door was open. He walked in to find Maude sweeping the floor, and she turned to greet him with a big smile. "Goodness, lad, thought I'd never see you again."

He put his bags down and grabbed her hands. "Told you I'd be back."

She looked him over. "You're skinny as a bean pole, and you look to be needin' a good sudsin'. And where would you be coming from?"

"Wales—and a good journey it was. How's your health?"

"Gout still keep'n my left foot flerkin' about. It's not been all honey and flowers. Up late at Danny Teevan's wake last night and that leaves me a bit wrung out. The old gnaff dringled away the past fortnight. A 'undred years into 'is life 'ee was. A fine wake it was. "A lot of groggin'." She put the broom aside. "Well, I'll fire up some water for your bath then scrape up somethin' to eat. Your room's like you left it. Ah, it's good to see you, but you do look skinny, lad."

At ten o'clock sharp on this crimson morning, Joseph, dressed in his best suit, and with fresh flowers in his hand, arrived at the Forsyth house and knocked. The moments it took for the door to open seemed like hours. When Ertha Forsyth finally appeared and looked at him her face turned to stone. "Yes. Can I help you?"

"Why—I'm Joseph, Joseph Turner."

"I know who you are, but I don't know why you came here."

"To see my betrothed, of course."

"Then you have come to the wrong place." She attempted to shut the door.

His voice rose as he forced his way in. "I must see Katherine. Would you please tell her I'm here?" He looked up to see her slowly descending the stairway. Seeing him she stopped and he rushed to where she stood. "Katherine!" When he reached out to her she drew back, looking at him as though he were a stranger. "Katherine, I had to come back for you."

Ertha's voice was sharply demanding. "Leave this house immediately—and never come back!" Her animosity and her shouting over Katherine's silence baffled him.

Katherine spoke with an astonishing coldness. "Mother, please leave us for a few minutes."

"I will not tolerate this intrusion. Surely you realize how this man's presence can complicate matters."

"Mother."

Ertha Forsyth left the room, then slammed the door shut.

"Katherine, what has happened? I don't understand. What has happened?"

Her face flushed with hostility when she turned to stare at him. "How dare you come here after all these months of not writing one word to me. How could you do such a beastly thing? How could you?"

The bouquet dropped from his hand as shock tremored through him. "I can't believe this. I wrote at least three times every week. Didn't you get the letters I sent?"

"I did not—simply because you failed to send any."

"Surely you know that I wouldn't lie to you. You must believe me. I wrote you constantly." He reached out to touch her.

She pulled away. "Not one letter did I receive, and surely you don't think for a moment that I would lie about it."

He shook his head sadly. "Of course not." After a long silence he said, "Katherine, somethin's very wrong. I'm afraid we've been betrayed. I'm sure of it." His voice had grown piteous.

"Betrayed? By whom? What could you possibly mean by that?"

"I don't know. Oh, I don't know. But I'm sure we've been wronged by somebody. I know it, Katherine."

She saw tears welling in his eyes. "Joseph, Joseph. I tried so hard not to lose faith. You will never know how hard I tried. Waiting day after day, month after month, without one word." Suddenly her own eyes were growing damp.

"Katherine, this is terrible. You must believe me. You must."

She stood for a moment with her eyes tightly shut. "Joseph, I suppose I do believe you. I could not believe that you had forgotten me. But—but it is too late, much too late."

"No—no don't say that. I have come back." He took the wedding band from his pocket. "Katherine, this is for you."

She turned away, refusing to look at it. "Joseph."

"Yes?"

"I am to be married within the week."

Stunned, he stood trembling in disbelief. "Katherine, that is impossible. Surely you won't go through with it. You just can't."

Her fingernails dug into her arms. "I must, Joseph. The preparations have been made. Invitations have been sent. It is much too late."

"Please, don't say that. We won't allow this to happen to us. It's not your fault or mine." He was still holding the ring out to her. "I beg you, Katherine."

"Joseph—please try to understand. It is too late."

"Katherine—"

"I have made up my mind." She was weeping openly. "There is nothing more to say."

He touched her arm and felt the trembling. "This is your final word?"

"Goodbye, Joseph." She turned swiftly and ascended the stairs. As he crossed the room he could hear her crying. He was through the door and moving down the road when the truth struck. Katherine Forsyth was gone from him forever.

The crimson morning had vanished. A cruel sun charred the waterfront. Hearing only the swishing of the waves, he walked slowly, aimlessly over

the quay and through Chatham Park. As he passed the entrance to their secret cove, the final hours they spent there broke into his memory like a weapon. Now those hallowed parts he had touched would be touched by other hands.

On the morning of the following Sabbath, Katherine Regina Forsyth was wed to Roger Becket in the Church of St. Mary. At noon Joseph left for London.

He reached home feeling uprooted and a heart awash with anguish. The days were without life; nights were without dreams. He seemed to swim through both without moving. For the first time he had dared to commit himself to love. Now that commitment had met a treacherous death.

William, sensing his torment, patted his shoulder. "Somethin's wrong, Billy. Feel like talking about it?"

"You're right, Daddy, somethin's wrong, but there's nothin' to do about it, so there's no use talkin' about it."

"All hands! All hands! Thirteen ships to the starboard!" A midshipman raced off to pass the count on to Nelson. The French fleet had been sighted. Gully dropped his mop and ran toward battle station four. The drummer boy's roll was calling six hundred men to their stations. A red pennant over a blue flag fluttered to the topmast of the *Vanguard*. Nelson's favorite signal: "Engage the enemy more closely." Captain Sir Edward Berry shouted orders from the upper deck. Topmen swarmed the riggings and hauled down unnecessary sail. Gun crews loaded shot racks with twenty-four-pound cannon balls. Young powder monkeys lugged cartridges for the carronades. Musket snipers positioned themselves behind rolled hammocks. Livestock and Nelson's furniture were lowered to smaller boats for safekeeping. Landing nets were hauled up. The ship's surgeon arranged saws, blades and tourniquets next to the mess tables. Bottles of rum—the anesthetic—were stacked beside a barrel to hold amputated limbs. Gully was pulling a tub of hand weapons when he saw the men-of-war. They were only a thousand yards away. He shuddered. His squadron had formed its fighting line and was closing in. The cartridges were primed and ready, the cannons wheeled into position.

"Fire."

The gun captain yanked the lanyard. Never had Gully heard such a sound, felt such a jolt as seventy-four-gun broadsides boomed. The big guns recoiled.

"Reload!"

"Fire!"

Gully and another sailor were lifting a twenty-four-pounder when the *Vanguard*'s wall blew apart from a direct hit. He went down. The blood of a score of broken men was gushing over the deck.

Through smoke and fire he saw a torso quivering next to him. A leg had fallen across his leg. A blood-streaked head rolled against him. He tried pushing himself up. Horror struck! His left hand was gone! Everything went black. He came to for a painful moment to gulp down a cup of rum. Then the surgeon's saw cut into his arm.

The Battle of the Nile lasted throughout the night; delirium spared Gully the full horror of it. The last gun fired just before dawn, and sunrise revealed a watery grave. The lines of warships that had faced one another were now a mass of floating hulks with shattered masts. Nearly two thousand mangled and scorched bodies covered Egypt's Abukir Bay. No British ships were lost. Horatio Nelson, with only a scalp wound, had emerged victorious, and all England was singing the admiral's praises.

Joseph dropped his head into his hands after reading the *Times* account. "Gully was on the *Vanguard*. Surely he's gone."

William sighed. "Perhaps God protected him, son."

"Wasn't a God there to protect him. I just hope to see him again."

"Have faith, son. Have faith."

CHAPTER FOURTEEN

Three years had gone by without diminishing Joseph's painful thoughts of that catastrophe on the Nile. During those slow-moving years he had bathed in grief. Nothing could push fears of Gully Cooke's unknown fate from his mind. His mother, still at Bethlehem, had just recently forgotten her name. And in spite of Joseph's unyielding support, William was still in constant fear of hunting for bread in the rubbish.

The Academy's Board of Governors, responding to the praise given his *Dustanburgh Castle* and *Sunrise After a Squally Night*, was beginning to grant him lofty respect. He was spending more time there, keeping a casual eye on twelve new probationers. He lent his feelings about a couple of them to Tom Girtin. "They think themselves so big, I wonder how they fit themselves into the classroom." Now, more than ever, he was breaking rules, avoiding "straightfingers" and trying to ferret out the mystery of that boiling, raging sun. Despite the passage of time, he had still not recovered from the tragic episode at Margate.

Tory and Whig talk hummed throughout the Ale Cellar as William and Tom gorged themselves with deviled kidneys and grog. Tom took two swigs and made his point. "You have my ear but my heart no longer weeps for you. It's been three years since that affair soured on you and you're still churned up about it. Come, friend, it's over. 'Twas just a bad experience. Lay it behind."

"Forgettin's not to be easy."

"I know. Had a few jilts myself, but cripes, man, there's hundreds of her out there just waiting. Let's have another grog." They downed two more, the last one firming up their resolve to break off with Dr. Monro.

Monro sounded as if he was inviting them to doom, when he let them in. "A bad day I've had of it. Cozens passed on about an hour ago."

"Cozens?" Perhaps you'd like being alone this evening."

"I must confess to extreme weariness, lads."

"Then we'll drop in next week. Sorry, sir." Their sorrow was genuine and they headed back to the Ale Cellar to soften it.

At breakfast William adjusted his spectacles and read the review. "We never beheld a work of its kind to strike more awe and sympathy in its spectators. Turner's *Fishermen at Sea* is one of the greatest proofs of an original mind." He handed the clipping to Joseph. "The Sunday *Times*, Billy. That must fill you with joy."

"It's good to hear that about my first oil." Joseph stole a look at his father; years of worry were showing. "I'm off on another tour in a couple of days, Daddy. Will you be needin' anything while I'm away?"

"Nothin' comes to mind. Where will you be goin'?"

"To the Lake Country, then further on."

William smiled. "By the way, are you and that lass from Margate plannin' to get married? It's been a long time. She still chewin' at your heart?"

"Nothin' good came of that, Daddy."

"Well, there'll be others."

"I've no wish to rush to the altar."

Two mornings later, with a traveling bag, a small valise and an old umbrella that unfolded into a fishing rod, he boarded a stagecoach for the north country.

Through Leeds, Durham, Berwick, along the Tweed and over great stretches of Lake Country he went. After two months he came to Lancaster's King's Inn, bathed, went to the dining room and took a table in the rear. He was studying the bill of fare when he sensed someone at his side. He looked up. "Reginald. What a pleasant surprise."

"So good to see you, Joseph. Are you alone?"

"I am. Please join me. Sit down. Sit down."

Both ordered mutton chops and baked potatoes. They ate slowly, talked of the weather and other unimportant things. They were eating bread pudding and coffee when Reginald asked Joseph what had brought him to Lancaster.

"At the end of a tour. Headed home. And what brings you here?"

"Well, I've come to settle Mother's estate. She held a bit of property here."

"Oh?"

"She passed on recently—a lung ailment, along with other complications."

"So sorry."

"Quite a shock to us. Happened suddenly. Took to her bed on Monday and a week later she was gone."

"Indeed a shame. And Katherine, how…how is she?"

Reginald's long sip of his coffee was deliberate. "Haven't seen her recently. We spent some time right after the funeral." He took another long sip. "Joseph, you must please forgive my mentioning that unpardonable situation."

"Please, Reginald, go ahead."

"Well what I have to say will perhaps mean little to you at this point, but you should hear me out."

Joseph's eyes dropped to the last of his bread pudding. "Yes."

"Both Katherine and I know that your letters from Wales were intercepted. A terrible thing to admit. Mother was responsible."

Joseph's eyes closed for an instant, his thoughts flashing back through time to that stony face confronting him at the door that terrible morning. Anger flushed through him.

"We found them in the attic when we went to store her belongings two days after the funeral. Katherine was inconsolably distraught, and I as well. But the damage was done. I am terribly sorry—for both you and Katherine."

"Yes, indeed, the damage is done, but I do appreciate your tellin' me." He had spoken without apparent rancor. Conversation dwindled to silence. No longer able to bear it, Joseph got up, held Reginald's hand for a moment, and then went to his room. Clearly now, Ertha Forsyth lay inside Hikkon's warning. He should have known. Katherine should have known. Yet in their moments of devastation, neither of them could have imagined the depth of Ertha Forsyth's venom. She had gone to death a victor. Now, three years later, the past had arrived to mar the peacefulness he had found in Yorkshire's hills.

Joseph returned to Covent Garden to find William in bad spirits. "Your Mum's been askin' for you, Billy. I'm to visit her tomorrow and I think you'd

better go along."

"For sure I will, Daddy."

Hurtful memories surged in Joseph when they entered his mother's room the next morning. Pale, drawn and extremely thin, she stared out the window. Joseph went to her and kissed her cheek. "Hullo, Mum. It's good to see you.

"Oh—it's you, Billy. Where have you been?"

"Up in Yorkshire, Mum. It's beautiful up there."

"And you're enjoying your work?"

"Very much, Mum. Very much."

"Billy's notices will make you proud, Mary. I'll read them to you if you like."

"Some other time, Daddy. Mum seems tired."

"So I look to be tired, Billy?"

"Perhaps he's right. I'll wait."

"I'm quite capable of—" She broke off suddenly, turned to the wall and started screaming. "Let me go, you devils. Let me go. Let me go!" An attendant looked in, then went to get Dr. Monro. She had screamed herself into complete exhaustion by the time he arrived. Moments later she slumped into a fitful sleep with her lips moving soundlessly against her pillow, her mind swimming toward nothingness.

On the way out Monro confronted them with the truth. "I hate saying this, but she is hopelessly insane, and there's no reason to believe she will ever improve. I'm sorry for both of you."

Joseph's hand raised to touch his father's shoulder then fell away. They returned to the house. William warmed some soup and they sat down to the table. To eat in such overpowering silence was like eating in a tomb. "Daddy, we must move from here."

"Move?"

"Yes. It's best for both of us."

Through grim lips William went on spooning in the soup.

Standing room only was available for the musicale at Vauxhall, but Joseph and Tom sat dead center in the second row. Applause met Sarah Danby as

she bowed, then gave an encore. Sweet and clear her voice flowed, and with each rise and fall of her breasts Joseph became more enraptured. Two more encores followed before she was allowed to exit the stage.

Afterward, at a café next door to the hall, Sarah and her husband, John, sat opposite Joseph and Tom. The four of them had come for coffee. Joseph's eyes were still filled with Sarah when her husband spoke to him. "Tom informs me that this is the first time you have heard my wife sing."

"Yes. But surely, it won't be my last time." His eyes shifted to Sarah's. "Your voice is beautiful."

"Thank you, sir. I love singing John's compositions." She patted her husband's gnarled hand. "They are my favorites."

"As well they should be," Tom added. "John is unsurpassed in glees."

Danby acknowledged the compliment with a smile. "You are both flatterers, I fear." He turned to Joseph. "And you are a painter of first rate, I hear."

"My profession, but how I rate is yet to be determined."

Tom snickered. "Ah, such modesty. He's almost as good as Girtin."

Sarah laughed. "Tom, you are hopeless."

John Danby frowned and stirred uncomfortably, and as he sat his cup down his hand trembled. "You must visit us sometime, Mr. Turner. Sarah's cooking equals her voice."

"I'll agree to that," Tom replied as the Danbys rose to leave.

"I'd like that, sir," Joseph said, and his eyes remained upon Sarah as she preceded her husband to the door.

"You're smitten with the lady, Turner."

"Smitten? What gives you cause to say that?"

"Come, come. You were inside her all evening."

"Was I that obvious?"

"Don't let yourself get upset about it. Old Danby's used to everybody goggling at his young wife."

"Ah, but she's sure got a beautiful voice."

"And a beautiful body, I'd say."

"I'm not to disagree with you there."

It was past midnight when Sarah Danby awoke and realized her husband was not in bed. She found him in his study, bent over and grasping his stomach. "John, what's wrong?"

"Just a slight discomfort."

She touched his brow. "Your fever seems seriously high."

"Really, Sarah, there's no reason for concern."

"You're absolutely sure?"

"It's nothing, dear. Nothing." He took her hand. "Back to bed. One would think I'm growing old." He attempted to laugh but the effort turned into a groan.

"I insist on going for the doctor, John."

"And I insist that we go back to bed."

Before long he was snoring. Worried, unable to sleep, she got up again and went to the kitchen for a cup of tea.

When finally she returned to bed he lay still with his face buried into the pillow. She touched his brow. The fever was gone, but replaced now by a damp coldness that sent chills through her. "John . . . John!" He didn't stir. "Oh . . . my God . . . my God." He was dead. Overwhelmed, dazed by the sight of him lying lifeless, she stood for several terrible minutes moaning in grief. With tears streaming, she lifted the sheet over him, then went slowly to where their three children lay asleep. There in a rocking chair she sat weeping until dawn.

The funeral was sorrowful. When at the graveside Sarah's eyes shut and she seemed close to fainting, Joseph quickly stepped forward and took her hand. She didn't know whose hand had touched hers, but she welcomed the touch. At that moment any comforting hand would have lessened the pain.

CHAPTER FIFTEEN

Summer crept by. Autumn passed and winter was melting into spring when they met by accident on Maiden Lane one afternoon. She was overburdened with packages and he offered to help her home. "Well, that's most kind of you, Joseph."

"'Twould be a pleasure."

The door of their past meeting had opened and they entered it. Very soon Joseph was going out of his way to ease the pain of Sarah Danby's distress, especially on weekends. They had a couple of picnics for the children—Marcella, Caroline, and Jonas—walked along the Thames and frequented the Piazza Coffee House where they had first met. Gradually, most cautiously, the relationship had grown into courtship.

The night was moonlit and they sat silently by the wall of jasmine in her backyard. She showed no surprise when his hand moved to her waist; after a slight hesitation she leaned into his embrace. When their lips met for the first time, two years of restraint suddenly melted away. The children were asleep when they climbed the stairs to her bedroom. There, behind the locked door, they spent the night. And her wantonness drove him into a frenzy.

They awoke the following morning pleasantly fatigued. She went to feed her children, sent them off to school, and then returned to him. He was reaching for her when she turned away, weeping.

Confusion swept over him. "Why—what troubles you Sarah?"

She wept on for several minutes before answering. "Joseph, I hope you attach a sense of permanence to all this. I am not a loose woman."

"Of course, of course I do. I understand. You're not to worry." Slowly the tears stopped and she eased her face into his neck.

Desire still flowed through him when he walked into the good, sweet morning. Sarah Danby had left him remembering moments colored with

amber and honey. He felt reborn, as though a thirsty flower had opened its petals to him.

His thoughts jumped ahead as he walked along Maiden Lane. Bacon, Nollekens, Bourgeois, Gilpin and Stothard would be in his corner. Joseph Farington? Well, he wasn't sure. He was the one to be conciliated. His vote could make the difference in his being made an associate of the Academy. Then there was this new bylaw that laid eligibility at age twenty-four. He was only twenty-three. "Well, I'm goin' to bloody well try."

The prestige Joseph Farington sought within the Academy exceeded by far that which he actually enjoyed. Fingering his muttonchops he smiled as Joseph entered his parlor. A tall slender man, he towered over Joseph as he stood to greet him. "Ah, I've been expecting you, young man. Have a seat. What have you been working on recently?"

"Mornin', sir. Workin' at several commissions."

"Drawing at Lord Yarborough's estate I hear."

"Yessir."

"He's a tough one to please. How did it go?"

"Just fine."

One held the favor, the other was hoping to gain it. The older man took the initiative. "I see that you have entered as a candidate."

"Yes, that's so."

"You're aware of the new bylaw?"

"Yessir, but I think it's a bad rulin' and I'm ignorin' it."

"And you're sure all the others will go along with you?"

"I'm feelin' that they will, sir. I've won over most of the connoisseurs and critics. I shouldn't think they'd overlook that."

Nervously, Farington began rubbing his thick black eyebrows. Perhaps the young squib was bluffing. Maybe not. But such an array of support was not to be opposed. "Impressive, Joseph." What he actually felt was hidden in the smile that suddenly wrinkled into his bony face. "Well, lad, you can depend upon my vote."

"I'm thankful to you, sir." Farington acknowledged his gratitude with a bob of his head. Joseph changed the subject. "I'm thinkin' about movin' from my father's house. Have you any thoughts on that?"

Flattered at being sought as a source for such advice, Farington answered. "I beg to suggest that you take simple lodging somewhere, lad. A large house has its encumbrances."

"Thanks, sir. I'll remember that."

Farington watched from his window as Joseph crossed the street. He had decided to make some inquiries about the matter. A promise made was not necessarily a promise kept.

A letter from William Beckford was waiting for Joseph when he reached home, inviting him to his estate at Fonthill. He wanted drawings made of the abbey he had erected there. Joseph wrote back his acceptance and arrival date. A week later, he was welcomed into Beckford's spacious residence by an attractive Chinese woman who wore a long black silk dress. "I'm Madame Chung, Mr. Beckford's assistant. Please come along. The master is expecting you."

Joseph was taken aback as she led him down a long corridor heavily draped with green and blue silk. A life-size figure of a gilded Buddha sat by the ornately carved door where she stopped. She gently pulled on a silk rope and the door opened to the sound of a gong. She bowed, then left.

"Come in, Turner. Please sit down." Beckford, his legs crossed beneath him on a huge pagodalike chair, had spoken without looking up. His eyes were glued to a large sheaf of paper he was scribbling on. The walls surrounding him were also adorned with silk and a heavy aroma of incense permeated the large room.

"Good morning, sir," Joseph answered, then sat down on a silk settee that resembled an oversized pillow. It immediately struck him that Beckford resembled the rotund barkeep at the Ale Cellar. Pink-cheeked, balding, dressed in a black silk kimono embroidered with dragons, he seemed like a stranger to the trappings that surrounded him.

"I'm in the midst of a novel, Turner . . . romantic and very absorbing."

"How long have you been at it?"

"Only two days and a night—but without a stop."

"Then you're a long way from the end."

"Oh heavens, no. I expect to finish it tomorrow."

"Tomorrow?"

"Indeed so." He changed the subject abruptly. "I'm anxious for you to have a go at the abbey."

"I'm lookin' forward to it."

"Good, good. Now, my time is short. But would you like to view two of the universe's greatest masterpieces before you start work?"

"I surely would."

"Then come along. They're in the next room." Joseph followed him to where a score of large paintings rested on the floor against a wall. With great care, he uncovered two of them and smiled. "*Sacrifice to Apollo! The Landing of Aeneas!* Incredible, yes? Both are beyond the power of imitation." He had hardly looked at either painting. He was enjoying the astonishment on Joseph's face.

"Never thought I'd see them so close."

They returned to Beckford's workroom. "Ah, what it took to get them here—intrigue, murder, through French privateers, Algerian corsairs, over refugee roads from Rome to Naples hidden in a wagon, then into an old *polacco*. They barely made it to Palermo through a monstrous storm."

"And from Palermo?"

"Hidden in an armed vessel arranged for by Nelson himself. Enemy ships kept up their chase all the way to the port of Falmouth." Shaking his head he sighed. "The world owes Fagan and Grignion for risking themselves during the venture." The gong sounded. The door opened and Madame Chung stood waiting. "Au revoir, Turner. Have to get back to work. You will begin sketching at once?"

"This afternoon, sir."

"Fine, fine. I'm anxious to see the results. Have a pleasant stay." He was busily scribbling before Joseph even cleared the doorway. Only a day was left and the novel was only half finished. Madame Chung showed Joseph to his quarters—silken quarters—bowed, and left.

The drawings of the abbey were completed in a week. Beckford, overburdened with revisions, observed them from where he bathed in a tub of warm water mixed with goat's milk. Joseph placed each one separately on an easel

for viewing. "I like them, Turner. You've done an exceptionally fine job and I'm most thankful."

"I'm pleased, sir."

The word "pleased" had been carefully chosen. Joseph was far from ecstatic about those drawings. As he worked at them, those frustrating hours under Tom Malton's heel had come rushing back. Accurate perspective, correctly defined lines. These had been Malton's dull and monotonous priorities and, as well, those for the abbey. For nearly a week his imagination had been of little use. He was only working to put some bread on the table. But then, that's what commissions were all about. Furthermore, with the possibility of becoming an associate of the Academy in the offing, Beckford's name on his list of patrons wouldn't hurt.

After mulling over Farington's advice for several weeks, Joseph rented rooms in Harley Street. He was signing a lease for the landlord, the Reverend Mr. Hardcastle, when violent stomping erupted on the floor above them. Hardcastle's eyes lifted. "Madame Serres is on the premises. Terrible tempered, that woman. It's a wonder her poor husband can think, let alone paint with her goings on."

"A princess, I hear—the Duke of Cumberland's daughter?"

"No kin to him whatsoever. It's a lie she spreads around."

A scream came above the stomping. "A blessing they only have limited use of the place—from ten in the forenoon until three."

"No bother to me."

"Thought it best to alert you to the situation." Hardcastle shook his head. "Such tantrums."

Joseph suppressed a sigh. Tantrums had long been a part of his daily life. As he went toward home it crossed his mind that Sarah Danby lived close by at 46 Upper John Street and the thought of it warmed him.

His porridge went untouched at breakfast the next morning. William observed him with a knowing eye. "What's eatin' at you, Billy?"

"Nothin'."

"The council votes this morning."

"That's so. Sixteen painters and three architects on the list."

"And I'd wager not a one feels like eatin' this mornin'." He filled Joseph's coffee cup. "How many vacancies?"

"Only four. I'm told Sandby and a few others are for Woodforde."

"Leave worryin' to the others, Billy. You're givin' them enough cause lately."

"Daddy?"

"Yes."

"I've taken lodgings up on Harley Street."

William sat speechless for a few moments before getting up to clear the table. "Well, I suppose you must do what you think's best."

"It's just that I'm needin' more space for work. When you're ready you can move in with me. Meantime I'll be spendin' time here as well."

"It's best, Billy." Silence took over the room. William put the dishes to soak and left for his shop. Joseph remained at the table immersed in guilt and apprehension. It was half past eight and the vote was already under way.

Four hours had passed. Joseph was in his room packing his clothes when a knock came at the door. Charles Brookfield, a probationer, was there. With a studied loftiness he said, "Mr. Turner, I've been sent by Mr. Farington to inform you of your place as an associate of the Royal Academy."

With equal loftiness Joseph answered, "Thank you, and pass on my gratitude to Mr. Farington." He then hurried to his father, with a smile that said what William wanted to hear.

The older man shut his eyes and plopped down in his barber's chair. "Congratulations, Billy. Now go put somethin' in your stomach. Surely you're in need of it."

Suddenly Joseph's smile faded. "Daddy?"

"Yes, son."

"I'm packin' to move."

"Oh . . . oh? You'll visit often I hope."

"Indeed I will, Daddy. Well—I must get on with my packin'."

The shop had grown unbearably quiet.

"God bless you, son."

On the last day of 1799, Joseph was given his diploma. That night, with his father and Tom Girtin, he went to the Academy Club to pay his respects. Farington came over and gave him a pat on the back. "My congratulations. And I have just come from the exhibition hall. Your *Battle of the Nile* does its walls justice."

The compliment was strangely timed. Joseph had been thinking about Gully Cooke. The painting, violent with human carnage and fire, could have portrayed his end.

His rest of the evening found him suspended between two irreconcilable realities—Gully Cooke's fate and his own good fortune. He laughed at Tom's jokes, but without the usual enthusiasm; accepted the compliments graciously, but with a certain pensiveness. He and William neared home when he came straight out with it. "Too bad Gully wasn't with us tonight."

"'Twould of made the evenin' complete."

"Ah, but surely it wasn't."

They had reached the door. "I've a feeling he was there in spirit."

"I hope so." He then took the diploma from his pocket and handed it to his father. "This is for you."

"But it's yours, son. You earned it."

"We earned it, Daddy. Have a good night." Gully Cooke still occupied his thoughts as he went on toward Harley Street.

CHAPTER SIXTEEN

Joseph sat uneasily at the head of the table. Sarah had served a fine meal, but her children were putting him on edge. Neither their eyes or manners offered welcome and Sarah shared his discomfort.

"Children, Mr. Turner has become our dearest friend." Silence came to the table. "And he will be very close to us from now on. Isn't that so, Joseph?"

He smiled and nodded in agreement, understanding clearly what she was conveying to him, and to her children.

She turned to Marcella, the eldest. "Darling, Mr. Turner loves poetry. It would be so nice if you recited some for him."

"Please not, Mother."

"Just one?"

Hastily Joseph cut in. "Some other time, Sarah, but I do so look forward to it." He glanced toward Marcella, expecting a small gesture of thanks. She showed none. Avoiding his eyes, she feigned sleepiness and asked permission to go to bed. The issue was settled.

"Good night, sir." The chorus fell on him like a chunk of wood.

"Good night. Sleep well, children." The three of them kissed their mother's cheek and departed.

Two hours passed before Sarah and Joseph entered the bedroom. She had spent the time in between doing what Marcella had failed do—reading poetry. Now Joseph sat on the bed pulling off his boots. "I'm afraid your children find their father's shoes hard to fill."

She leaned forward and kissed his brow. "And what prompts such feelings, Joseph?"

He smiled weakly. "Well, it seems rather clear to me."

She reached for his hand and pressed her lips to it. "You are not to fret. They were very fond of their father and find it hard to accept his absence. They will grow to love you as I do." She stood for a few moments looking

toward the floor. He glanced at her. Her thoughts seemed to be adrift—beyond him, beyond the room. Turning slowly to a chest of drawers she opened one and took out an envelope wrapped with a pink ribbon. She smiled, then pushed it into the pocket of his coat.

"And what is that, may I ask?"

She moved to him and kissed his cheek. "A secret—a great big, beautiful secret, and you are not to open it until tomorrow." She kissed him again. "And only when you are alone." Again she became quiet as tears suddenly clouded her eyes. "Oh, Joseph, I'm so afraid."

"Afraid of what, my dear?"

She was smiling again. "Of tomorrow, I suppose."

"And what happens tomorrow?"

"Oh—let's wait and see."

Later as she lay asleep in his arms, the possibility of marriage crept into his thoughts, and, as well, the recurring images of a mad mother, a tormented father and the anguish of those final moments with Katherine Forsyth. These unsettling images and others roamed his thoughts as he fell asleep. At six o'clock the hall clock awakened him. He dressed hurriedly, embraced Sarah and left by the rear door.

A stray cat was the only sign of life on Harley Street when he reached there. A shattered wineglass and a woman's slipper with a broken heel lay at the entrance. "Madame Serres must be on the premises." He went to his workroom where sketches for a new painting were strewn about. *The Fifth Plague of Egypt* was under way. After a hard roll and tea he started working. Then abruptly he stopped. Sarah's envelope had crossed his mind. He went to the closet, took it from the pocket and tore it open.

Joseph, dear, I am expecting.

The world stopped!

For two weeks he worried in seclusion. The meanings of right or wrong became ungraspable. Her situation—her awful situation—was burning into his conscience, pleading with him to understand the depth of her anguish. Marriage, only marriage, was the gentlemanly way out—but to a woman

with three children who seemed to loathe him? Hour after hour that problem hounded him without flinching. It stayed with him, doggedly interrupting his work, just as he feared it would if he took her as his wife. Scorn would be heaped upon her for allowing him into her bed. And indeed he loved that bed; it had become his Eden. But without marriage they could no longer share it in peace. His sense of propriety plunged downward, leaving him with a doubtful choice—lust or freedom.

On Monday of the third week, still confused and weighed down by his cowardly behavior, he walked toward her house. A half block away he stopped to stare at it. Finally, he went to the door and rapped twice. Three more times he rapped. Suddenly he was filled with premonition. Had she packed up the children and fled in shame? He was turning to go when the door opened.

"Sarah."

She appeared, looking at him with disdain.

"Might I come in?"

"And for what reason?"

"Please, Sarah, I must come in."

He entered slowly. She sat down on a divan, and when he sat beside her she moved away.

"What can I say, Sarah?"

"Of that I wonder myself."

"I've no explanation other than I've been torn with confusion."

"Really, Joseph. How sad. I see I have reason to pity you."

"I ask forgiveness."

"Forgiveness? I thought that perhaps you had come to ask for my hand."

"I've considered that."

"Really, now. How decent of you."

"I'd rather you strike me than speak so scornfully. I've serious problems at the moment."

"Indeed? And as if I don't have any problems. If that alone has kept you away, please go. A dishonored woman can only make things worse for you."

At loss for more to say he went to stare out of the window. Then quickly he turned back to her. "For the moment, at least, I can't marry you."

"Well—your frankness is appreciated. What do you expect of me now?"

"You...you have every right to refuse." He paused. "But I beg to carry on our relationship."

"More sexual amusement. Is that it? And if I refuse?"

He went back to her. "I hope you won't. Please . . . please give me time. I love you. Oh, so dearly I love you, Sarah."

Such earnest pleading had hit the mark. She took a deep breath. "Oh, how terrible. How terrible. Something must be done, Joseph."

He reached out to her, and hesitantly she rose and leaned into his arms. "Sarah—my dear Sarah. You're not to worry. Things will work out for us. I promise you. I promise you."

She gathered in his words and, for the moment, found them without much worth. But the two exasperating weeks she had spent alone had left her in need of such a promise.

The children returned from school to find their mother's bedroom door locked. "I have a terrible headache," she called out to Marcella. Joseph lay beside her, content, but somewhat annoyed by the interruption.

By August that promise was ravaging Joseph's sleep and his soul was being devoured by guilt. And that guilt was imperiling his freedom. Sarah's stomach had extended to a fullness unbecoming to a widow direct from mourning. To those who revered the late John Danby, her pregnancy was appalling. By now, Joseph felt besieged by her complaining about every-thing, especially his neglect of her because of work. She had expected that as he approached fatherhood he would become more loving and dutiful. Instead he appeared somewhat oblivious to her and the child she was carry-ing. Rage was building inside her, and rightfully so. She was questioning his behavior one morning when his patience fled and his discontent surfaced. "Sarah, what's gettin' into you? Your constant naggin' drains me of all desire to work."

"And you drain me of all desire to bear your child. Lately, you only show regard for your work."

"Without work my life ends." He glowered at her. "I do love you. I do care about you. Stop playin' at dramatics and try, if you can, to realize that creativity's not turned off and on like a water spigot. It never stops demandin', even while you're sleepin'. For just once try to understand that!"

"Your voice raises above that of a gentleman, Joseph. I am quite aware of what creativity demands. And try, if you can, to remember that my late husband was blessed with it, yet he never used it as a reason to neglect those he loved."

Her words angered him even more. "I see you've got it all figured out!" Grabbing his hat he stormed from the house. Sublimity with Sarah Danby was slipping from his grasp. Bachelorhood was setting a huge price. But marriage? It would be even more costly.

"A dishonored woman." She had spoken it with such splendid sarcasm. Now, more than ever, he was determined to hold on to freedom. "Painting's what life gave to me, and I'm not allowin' man, woman or child, to turn it into ashes." This he firmly declared to the silence of his room.

The insistent cry of a baby filtered down from the second floor as a young lady opened Sarah's door for him on the first of September. He had never seen her before. She held a bloodstained sheet and he stood for a moment perplexed. Then a voice rang out. "Lucinda, fetch a batch of clean towels and more warm water!"

"Yes, ma'am!"

"I'm Mr. Turner. Mrs. Danby expects me."

Before she could answer he was taking the stairs to Sarah's room. The baby had arrived and a plump midwife was washing it in a porcelain bowl when he entered. She gave him a big smile as he stood with his hat in hand looking on. "I'm Mrs. Heemskirk. 'Tis a lovely girl, sir, and some mighty good lungs she's got."

He turned toward Sarah, who lay asleep with her face to the wall. "Is she alright?" he asked in a whisper.

"Oh, she'll be fine, sir. Had a bad time of it, but no need for worry." He leaned forward and stared at the infant. "Why is it crying so? Is it alright?"

"The poor thing's been shut up for nine months, sir. Got a right to bawl."

Lucinda returned with towels and water and he retreated to the downstairs parlor and flopped down in a chair. "So—a father I am. Hard to believe." How would this child affect his life? What would she mean to him, and he to her?

The baby had cried itself to sleep and he was nodding away when the children tromped through the door. They stopped and looked questionably at him. "Good afternoon, sir."

"Good afternoon—a big surprise you've got coming to you."

"Surprise, sir?" Marcella asked, her eyes widening.

"You've got a new little baby sister."

"They flung down their books, but Joseph halted them before they could mount the stairs. "Children, your mother's sleeping. Best that you wait until she wakes up." From his pocket, he took peppermint sticks and handed them out. Marcella smiled. "Oh, thank you, sir." One by one, Jonas and Caroline thanked him.

Joseph was mildly surprised. For the very first time they had smiled at him. He smiled back. Their sudden friendliness had caught him off guard. "Would you mind if I tried my hand at fixing supper?"

Marcella answered, "I can cook, sir, but if you would like to help it would be just fine."

"Good, then we will do it together."

The potatoes had been put to boil when Lucinda called out, "Madam's awake. You can come up now."

The children with Joseph at their heels stepped cautiously into Sarah's room, went to the crib and stared at their sister. Joseph sat on the bed beside Sarah, took her hand into his and kissed her brow. "I'm told you had a hard time of it."

She smiled weakly. "True, but she's a darling, don't you think?"

"I do—I do, but I worry for you. Is there still pain?"

"None whatsoever. Just a bit tired."

"You must rest. Marcella and I are fixing supper."

"You will find her quite efficient."

"What's its name to be?" Jonas asked.

"We haven't chosen one as yet," Sarah answered. "Would you like to suggest one?"

He scratched his head and shut his eyes in thought for a moment. "How about Mike? That's a good name."

"That's a boy's name," Marcella informed him.

"But it has no long hair. How do you know it's a girl?"

Mrs. Heemskirk promptly supplied the answer. "Lad, papers come pinned to every baby's backsides sayin' just what they're meant to be. So there's no doubt."

"Mother, may I suggest a name?" Marcella asked.

"Of course, darling."

"Evelina—Evelina Danby."

"Ah, a pretty name it is, lass." Sarah and Mrs. Heemskirk nodded in agreement.

After a pleasant supper, Joseph was allowed to hold Evelina in his arms for a few moments—and he held her as if she were made of the most fragile substance. For the first time he felt pleased sitting among Sarah's children. Jonas touched the tiny dimpled hands. "They're like cotton."

"The hands of an artist for sure," Joseph said proudly.

Marcella went to stand before the hearth. Sarah touched Joseph's arm. "She has a surprise for you." She bowed to her daughter. "Please, darling, go ahead."

Joseph smiled broadly as Marcella began her recitation.

"Of nature's various scenes the painter culls
That for his favorite theme, where the fair whole
Is broken into ample parts, and bold;
Where to the eye three well-marked distances
Spread their peculiar coloring. Vivid green,
Warm brown, and black opaque the foreground bears
Conspicuous; sober olive coldly marks
The second distance; thence the third declines
In softer blue, or less'ning still, is lost
In faintest purple."

Joseph beamed. "How wonderful, Marcella—how wonderful, indeed. That was a verse from Thomson?"

"No, sir. It's from Mr. Mason's 'English Garden'."

"Ah, yes, to be sure, and so well you read it."

"It took a month to remember the lines."

Evelina burped a mouthful of milk on his waistcoat and he stared at the mess as Sarah handed him a napkin. "Criminy. Why'd she do that?" he asked laughing. "Could be she doesn't like the looks of my waistcoat?"

Evelina's arrival had brought joy to the Danby household, but an uneasiness that stirred inside Joseph surfaced a week later as he and Sarah lay in bed.

"Hardly a word have you spoken since supper, Joseph. Are you unhappy about something?"

He shut his eyes and shook his head. "No reason to speak about it, I fear."

"But I beg you."

His sullenness grew as she waited. "It's a fetching child you've given me, Sarah."

"Yes," she murmured. "And you had a considerable amount to do with that."

"There's somethin' I dislike nevertheless." She half-turned, as he went on slowly. "Certainly it's somethin' to do with Evelina but . . . but . . . "

"Joseph—what is your displeasure?"

"Well, I was readin' her birth papers today and there's no mention of me as the father."

"Ah, so that is it. You object to the surname of Danby?"

"To be sure I do. Turner's her father's name."

"Then Joseph surely you must realize that only through proper marriage can she carry your name."

He thought her answer over for several moments. "So that's on her mind again," he thought. Abruptly he turned his back to her.

It was the following day. The hour for gaslight had arrived and a sharp chill was creeping into the December evening. Passing Squire Tompkinson's

house Joseph saw the windows ablaze with candlelight. A long line of hansoms waited out front. The squire was entertaining. Walking on, he dug his hands into his pockets. Deep in the fold of this coat he hadn't worn for nearly four years his fingers touched it—that wedding band for Katherine Forsyth. Now it was feeling like a thorn in his fingers. Why hadn't he thrown it away? Having lifted it from his pocket, he was contemplating hurling it into the darkness when her voice echoed through his memory. Courage failed him. Without any explainable reason he put the ring back into his pocket. So suddenly it had brought back the hopelessness at Margate. But as he went on the memories dwindled to nothing beyond oblique curiosity. A question entered his thoughts: "I wonder where she is now?"

Unknown to Joseph, she lay now curled in despair on her bed in London's East End. Having just been awakened by her husband's knock at the door, she had stirred but remained silent. He entered slowly and stood looking down at her. Through a veil of tears she fixed his silhouette in her sight, observing him as one would a beast. During the past four years he had revealed himself as a man who seemed to despise her, who used her mainly to satisfy his need for authority. For five leaden minutes he stood there in the shadows, taunting her with hostile silence. What evil possessed him at this moment, she wondered. So much she wanted to scream out her hatred for him. But she lay there waiting. Then, not having said a word, he left the room.

When she heard his footsteps on the stairs she got up and put on a dressing gown, puzzled about the hopelessness of her marriage to Roger Becket, for whom she held only contempt. No longer could she stand the silent weeping. The decision she had sidestepped for so long was explicit. Daily she was plotting her escape.

CHAPTER SEVENTEEN

The new century barreled in overnight drenched with grog, ale and champagne, and the pictorial romanticism moving in with it warmed Joseph's heart. He felt zest for its masters, a sense of adventure and unlimited energy. Preparing for that Grand Tour he hoped to take one day, he was studying French, attending lectures and reading good poets. Thomson's classical poem, *Summer*, had inspired *The Fifth Plague of Egypt*. ("Moses stood amidst swirling dust and smoke tossing soot into the air. At his feet man and beast were dying.") Almighty vengeance was the theme. *Aeneas and the Sibyl*, his most recent painting, seemed to speak to him with a veiled meaning. Aeneas had rejected his lover, Dido, for a higher destiny. Sarah could have related this to the strain that Joseph's recent neglect, and other behavior, was once again putting upon their relationship. He had arrived one afternoon to find the household withdrawn into solemnity. Marcella, with renewed aloofness, informed him that her mother could be found in her bedroom. Without bothering to remove his hat, he had gone there to find Sarah in tears.

"What is wrong?"

She bit into her lips. "Oh, I'm so deeply distressed."

He took off his hat and sat on the bed beside her. "Now what's troublin' you?"

"Do you really care?"

"Wouldn't of asked if I didn't."

"Well—I suffered a gross insult today."

"Insult? Who insulted you?"

She sat up, plumped a pillow in her lap and dug her face into it, sobbing uncontrollably. Gently he put his arm about her shoulders—only to have it shoved away.

"Who insulted you and how?"

"If you must know, a schoolmate accused Marcella of being the daughter of a trollop."

"Well, well now, only the nonsense of some silly child."

"Call it what you like but I feel truth in it."

"But why?"

"Why? Why, you ask? You, of all people should know why!"

"I'm sorry. Do you hear me? Sorry."

"Sorrow does me little good. I am a sinful, unmarried woman. Evelina is the truth of it."

He sprang up and stomped down the stairs and took Marcella aside. "Child, your mother's a fine lady. You are not to let a stupid remark by some dunce hurt you."

"I think no less of my mother for what was said, but surely the remark hurt."

He gently patted her shoulder then went back up the stairs. At the top of the landing he found his hat on the floor. It had been thrown there. The door was shut and locked.

Anger boiled inside him as he left Upper John Street. "Marriage! Marriage!" Her reason for mentioning it had cut into his conscience like a knife.

After lunch with his father the following day he posted a short, curt letter to her. "I am to take a month's tour of Wales." Ten soiled pound notes were included. After reading it she went to stand by the window. Gazing out at the wall of jasmine where they had experienced their first kiss, she tore the note in half and went to nurse Evelina.

By foot, horseback and stagecoach he traveled the wildest country he could find. There were moments when he considered breaking off with Sarah forever; days also when those Edenful nights came rushing back. Then, only hard work softened the longing. He went on through Wales climbing hills, descending into the valleys, villages and hamlets, struggling with the mystery of the unconquerable sun.

Heavy fog swirled over the countryside as he rode in a small coach toward Hereford one morning. An elderly woman who sat opposite him was biting into a roll when suddenly the carriage slowed, pitched forward, then swung to a stop in a ditch. She screamed and landed on him as they fell to

the floor. Pushing her aside, he opened the door, scrambled to his feet, and climbed out. The driver, a skinny young man with black muttonchops, was crawling out of the ditch. Lying on its side was the horse, with foam oozing from its mouth. It kicked a couple of times, shuddered, then lay still. The driver ran his hand along the animal's chest, stood up and shook his head. "The critter's dead, an' without no warning a'tall. I've been pissed on. Just bought that bloody 'orse two days ago. Ah, me woman prayed to me not to lay out the guineas for ut. 'Twas right she was."

The old woman peeped out, saw the dead horse and screamed again. "Lord, be with me," the driver moaned. "That old granny's 'ad the woefuls ever since I picked 'er up. What ta do with 'er now?"

"Well, what do we do?"

"Haf to git anuther 'orse at Hereford."

"And how far's Hereford?"

"About a mile I'd say." He looked down at the dead horse and shook his head again. "Ach, I'll bet that swindler who sold him to me know'd its days was numbered."

"Who'd you buy it from?"

"You'd not believe ut—a high-nosed bible thumper."

"I'm to go on by foot. You'd better stay with the old lady. I'll send help."

"'Twould be decent of ya, guv'nor. Ya kin leave yur belongings."

"Better off with me, I'm afraid."

"'Tis yur wish, guv'nor." Hurriedly he placed Joseph's baggage on the road.

With his traveling box, a valise and umbrella, Joseph started off. The fog rolling down from the hills was so thick he could hardly see a hundred paces ahead. Had it not been for the road he would have lost all sense of direction. He was mumbling his discontent when he saw a dark form moving toward him through the fog. It was a small man with blood streaming down his face. Seeing Joseph he stopped, and for a moment they glared at each other. The stranger stumbled on, but after a few feet he collapsed in the center of the road.

Joseph was helping him to his feet when voices came from the distance. Four men carrying muskets emerged from the fog. "There they are!" They came rushing toward them.

"What's goin' on here?" Joseph asked in bewilderment. "What's the meanin' of this?"

The leader aimed a musket at him. "Thought you'd help him get away you did. Now you'll hang with him!" Joseph was thrown to the ground and bound with a rope.

"I've helped nobody!"

A fist struck his mouth. "Hold your jaw or you'll get worse!"

Joseph chose to remain quiet and angrily he watched as they bound the man and lifted him to his feet. Then the six of them started back toward Hereford. At Joseph's polite request, they took along his traveling box, umbrella and valise. A quarter of a mile out of town they hailed a farmer with a flatbed wagon, who hauled them to a gaol. There Joseph was dumped into a dark cell.

Midday had arrived before a spindly man with sagging shoulders came with a candle and looked in on him. "Your name?"

"Surprised you'd bother to ask."

"Your name?"

"Turner! Joseph Mallord William Turner!"

"Hold your voice down. How long have you known Holworth?"

"Holworth? Who in blazes is Holworth?"

"The prisoner you helped escape. Don't fake innocence."

"I'd never seen him before he comes stumbling up the road."

"And why was you walking the road at such an hour?"

"Makin' my way to Hereford."

"With all the guineas we found on you, you're walking to Hereford? Come man, out with the truth."

"If you'd like hearin' it, I'll try tellin' you."

"Well—go ahead."

Sullenly, Joseph explained the circumstances.

"You've proof of such a tale as that."

"I've proof of nothin' outside a swollen jaw."

"This driver's who lost his horse—do you have his name?"

Scowling, Joseph searched his pockets and pulled out a slip of paper. "Mind bringin' that candle of yours closer?" Cautiously the man did so.

Joseph squinted at the scribbling. "Name's Hardwick."

"Dwarmer Hardwick?"

"Hardwick's all it says. You can find him and his dead horse back up the road."

The inquisitor's attitude softened. "Alright, we'll soon know the right or wrong of your story. For your sake I hope it's right." Joseph was left sitting on the floor mumbling to himself.

Three hours passed before the man returned, contrite and apologetic. "My regrets, Mr. Turner. It was all a mistake," he said unlocking the cell door.

"Your regrets," scoffed Joseph, "will be attended to by my lawyer. Now fetch my belongin's and guineas and let me be on my way."

At the inn where Joseph found lodging the barkeep told him that Frank Holworth's hanging was to take place the next morning.

"What's he to hang for?" Joseph asked.

"'Ee filched a mutton slab at Takaber's butcher shop. 'Twas the bugger's third offense. 'Ee 'ad ut comin' to 'im."

"A slab of mutton. Poor devil," Joseph muttered. He rubbed his sore jaw and ordered a grog.

"'Tis 'is wife and four young'uns to pity I'd say."

It had been a bewildering day. After six more grogs, Joseph stumbled off to bed.

HEREFORD CHRONICLE, 1800

AUGUST. TUESDAY, 9

BETWIXT 5 AND 6 AT MORNING.

FRANK HOLSWORTH, CONDEMNED THIEF,

PAID HIS DEBT TO THE KING. A COIL OF ROPE WAS PUT ABOUT

HIS NECK. THE OTHER END WAS FLUNG OVER THE GALLOWS

AND HE WAS DRAWN UP TO STAY THERE UNTIL ALL LIFE

DEPARTED HIM. THE TEN LASHES HE TOOK BEFORE THE
HANGING SUFFICED FOR HIS ATTEMPT TO ESCAPE JUSTICE
WITH THE HELP OF AN ACCOMPLICE THE MORNING OF THE
8TH. A SEARCH FOR THE OTHER CULPRIT IS STILL GOING ON.

A short portly gentleman in a frock coat and top hat arrived at Sarah's door during the early part of September. "You are Mrs. Sarah Danby?"

"I am indeed."

He handed her an envelope. "I was instructed to bring this to you." He tipped his hat and turned to leave.

"Who, might I ask, is this from, sir?"

"Truthfully, madam, I don't know. The contents, I am sure, are self-explanatory. Good day."

She went inside and instantly opened the envelope. Another £10 bank note. So perfectly she knew who had sent it. Two days later a letter from Lancaster arrived. It read simply:

My dear Sarah,

I will be back next Saturday morning.

I hope welcome meets me at your door.

I send my love to you and the children.

Joseph

Rarely did she utter an obscenity, but now she allowed herself one. "Mizzler."

He returned to her doorstep on a Sabbath afternoon loaded with presents. He knocked gently on the door and moments later Jonas opened it.

"Ah, Mr. Turner, you're well and back from the hospital."

Joseph blinked his surprise. "Hospital?"

"Mother told us you'd be back when you were all mended." He grinned. "Bring some peppermint?"

"To be sure I did." He dumped the presents on a sofa and pulled peppermint sticks from his pocket. "And where's everybody?"

"My sisters are out but Mother's here."

At the mention of her name, Sarah came with Evelina in her arms. "Well, you are back," she said with a forced calmness.

"And glad to be." He kissed Sarah's cheek before taking Evelina into his arms. "My, but she's growin'."

"Enough time has passed, wouldn't you say?" Softening the steel in her voice she added, "It's nice to see you well again."

It was obvious now. She had attributed his absence to an illness. "Is the welcome mat out?" he asked, smiling.

She too smiled, but let his question go unanswered.

He took Evelina and kissed her. "The welcome sign's out for your daddy."

Sarah's eyes flashed at him, held for a moment, then she took the child back. After supper, Joseph handed out the presents—a doll for each of the girls, a small replica of Commodore Nelson's *Vanguard* for Jonas. As he handed Sarah a beautiful necklace he took her hand into his. When she pressed his hand warmly he allowed his thoughts to roam. So soft and voluptuous she looked in the candle glow.

The children had gone to bed. The house had become quiet and they sat close together on the sofa. She listened in meditative silence as he relived the horrifying incident outside Hereford; as he spoke his sorrow for having left so abruptly and, with his hand about her waist, of how much he had missed her. Having arose they were moving toward the stairs when she stopped at the coat rack. There, with a courteous smile, she removed his hat and handed it to him. "Good night, Joseph."

"But—"

"Good night, Joseph."

The room had suddenly turned cold, and all of his longing was encompassed in his reply. "Well, a good night to you—Mrs. Danby."

The politeness in her smile grew deeper. "Good night."

He shot her a hurtful glance, then walked out the door.

Tom Girtin was all smiles when they met by chance the following morning on Maiden Lane. "Joseph, I've good news. I'm off to France next year."

"And how'd you manage that?"

Tom laughed. "When the Under Secretary of State's your patron, anything's possible."

"Like to get there myself. If only they'd get that bloody treaty signed."

"The Frenchies are coming around. They miss our boiled tripe. Are you for lifting a grog or two?"

"Like to, but Daddy's waiting.

"A good hullo to him. I'm to see you later."

The hangdog look on William's face, the helpless slump of his shoulders projected serious trouble. "Your Mum's in terrible shape. The people at Bethlehem are giving up on her altogether—saying she should be in Islington, where she'd get better care."

"Could be they're right."

"But the place is more costly."

"I can well afford it, Daddy. "Come—put on your coat. We have to get over there right away."

Bound hand and foot, roped to a bed without sheets, her mouth stuffed with a gag-cloth, Mary lay shuddering in a room so cold Joseph and William failed to remove their overcoats. Crusted blood was on her chin and lips—evidence of another tongue-biting—and her neck was bruised to a blackness.

"Arrugh! Arrugh!" Mary's muffled cries sent a chill racing up Joseph's spine.

"Almighty God," William moaned. "Almighty God."

"This is inhuman!" Joseph burst from the room and stormed down the corridor. "Where's Monro? Where's Monro?" he asked heatedly as he rushed into the doctor's office.

A thin balding man sat at Monro's desk. He jumped to his feet, shaken by Joseph's violent entrance. "Who might you be and what do you want?"

"Damn who I am! Where's Monro?"

"If you must know, he's spending the fortnight at the royal quarters attending His Majesty. May I be of service to you? I'm his assistant, Dr. Curlough."

"Indeed you can!" Joseph bellowed. "My mother's being treated like a beast and I'll not put up with it for another second!"

"Please, sir. Calm down. Now, what is your name? And who is your mother?"

"My name's Turner, and that woman you've got roped in that bloody cold room without a stitch on is my mother! Now I'll mince no more words with you. I want her out of there and into a warm place right now!"

Curlough picked up a hand bell from his desk and gave it a vigorous shaking. Two orderlies came hurrying down the hall. By the time the four of them reached Mary's room William had placed his coat over her. He stood now with his head buried in his hands shaking with grief. Mary, meanwhile, was trying to kick away the coat.

Curlough gave his orders very swiftly. "Take the patient back to her assigned room." Then he turned to Joseph. "The cold room is not meant for punishment. It's to help calm patients when they became violent and unmanageable."

"I think you're a bloody liar. You're trying to kill her off and I won't have it." He pointed to the black bruises on her neck. "What are those from—chokin' her?"

Curlough waited until they had taken her from the room before he gave an explanation. "Your mother was attempting to hang herself. We caught her just in time."

"Almighty God," William moaned.

Stunned to silence Joseph stood for a moment staring at the floor. Then placing his arm about his father's shoulders he walked him slowly into his mother's room.

She was asleep before they left, Joseph placed his hand on her cheek for a few seconds. "Poor Mum—poor Mum."

A flurry of rain struck them when they exited the building.

After a block, Joseph looked back. In the dark broadening distance, Bethlehem resembled a tombstone rising from the wet earth.

"I've decided you're to come and live with me," he said before leaving William at his door.

"Well—I'll have to think it over, Billy."

"There's no thinking for you to do, Daddy. I've already thought it out. Now please, pack up your belongin's this week." He was now the sole deci-

sion maker for the family. His father's business was finished and his mother was nearing her end. Hikkon's words, echoing back through years, came to his own lips. "Mum's in the state of becomin' what she's to become, Daddy. Nothin' we can do about it."

William moved in with Joseph a week later. Hoping to make himself useful, he immediately began putting Joseph's sketches, drawings and canvases in order. Word came shortly after that Islington had agreed to take Mary as a patient.

"Do they set a date?" Joseph asked.

"Anytime after Christmas seems to be alright with them."

"Then we should plan for two days after."

CHAPTER EIGHTEEN

Joseph found Farington in a murderous mood when he came to his house on a December afternoon. The older man motioned him to a chair. "That maniac Napoleon has dealt the Empire a serious blow. Russia, Sweden and those stupid Danes—weaklings, rats."

"Sorry, don't know what you're getting at."

Farington lifted a newspaper from the floor and pointed to the headline. "Read that."

It was in large letters. "FRANCE AND BALTIC STATES IN NEUTRALITY ARMS PACT." With a casualness that irritated Farington even more, he handed the paper back. "A declaration of more hostilities?"

"It's worse. Much worse. Most of our flax and hemp comes from those states. He's no need to declare anything. The Baltic's closed to British shipping."

"Flax and hemp?"

"And timber as well. The Royal Navy depends upon it for masts."

Joseph was suddenly remembering that Farington's family shipped timber for Russia and Denmark. "Well what's to be done about it?"

"I'll tell you what's to be done about it. I've just left the Admiralty. Our fleet's to pay the Danes a visit and demand their splitting with the little monster."

"And if they don't?"

"Then the fireworks start."

"Cannonball diplomacy."

"Call it what you may, Turner, that's the way things will go."

"So—another command for Horatio Nelson."

"Quite so, but first we'll have to drag him by the heels from Emma Hamilton's boudoir. Poor Fanny Nelson's quietly suffering the brunt of their scandalous affair." He turned and faced Joseph straight on. "Now tell me, what is it you wish to discuss with me?"

"Several things, but I fear it's not the time."

Farington took back the paper and tossed it to the floor. "Never mind. I'll hear you out."

"'Twas nothin' much. I'm off to Scotland this summer and thought I'd drop in to tell you as much."

Farington eyed Joseph with a bit of distrust. "Good country for work. Wild, beautiful. Its lakes remain unsurpassed."

"Yes—yes indeed. I'm lookin' ahead to it." Halfway out the door he turned back. "By the way, there's word bobbin' around that I'm bein' considered for full membership at the Academy. Anything such as that passed your ear?"

"No, Turner. Not even a whisper of such a thing."

"Then a good day to you, Farington."

"And to you, Turner."

Walking along, Joseph was somewhat pleased with the little game he had played. Farington wasn't a good liar. He knew bloody well the rumor *was* bobbing about. The old bird loved to keep you hanging. He smiled. The slop about Nelson and Emma was old hat. People in high places frequently ignored the ears of their hirelings. Tom Girtin's ear had drunk in the prattle of his patron, the Under Secretary of State who, after a few grogs, had spread details about the affair like a town crier. What Tom knew would have curled Farington's eyebrows. But Joseph wasn't one to peddle gossip, surely not with his own house so susceptible to it. What's more, if Lady Emma was half the woman Sarah was in the boudoir, then certainly he understood Horatio's passion for her.

As he rounded the corner, a squat, heavyset man stepped out in front of him. "Holy cats, guv'nor thought for a flash you was me lost brother." When the man laughed, Joseph saw that he was toothless. He was heavily bearded, dirty and smelled of the sewer.

"For sure I'm not your brother," Joseph replied. When he attempted to walk away a beefy hand fell on his shoulder.

"He was a runt like you and 'ee had yur nose. Turned into a cushion-

cuffer 'ee did. Savin' souls while I went about cuttin' throats." He pointed to his boots. "Look—blood spots still stickin' to the dust on me clumpers." He slashed a finger across his throat as though it was a blade. "Islington's me sleepin' place at times. It's where I got bread and cheese in me brains. Been there forever—comin' and goin', comin' and goin'."

"Islington?"

"Bad place it is, mate. Crazies everywhere. What's your name?"

"Frank—Frank Gerhauser," Joseph lied.

"Never heard such a name before."

"You live at Islington?"

"At times I do." He drew in a big whiff of air and coughed it out. "Look ahead to dyin' do you?"

"Not soon, I don't." Slowly Joseph started moving off.

"Thief at Islington called Klinker. 'Ee's always after some trolley's greens, 'ee is. I'm to finish him off someday. Could you come down with a copper or two, mate? Me belly's empty and I'd like a bunt' a tea. Need spurrin' up."

Joseph fished a coin from his pocket, tossed it into his hand then hurried off.

Madness! It seemed to be spreading like wildfire. His thoughts wandered to his mother for a moment, then back to Farington's woes. The general substance of them related to his problem as well. He wanted very much to cross the Channel the coming year. Farington wanted his fortunes left undisturbed. He didn't care a snit about that affair between Nelson and Lady Hamilton.

But, for the moment, Nelson no longer idled with Lady Emma. He had already rushed back to the quarterdeck to prepare for action, shouting: "The damned Danes are crying diplomacy. I hate pen-and-ink men; a fleet of British ships are the best negotiators in Europe!" His sights were aimed at grander game—the Russian fleet.

Joseph had gone on to Roch Jaubert with a more immediate problem. A close friend and confidant to Sarah, the jovial Frenchman snapped to the point. "Sarah tells me Cupid's playing nasty games with the two of you."

"A good way to put it, I'd say."

Jaubert poured tea. Well now, Joseph, what seems to be the trouble?"

"You are to understand, Roch, this is in confidence."

"Of course."

"We've not been at our best for some time now. It's the kids and their feelin' against me. For a while after Evelina came things were fine. Then some busybody's started sayin' frippy things about Sarah, and it took hold of them."

"And they're making you pay the price."

"That's it I'd say. They hold me to blame."

"And where do I fit into all this?"

Reluctantly he went on. "You're a good friend to Sarah."

"Have been since she was a toddler, and I still am."

"Perhaps then you'll do us a favor—and with no cost to you."

"Yes."

"I've found a place for us on Norton Street and, if you're so obliged, I'd like you to sign the lease in your name to keep down scandal."

"Well, that indeed poses responsibility on my part. You do agree to that, Joseph?"

"I do indeed, and I'd think no less of you for refusin'."

"It's not too much to ask, Turner—providing you foot the bill." He lifted his cup to Joseph.

"I will for sure."

"Then it's all set, I'd say. Make the necessary arrangements and I'll do the rest."

"Both Sarah and I will be indebted to you."

"No need for that."

"Tell me, Turner—is Sarah expecting again?"

Joseph stiffened and put down his cup.

"For heaven's sake I hope not. Why'd you ask?"

"Idle curiosity, Turner. No business of mine in any case."

The question had left Joseph unhinged. Inscrutably his eyes took in the contours of Sarah's stomach when they met an hour later.

"Why do you look at me in such a way, Joseph?" she asked.

"I'd like the truth, Sarah."

She stood before him perplexed. "Truth—truth about what? What in the world are you getting at?"

He spoke in a rapid, agitated voice. "Tell me. Tell me! This is no time for little-girl games! Are you expectin' again?"

Angrily she turned on him. "So—and would it really upset you so much if I were?"

Perhaps he'd been a bit ruthless. He started to explain himself, but she was not to be stopped. "You, Joseph Turner, are a man of low bearing. I would not have another child by you if you were the last man on this earth. Now I would be most happy if you left this house."

He sighed heavily. "Well, Sarah, we just can't afford it now. Later, maybe, but I've much too much to do right now and—"

"Would you please leave?"

"Sarah."

"Yes."

"I'm to take the place for us on Norton Street."

"I would advise you not to take it."

"But it's all arranged and Jaubert's agreed to help."

"Good evening, Joseph." She turned quickly and went up the stairs.

Jaubert signed the lease, and despite her anger, Sarah went a week later to tidy up the place. To Joseph's amazement, she left without so much as a caress, vowing to never return. He could only assume that her behavior was meant to extend his agony.

Two months crept by. Diplomacy had failed and the Danes were waiting. The wind was out of the southeast in exactly the direction Nelson wanted. The first broadside was hurled across the water shortly after ten. By noon, the cannonading had reached a shattering crescendo from both sides. A few hours later, the Dane's surrender flag fluttered to the mast top.

Two hundred fifty English dead. One thousand thirty-five Danish dead and wounded. Nelson took just enough time to mend his battered fleet then sailed forth to encounter the Russians in the Gulf of Finland. There was no

need to fire a shot. Earlier in March, Czar Paul I of Russia had been assassinated, and with him died the League of Armed Neutrality. Napoleon, his once-proud navy reduced to only thirty-nine ships of the line and 213 frigates, was in serious trouble. It was time to deal with the Royal Navy, an awesome force he could not face head on. Suddenly—too suddenly—he proposed peace. Obviously, he needed time to patch up his shattered fleet.

Peace had returned to Sarah and Joseph in April. Now he could relish the fruits of it—long sensuous hours at Norton Street. Peace for England as also on the horizon—at least strong signs of it. Like his countrymen, he wanted to be done with war. Only then could he cross the Channel to France. And indeed, things looked promising. With Tom Girtin, he was witnessing a crowd celebrating at Pall Mall. Some, expressing their gratitude, joyfully pulled the French envoy's carriage through the streets.

Tom was drunk. "I'm not to be taken in by all this hubbub. That runt Napoleon's feeding them sour honey, sucking them in. They're dafts to think he's wiping blood off his boots." He staggered to a halt and gazed angrily at a newspaper headline. "Treaty my arse. It's rotten spinach, a crock of dung. That horse leech wants peace with nobody, not even his mother. My word for it, he'll be at our bones before the year's out."

"Hope you're wrong, Girtin. I'm still set on crossin' the Channel."

"Then you've a long wait, I'm afraid. No worry from me. I'm off to there no matter what. That rogue's not to stop me." They crossed the street. A woman of the evening stood on the corner looking for trade. Tom nudged Joseph. "Look—a sparrow catcher." He called out to her, "Could you lend me a free rub, duchess?"

"Try your fist, mate."

"Now that's a cheery one for you."

"Serves you right, Tom."

Fearing to leave him on his own, Joseph hailed a fly, took him home and made sure he was well inside the house. He walked then with two things occupying his thoughts—France and the warmth of Sarah awaiting him at Norton Street.

She sat staring at review clippings cut from the newspapers. "Hullo, Sarah." He kissed her cheek as his hands touched her bosom.

"Hello, Joseph." She glanced up at him for a moment then went back to reading. He planted another kiss upon hair "Why do you bother to read that rubbish? It's mostly nonsense."

"You read them didn't you?"

"I gave them a quick once-over."

"Well, your friend Mr. Beaumont's putting his spiteful tongue on your *Dutch Boats*. He thinks the sky's too heavy and the water resembles soap-suds."

"It's his arse that's too heavy. And his buttercup, Constable, thinks I copied Vanderveld. Well, the devil's fork for both the blackguards." Abruptly he turned away from her. "A'nough. I've come for honey and you're dousing me with sour milk."

She went on. "I loathe the Corcupine's comment about your *Army of Medes*—"

"Stop it Sarah. I've heard a'nough of their guff."

Having taken his words as a personal affront she laid the papers aside and answered with hurt in her voice. "I understand, Joseph. I understand perfectly."

He went to the bedroom where he hoped she would join him. Half undressed, he came back for her five minutes later. She was gone, leaving the criticisms to stare at him from the table where she had dropped them. Fired with disappointment and disgust, he grabbed them and flung them to the floor. "I'm not to bow to some jackass who's never lifted a brush. The sea's not all pretty blues and greens. Soapsuds. They're in every bloody wave!"

CHAPTER NINETEEN

Had Katherine Becket turned left out of Grosvenor Square, and Joseph turned to his right, they would have met. The very opposite happened. He went left for several yards to an alehouse to have grog with Tom Girtin, who was sailing for France the next day. She went right, continued on for another block, and entered a small shop. She left shortly afterward with a rather large package, but she carried it with ease.

The housekeeper called from the top of the stairs when she entered her house, "That you, ma'am?"

"Yes, Marie. Has Mr. Becket arrived?"

"Not yet, ma'am."

Katherine hurried to the cellar, looked around for a few seconds, then placed the package behind a huge trunk. After a quick search she found an old blanket and flung it over her purchase. She was halfway up the stairs when the front door opened and Roger Becket came in and looked up toward her. "Ah, Katherine, you have been out, I see."

"I have."

"And where to may I ask?"

"Shopping." She glanced down at him. He was pacing back and forth with a frown on his face.

Escape was still foremost on her mind as she closed the door to her room. She had grown to think of herself as a prisoner rather than a wife. As she brushed her hair she thought back over the meaningless years she had suffered with him. They had all passed without love or even friendship. Hoping that things might change for the better, she had hung on, thinking of Joseph now and then, regretting that terrible morning of their parting. She sighed and began dressing for dinner. Roger Becket insisted upon eating at exactly seven; not one minute later.

Firelight flickered over the massive table where they ate—he at one end and she at the other. The distance between them necessitated her

speaking more loudly than she found to be comfortable, and even this seemed to please him. At forty-five, he still appeared athletic and virile, with broad shoulders. He was over six feet with keen features. The graying at his temples added to his handsomeness. His law firm had been highly successful for many years, and family inheritances had left him extremely wealthy. With such good fortune blessing him, she found it hard to understand his odd behavior.

They were having dessert. "Katherine—my nephew from York is arriving tomorrow to spend some time with us."

"Oh? I would have thought you might have told me earlier."

"I didn't feel it was necessary."

"It is your home, Roger. You are to do with it as you wish."

"Ah, thank you Katherine." He wiped coffee from his lips with a napkin. "His name—if you care to know—is Alston Beaumont."

"Your sister Hortense's son?"

"Her illegitimate son."

"Not a very kind remark, Roger."

"Kindness, my dear, does not spare one from bastardy. A bastard remains a bastard all his days."

Staring at him, she asked in the calmest of tones, "Roger, can't you see the hopelessness in our marriage? Why do you insist upon continuing?"

"Because I love you. Isn't that a good enough reason?"

The lie, so ridiculous, dismayed her. "But surely you realize that I hold no love for you."

"Come, come, you are at your worst tonight. Let us retire to the drawing room for a brandy."

"I intend going to my bed."

"Ah, even better to share it there."

Not once had he attempted to consummate their marriage. He was playing a new game.

"I'm afraid that's out of the question."

"And why—am I not your husband?"

"You haven't been since we married, nor I your wife."

"Ah, but tonight all that could change."

Her face reddened as she left the table. "Your mood is most strange this evening, Roger. More brandy will hardly improve it." She left him and went up to her room.

For the next two hours he drank heavily. Then he pulled up from his chair, climbed the stairs and rapped on her door. "May I come in?"

"What is it you want?"

He was well inside the door before answering. "To sleep with my beautiful wife for a change." As he spoke he was already undressing.

She lay trembling, knowing that she could not possibly profane herself in the arms of this man she so intensely disliked. "You will please leave. I am very tired." Her voice was more pleading than assertive, but he went to her and roughly covered her body with his. His heaviness and the stench of brandy repulsed her. Fearful of copulation, she held her breath, but that fear was needless; he was as limp as thread. Suddenly he tore her nightgown open, laying her bare. His lips ravished her shoulders, neck, breast and on downward until they quivered violently between her thighs.

When at last the wildness was gone and he was spent he lay staring into the darkness. "Well—I have behaved badly, Katherine. Nature has done a terrible thing to me. I should have explained years ago. I ask for your forgiveness."

She remained silent. It was too late for forgiveness. She might have understood his impotency, but the vileness with which he had disguised it made his plea detestable. "I'm sorry for you, Roger, but you should not expect me to ever forget your cruelty. Now, more than ever, I want a divorce."

"No—I will not give you up."

"You expect me to go on like this forever?"

"Forever."

"Roger, I am a normal woman—and you still would have me go on?"

"Yes, Katherine."

The following morning a young man with a dark moustache and piercing blue eyes appeared at the door with two valises. "I am Alston Beaumont, Roger's nephew."

"Yes, he is expecting you. I am Katherine Becket. Come in."

The Paintings

Joseph Mallord William Turner

ENGLISH, 1775–1851

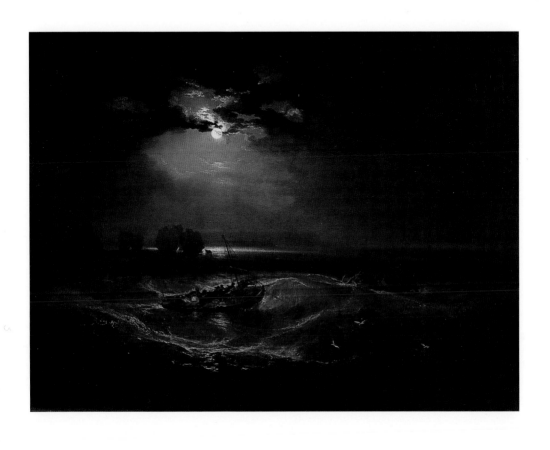

Fishermen at Sea, exhibited 1796
Oil on canvas, 91.5 x 122.4 cm. Tate Gallery, London, Great Britain. © Tate Gallery,
London/Art Resource, NY

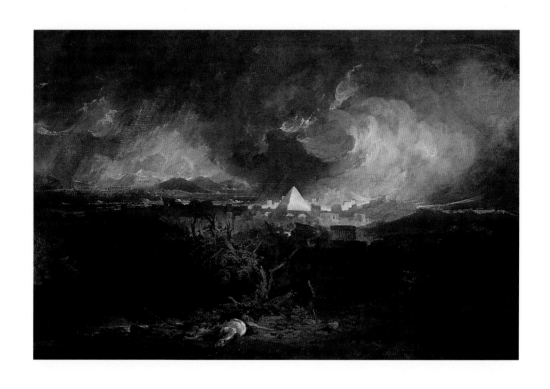

The Fifth Plague of Egypt, 1800
Oil on canvas, 124 x 138 cm. Indianapolis Museum of Art, Gift in memory of Evan F. Lilly

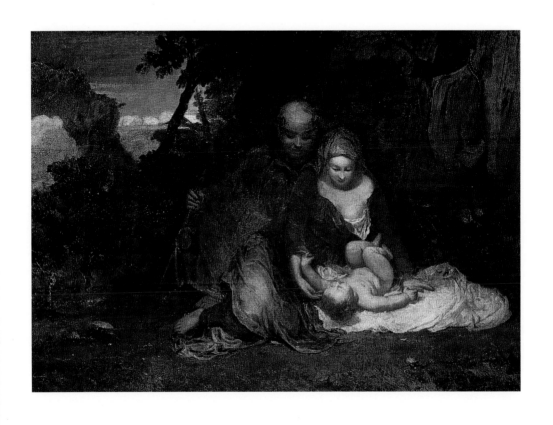

Holy Family, exhibited 1803
Bequeathed by the artist in 1856. Oil on canvas, 102 x 141.5 cm. Tate Gallery, London, Great
Britain. © Tate Gallery, London/Art Resource, NY

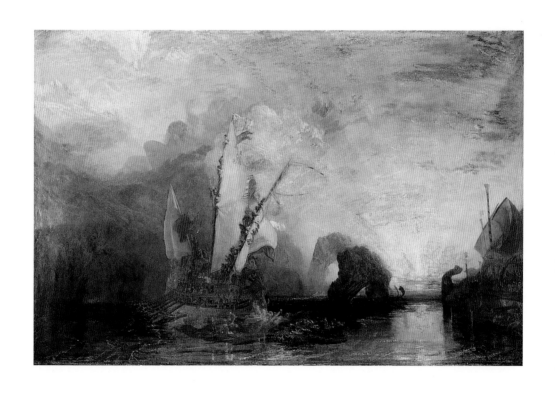

Ulysses deriding Polyphemus, 1829
Oil on canvas, 132.7 x 203.2 cm. © The National Gallery, London

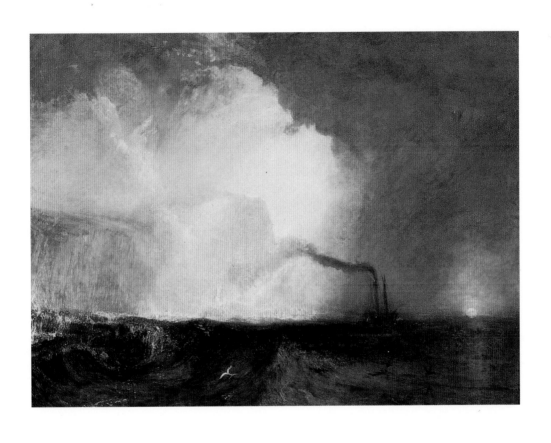

Staffa, Fingal's Cave, 1832
Oil on canvas, 91.5 x 122 cm. Yale Center for British Art, Paul Mellon Collection. USA/Photo:
Bridgeman Art Library

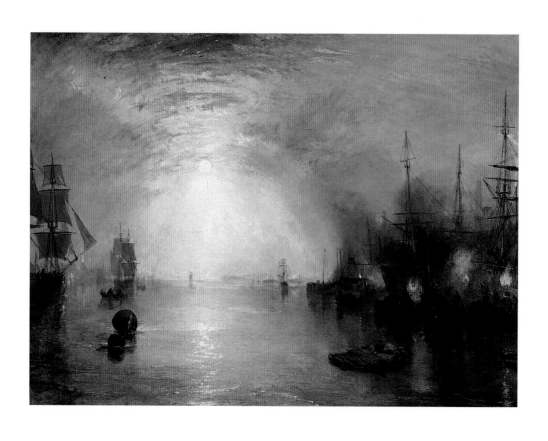

Keelmen Heaving in Coals by Moonlight, 1835
Oil on canvas, 90.2 x 121.9 cm. National Gallery of Art, Washington DC, Widener Collection

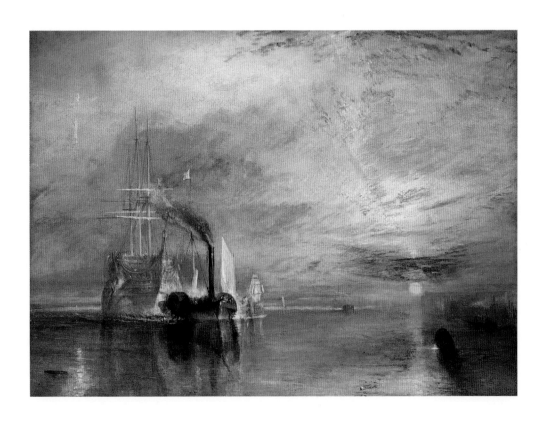

The Fighting 'Téméraire' tugged to her Last Berth to be broken up, 1838
Oil on canvas, 90.8 x 121.9 cm. © The National Gallery, London

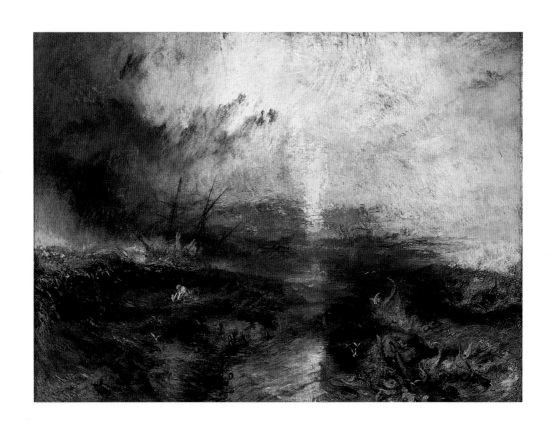

Slave Ship (Slavers Throwing Overboard the Dead and Dying,
Typhoon Coming On), 1840
Oil on canvas, 90.8 x 122.6 cm. Museum of Fine Arts, Boston. Henry Lillie Pierce Fund; 99.22
© 2002 Museum of Fine Arts, Boston

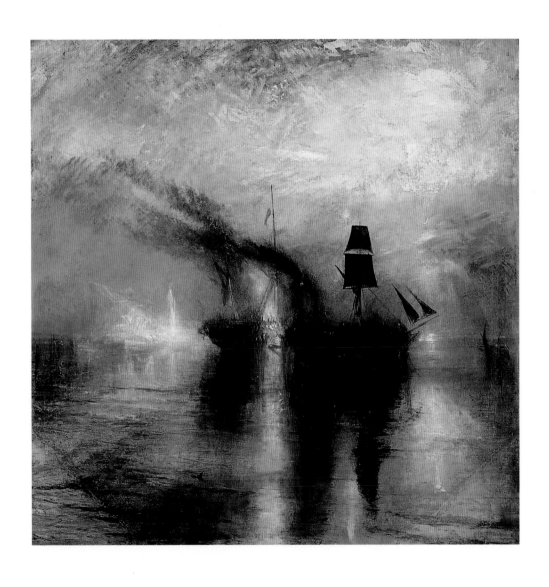

Peace—Burial at Sea, 1841

Oil on canvas, 87.0 x 86.5 cm. Tate Gallery, London, Great Britain. © Clore Collection, Tate Gallery, London/Art Resource, NY

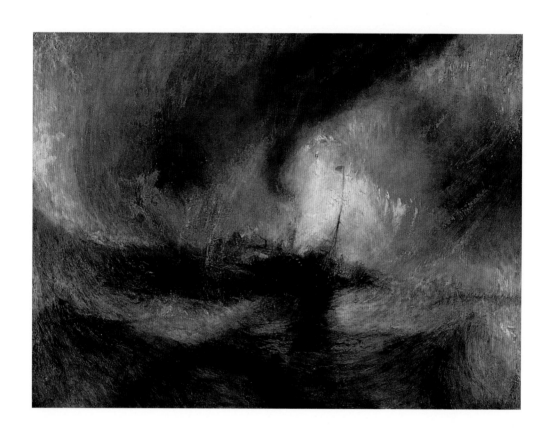

Snowstorm: Steamboat off Harbor's Mouth, exhibited 1842
Oil on canvas, 91.5 x 122.0 cm. Tate Gallery, London, Great Britain. © Clore Collection, Tate
Gallery, London/Art Resource, NY

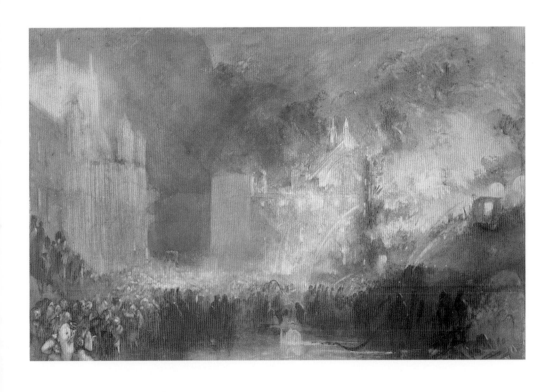

Burning of the Houses of Parliament
Watercolor, 29.3 x 44 cm. Tate Gallery, London, Great Britain. © Clore Collection, Tate
Gallery, London/Art Resource, NY

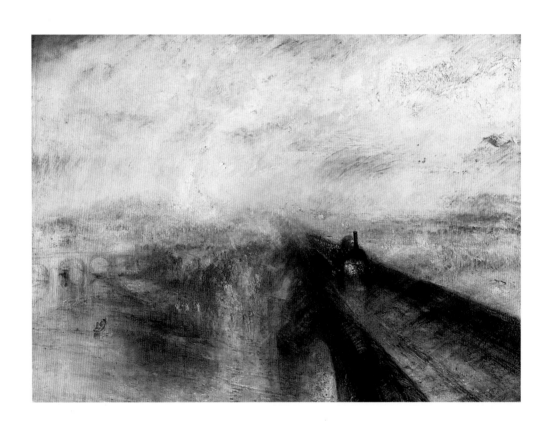

Rain, Steam, and Speed—The Great Western Railway, before 1844
Oil on canvas, 90.8 x 121.9 cm. © The National Gallery, London

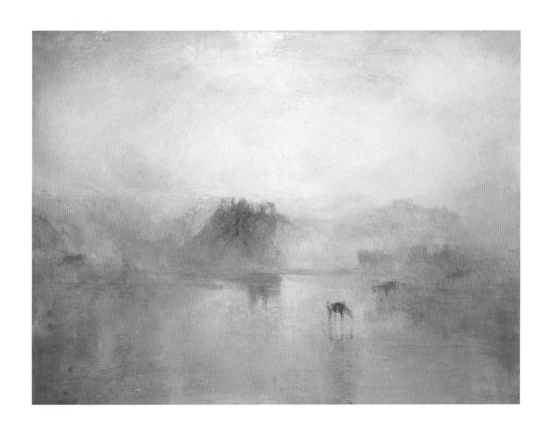

Norham Castle, Sunrise, 1845
Oil on canvas, 91 x 122 cm. Tate Gallery, London, Great Britain. © Clore Collection, Tate
Gallery, London/Art Resource, NY

CHAPTER TWENTY

The twelfth day of February in 1802 was cold and dreary, and for Joseph, bubbling with uncertainty. He sat before the hearth with his father that morning while the Academy's council took the vote. By eleven o'clock, two of the three vacancies for full membership had been filled. The choice for the third then fell between the architect Bonomi and Joseph. Both had supporters, and both had antagonists, but Joseph's supporters were in the majority. At one o'clock a young messenger from the Academy brought him the good news. William was overcome with joy.

"Billy I think you should go thank the selectors, treat them to a small dinner. Somethin' like that."

"I'll not do that, Daddy. Had they not found me deservin' they wouldn't have elected me. I won't go thankin' them for performin' a simple duty."

"It's just good manners, Billy."

"I'm sorry, Daddy. 'Twas my merits that got me in, so I'll give no dinners or make no calls."

"They'll be thinkin' you're ungrateful for not doing so, I'm afraid."

He patted his father's shoulder. "Let them think what they want. I'm not to be a knave to their opinion."

The following morning he to went to give the news to Sarah.

"How splendid, Joseph. How happy you must be. She kissed him warmly. "Joseph Mallord William Turner, R.A. It sounds so majestic."

"I'm more excited about layin' eyes on my daughter. Where is she?"

"Oh, the dear is right in the middle of her afternoon nap. I'm afraid she wouldn't be too happy about being awakened, even for a distinguished academician. But do come and take a peek at her. She's growing like a weed."

Quietly she opened the door to an adjoining room. The sight of Evelina asleep brought a smile to his face. "She's sleepin' so peacefully."

"She should be awake in about an hour. Can you wait?"

"Ah, so much I'd like to, Sarah, but I'm due at the Academy in a half hour."

"Then you had better be on your way."

"I'm awful sorry."

"You're not to worry, Joseph. She won't be going anywhere soon."

"I'll come visit her this weekend."

"She will be expecting you. And again, congratulations." He walked with his thoughts on Evelina. What was she to become? His thoughts, rolling back to his own infancy, failed to awaken any memory beyond some watercolors William had given him on his fourth birthday. When would she start that strange process of remembering things? Would she, like her mother and father, acquiesce so willfully to passion? He smiled. "Such questions about a child still wettin' diapers."

March's deceptive winds blew peace into the French town of Amiens on the month's twenty-fifth day. The treaty was signed and the long trouble between England and France seemed to be over. Joseph began preparing for his departure. William assisted him in every way, sorting out brushes and packing sketchbooks and canvases. Joseph could only smile at his enthusiasm. "Daddy, the way you're goin' on one would think I'm off to heaven."

"Well, Billy, it just about amounts to that."

But for Sarah, being left alone with his newly born and her three children did not seem so fortunate. She resisted complaining, but secretly she feared that Paris with all its lascivious pleasures posed a serious threat to their already shaky relationship.

Yet, no lovers could have experienced a more impassioned farewell. Touched by the glow of a full moon coming through the bedroom window, they reclaimed the bliss of their very first hour of intimacy. "You will remember us here waiting, Joseph?"

"I will indeed. You're not to worry."

The crossing to Calais was lamentable. Foul weather and a turbulent sea gave sour stomachs to most of the passengers on the old sailing packet. But Joseph felt orderliness in the howling wind and the huge waves splashing against the hull. That was the way he always expected it to be.

Outside Calais, the sea was still angry and much too rough for the packet to safely make harbor. For hours the ship tossed about offshore, trying the patience of Joseph and three other passengers eager to reach land. Joseph saw their chance to escape the packet when a fisherman in a large rowboat came close to them. *"Monsieur. Monsieur!"* Joseph shouted. *"Beaucoup francs pour votra bateau du envers rivage. Beaucoup francs. Oui. Oui. Beaucoup francs!"* If the fisherman misunderstood most of what he was saying certainly he understood the words *"beaucoup francs."* *"Oui. Oui!"* the man shouted back, and he pulled alongside the packet. Disregarding the captain's warning, they threw their belongings into the smaller boat and after several attempts the four of them got aboard.

Violently the waves slammed in, pushing the little boat farther out to sea. The youngest of the group, a boy of about sixteen, started screaming. "I can't swim. Oh, God, we're going to die. We're going to die!"

"Ta gueule!" the fisherman shouted. *"Vous n'allez pas mourir!"* And to assure him that death wasn't near, he went calmly about his rowing. For a full hour they inched toward the shoreline. As they came closer to it, the fisherman secured a long rope to the prow. When they were only a few yards out he hurled the loose end of it to the banksides. Two watermen grabbed at it, but they were late; the rope's end disappeared beneath the waves. The fisherman pulled it in, coiled it around a small anchor then hurled it back again. Catching it this time, the men began pulling the boat toward shore.

After paying the fisherman and collecting their belongings, the four travelers started off toward the pier. The wind was still rushing in and the storm showed no signs of abating. Joseph glanced at the boy. He seemed to be recovered from his fright. "And how would you be now, lad?"

"Fine I am. Sorry I lost courage out there. Bit ashamed of myself."

"You're no less a man for that. It takes courage to show your fear. All of us were a bit scared, to tell the truth of it." He patted the boy's shoulder. "Luck to you, lad, and don't forget the experience. Nothin' shameful about it." He hurried toward the end of the pier from where he could look out to sea, then took a sketchbook and chalk from his valise. He *had* been concerned about their safety, but the scene before him made it worth the risk.

Except for a small patch of blue rimmed by white cloud fluffs the sky was purplish black. Fishermen were preparing their *petit bateaux*. With her sails billowing, the old packet was at last plowing through the boiling whitecaps toward shore. And he stood at last in France.

Contentedly, Joseph sat sipping red wine outside the pension where he spent the night. The clouds had rolled back; the sea had calmed, and a huge red ball of sun floated above the sea. Fishermen and their women roamed a claw of the ancient pier. Joseph's eyes swept the ramparts, and followed a road that disappeared into a field of sward. A quarter mile further on, a dozen small houses huddled together at the upper part of an incline. He was taking his sketch pad from his pocket when the voice turned him about.

"You are an acquaintance of Tom Girtin's, are you not?" The inquiry was from a young Englishman sitting at a table a few feet away.

"I am indeed. And you are a friend of Tom's?"

"Oh, no. I too was an apprentice to Dayes for the bit of a year. Used to see Girtin coming and going. Never spoke to him, however. Did see the two of you at the Ale Cellar one night." The stranger smiled. "You were having trouble with the barkeep."

Joseph laughed. "Ah, so well I remember. 'Twas the eve of the New Year."

"That is so." The man introduced himself as Christopher Jones and his friend, who sat beside him, as Lawrence Barrows.

"Turner, Joseph Turner. The two of you, are you painters?"

Barrows entered the conversation. "We aspire to be. About to take our first tour of the Continent."

"That's what I'm about. Headin' for the Alps, then on to Paris."

"Those are pretty much our own aims," Jones interjected.

"Do you know the country?"

"First time ever," Joseph admitted.

"We're considering buying an old cabriolet from the owner here, then selling it at the end of the tour. His brother's offered his services as a driver. Perhaps you'd like to join us."

"What's he asking for the cabriolet?"

"Thirty-two guineas."

"And the driver?"

"Five livres a day. He'll pay his own expenses."

Joseph thought it over for a few minutes. "Comes to about seven shillings a day for each of us. Seems fair to me. One thing you ought to know, however."

"Yes."

"I work alone."

The deal was settled. Two mornings later they were on their way.

They took the Malle-poste route through Auxerre and Macon, where wine-grape harvest was at its height, then spent three days sketching at Lyons. And there Joseph began his diary in a small, tattered red book.

> August 5
>
> Two days to Grenoble. Three days at Lyons. Good sketch-
> ing but lousy food. Jones and Barrow hardly speaking. Not
> to worry myself about them. On to Geneva and then
> Chamonix tomorrow. Hope for some climbing there.
>
> August 20
>
> Climbed at Mont Blanc and Chamonix.
> Great precipices. Passed over Val d'Aosta. Crossed Great
> St. Bernard to Martigny, then to Rhone and Vevey.
>
> August 29
>
> Traveled hard. Reached Lucerne yesterday. Malathar's a
> good coachman. Steady and dependable. Jones is sick in
> bed. Barrows is nursing him. No doubt, about it, they're
> lovers. Lakes like jewels. Mist drifting through mountains.
> High clouds. Malathar brought along bread, *ecrevisses* and
> white wine. Ate beside the lake.
>
> September 12
>
> St. Gotthard pass today. Got as far as Devil's Bridge.
> Bloody good thunderstorm. The pass was something to
> see. Start for Paris tomorrow. I like that. Had enough of
> Barrows, Jones, bad lodgings and red tile roofs.

Barrows was asleep as the cabriolet rolled through the outskirts of Paris at dawn. Jones was writing a letter and Joseph was reflecting on the journey. "Well, Turner, did you find the trip worthwhile?"

"I'd say I did. The Alps were worth it all. And you?"

"Can't say as yet. Have to take a good look at my sketch pads."

The Grand Chartreuse, the Mer de Glace, Mont Blanc and the falls at Schaffhausen were also tucked away in Joseph's valise—all with colors more important to him than form. He was on trial, not before his critics but before himself.

A thin overcast veiled the sky as they entered Paris. The driver was paid, and after checking into a small hotel on the Left Bank, Joseph hurried to the Louvre. The spacious walls were filled with the masters—the magnificent spoils of Napoleon's conquests. By wagonloads and barges, they had been brought in the *Apollo Belvedere*, the *Laocoön*, nine Raphaels, two Correggios, the Medici *Venus*, three Rubenses, numerous Titians and Tintorettos. In an incredible range of color these, and hundreds of others, represented an awesome outpouring of genius. Napoleon, despite his cruel hand, had assured him a glimpse of a grand gathering.

Early the following morning he was back, gazing into the silence of a Rembrandt, when he felt the presence of someone at his side. John Farington was smiling at him. "Well, Joseph, we do meet in the strangest of places."

"Ah, so pleased I am to see you. Just got here from the Swiss country."

"And how did it go?"

"A few setbacks, but worth it."

"You're to stay here for a while?"

"Until November, then back to London."

Farington motioned at the Rembrandt. "And what's your opinion of the great master?"

"A bit disappointed."

"Any favorites?"

"Wilson and Titian. And I'm finding Poussin much better than some of my associates think him to be,"

Farington smiled. "And I'm one of those associates."

"You are for sure. I've a good memory."

"Unfortunate news about your friend Girtin."

"What's happened?"

"You didn't know? He's desperately ill. His lungs they say, and it seems he's without a chance."

"Oh—no. Oh, so sorry am I to hear that. Poor Tom. I must get word to him right away."

"I'm returning in a couple of days and I'd be most willing to take a message." He took out a pencil and scribbled on a card. "I'm at the Creville. Just a block from here. Come have lunch with me tomorrow. I'd like to see what you've been up to. Sorry, but I have to hurry off. Late for an appointment."

"Ah . . . yes . . . yes . . . to be sure." Joseph's thoughts had gone adrift; the Louvre grown unbearably quiet. "Only twenty-nine and on his way out," he thought. He left shortly after, crossed the Seine at the Pont Neuf, then turned onto the Boulevard St. Germain. "Gully Cooke, now Tom. Ah, their friendship's turned into a sad business." As he walked, everything— the trees, the street, even the people, seemed suspended in mournful silence.

"Your Switzerland is all light and shade," Farington commented after viewing Joseph's drawings.

"That is what I intended; they will be even more so in watercolor and oil."

"I'm anxious to see the results."

"And I'm just as anxious." Joseph pulled an envelope from his pocket. "This is for Tom. I'd appreciate your gettin' it to him as quickly as possible." He pushed back from the table, stood, and hastily gathered in the drawings. "Fine lunch, Farington. Have a good trip back."

The Louvre became his home. There, while distressed for Tom, he worked religiously, analyzing the masters and filling his notebook with ideas and criticisms. More than any of the others, Poussin understood the subtle link between color and emotion. But, most importantly, Napoleon's glorious cache let Joseph see what he had hoped to see: subject matter daringly rendered in color that was not defined through form alone.

Bleak October light coming through a window spread over Tom's bed. Evelyn, his wife, handed him Joseph's letter. "Shall I open it for you?"

"No, my sweet. I want to do that."

She glanced at him as she left the room. He had grown pitifully thin and feeble. He opened the letter.

> Good friend:
> Bumped into Farington at the Louvre. He tells me you've taken to your bed for some reason or another. Hardly like you. So off your arse and on to your feet. I'm looking to lift a few grogs at the old Cellar when I get back. Just came from the land of the Swiss. Beds made out of rock, wine's spiked with acid, and the roof tiles are colored of rot'd spud peelings. The mountains save them—puts them several notches above Scotland and Wales. Hope you're rich from your tour over here. You're to expect me at your door in a couple of fortnights. I'll give six raps. That way you'll know it's not a bill collector. Bless you friend. I'm missing you.
>
> Joseph
> Paris
> October 10, 1802

He managed a smile then let the letter slip from his hand.

The Channel was mildly choppy, the winter day clear and cold when Joseph took the same packet boat back to England. A premonition had grasped him before he reached London on the ninth of November. He talked with William briefly then hurried to Tom. Sarah would have to wait.

Evelyn greeted him with terrible news in her eyes. They held hands for a moment then she took him to Tom's room. He stepped to the bed. "Tom?"

Girtin's back was to him but he turned to look up. "Joseph. It's you." He smiled weakly. "Glad you came. The bill collector's come and gone."

The weakened voice, once so bold and swashbuckling, plunged Joseph to silence. Tom squinted. "Why the awful frown. Come off it."

"What does the doctor say?"

"Summer's gone, Joseph." Wind stirred the bare branches outside the window. Tom glanced at them. "All the leaves are gone."

"Tom, can I repeat what an old man once told me back in Wales?"

"I'm listenin'."

Softly, distinctly. Joseph spoke. "Death's potential in every man's life." He took a deep breath. "So much I believe that, Tom."

"There's beauty in the thought. I owe you for that."

"You owe me nothin'. It's I who owe you."

"No time to argue the point, I'm afraid." He lay thinking for a few seconds. "Joseph."

"Yes?"

"I wonder what our work means to the future?"

"It's to leave its mark, Tom. Be sure of that."

"Perhaps . . . perhaps." Painfully he extended his hand to Joseph's. "I'm tired." It dropped as his eyes closed. Only the scraping of branches against the house broke the stillness. Evelyn went to touch him. His eyes opened for and instant, then closed for the last time. "I'm . . . I'm headed west, my sweet." Several minutes passed before death crept into his face.

Tom's mother and young brother were arriving just as Joseph was leaving. He touched her shoulder. "I'm awful sorry, Mrs. Girtin . . . awful sorry." His anguish had told her.

"Oh, my son . . . my son," she wailed. Then slowly she went on toward the room where he lay.

Two hours later Joseph and Sarah fell into each other's arms. Midway into their kiss he said, "Sarah, Tom Girtin just died." She went limp in his arms. "Oh, poor Tom . . . poor Tom."

At the burial, Joseph and William stood with Evelyn, her son Richard, Tom's mother and brother and a gathering of mourners that included Dr. Monro and Monsieur Rigaud. During midday, as pastor Nixon read the last rites, Tom's spirit, radiant and boisterous, still hovered—over the Thames,

over Covent Garden and all its grog houses. Without him all those places would seem like motionless trains. His spirit didn't hover alone. Hanging close beside it, hopelessly immersed in it, was Joseph's silent grief.

Joseph found little to celebrate on Christmas day. He spent part of it with William, the remainder with Sarah and the children. He would like to have taken William along to Sarah's house, but there was Evelina, his golden, close-locked secret that might prove unpardonable to his father's straitlaced heart. Most certainly, "marriage" would be the first word out of his mouth. Evelina was approaching two by now. His disposition improved when she reached for his hand and called him "Da-da." The joy on his face went unnoticed by Sarah. She was enthralled with the necklace he had brought from Paris.

Shortly after the holidays another honor was bestowed upon him. At the age of twenty-eight he was elected to the Academy's council. Another precedent. Another responsibility—to help shape the Academy's future. The immensity of his new position dawned upon him during the council's first session. A five-year power struggle had left it fiercely at odds with itself. George III, the Academy's troublesome sponsor had ordered two parties to be formed.

One for the court, one for the Academy. The Royalists, definitely the King's men, were Copley, Bourgeois, Beechy and Wyatt. The Democrats, whom George considered to be subversives, were Humphrey, Rossi, Soane, and now Turner. In the offing, new problems were rumbling, threatening to keep the two parties at each other's throats. Joseph left the session with the vivid realization that he was being thrust into the teeth of a bitter storm.

CHAPTER TWENTY-ONE

In the months that had passed, Alston Beaumont had stayed on in the Becket household. To Katherine, he had become a strange and unwelcome guest. Very seldom had he engaged her in conversation and rarely did he leave the house. Mostly he spent time thumbing through books in the library, as though he were engaged in research. It never crossed her mind to inquire of his need to absorb so much legal knowledge. Perhaps he was to become a barrister like Roger. She found it strange that upon her leaving the house she always returned to find Alston gone. Invariably, he returned within minutes of her arrival to peer coldly at her from a distance.

Marie, the housekeeper, was gone for the week. Katherine, having read that Joseph's work was included in the current Academy exhibit, allowed her curiosity to get the better of her. Suspecting now that she was being followed, she slipped out the cellar door, hurried up the alleyway and crossed to the square and hailed a fly.

She left the fly two blocks from the Academy, glanced back, then quickly walked the remaining distance. She entered the building flushed with concern. The possibility of running into Joseph was suddenly bothering her. She went directly to the gallery. There she was immediately caught up in the familial tenderness of Joseph's *Holy Family*. The simple purity of *The Festival Upon the Opening of the Vintage at Macon* held her eyes next. Many minutes passed before she moved to *Calais Pier*, which critics were giving lofty praise. But there stood one gentleman close to her who, after a long disapproving look, began imparting his feelings. "The whole thing looks to be hacked up with a knife. And those colors are far too bright. Downright ugly." He shook his head with disgust. "Tell me, West, when before this moment have we been asked to accept a white sea?"

"I must disagree with you, George. The man's reaching out, taking a far deeper look than most."

"Bah. He debauches art in every respect."

Katherine was frowning as the two men moved off. *Calais Pier*, she thought, was the most exciting painting she had ever seen. Sir George Beaumont's comments to Benjamin West, the Academy's president, had truly upset her.

Suddenly she held her breath for a moment. Joseph was coming toward her with an ugly scowl on his face. She tensed and her heart raced as he came nearer, varnishing brushes in one hand, his hat in the other. As her lips parted to speak he looked directly at her—through and beyond her—without realizing who she was. Apparently angry, he went for his coat and left. Sir George's venomous appraisals had obviously reached his ears, and he couldn't stand being in the same building with the scoundrel. For a moment she stood, hopelessly confused, then she also left.

She had reentered the house and started up the stairway when she sensed a slight movement in the dimness. Alston, with several books in his hands, stood smiling.

She eyed him suspiciously. "Good afternoon, Alston."

"Good afternoon, Katherine."

She was reading and having tea in the drawing room when suddenly he entered and sat on a divan opposite her.

"Would you care for tea?" she asked.

"Yes, thank you. My nerves are at a pitch. It might help."

She poured for him. "And why are you so nervous, might I ask?"

"Roger's making such terrible demands of me. It's getting worse and worse."

"Demands? Concerning what?"

"It is impossible to talk about, really."

"Then I won't push." She glanced at him. He was chewing constantly at his bottom lip, gazing at the floor. "Would you like sugar?"

"Yes—yes please."

When she lifted the silver bowl to him he suddenly grasped her wrist, holding on to it until she managed to pull away and get to her feet. "Please, Alston—what are you doing?"

"Katherine, I love you. I love you. For so long I've wanted to tell you."

"Surely you don't realize what you are saying. You can't."

He rose pleading with her. "Please try to understand."

"There is nothing to understand. I am the wife of your uncle."

"You loathe him as I loathe him."

"Nevertheless, I am wedded to him. You have no reason to love me—nor I you." Without further words she left him and went to her room.

Using illness as an excuse, she avoided dinner with her husband and his nephew. Later she heard their voices flaring angrily from the drawing room. She slipped on a robe and went to listen from the darkness at the top of the stairs.

"I've grown bloody tired of doing your spying, Roger."

"You've no choice and you damn well know it. I've enough in that dossier on you to send you to the gallows in ten minutes. And were it not for your beastly mother I'd have done so long ago."

"You're the beast, and in time you'll get your comeuppance!"

"Not before you get yours, you bastard!"

"You, my dear uncle, are to go frig yourself!"

"Don't call me uncle!"

A door slammed and she hurried back to her room. The silence downstairs had grown terrifying. So he was spying upon her. She couldn't stand it any longer.

It was two in the morning when she slipped down to the cellar. There in the darkness she lifted the blanket and felt for the package she had placed behind the trunk. It was still there. After several minutes she was back in her room tearing away the wrapping paper. From it she lifted a valise and hurriedly filled it with clothes she had set aside for this appointed moment. Then she was gone. A fly stood at the corner of the square. She opened the door and got in.

"Where to, madam."

"Number 16 Queens Road."

Marie Ducrot, after her week off, arrived at exactly nine o'clock Monday morning. She found the door to her master's room closed. She assumed he had gone to his office, but felt it strange that her mistress was not up and

about. Her door, like Alston Beaumont's, was closed, but never did she sleep so late.

Marie had been at work for two hours before she rapped gently on Katherine's door. When no answer came she peeked in. The room was in disarray and deserted. A note had been slipped beneath the door, and assuming it was left for her she picked it up and was shocked at what she read.

> Dearest Katherine,
>
> I have left for good. Roger has made my existence here unbearable. He is an animal, and surely you would be justi- fied in ridding yourself of him. Please forgive my sudden outburst yesterday. It sprang out of a desire I have with- held for a long time. I have grown to love you in the months I've been here. And I shall remember you always.
>
> Alston

Nervously, Marie folded the note and placed it on the night table. At pre- cisely twelve o'clock she rapped on Alston Beaumont's door, pushed it open and looked in. Roger Becket lay sprawled naked on the floor—stiff in death.

Calais Pier, *Festival at Macon* and *Holy Family* were still getting considerable attention. Sir George Beaumont was still leading the voices of dissent. He had written: "*Calais Pier* reminds one of veins in a marble slab." Other reac- tions came from all sides. From the *Sun*: "The sea looks like soap and chalk. The figures are flat with dabs of gaudy color—a waste of ability." From Joseph's fellow academician Henry Fuseli: "Both *Calais* and *Macon* show a great power of mind, but the foregrounds are too undefined. From the por- traitist John Hoppner: "I loathe his carelessness. Genius lost in affectation and absurdity." From the painter James Northcote: "I see only novelty, incongruity and confusions." And from another, John Opie: "I so admired *Macon*." John Constable turned thumbs down on everything. He remarked, "In a landscape way they are all most miserable. I am duly surprised that young artists find his work to be of such superior order."

It was enough to sour William's stomach. At supper he asked Joseph, "What do you make of all this hubbub: This Hoppner saying there's too much left to imagine. Don't know what he means."

"Nor does he. His mind's without a spoonful of imagination."

He gazed at the wall with his temperature rising. "Old William Blake once said, 'I can look at a knot in a piece of wood till I am frightened at it.' That's a mind with imagination." William's eyes followed him as he sprang to his feet and began pacing the floor. "No—I'm not going to back down. I'll stand firm against the whole lot. The sun's to bless Fechner's grave. There's more to paintin' than layin' on color. If only we'd use imagination like nature does! The sun, earth, sea and sky speak poetry. It's not only the twist of a pencil or a brushstroke. Somethin' beyond that pushes my thoughts around. My mind stays open. My heart and hand does the rest. Bah! Such little minds. If I listened to them I'd be chewed up and spit out like stale bread!" The entire Academy gasped the next day at the price of four hundred guineas Joseph put on the *Festival at Macon.* It gasped even more when he absolutely refused to dicker.

It was the first Monday of the month. Scowling, Joseph sat listening to the council members squabbling over a move to increase salaries of the Academy's officials. He had seconded Soane's proposal to invite a committee of enquiry.

"Insult!" the Court party screamed; then they rose as one and walked out. There was no quorum. The General Assembly condemned the four Royalists. The Royalists threatened Benjamin West, the president of the Academy, and demanded that he ask the King if the Assembly had such power. And for that, resolutions of censure were unanimously carried against them—and a rule forbidding re-exhibition of a painting by West.

The trouble was leaked to the press. Accusations were flung about. All council members were asked to sign a statement saying they had no hand in the press leak. The Royalists ignored the request and the Academicians voted for their suspension. West informed the King.

"That resolution is to be expunged!" roared His Majesty.

"Tyrannical!" agreed West.

The royal letter was read twice at the annual general meeting of the Assembly. Twice it was heard in deadly silence. A vote of confidence was called by West, and he was reelected president.

Throughout the skirmishing, Joseph had thrown his weight against the Court and royal tempers were frayed by his conduct. Bourgeois said to him tauntingly, "When premiums are to be adjudged for architecture and sculpture I vote with those most conversant with those respective studies."

Joseph replied, "You might do the same when paintin' or drawin' is in question."

Bourgeois' face reddened. "Turner, you are indeed a little reptile."

"And you are indeed a big reptile."

A distaste for violence had kept Sarah from reading the weekly feature story in the *London Illustrated*. The sketch of the naked corpse lying on the floor gave her the shivers. Yet she found the drawing of the woman next to it hauntingly beautiful. "A strange situation indeed," she said, mainly to herself.

Joseph worked at a canvas. "What situation?"

"Oh, it's all so involved. A prominent barrister is found murdered and both his wife and nephew left the house on the same morning—neither of them knowing he had been harmed."

Certainly one of them did it—probably both."

"She looks far too innocent."

"The most dangerous kind, the innocent lookers."

"Well, pity the poor woman. Her story seems quite honest."

"Why not pity the poor barrister? He's the dead one."

"I can't help but feel that she is innocent."

Joseph was sleeping soundly when Sarah left around midnight. As she closed the door, she felt as if she had been used; she felt as well a kinship to the accused woman—used and debauched. The copulatory madness between her and Joseph would have to settle into something more rewarding or come to an end. The house on Norton Street was little more than a bagnio now. Hardly were they through the door before they were stripped and into bed.

Desire had been replaced with lust; the next station was obscenity. Walking along she noticed a girl standing beneath a gaslight. A gaudy red dress fit snugly about her buttocks and her long blonde hair was piled high on her head. A hansom drew up beside her and she stepped toward it, had a few words with someone inside, then went back to stand beside the lamppost. Obviously, her price had not been met. Sarah frowned at the horror of such a profession, then realized that she had no reason to feel so chaste.

Joseph awakened to a fine morning. Sarah had left him warmly satisfied, but he suffered a pang of guilt for having not gotten up to see her home. She had left the bed with the quietness of a cat.

He suddenly remembered her remarks about the murdered barrister. He never bothered with stories of that sort. "All wild stories for sellin' newsprint." Involuntarily, he felt on the floor for the weekly. It was still there with its pages folded to the drama. He lifted it and glanced at the sketch of the corpse—a bad drawing even for the *London Illustrated*. Indifferently, his eyes moved toward the drawing of the woman then widened as he gasped. It was his own drawing of Katherine Forsyth. "I cannot believe this. I can't believe it!" He sat up on the side of the bed, devouring every word of the account, especially her plea of innocence and her explanation. Number 16 Queens Road, where the fly had eventually taken her, turned out to be a flat kept by her brother Reginald's company in London. But she could show no proof that she had reached there before her husband had met his death. It was her whereabouts on that morning that made her a suspect.

Joseph read on. Alston Beaumont's testimony had shed little light on the situation. Certainly the note he had placed beneath Katherine's door pointed the finger of suspicion in her direction. "You would be justified in ridding yourself of him," it had read.

"And you were unaware that Mrs. Becket had already left the house when you placed the note beneath her door?"

"I was, sir. I thought she was still asleep."

"And the deceased—did you have words with him prior to your leaving?"

"I did not, sir."

"None whatsoever?"

"That is right, sir."

"Mr. Beaumont, according to Mrs. Becket you and your uncle exchanged harsh words the night before. Is that so?"

"That is so, sir."

"Was there any physical violence between the two of you?"

"None, sir."

"Can you speculate as to why he might have met death in your room after you claim to have left the premises?"

"I'm sorry, sir, but I can't."

"Did you suspect that Mrs. Becket was planning to leave her husband?"

"I was hired by my uncle to watch her for that reason."

"And you fell in love with her meanwhile?"

"I did, sir."

"Did she return your affections?"

"No, she did not, sir."

"In the note you left her you spoke of her justification for ridding herself of the deceased. Why did you think thus?"

"He was terribly mean to her, sir."

"Why were you and your uncle at such odds?"

"Well—we just didn't see eye to eye on many things."

"Nothing more serious?"

"Nothing, sir."

So read the first interrogation of Alston Beaumont by M.C. Crawford, an investigator for the Crown.

An hour passed before Joseph finally laid the paper aside. So she was now Katherine Becket—and in trouble serious enough to put a rope about her neck. The possibility clawed at him. Twice more he read the entire account. And twice more he told himself that her plight was no concern of his.

"M.C. Crawford. M.C. Crawford." The name was rolling in from the past. "Of course. Of course." He had once been a customer of his father's. He had even purchased one of his drawings from the shop's wall.

With his thoughts whirling, he ate, dressed and attempted work, but that turned out to be only a gesture. He muttered, "None of my business— none whatsoever." Over and over he told himself that throughout the day and until he went to sleep.

(In the middle of the night a tall dark stranger wearing a black mask and a long black cape beckoned to him. Silently, he followed. Dawn was opening when they reached the gates of St. Sepulchres, Holborn, where a bearded man rang a bell and chanted a prayer for the woman who was being carted to the gallows. Then through the mist he saw her. The cart was drawn by a white horse, and very slowly it was moving toward them. A black veil covered her face and she wore a white bridal gown. From a basket she was tossing flowers to people who watched from the roadside. The cart stopped and the old bellman stepped forward and handed her more flowers. "Who is she and why's she to hang?" The stranger, whose cape had suddenly turned red, only smiled. They followed the cart to St. Giles-in-the-Fields where the stranger took a mug of ale from beneath his coat and offered it to her. She lifted the veil above her lips, drank most of the ale, then handed the goblet to Joseph. He took it and gulped down what was left. The bitterness of it lingered on his lips. The stranger then stepped up and fastened one end of a rope to the cross beams of a gibbet. He knotted the other end around her neck. Then smiling he gave the horse a mighty lash with a whip. Away went the cart to leave her kicking in the air. When she was finally lowered to earth the stranger asked Joseph to remove her veil. Slowly he pulled it from her face. Horror. Horror! There in the dirt lay Katherine, with blood foaming from her mouth.)

"No. No. No. No!"

William came running to Joseph's room. "Wake up. Wake up, Billy. You having a bad dream? Jolted awake, he did not speak. Horror would not allow him it. The bitterness of the ale was still on his tongue. He was wiping away sweat when William turned back to his bed.

How much truth was there in a dream—such a shattering dream? He shuddered at the thought.

Day after day, he had quarreled with his conscience, begged it to abandon its nagging. And over and over again it asked him why. His answer was

always the same. "Katherine Becket's no concern of mine. Furthermore, there's little I can do." Yet, the agony in him failed to confront that quarrel. A week later he sat nervously waiting outside M.C. Crawford's office. At ten o'clock he was shown in and the investigator rose to greet him. "Joseph, it's been years since I saw you."

"Indeed, sir, it has been."

"And your father, how is he?"

"Fine, sir, but missin' his business very much, I'd say."

"And I do miss him. That powder tax hurt a lot of people." He pushed back from his desk and removed his spectacles. "Now tell me, Joseph, what brings you to see me?"

He rubbed at his chin before answering. "Somethin' of a very serious nature. It—it has to do with that Becket murder case."

M.C. Crawford replaced his spectacles and leaned forward. "Yes, yes, go on."

"I'm to have your confidence in the matter?"

"You have it, Joseph."

"I'm doin' this without the knowledge of Mrs. Becket. She's not to know I came to you."

"You are an acquaintance of hers?"

"Somewhat."

"Well, Joseph, go on. What is it?"

"Have I the promise from you, sir?"

"You have, you have."

"Well, there seems to be some mystery as to her whereabouts on the mornin' her husband met his death."

"There is for sure. We have only her word that she was alone and at her brother's house at the time."

"She was—but she wasn't there alone. I was there with her."

Crawford frowned. "You are romantically involved with her? Is that what you're saying?"

"Yes—somewhat. She's much too ashamed to tell you. So I feel obliged to do so."

"Well, Joseph, I must confess to astonishment."

"I ask no more than that you remember your promise."

"That I shall, Joseph. That I shall. I'm thankful to you for coming. This may help clear a few things up."

"I felt it my duty, sir."

Joseph had reached the door when Crawford hailed him. "I've a favor to ask. You didn't sign that drawing I bought in your father's shop years ago. Now that you've attained such prominence, perhaps you'll attend to that."

"One favor deserves another. I'll come by and sign it for you."

"Good. I'd appreciate that."

He was questioning his lie before he reached the street. Why had he completely ignored the danger it entailed; fallen prey to his emotions? A ridiculous possibility entered his thoughts. Maybe you're still in love with her. No—that was long since over.

CHAPTER TWENTY-TWO

Still drenched with confusion, he met even more when he reached the Academy for a council meeting. The election of Smirke as keeper for the incoming year had inflamed the Royalists. He had won handily against Rigaud, a favorite of the King. Now, he was being looked upon as dangerous. The reason, at least to the Royalists, was indisputable. After Marie Antoinette's execution, Smirke had blithely suggested the guillotine's use upon some other crowned heads.

West had consulted the King about the situation, but to no avail. His Majesty was too deeply engaged in consultation with a tree that he had mistaken for the King of Prussia. Chaos reigned. To Joseph it looked like the Academy was under the shadow of disaster. With his thoughts shot through with his mother's problem, Sarah Danby problems, and now Mrs. Becket's problems, he steered clear of the heated discussion. At the close of the session he wearily arose from his chair. "Gentlemen," he said, "With great sorrow I ask the council to accept my resignation." Without waiting for a response from his startled associates, he walked quickly from the room.

West followed him to the foyer. "I think you have acted too hastily, Joseph."

He slammed on his hat. "I'm sick and tired of listenin' to old rakes makin' fools of themselves. Good day, West." The March sky was pouring rain. Without flinching he walked into it. For the moment at least, he was alone in himself.

Rain was still coming down when William answered the banging on the door. A burly workman was there wet to the skin. "I've the lumber for Turner. Where would you be wanting it put?"

William glanced at the wagonload of timber at the curb. "You're sure it's for this address?"

"It's 15 Harley Street the order says. Your name Turner?"

"To be sure it is."

"Then where am I to stack it?"

"Best there at the side of the house." What was Joseph up to he wondered.

The question was answered when Joseph came in an hour later. "I'm to build my own gallery. I'm sick to death of the shovin' and pushin' goin' on at the Academy. I've just quit the council."

"You're not to exhibit there anymore?"

"That I didn't say, Daddy, but I'm to show most of my work right here from now on. The Academy's not the be-all and end-all."

Two carpenters arrived the following morning. After two days of work the gallery was taking shape. It was finally finished on the first of April. Joseph and William spent two days hanging the pictures. Nothing was left in the room that suggested anything other than its sole purpose: to present the art of Joseph Mallord William Turner—and without charge.

Two mornings later, a freckled, serious-faced boy entered the gallery. "Would you be Mr. Joseph Turner?" he asked.

"I am indeed. And who might you be?"

"I'm Jeremy Wiggins and I've come for a look at your paintings."

"How'd you know about my gallery?"

"My father told me. 'Ee's Tom Wiggins, the carpenter who worked for you. I'm to be a painter someday, and 'ee thought I should come."

"Welcome, Jeremy. Go right ahead and look over the whole lot, then come back and tell me what you think." Joseph smiled at his father. "Well, Daddy, we've just had our first visitor—and it pleases me that he's so young."

"It's a good sign, Billy."

A half hour had gone by and the boy was on his way out. "Thanks for letting me 'ave a look, sir."

"How'd you like what you saw?"

"I'm a bit puzzled, but I'd say you're awful good."

"Ah, fine to know, but everybody's not going to feel the same as you."

"'Ardly think you'd care about that. My father says you're so looked up to."

"Now tell me: What is it that puzzles you?"

"Mostly the sea water I'd say. Was it as downright white as you show it to be?"

"For a rare moment it was—and a good painter's always on the lookout for rare moments. So you're to be a painter. Have you started yet?"

"Since six I 'ave been at it."

"Then you must be good by now. You look to be about fifteen."

"Fourteen, and 'opeful I am."

"Any other thoughts about my work?"

"Like I've said, it's good—but not much 'appiness in it, but I liked the stormy ones."

Joseph pondered that last statement after the boy left. The bloody Nile, *The Destruction of Sodom, The Deluge*—all showing doom that man had brought on himself through greed and violence. "The lad's right. Not much happiness shows on those walls, Daddy."

"But there's truth and beauty."

"Ugly truth," Joseph mumbled. He thought of himself at fourteen, of the confusion that kept him at odds with reality. It had been an endless storm.

Joseph's honorable lie had sent M.C. Crawford in full pursuit of Alston Beaumont, who was brought in, imprisoned at Newgate and questioned with intensity. He gave in, and his story prepared his own grave. Drunk and naked, Roger Becket had come to his room that morning, and made indecent sexual demands of him. "When he tried to force the situation I struck him with a silver candle holder. When I packed my clothes and left he was still lying on the floor. He was groaning, but surely I didn't expect he would die from the blow."

Roger Becket's private papers revealed a dossier that accounted for his sinister domination over his nephew. Evidence proved that Alston had poisoned his stepfather after forcing him, at gunpoint, to sign his fortune over to his mother.

A gallows was erected near Smithfield and Alston was executed with three other murderers. For his double offense he was made to hang there for six days, so that the crows could get at him. The *London Illustrated* showed sketches of him with two crows perched on his shoulders. One pecked at his

ear, the other at his eyes. Seeing the fate of Alston Beaumont, Joseph shuddered.

Roger Becket, cruel though he had been to Katherine, proved extremely generous to her in death. Unexpectedly, she found herself to be a very rich widow. Having done nothing to deserve such wealth, she felt small contentment in it. As for the house, the thought of spending one night there appalled her. The codicil placed it, and a larger house at nearby Chiswick, in her possession.

She moved to the country, but idleness there was soon weaving a thread of discontent. She was determined to put her wealth to good use—nothing more. It was the memory of working with homeless children in Margate that eventually prompted her decision. The country house would become an orphanage. Rental of the London residence could help support it. With her plans in motion, she felt contentment. The huge estate, with its spacious green lawns, would be like heaven to homeless children. By spring, Margate House stood ready and waiting. Before June was finished, twenty-five boys and girls had already come dreaming into its warmth. Roger Becket had helped turn a cherished memory into a miracle.

A message had come to send William and Joseph hurrying by carriage to Islington. The silence had become oppressive as they rode along.

"April's in full bloom, Billy."

"Yes—at its best, I'd say."

"Could use some rain. The earth's bone dry."

When the asylum loomed up before them. William gave it a mournful glance. "I'm feeling this is the end of your Mum."

"Have to hope for the best."

"I'm sorry to say it, Billy, but she'd be better off gone from us."

"I'd agree, Daddy. Mum's payin' too dear a price."

Inside they were met by a young man. "You must come quickly. I'm Dr. Rappaport. Mrs. Turner has been my patient for the past week." As they were about to enter Mary's room, a nurse came out, looked sadly at the doctor, shrugged and moved down the hallway. Her gesture was sufficient.

Rappaport blew out a deep breath. "Well . . . I'm terribly sorry. I'm afraid we're too late." He opened the door for them and they went to stand beside her bed; to stare at her lying dead.

"Mum's . . . gone." Like whispers from out of the distance, those words hung in the silence, confirming her end.

At ten o'clock in the morning on a very clear day they buried her beside Mary Ann. And, along with their grief, came the terrible memories, memories they both had paid for. Night arrived and William smelled its loneliness. The teeth of it bit into him. Mary had paid her harsh debt. Now she could sleep in the kind of peace that drowned all misery. Moonlight came to his window; softening the darkness. He sighed. Morning would bring a new day, and the world would start moving again.

The memories flowed through Joseph like dark water. He kept thinking back, recalling her good moments; and the splintered ones when her tongue became rough as flint. He had witnessed both sides, one soft as snow, the other like sputtering fire. Now, lumped together, they were like burning shapes swimming in his thoughts. But what happened, or didn't happen was of no consequence now. She was the truth of his childhood.

Sarah remained strangely quiet after coming to Norton Street one September afternoon. Joseph had not expected her. As he sketched she paced the room. "You seem troubled, Sarah. Something bothering you?"

She stared out of the window without answering. He turned and saw that she was weeping. He got up and went to her. "My dear, you *are* troubled." She began sobbing heavily as he put his arms around her. "Tell me why you're cryin'?"

She brushed away the tears. "You have hardly bothered to look at me lately."

"Well, if that is so I am at fault." He kissed her cheek. "But I do look at you—sometimes when you don't know it. With the gallery to run now, there's so many things to worry my head." Desperately, he wanted to get back to the sketching, to keep the rhythm of the storm he was creating. As he patted her arm she took his hand and placed it on her stomach.

"Good Lord—you're in a family way again."

"I have been, Joseph, and for some time now."

His hand fell away and abruptly he turned back to his work. His silent fury charged the air, tearing at her. "Well, Joseph, you seem to be struck dumb."

"I'd be lyin' to say I wasn't."

"Well, I expected as much."

"What's done is done."

The moment seemed to have taken on tragic proportions. An even greater silence severed it as she went to open the door. Remorse suddenly splashed through him. He rose from his chair. "Sarah—"

Only the sound of a slamming door answered him.

CHAPTER TWENTY-THREE

Tom Girtin had been right. What happened once was happening again. Napoleon's boots were slithering in new blood, and the Empire raged at his deception. It was exactly one a.m. William Marsden, First Secretary of the Admiralty, had just snuffed out the candles and gone to bed when his manservant knocked on his door. "Sir, a Captain Beauford is here to see you. He says it is extremely urgent."

Marsden rose on his elbows. "I'll be down presently." The naval officer who waited did indeed have an urgent message. His ship, the *Pickle*, the British fleet's fastest schooner, had for nine days plowed through punishing gales between the Spanish coast of Cadiz and England to bring the news. At the sight of Marsden he sprang to his feet and saluted crisply. "We have gained a great victory at Trafalgar, sir." He paused. "But we have lost Lord Nelson."

Marsden gasped. "Good Lord."

"I am to inform you that the admiral's remains are en route to England aboard his flagship, *Victory*."

Marsden was silent for a moment, then said, "Thank you, Captain. The Admiralty will be duly informed."

During one fierce, bloody afternoon Napoleon's combined French and Spanish fleet had been silenced, his naval power destroyed—but at heroic sacrifice. All England would be stunned.

The battle had been fought on October 21, 1805. On the morning of December 22, the *Victory* entered the mouth of the Thames, all 3,500 tons of her sailing under four acres of billowing canvas and bristling with one hundred and two cannons. Offshore, among the spectators, Joseph was putting the *Victory* on paper. When she anchored off Sheerness he hurried aboard to make sketches of the men who had sailed with her into battle.

The air was damp and cold; the mood mournful. Weary officers and tars roamed the main deck, some in bloodstained uniforms. Four tars carried a wounded officer in a sling. Another officer with a bandaged head was being placed in a lifeboat. A stocky young tar with a pigtail was swabbing the deck. He looked up. Suddenly his brow puckered as his eyes widened with astonishment.

"Joseph!"

A familiarity in the voice swung Joseph about. The leathery squarish face stunned him. "Gully. Gully!" They lunged toward one another and embraced like two joyful bears.

"It's bloody great to see you, Joseph."

Joseph stood shaking his head in disbelief. "Oh, how grateful I am to see you. I thought—"

"You got my letters?"

"One—right after you got press-ganged." This friend he thought to be dead stood before him—his boyhood fat replaced by muscle, the eyes reflecting hard years at sea. "You're to get out of all this now, I hope."

"Can't say." Gully lifted the nub of his left arm. "With this, what's a dumb tar to do?"

Shock covered Joseph's face. "Criminy, when did that happen?"

"During the Nile battle."

"I'm so sorry, Gully."

"Not a'tall happy about it myself. Nothin' to do about it." Cold wind was blowing from the north and they went to sit on the starboard side to escape it. "Your Mum and Dad—how are they?"

"He's fine but with no business anymore. Lost Mum awhile back."

"Ah, so sorry I am. Such a good lady, your Mum was."

"Suffered terribly at her end. Better off she's gone, I'm afraid." Quickly, he changed the subject. "Now tell me, what are your plans for gettin' out of this bloody navy. Your bad luck can't go on forever."

"I've no love for it. I'm to wake up dead for sure some morning. But what's left to me with no fit occupation in sight? Things are to calm down now I hope. Napoleon should have had a'nough poundin' for a while. I've the good luck of being Captain Hardy's cabin boy. He took a likin' to me

after I made sketches of him. He even pushes me to draw now and then. I've a small batch saved up."

"I'd like seein' them, Gully." He glanced up at the mainmast. Replaced, it showed none of the hell the *Victory* had gone through. "Tell me, Gully, what was it like?"

"'Twas a bloody nightmare. Thirty broadsides blastin' us but Nelson keeps movin' in. Captain Scott gets hit and Nelson has him tossed overboard. Our sails are rags but he goes on in—firin' from both sides. Inside a few minutes hundreds dead. Arms, legs, heads—all over the decks. Our mainmast topples and the steerin' wheel's knocked out. I figgerd we're finished. But Nelson steers by tiller and heads straight for Villenueve's ship. Blows it to splinters. His men burnin' alive, jumpin' overboard and drownin'." His nub pointed to an area of the deck. "Nelson was right there when he got a musket ball through his back. They say Villenueve lost over four thousand but we lost a lot, too. Not one little powder monkey left." His head shook despairingly. "Just kids. 'Twas bloody awful."

"Gully—you've got to get out. For ten years you've—"

"All hands!"

Gully jumped to his feet as Joseph scribbled on sketching paper. "Here's my address. Come to see me."

"All hands. All hands!"

"I'll try. Goodbye, Joseph." Then he was gone.

Joseph's small prayer had been answered. Gully Cooke was alive—but missing a hand and still in bondage. Climbing to the poop deck he stared at the spot where Horatio Nelson had been shot. His eyes then searched the deck below for Gully, but he had disappeared.

Calamity had befallen England. George III, who looked with such disdain upon Nelson's affair with Emma Hamilton, now wept unashamedly. Even cockney prostitutes mourned their hero as he was removed from a cask of rum after the *Victory* docked. He had been preserved, upside down, for his final voyage. He would have been highly pleased with the funeral procession. Thousands upon thousands jammed Hyde Park and St. Paul's Cathedral to bid him a hero's farewell. Joseph watched from an upper

window in Barnaby's Leather Establishment. To the mournful strains of Handel's "Death March" streamed the cortege: troops of Light Dragoons, 10,000 infantrymen in scarlet coats and black shakos. The *Victory*'s crewmen carried his shot-rent ensign, and walking proudly among them was Gully Cooke. Then came the peers and nobles led by the Prince of Wales. It was a lengthy procession. The first horseman reached St. Paul's before the last carriage had left the Admiralty. The service itself was four hours long. After laying flags on the coffin, the crew tore pieces from the ensign to place next to their hearts.

Dusk and snow was falling as Joseph made his way home. He bought a newspaper and read the bold print:

BRITONS!

Your Nelson is dead

God hath given us VICTORY!

His Arm is not cold in Death, nor

shortened that it cannot save.

BRITONS!

Fear GOD. Fear SIN. And then

FEAR NOTHING.

"Fear for that bloody Napoleon," he grumbled. "We're boss at sea but the Continent's still under his heel." He turned toward Harley Street, convinced that another stretch of bloodshed lay ahead.

Book Two

CHAPTER TWENTY-FOUR

Five years had passed since the Battle of Trafalgar, but in 1810 the daggers were still drawn. Smarting from defeat, Napoleon had ordered all countries under his control to cease trade with England. The Empire had countered by blockading all European ports, cutting off their outgoing trade. War would go on; the domesticity that England had hoped for was shattered. And so was Farington. His family's hemp and timber business was at its worst.

A scowl stayed on his face he lunched with Joseph at the Cock and Bull. "His Majesty's to do something about that runt once and for all. But he's so racked with family problems he has little time for anything else."

Joseph's smiled wryly. "Princess Caroline's havin' her troubles again, I see."

"His Majesty's ordered an investigation."

"What's the Prince's lady being charged with this time?"

"Adultery."

"With who?"

"Several men of prominence—one to which she was accused of bearing a son. Even your friend Lawrence is on the list."

Joseph's brow arched. "Sir Thomas? I can't believe it. He just did a fine portrait of her."

"Well, he's cleared himself with an affidavit. Claims he was never alone with her except in her drawing room where the door was never closed."

"Well—looks like His Majesty's to have less time to meddle in Academy affairs."

The inquisition commenced a week later, and Caroline expressed her indignation rather calmly. "I have committed adultery with only one man—the husband of a Mrs. Fitzherbert." Guffaws resounded throughout the Empire. And, with the King off their backs, certain Academy members who were

normally at each other's throats were enjoying tea with one another. Joseph found solace in this.

He was also finding solace in the modest house he had taken at Hammersmith on the Thames. He shared it with his father, and it was tended by Hannah Danby, Sarah's strange niece. The area was free of grime and noise, and a shaded garden spread to the river's edge. Finding it absurd to work inside, he was painting in the open. Some of his contemporaries criticized him for this. "Open-air heresy. Oil painting is for the studio." He waved them off with a chuckle. "Who'er they to say how and where a man's to paint? Paint with my arse if I chose to."

Tranquility also reigned at his gallery in London. It was running smoothly, and after totting up his stockholdings he arrived at the figure of seven thousand pounds two hundred. "A tidy amount for my labors I'd say, Daddy."

"I'm to agree with you, Billy."

The critics were still growling. The *Sun* wrote off his *Schaffhausen* painting: "Turner is a madman. Instead of boldness and grandeur, his picture is marked by negligence and coarseness." Benjamin West snarled, "His *Garden of the Hesperides* is intoxicated with extravagances, and *Sun Rising Through Vapor* shows proof that he's falling off, running wild with conceit, debauching the Empire's young artists."

Joseph could afford to ignore them. His paintings were being bought by Lord Essex, the Earl of Egremont, Sir John Leicester, Walter Fawkes and others known for their superb collections. Moreover, he was now dominating the best of London's exhibitions. The preceding year W.F. Wells, a patron, had suggested that he produce books of his work that would display the range of his talents. The title *Liber Studiorum* was suggested. "A fine engraver could be selected to work under your supervision. I'm convinced they'd sell very well," Wells had said. Joseph had balked. "Understand, Turner, inferior engravings after your death could hurt your reputation."

"Never that!"

He had just turned thirty-five when the first installment appeared. And, for reasons that salved his own conscience, he had begun thinking of

himself as a dutiful and proud father. Sarah's financial problems had become his. Evelina was eleven now, and sprouting into loveliness. Georgianna, his second daughter, had, at the age of six, grown into a pretty girl with reddish hair and large blue eyes. With a mind of her own, she was already expressing distaste for things she didn't approve of, especially the Catholic school she attended. Joseph had bought a doll for her birthday, but neglected to wrap it.

"Who's this for?" William asked when seeing it on Joseph's bed.

"Oh—oh, it's for Wells' grandchild. Sending it off to her tomorrow." The lie weighed heavily on him. Evelina and now Georgianna—two grand-daughters he had never seen or heard of? William would never understand.

Georgianna's personality sat far apart from those of her siblings. Extremely stubborn, she had demanded entrance into the universe a month before the time set for her arrival, then added confusion by attempting to arrive feet first. This had brought Dr. Fitzroy serious problems and extreme pain for Sarah, who suffered for nearly three hours. After such an entrance one might have expected an outcry from her equal to the seriousness of the occasion. Instead she had greeted them with a radiant smile.

When she turned four Joseph had given her a kitten. She baffled the household by naming it Anna Igroeg. Evelina took a week to figure it out. Her sister had simply spelled her own name backward.

Georgianna's dietary adventures held the family in awe. Her favorite dessert, which she prepared herself, was sour milk stirred into syrup and topped with pickles. Another favorite was brown sugar thickly spread between slices of raw onion. Peppermint sticks Joseph brought were saved to dip in mutton gravy. Evelina's stomach turned sour from just watching. But Georgianna's concoctions served her well. Unlike the others, she seldom suffered colds or bouts of diarrhea.

Fondly she coddled her birthday doll that Joseph had brought, but it failed to alter her complaint. "It's an awful place and I'm not going to go back to that school."

"You'll go back, Georgianna, and you're not to tell your mother what you will do or not do."

"I hate that place. I hate it!"

"I will hear no more of this. Now you go straight to your room and stay there until dinner. Do you hear?"

She did hear, of course, and clutching her doll she bolted up the stairs.

The parlor had grown quiet and Joseph stood with his back to Sarah, who paced the room in despair. "Oh, such a terrible attitude she has toward school—toward just about everything."

Joseph smiled. What he was about to say was left unsaid when a knock came at the door. Sarah opened it to a plump, elderly nun with anger in her face.

"Why, Sister Clarenda—please come in."

Sister Clarenda's mood was not attuned to niceties at the moment. She gave Joseph an icy stare and her eyes questioned his presence.

"This is Georgianna's father, Sister."

"Well, how do you do."

He managed a quick bow. "Won't you have a seat?"

"I've no time for that. I'm here about Georgianna. She's worn our patience to the bone. Her behavior's beyond belief, and there must be improvement or we will not have her back. She is the very devil itself, making a constant fuss for the whole school to see."

"Oh dear, dear," was all Sarah could bring herself to murmur.

Joseph looked with mild alarm at the nun. "But she's only a mite of a child. What, pray tell, is it she does that's so bad?"

Sister Clarenda gave him a chilling stare. "'Twould be hard to find something she does that's not bad. I tell her to make a letter one way and she does just the opposite. When the others sing she stands with her lips shut tight. She refuses the prayers and won't shut her eyes when they're being said. While all the others run about at playtime, she places herself against a wall and won't budge or speak to a soul." She opened a sheaf of papers. "Here's a fine example of her hardheadedness. She was instructed to chalk in the horse with either brown or black chalk. Take a look at what she did."

Joseph looked and could hardly suppress a laugh. The horse was green with pink ears and red, white and blue legs. "Why, Sister, I find that very imaginative."

"Then you see nothing wrong in what she's doing?"

"Not in this instance, I'd have to say. It's only as the child imagined the horse to be."

Sister Clarenda snatched the drawing from his hand. "So—you're to agree with her conduct, Mr. . . . ?"

"Joseph—just call me Joseph. And I'm to agree with nothin'. It's left to the child's mother." He turned and went toward the kitchen. "Good day, Sister." Georgianna had shown herself to be creative—and with her father's sense of independence. She was certainly his daughter, and suddenly, his favorite daughter.

Sarah was struck with embarrassment. She wanted her children thought of as most obedient Catholics. After Sister Clarenda left and she went to the kitchen where Joseph was drinking tea. "You were extremely rude to her."

"I'd no such intentions, though she was deserving of it—storming in here like she was to rip things apart."

"It would be to Georgianna's good if you went to the school and apologized."

"I'll do no such thing. I'm in agreement with the child on just about all counts." He slammed his cup down. "That fat Catholic sister of false purity is a tyrant."

Sarah stiffened. "That was a dastardly remark for which I shall never forgive you."

"It's what I felt."

Turning swiftly she left the room. He stood listening to her feet angrily attacking the stairs to her bedroom.

En route to Hammersmith Joseph spoke to himself. "I've had a'nough. The woman's hopeless. Always will be. I've been plenty good to her and the children. I've provided and provided. Only marriage can sweeten her tongue. I'm not going to tie myself down to a crabbing woman and five children. I'm going to keep my freedom." Sarah Danby was close to becoming a part of his past.

For her, Joseph's rudeness and his slur against her religion was embarrassing and disheartening. John Danby had made Catholicism the article of

his family's existence. Now, lying sleepless, she accepted the blame for her predicament. "I yielded too quickly. Now he's subjecting me to treatment more readily accorded a whore." She, too, was thinking about shutting him out of her life. But she saw folly in doing it too quickly. Total responsibility for five children was more than she was ready to take on. She would have to wait. She couldn't completely alienate him, nor could she go on compromising her pride. A livelihood of some sort might insure her independence. Vaguely she had been considering singing again. With proper coaching she could put her talent back to work. "Preston Laurence." The name entered her thoughts. He was a respected agent and a good friend. Perhaps she should go speak with him. But maybe not. No need to rush things. She was flirting with independence, but without much enthusiasm.

Georgianna's unpredictability was swirling through her when Sarah and she arrived at school the following morning. Sister Clarenda sat stiffly at her desk, expecting obeisance from the little sinner. Sarah spoke softly. "Well, darling, Sister Clarenda is waiting,"

"Waiting for what, Mother?"

"For you to apologize for your behavior—to say that you are sorry."

"But she herself tells us that God wants none of us to tell a lie."

"Indeed that is the truth."

"Then I'm not to say I'm sorry, because I'm not."

Sarah slumped into herself, bowed to defeat. But not so the formidable Sister Clarenda. The faith manifested in her was being thoroughly tested. "You are not to worry yourself, Mrs. Danby. Leave her to me." Soaked in shame, Sarah touched her daughter's shoulder and left. The room was filling as Georgianna went to her seat.

The day began with a prayer, and all eyes were tightly shut, except those of Georgianna. Through the glimmer of her lashes Sister Clarenda saw this act of defiance. And it remained, in one way or another, through reading, writing and arithmetic. When the bell rang for recess the seats emptied instantly. "You, Georgianna Danby, are to remain in this room and undergo Penance." With snickering coming from all directions, Georgianna remained in her seat.

Sarah was knitting socks when Sister Clarenda reappeared at her door. "Bring forth that child. I'm taking her back to school for the rest of the day."

"What do you mean, Sister? Georgianna is not here."

"Then where is she? She's nowhere to be found at school."

"Oh my Lord. My Lord."

"Well, we must not become too upset. She must be on her way here." The two of them combed the area between home and the school. There was no Georgianna.

Evening had fallen at Hammersmith. Joseph, reworking *The Thames at Weybridge*, broke off when he heard his father's voice raising angrily. Hurriedly, he got up and went to the front of the house to see Constable Finchley in the doorway. "Good evening, Constable. Can I be of any help?"

"I've a serious message about your daughter, Georgianna."

Joseph gulped. "There's a mistake, Daddy. I'll talk with the constable."

William left them and Joseph spoke softly. "Now Mr. Finchley, what's the message and who's it from?"

"It's from a Mrs. Danby—and I hate telling you but the child's...missing since morning. There's a search for her all over London, but with no success. Mrs. Danby's asking for you to come right away."

"Thanks, Constable. I'll do so right away." His voice had trailed off to a murmur. Worry had set in. Finchley started off then turned back. "Why'd the old boy lie to me, I'd like to know?"

"Just a little mix-up. Sorry." After closing the door he stood in thought for a moment. Georgianna missing? He dressed quickly and took a hansom to London.

"Strike back, Georgianna!" The demon inside her head had demanded action. Two minutes into her imprisonment she had grabbed her coat and exited the building. After reaching the street she had turned in the opposite direction from home, passed St. Anne's Church, drifted across the busy intersection and continued down the sidewalk. She had gone only a few feet when a scream pierced the air. From the scaffolding under which she walked the form of a workman hurtled downward. His boot struck

Georgianna's head and she went down. A crowd closed in. "The poor bloke's neck's broken," someone said. "That child, who does she belong to?" Faintly, Georgianna heard the inquiry before slipping into complete oblivion. A large woman rushed forward and knelt beside her. "Oh, my child. My child. Please—someone help me. I must get her to a doctor."

A workman had responded and lifted Georgianna into a hansom. The woman climbed in beside her, shouted an address at the driver, and his horse took off in a trot.

It was an eerie atmosphere into which Georgianna awakened an hour later— dim, candle-lit and scented with perfume. The bed was so large she seemed to float in it. The painting of a huge woman with three black cats on her lap stared down at her. At first she thought she was dreaming. Then suddenly she knew that she was indeed awake, with a sore head, and in room she had never seen before. She touched the bandage on her head and fear flashed through her. "Mother. Mother!" A black cat leapt over her and fled as the woman rushed into the room. Two large necklaces jangled against her breast.

"Quiet, my child, quiet." She came to the bedside. "Your mother has gone and I'm your new mother. And you are now named Angelica and we're about to take a beautiful boat over the sea. But first you must sleep some more."

A thin, short man in a frock coat appeared in the doorway. "How is she?"

"She's fine—just fine, aren't you, darling?"

The man observed the woman with a frown. "Absolute insanity."

"Just you leave matters to me. Things will work out."

"I'll have no part of this," he said, then left.

Scotland Yard had not intervened until the morning of the following day. By noon, however, an Inspector Langford was at work on the case. With Sarah, Joseph, Sister Clarenda and Kenneth Dows, a janitor from the school, he sat in Sarah's parlor taking notes. Dows was offering information. "Right next to the scaffolding I was when the poor bloke fell to 'is end. 'Appened so fast it

did. And 'aving gone to the aid of the poor man, I'd give scant notice to the child 'til the woman runs over to claim it." He paused, consulted his memory. "Thinking back, guv'nor, I'd of sworn that child wasn't 'ers a'tall. I've doubts now that she'd ever laid eyes on it before. She 'ad a large wart on her nose, I remember. And by 'erself she was. Then she rushes in and lays claim to the child."

"Would you have recognized Georgianna had you seen her clearly?"

"Oh, to be shore I would 'ave. Many's the time I've seen her standing alongside the wall at playtime."

"Can you remember the kind of clothes the child wore?"

"To be 'onest, no, guv'nor. A big woman she was and all over the child like a mother hen. Never got a good look a'tall. The next thing I know she's got the young'un in a hansom and gone in a 'urry." He shook his head. "Couldn't say if it 'twas a boy or girl."

Langford asked questioning for another two hours. After he left, Sarah, despaired and exhausted, took to her bed. Joseph made a detailed sketch from the description Dows gave of the woman. He also gave Langford a drawing he had made of Georgianna. Two days later pictures of the victim and suspect ran side by side on the front pages of London's newspapers.

Katherine Becket hurried to the inspector's office at Scotland Yard that same afternoon. Langford looked at her and spoke gruffly. "I'm told you might have information concerning the missing Danby child."

"It may be of some consequence, maybe not."

"Well, go on, madam. What is it you have to say?"

Katherine took a newspaper from her handbag, unfolded it and pointed to the sketch of the woman Joseph had made. "Inspector, I have a home for children at Chiswick called Margate. Nearly three months ago this woman and her husband, I'm quite sure, came to adopt a child. After investigating we felt they were not acceptable as parents, so they were refused."

"And you are sure this is the same woman?"

"I am indeed. I could never forget her face or that large wart on her nose."

"Their names and address, do you have them?"

"I do," Katherine said, placing a sheet of paper upon his desk.

He scanned it quickly. "Vera and Anthony Mascola. Number 64 Holborn Hill. This address is correct?"

"I can only assume so. I received letters from her at this address."

"And why did you refuse them?"

"They were both beyond the age limit we set for couples who wish to adopt young children. More importantly, we found that Mrs. Mascola had spent considerable time in a mental institution."

"And this was three months ago that they came to you?"

"Near to that."

Langford rose to his feet. "Thanks so much for your help, Mrs. Becket. Our office will stay in touch with you."

"I will be happy to help you."

"Perhaps you have done that already."

With two of his men, Langford lost no time in arriving at 64 Holborn Hill. An elderly man came to the door. Langford flashed his credentials and they were let into a house without furniture. Only a wooden crate sat in the parlor. It was addressed to Signor A. Mascola. The destination: 23 Via Viattorria. Palermo. Sicily. The caretaker explained that it was to be picked up that same afternoon and placed aboard the boat *Santa Maria*. The old man gave more information. "It sails tonight from Southampton."

"Under no condition is this crate to leave these premises," Langford ordered.

"No, sir. I'll see to it, sir."

"How long have they been gone?" he asked.

"Close to a half hour I'd say."

"And how many were they?"

"'Twas him, his wife and a mite of a girl."

As though to announce the beginning of pursuit, a thunderclap ushered in a storm. The wind blew in suddenly; leaves swirled into the air. The sky went black and sheets of rain poured down. Langford's driver suggested waiting out the storm. The inspector refused him and the carriage sped on.

They had just entered a sweep of open country when Langford saw the green coach. Excessive baggage roped to the rear and top of it. "Overtake that carriage ahead, Wilson, then hold alongside so we can have a look!" They raced ahead to come even with the green coach.

"Slow to their gait, Wilson. Slow to their gait."

Wilson reined the horses in, and as he did Langford saw what he wanted most to see—the bloated, chalk-white face with a large wart on the nose. Vera Mascola was scowling at him. "Scotland Yard!" He shouted. "Pull over and stop!"

As her carriage slowed Vera Mascola shouted at her driver. "Go on, man. Go on!" Her order went begging. Langford's driver had pulled ahead in a blocking maneuver. With both carriages stopped, Langford and his men jumped out and quickly surrounded the fugitives.

"What is the meaning of this? What are you? Robbers, bandits?" Vera's voice was charged with anger.

"I'm afraid you're reversing our roles, madam!" Langford shouted back. "Now please, no trouble. Where is the girl?"

"What girl? What are you talking about?"

Anthony Mascola's head appeared at the window. "She is here, sir," he admitted meekly as he pushed Georgianna forward to be seen.

She looked at the inspector with distrust. "Who are you? Where is my mother?" she asked.

The calm with which she had spoken all but stunned the inspector. "I'm Mr. Langford and I've come to take you home."

In a matter of moments, both carriages were headed back through the rain toward London, and Georgianna spent most of the journey giving an account of her experience. More like an adventuress than a child snatched from the hands of kidnappers she told, with superb nonchalance, how she had bitten Mascola's hand and scratched Madam Mascola when they tried to pet her. She admitted to having said only four words to them, "I want my mother. I want my mother. Even when they asked me what I wanted for supper I told them I wanted my mother."

Georgianna couldn't figure out how she got to be with her abductors. She could only remember being shut up in that classroom.

"Tell me, young lady, where were you going all alone?" Langford asked.

"Just taking a walk, that's all."

The inspector smiled.

Joy and celebration awaited her at Upper John Street. Sister Clarenda came with an attitude that suggested righteousness had been born in the depths of the child's soul. Flooded with questions, Georgianna gave answers of fairytale proportions. Certainly, she was convinced of her importance. Joseph beamed. Sarah, in spite of her exhaustion, held her on her knee most of the evening. Her daughter had survived an experience stretching far beyond her imagination.

At Langford's suggestion, Sarah wrote a letter of thanks to Margate House. Katherine Becket had asked that her name be withheld, so Sarah expressed her gratitude to whomever it might concern: "Had it not been for you I might never have seen my child again." She wrote at the end. "Georgianna, her father, brother and sisters will be forever grateful. If we can ever be of service to you, please don't hesitate to let us know. God bless you. Sarah Danby." She then asked Joseph to send Margate House a painting to show the family's appreciation.

"To be sure I'll do it—but it's to go unsigned."

The abduction brought Sarah and Joseph back to more voluptuous evenings. Pillow talk flowed, and with the rekindling came serenity, until Sarah began pushing him toward the altar again. His freedom was being threatened once more, and contentment winged away. She realized at last that his work, not she, would always be his real passion. On one summer evening their love-bed on Norton Street went completely sour. Not as much as a finger touched the other. After a long silence she rose and dressed. Feigning sleep, he lay watching her. She was about to leave when he got up to stand naked before her. "You're goin' without sayin' goodbye."

She was silent for several moments. "You are unhappy. Is that not right, Joseph?"

"And why would you say such a thing?"

She smiled sadly. "I'm quite sure that you have had enough of me. Our affair has burned out, Joseph."

He fixed his eyes upon her in the dimness. "I'm to be frank, Sarah . . . "

"Yes?"

"I'm sorry. Maybe we should part for a while."

"Not for a while, Joseph. Forever. I, too, must be frank. You have never loved me, or forgiven me for having Evelina and Georgianna."

"You're wrong, Sarah, I—"

"Please, Joseph, hear me out. They are my children and my burden, and I no longer want them to look upon me as your common mistress."

"They are my love and burden as well."

"No longer do they need to be your burden. From now on you can simply forget they exist."

"That's a very brutal attitude, Sarah."

"I don't feel so. I accept complete responsibility for them. That is the way I prefer it."

"Impractical, I'd say."

"Perhaps, but I will not allow them to go about the rest of their lives looking to you for anything."

Guilt knifed through him. "Maybe they should have a say in the matter."

"No, they will not. From this night on, I will have them think of you only as someone who is dead."

"You do seem to loathe me."

"No, Joseph, I shan't go around loathing you. Perhaps if I still loved you, I might. But I don't. I can only look upon you as a sort of scoundrel."

"Scoundrel?"

"Surely you could think no better of yourself after what you have put me through."

His hand reached to touch her. She pulled back as though it might burn. "I'm sorry to have it end this way, Sarah. I still care for you."

She picked up her hat. "And so does the butcher. And so does the baker, and the man who washes the windows. They care for me because I'm a nice lady who provides them trade. You once cared for me because I was the nice lady who gave you her body. Your kind of caring is no longer enough, Joseph. Sarah Danby needs love, the kind you don't have to offer."

She walked to the door and opened it. "I'm to be independent from now on, Joseph. You have made me that way. Maybe someday I'll bring myself to thank you for that. Goodbye."

Then she was out the door and gone, leaving him to stand naked and alone. He sighed and got back in bed, covered his head with the sheet, but her voice, bitter and accusing, echoed through the stillness, denying him the blessing of sleep.

Margate House sat beneath an umbrella of large oaks near a loop of the Thames. Sixteen sprawling acres surrounded it. Now, in the heart of summer, Katherine was having a picnic on the front lawn for the children when a dray came up the drive. When she went to inquire about it the driver smiled. "A gift for the premises.?

"And who is it from, may I ask?"

"A Mrs. Danby," the driver answered. It was rather large, and she asked for it to be placed in the front parlor. She gasped when the brown wrapping paper fell away from the sides. Margate Harbor confronted her. Immediately her eyes searched for the artist's signature. There was none.

"Margate, my beloved Margate. How appropriate for the shelter." An orange ball of sun burned through the mist. The tide was high, amber and honey-colored and patches of white rippled the flow. Two tugs bobbed in the gray morning light. An old hoy slanted leeward with its sails arguing with the wind. In the far distance the chalky cliffs of Thanet Isle climbed into haze.

> My dear Mrs. Danby,
> With greatest joy we received the beautiful painting.
> We will always remember your generosity. Please tell
> Georgianna that her gift now hangs in our front parlor over
> the hearth, and that we all love it. So superbly it catches
> the mood of Margate and the beauteous sights that sur-
> round it. Would it be possible to have the artist's name? He
> is to be congratulated. How thankful we are. If by chance

you ever have time to visit us we would be more than delighted to see you and welcome you. We send our love and sincere thanks.

The Staff at Margate House
July 3, 1810
Chiswick

Margate House
To the Staff,
Thanks so much for your kind letter. Both Georgianna and I are so happy that you like the painting. It is so very small compared to what you did for us. Indeed I would love to visit the home someday in the future. It is such a worthy cause you have undertaken. The good Lord is to bless you for it. Our love to you and the children.

Sarah Danby
July 8, 1810
P.S. I'm sorry, but the artist chooses anonymity.

Quite simply, a duality of secrecy surrounded Georgianna's gift. Its creator had not been forthcoming with his role as artist or father. Its recipient, having emerged from her husband's tragedy feeling that her name was besmirched, had accepted it in the name of her staff: her secretary, two housekeepers, two cooks, a gardener and a janitor. Of the thirty-three children who now peopled the Becket mansion, nineteen were boys, the rest girls, ranging in age from five to thirteen—all loved, well-fed and content. Margate's founder was sure she had done the proper thing with her inheritance. It was half past two in the afternoon. She looked toward the children romping the lawn. Never before had she been so contented.

CHAPTER TWENTY-FIVE

"Scoundrel!" Sarah's voice seemed to knife into his carriage as it approached Walter Fawkes' Yorkshire estate. "Scoundrel!" His conscience bled and he bathed in its blood. So genuinely she had lifted her pride and, try as he did, he failed to find fault in that. Neither could he hold one ounce of disbelief in the finality of her goodbye. With dry eyes she had said everything most emphatically—no longer would she, or her children, be imprisoned by his uncertainty. Now, whether he liked it or not, his conscience was whispering, "You are a scoundrel, Billy—and you've lost a fine woman, in spite of your long list of complaints." It was too late. Far too late.

Sun streaked through the wooded approach to the estate as the coach entered the gates. Beyond were acres of moors and a magnificent view across the River Wharf to a misty ridge forming the wall of a valley. Then Farnley Hall began its majestic rise. On its north end, the Tudor section; on the south, looking toward Wharfdale, a commanding neoclassical wing. Walter Fawkes, Joseph's foremost patron, had invited him for two weeks of sketching and fishing. As he left the coach, two huge wolfhounds bounded toward him wagging their tails, and close behind them came Fawkes' young son, Hawksworth. Joseph flung his arms around the boy. "Hawkey. How's my favorite lad?"

"Fine, sir. Happy to have you back."

"And your brothers and sister—where are they?"

"Away at school until the holiday."

"Ah, I'll miss them, I will. So, Hawkey, it's your luck to get this whole bag of sweets."

"Welcome back, Joseph." Walter and Mrs. Fawkes had come out to greet him.

He gave his hosts an admiring look. "You're both as handsome as ever." He was correct. Walter, at 41, was lean and athletic with the bearing of an aristocrat. His wife, who could have been mistaken for his sister, comple-

mented his appearance. Both had chestnut hair and the invigorating climate of Yorkshire's moors had heightened their complexions. At eleven, Hawksworth was a bit pudgy, but endowed with their features.

A servant came for Joseph's bags. From one he took a volume of Byron's poetry and presented it to Mrs. Fawkes. She thanked him graciously, then hurried off to hide the volume she already possessed. After a dinner of grouse and cuckoo birds, Joseph and Fawkes took brandy in the drawing room. Prominent in the antislavery movement, Fawkes damned slavery's evils for nearly an hour, then began lambasting the Crown. "There has to be parliamentary reform." He downed a brandy. "We've known this for ages but done nothing about it."

Cautiously Joseph posed a question. "Your York Committee—I thought it was to be the people's defense against aristocratic domination. Is that not so?"

Fawkes waved a hand in disgust. "That, Joseph, has become an engine in the hands of the minister, to tax, insult and enslave the people of England." Pouring more brandy, he went on. "Both the Crown and war have brought corruption to its maturity. The crisis has arrived, and we have to amputate that poisonous tumor, otherwise we're lost."

Clad in a nightshirt, Hawksworth stuck his head through the door. "Good night."

Joseph waved. "Good night, lad."

Fawkes lifted another brandy. "We have to put a stop to all the nonsense. My God, are we blind to the French Revolution? Any fool knows that Charles and Louis were their own executioners." Woozy from brandy, Joseph had begun to nod. Fawkes rose from his chair. A shooting party had been arranged for the following morning and his hand had to be steady. Before leaving he summed up his discontent. "Joseph, I covet power. If only I had it to point out to my countrymen that they are in danger." He yawned. "Well, a good night to you, my friend."

"And a good night to you, Walter." The first day at Farnley was finished.

Joseph undressed and stood naked before the mirror. "Lookin' beyond your years, Billy. Growin' a bit dumpy. Have to cut down on the gravy—do

somethin' about the shaggy hair." He pulled a nightshirt over his head and got into bed.

Morning arrived rose-colored and clear. He ate breakfast, arranged his workbox, and thirty minutes later, with Hawksworth at his side, he was bouncing along in a tandem toward the shooting grounds. A long shooting iron was at his side.

"You a good hunter, Hawkey?"

"I have no feeling for it, sir."

"Nothing to be sorry about, lad. I've no feelin' for it either. But that's our little secret. I'm goin' to sketch, eat and drink." Several shots echoed from the distance. "Ah, they're hard at it already."

Tents had been set up; dead grouse were strewn on the ground; dogs gathered around the kennel man; barrels of ale waited to be broached, and a servant was drawing corks from wine bottles. Over thirty hunters were strung out across the moors, and birds were falling to the earth. Fawkes was resting on a box gnawing on a slice of ham as Joseph stepped from the tandem.

"Fine morning for hunting, Turner."

"Even better one for sketching, I'd say."

"You're fortunate to have the choice."

"And how's the shooting hand today?"

"Quite steady. I've downed my share already."

Joseph reached for his sketch pads. "Well, I'm just about to get started."

Without another word he threw a blanket over his gun and started roaming the moors. He had sensed Hawksworth's longing to stay at his side, but he didn't encourage him. The lad would be bored among the hunters, but there was some serious sketching to be done, and he wanted to do it alone.

The hunt was about over when Fawkes invited him to try his hand with a gun. Reluctantly he gave in and a cuckoo bird became his victim. He felt sorrow for that cuckoo, shattered, plummeting down toward the moors. The moment had cut into him like a knife when his shot echoed through Yorkshire's hills.

Of all the great estates he had visited, Fawkes' was his favorite. His watercolors and oils hanging there had a lot to do with it. Now he was back, capturing Farnley Hall's spirit and magnificence—the drawing room with its Grecian furniture, harp, Broadwood piano and marbled chimneypiece; the classical pillars in halls, dining and reception rooms. As a special present for Hawksworth, he drew an old cupboard on bun feet with paper doors that opened to reveal a display of Cromwell relics.

From his window one afternoon, Hawksworth was amazed to see Joseph beneath his umbrella sketching during a violent storm. Rain was sweeping in, and lightning shafted down through the hills. Still Joseph stood there in the rain, sketching on the back of an envelope. Drenched, he entered the great building, met Hawksworth and showed him the sketch. *Hannibal Crossing the Alps.*

"I don't understand, sir."

"A new paintin' I'm at work on."

Fawkes' carriage carried Joseph homeward several days later. He was returning with warm feelings toward Farnley Hall, its inhabitants and Yorkshire's Hills. He glanced back through his years as he rode along. Indifferently, they stared back like letters from the past: to his mother's madness; to his father's devotion. He was their flesh and blood and his love for them was as measureless as wind. He had lost the love of Katherine Forsyth, then wrecked his relationship with Sarah Danby, probably with Evelina and Georgianna as well. He sighed. The wine and brandy had been good at Farnley Hall, but no better than the grog he had swilled down with Tom Girtin, Gully Cooke, Hans Fechner and Gig Pipes. He would always cherish their friendship. Memories. Some were good, some bad. He stretched out his legs. "Well, that's the way memories are, Billy." Of what he remembered, or didn't remember, was soon wandering the peaceful sleep that suddenly overtook him.

The fiftieth year of George III's reign was celebrated with a dinner at the Academy and Joseph attended. Problems with Napoleon were easing off, but not those of the royal family. Now came allegations that the Duke of

York—the King's second son—had peddled army commissions under the influence of his inamorata, a common tart. He was cleared, but shortly after, the King's fifth son, the Duke of Cumberland, was suspected of murdering his valet during a fit of rage. When Amelia, his youngest and most beloved daughter, died, the King's mind died with her.

Joseph sensed problems for the Academy when news came that the King had slipped over the precipice and could no longer rule. The new Prince Regent was highly cultured, but hopelessly irresponsible. He was now preparing to celebrate his accession in grand style. Carlton House, his plush palace, was being refurbished at a cost that generated parliamentary distress. With England's poor starving in great numbers, the Prince Regent had set aside one hundred and twenty thousand pounds toward one lavish orgy of food, drink and merriment for two thousand guests.

The Prince commenced his grandiloquent regency on June 9. He sparkled that evening. Having appointed himself a field marshal, his uniform gleamed with gold lace and a diamond star. A plumed wig and jeweled sword added to his splendor. The guests streamed into the great porphyry-columned halls, blue velvet anterooms and a Chinese drawing room swathed entirely in yellow silk. A gong summoned the revelers to a vast assortment of exotic foods, and gallons of French wine and champagne. When a hundred violins sang out with a Viennese waltz the Prince swept the Marchioness of Hertford into his arms and the ball began. In the sweltering heat, coiffures, wigs, ball gowns and uniforms wilted, but everyone danced on through dawn.

The cries came thundering from Percy Bysshe Shelley, Lord Byron and the satirist Leigh Hunt. The latter, whose attack was the most venomous, was thrown into gaol.

Soon all of England's economic troubles were dumped on the Regent's doorstep, and he turned to that sector of the nation that adored him most, the world of art. Joseph found the prince's interest in the Academy free of pretense. Where his father had meddled wickedly in its affairs, he spurred it toward excellence by giving full support to its painters. Thomas Lawrence

and David Wilkie were his favorites and both were knighted. But no knighthood awaited two of the Academy's most illustrious stars—John Constable and Joseph Turner.

Constable fretted silently while Joseph accepted the oversight with a shrug. "Princely patronage has its pitfalls. It can be a fetter upon genius," he told Farington. "I'd beg before I bowed to any royal patron's opinion."

"Acknowledgment from the royal quarters never hurt," Farington reminded him.

"Nobody can push a real artist to his heights. He's to do it on his own or he's lost."

"You never cease to stun me, Turner."

"I've further reasons to stun you in the future."

"And when are you to begin your lectures?"

The inquiry rankled Joseph. "When I'm bloody well ready."

"The entire Academy is waiting, looking forward to it."

"I hardly feel the same. I'm set for another tour."

Should a knighthood come your way, Turner, kneel and accept it graciously."

"I'd sooner squat and empty my bowels."

Farington was stunned once again.

The mention of the lectures brought on some soul-searching. Three years after his appointment to a lectureship, he finally stepped to the lectern to deliver the first of his discourses on perspective. Behind him, mounted on a wall, was an array of diagrams, illustrations and collected materials to help illustrate his philosophy. Nervously he shuffled his notes and glanced out at his huge audience. It was a blur. He then launched into a monologue so obscure that hardly a soul in the auditorium understood what he was talking about. For over an hour he went on, mumbling at times, defining the optical development of circular and vortex forms:

"The eye's not to take in all objects upon a parabolic curve for, in lookin' into space, the eye can't but receive what's within the limits of extended light, which must form a circle to the eye. Light's therefore color, and shadow the privation of it by the removal of these rays of color, or subduction of power; and these are to be found throughout nature in the rulin'

principles of diurnal variations. The gray dawn, the yellow mornin' and red departin' ray, in ever changin' combination, are constantly found to be by subduction or inversion of the rays of their tangents . . . "

Had it not been for the splendid collection of architectural drawings, domes, pinnacles and classical facades he would have put his audience to sleep. It was one thing to feel the force of creativity erupting inside; another thing to express it.

John Landseer, Farington and Beaumont discussed the merit of the lecture the following day. Landseer spoke first. "I admit to being somewhat deaf, but I could not well understand much the man had to say. His plebeian pronunciations were stumbling blocks I couldn't overcome."

Farington shrugged. "Intelligibility has never been set at a high standard by our lecturers. Reynolds was a first-class mutterer and Soane's terrible. Turner was puzzling, but his linking of poetry to art was quite fascinating."

Beaumont scoffed, "The man shows merit but the wrong sort. He's fatally seductively to young painters. They're copying him as though he were a saint. I'm going to push for the Academy to raise objections toward him." Had Joseph been a fly on Beaumont's shoulder he might have grinned. The Academy's board had just selected nine of his pictures for the spring showing.

As this discussion took place, Joseph and his father had just finished making alterations at the Harley Street gallery. They sat now amid rubbish and paint cans eating fish and chips. "So the lecture went well, Billy?"

"Seems so."

Sensing his son's reluctance toward further comment, William changed the subject. "So, you're off to Dover tomorrow."

"And none too soon. London's gettin' on my nerves and I'm needin' a rest from it."

"Be nice if you'd call on your Uncle Price at Exeter if you have the chance."

"If possible, Daddy, but I doubt it."

He cleaned his brushes. There was still packing to do. He had taken some clothing from his trunk when he saw the sailor's outfit he had bought

in Wales. He put it in his bag, and then went to bed. It was icy, ambushed by loneliness. "Another womanless night." Sarah's warmth was missing. Unsavory faces butchered his dreams. (A woman's face from somewhere in the past gazed down at him. "You're going mad. Mad. Just like your mother!" Beaumont bolted through the door, pointing. "You're crazy. Crazy. Crazy!") Jolted awake, he sat up wiping at sweat. The terror of insanity hovered in the darkness. Suddenly he was left with a terrible possibility. Perhaps his mother's affliction was claiming him. After a struggle, he slept again.

Sun pouring through his window at seven o'clock signaled a fine day for traveling. He got up, dressed, and after breakfast with William, went to take the stage.

Dover had its virtues. It was by the sea. Joseph didn't know a soul there, but it had met Tom Girtin's need one summer when he chose to escape the confusion of London. His need was the same—anonymity. The sailor's suit could help serve that purpose.

It was seven o'clock in the evening when the stage let him off at the Red Cock, the same inn where Girtin had stayed. Its brick facade seemed to have been washed by the sea. Joseph entered the cozy interior. The innkeeper, a large, jolly red-faced man, hailed him as he entered. "You're Mr. Twyne, I expect."

"That's right," Joseph replied crisply. "Nat Twyne."

The innkeeper extended his hand. "Name's Frank Bishop and glad I am to welcome you to the Red Cock. Your quarters are waiting and I'm hoping you'll find them to your liking." Frank Bishop's eyes twinkled and he wore a steady smile. "Come, I'll give you help with your belongings."

"Thank you, sir. Would be kind of you."

"Just Frank. Everybody here calls me Frank. I've not answered to 'sir' for as long as I can remember." They started up the stairway. "Put you on the third landing. From there the view's a heavenly sight. Nothing like you've ever laid eyes on before."

Frank wasn't blowing hot air. The view was spectacular. A huge orange-ball sun was slipping beneath the horizon. Whitecapped waves thundered against the cliffs, breaking apart and raining back into the sea. A pale half-moon already hung in the sky veiled with gray mist. Joseph's smile brought an even brighter one to Frank's face. "God sent, heh Mr. Twyne?"

"I'm to agree."

"Your letter says you're a friend of Mr. Girtin's. A fine man he is. How's he anyway?"

"Sorry to say he passed on a number of years back."

"Ah, what a pity—and so young he was."

"A great loss."

"Always full of laughter and fine tales he was."

"'Twas him alright."

"Well bless him wherever his soul might be. Would you be having supper with us tonight? If so, the eating room's open."

"Fine. I'll be right down." Nat Twyne. Nat Twyne. He'd have to get used to the sound of it. For the next couple of weeks that was the name he'd be answering to and it fitted the sailor's outfit.

Frank Bishop was taken aback somewhat when Joseph appeared for dinner. "Ah, Mr. Twyne, never would I have taken you for a seaman. You'll appreciate the Red Cock all the more. Believe it, I put Lord Nelson up here for a night once."

"That so?"

"Matter of fact he slept in the same bed you're to sleep in. Was it your good fortune to serve under him?"

"Unfortunately, no."

"Ah, the old boy saved England, he did." He handed Joseph a menu. "Trilby Redd's to serve you. She'll be along in a minute or two." Frank hurried off to greet other guests entering the room.

She came to take his order—and her dreamy eyes, sultry lips and superbly rounded thighs caught him totally off guard. "I'm Trilby and I'm to serve you while you're here. Would you know what you'll be having for supper?"

Another virtue attributable to Dover was its sole. Without hesitation he ordered it.

"Grog or ale, sir?"

"Grog."

Smiling winsomely, Trilby thanked him and went off toward the kitchen, and the manner in which she carried herself sent his desire on a rampage.

The sole justified the compliments Tom Girtin had paid it, but the rather excessive gratuity Joseph bestowed upon his waitress was not for that reason. It was instead sort of a forerunner of his intent toward seduction.

"Well—sir, I'm most grateful to you."

"You look to be deservin'."

She allowed herself a small blush. "Thank you, Mr. Twyne. Do have a good night."

He slept badly. For half the night he lay in the bed that Nelson was said to have slept in, twisting, turning and thinking about Trilby Redd.

Dover opened up to him the next morning, with fishermen mending nets along the shore and their women gutting the catches. Hordes of gulls swooped down for the entrails. The sun burned westward and soft cloud puffs scudded on the horizon. The tide was rising, slapping against the rocks. A huge strip of orange glistened on the gray water. How could such serenity live so close to the clamor of London? Nature was declaring itself with a vastness of water and jeweled white cliffs. Breathing deeply, he stood for a moment taking it all in, then he opened his sketchbook to let it share the solitude.

Only faint signs of that unconquerable sun were touching the cliffs when he turned back toward the Red Cock. At supper that evening he carelessly tossed patience to the wind. "'Twould be a great pleasure to have you pay me a visit, Miss Redd."

"Oh my, I'd have to give a lot of thought to that." For a moment he thought he had bungled his chances. Then with a toss of her head she looked at him and smiled. "It'll have to be after ten."

He waited until eleven, until twelve. Trilby Redd failed to appear. "Very well," he sighed, trying to put her out of his mind. She was still there when he finally dropped off to sleep.

For the next two evenings he took his meals at the Boar's Head, a half mile down the road. Maybe he had pressed too hard. Best to show that he wasn't so anxious.

At precisely ten o'clock on the fifth night a delicate rapping came on his door. Springing to his feet he went to open it, and there she stood in a tight fitting red dress with a gardenia in the valley of her bosom. Before he could welcome her she put fingers to her lips for silence and slipped into the room. He smiled and spoke gently. "Well, you took your time showin' up."

"It's ten. That's the time I promised."

"Well, sit down. Glad you're here."

She sat down and daintily crossed her legs. "It's hardly ladylike. I take it you're lonesome."

"I was until you arrived."

"Well, that's a plain a'nough answer."

"I'm to be honest about it. I had a need to see you."

She shot him a glance of disapproval. "I have the feeling that you take me for a banksider. Is that so, Mr. Twyne?"

"Why—why, of course not. I'm takin' you to be a friendly woman. No harm to that is there?"

"I guess not. But I make no practice of visiting gents in their rooms."

"I meant well by my invitation."

"For yourself, maybe, Mr. Twyne," she said with a smile.

"Just thought it 'twould be nice to share time together."

"Have we a'nough in common for that, Mr. Twyne?"

"That's for us to find out, wouldn't you think?"

"'Tis a fair thought, I'd say."

"Are you against giving it a try?"

"Depends upon what's expected of me."

"You'd find me considerate." He glanced at the sweep of dark, reddish hair. "Your hair's beautiful."

"I 'ave my mother to thank for that."

He smiled. "She's done well by you in every way, I'd say."

"So you're a sailor?"

He breathed deeply before exhaling the lie. "Yes, but I'm retirin', gettin' out." Hurriedly he shifted the conversation. "How long have you worked for Frank?"

She groaned. "For two years now and it's two years too many."

"Seems like a nice enough gent—cheerful and friendly."

"Ah, but his heart's sour as a lemon."

"Then why do you stay on?"

"Work's not the easiest thing to come by around here."

"He speaks good of you."

"I have a mean time keeping his hands off me."

"Ah, so he's sweet on you?"

"He's a blackguard—and he's not to know I paid you a call."

"You have my word."

She uncrossed her legs and stood up. "Well, best I be going now. I have a hard day ahead."

"But why the hurry?" Disappointment had leapt into his voice.

"Best not to overstay my welcome." She was moving toward the door.

"But when do I see you again?"

She shrugged. "Oh, I'll have to put my mind to that. A good night to you, Mr. Twyne." She took a quick peek into the hallway then hurried off.

He stood for a moment, absolutely baffled, feeling deceived. Did she have a devil inside her head? "Well, Billy seems like you've misjudged the lady." He gave Lord Nelson's bed a wistful glance. "Nat Twyne sleeps alone on you tonight."

Whatever Frank Bishop's faults, neglect of his establishment wasn't one of them. The wood gleamed, the windows sparkled and a cleanliness prevailed throughout the entire place. He was studiously removing a smudge of dirt from the wall when Joseph descended the stairs the next morning.

"A cheery day to you, Mr. Twyne. Hope you had a good sleep."

"Slept like a cat."

"Ah, good to hear." He glanced at the easel and sketch pad beneath Joseph's arm. "So you're also the artist I see. A rip of a morning for drawing."

"A side thing with me. Find pleasure in it sometimes."

"Like hot coffee before startin' out? I've some brewing."

"My pleasure."

They sat at a table having a second cup when Trilby came in and spoke. "A fine morning to you both." She smiled nervously and went toward the kitchen.

"Mornin', Trilby." Joseph's eyes were on Frank. Frank's eyes were on Trilby. "Ah, that one does have some pretty apple dumplin's," he sighed.

"Didn't notice," Joseph lied.

Frank grinned. "Hard to believe, Mr. Twyne. You've a better eye'n that."

Joseph's thoughts jumped back to the night before.

"But she's no harlot, not her," Frank admitted with the shake of his head. "She raises many a baby-maker 'round here, but she's one to keep to herself."

Joseph found wickedness in their discussion; his silence puzzled Frank. "You've a family, Mr. Twyne?"

Evelina and Georgianna crossed his thoughts. "A father. My mother's deceased." He rose abruptly. "Grateful for the coffee, Frank. Now I must be off."

Joseph turned toward the cliffs. They loomed like towering sentinels in the brilliant light. He walked a mile before setting his easel up on the shore. The sea was calm. A tugboat pulled a barge through the shimmering water. In the distance, red sails billowed in the wind. He thought, "So, she's no harlot. Afraid Frank's a birdmouth."

Dover was a thicket of peace. For five hours he moved along the water-side, capturing its serenity. Walker's Pub sat a block from the shoreline. He went there for codfish and ale, sat for a while then worked his way back to the Red Cock. A note awaited him beneath the door. Hastily he read it.

> I've tonight off if you'd
> like to come to my place for
> supper I'd welcome you. I'm
> at 6 Grosse Pointe Road. Mine
> is the green door on the top
> floor. Seven's a good hour.
>
> T.R.

Pleasure streaked through him. He stored his equipment, then went down the hall for a bath. Someone was ahead of him and he stood outside to await his turn. Eventually, a towering man with shaggy eyebrows emerged. Joseph was halfway through the door when the man turned back to glance at him. "Sor'ee, sire. Tho't for a minit I know'd you." He then turned and went on.

It had been a disconcerting moment. Hurriedly Joseph went in and closed the door. The stranger's face had seemed fleetingly familiar. He

shrugged him out of his mind, bathed, went back to his room and pulled out the sailor's outfit.

He was about to knock at Trilby's green door when he heard laughter inside. Disappointment wavered through him. She wasn't alone. He knocked on the door, and it opened instantly. Trilby stood there smiling, her hair fallen to her shoulders and clad in a thin blue peignoir. "Welcome, Mr. Twyne. You're early." Her speech slurred from grog.

His eyes searched the room. "Your note said seven."

"Makes no difference, Mr. Twyne. Come right in and have a seat. And would you like a grog?"

Another standoff. He could have downed a whole keg. "For sure I would." He glanced at the partially opened door to her bedroom, then looked around. The place was small but tidy. He had expected green walls to match the door, but they were blue. There was a green couch, however, and four chairs and a chest of drawers. The scattering of pictures on the wall added color and a sense of domesticity. The oak floor was carpetless and polished to a high gleam.

From a pitcher of grog, Trilby filled a mug and set it before him. He saw then that she was barefoot. "There, sailor, and there's plenty more. It's time to rid myself of a bad week." She touched her mug to his then took a hefty swallow. The airy shift of her personality puzzled him. "Camilia. Come meet Nat Twyne."

She appeared in the doorway, the color of a peach, raven-haired, nearly six feet tall—and stark naked. Joseph sat speechless. Trilby and Camilia broke into laughter. "'Twas all a joke. Nat Twyne—all a joke." Half-heartedly he began laughing himself. Camilia went back into the room and returned in a scarlet robe. "Camilia's my best friend, and she's on her way to Paris." She filled their mugs. "Now we drink to the sailor boy."

Sole was for supper, but they never got to it. After four more grogs a sweet numbness overtook Joseph. But within the numbness he was blissfully aware of being stripped of his sailor's outfit; of fingers gently stroking; of his flesh being gently touched by other flesh—beneath and upon him.

And the blissful moments kept moving; missing nothing as they wavered him into honeyed exhaustion.

He slept through the next day. When Trilby served him at the Red Cock that evening she acted as though he were a stranger. "And what will you have for supper, sir?"

"You," he answered with a smile.

"Roast beef's at its best. I've the cook's word. sir."

"Roast beef."

"Grog?"

"Nope. Had my fill of it last night, thank you."

He had finished his meal and was getting up to leave. "The green door's to open at ten." She had spoken quickly and softly. Then she left.

Camilia had gone off to Paris and Lord Nelson's bed gone unused. The green door opened at ten. He entered hastily, put his lips to hers and before long he was drifting into ecstasy. Afterward they lay beside one another, he with his eyes closed and she with her face snuggled into his neck. He pulled her closer. "A sweet angel, you are—but a strange one. Tell me, Trilby, what's your honest thoughts about me?"

"Mixed feelings. A nice one you are but a bit of a liar, I'm afraid."

"And what's the meanin' of that?"

"I have a notion you know what I mean."

"Come—explain yourself."

"Don't think your name's Nat Twyne, and I doubt you was ever a sailor."

"You've good reason for sayin' such a thing?"

"Makes no difference to me. You must have your reasons." He lay quiet for a few moments stroking her shoulder. "My name's Joseph Turner. I'm no sailor, but a painter. Have been for most of my life. No mystery to it. Just wanted to get away from London, and my name for a spell. No more to it than that."

After a long silence she asked, "Would you be knowing a gent by the name of Pilkertan, or something like that?"

"Pilkertan. Can't say that I do. Why?"

"He's here to put his wife in the hospital for daffs outside Dover. He asked your name when I served him. I told him it was Twyne and he said there must be some mistake. So sure he was that he's seen you before."

"Maybe he has, but I've never heard of him." His fingers moved to her thigh. "Frank Bishop any the wiser about me?"

"Not mentioned it if he is."

He kissed the top of her head. "I'm hopin' to spend time with you in the future."

"I'd like that, but London's a long way off."

"Not so far I can't come here."

"We'll see."

"How'd you like a bigger place?"

She stared at him. "A bigger place, did you say?"

"Yes, where I could come to work now and then."

"Oh, I'm not to afford that on my pay."

"You're not to worry. I'm to take care of the costs." She lay thinking it over for a few moments. "Well, how about it?"

"'Twould be nice—I guess."

"Then I'll look around for somethin' while I'm here."

"And how long's that to be?"

"Another two weeks, I'd say."

Her breasts eased into him and he rolled her over. Ahead was a Sabbath morning, the day she set aside for rest. Rest would have to wait.

Fatigue sucked him (into the purplish smokescape. Winged reptiles streamed down belching fire. A gargoyle tumbling through the maelstrom dissolved into a pale mask, which wrinkled slowly into his mother's tortured face. Claws dug into her shoulders, carried her off into darkness. Hundreds of naked lunatics stood on Islington's roof, beckoning.)

"No. No. I'm not crazy!" Piteously his howl cut through the night.

"Joseph. Joseph."

He sprang up. Gently she pushed him back to his pillow. "You've just had a bad dream."

He lay breathing heavily. "Indeed I have."

"Something getting at you?"

"'Twas nothing."

"Bad dreams are to be talked about. They keep coming back if you don't." She drew closer to him. "Tell me about your dream. I would like to help."

"Thanks. Better not to talk about it."

"But I want so much to help."

"I'll come to forget it."

She sighed. "Alright, but mind telling me who it is that thinks you're crazy?"

The question had pierced him like a shot. "Why'd you ask that?"

"It was something you said in your sleep."

"I'm not to talk about it anymore."

"As you wish, Joseph, but you're to remember—I'll help if you'll only let me." With her head on his chest and his thoughts on Islington they awaited dawn in silence. So much he would have liked to share his anguish. But his dreams were not just dreams anymore. Furthermore, she was still a stranger of sorts, a sensuous one, but streaked with uncertainty. Burdened with disparate moods, she seemed to have come to him through the haziness of fog. Now, in so little time, she was offering an attentive heart.

She had found his proposal an invitation to a questionable future. But the scent of romance—so rare in Dover—would triumph. Joseph extended his visit another week. Three days before his departure he found a place to his liking with a view of the sea. It had once been a leather shop and was four times the size of her quarters. She was to fix it up as she wished. He asked only that a wall be removed between two rooms to make more space for his work. A fireplace was to be built, and he selected stone from a quarry. A green door, they agreed, would be appropriate. He contributed the funds she would need to carry out the plans. Now the time had come for him to depart.

Morning sun dazzled the cliffs when they went to the carriage station. She touched him as he was about to board. "I'll be here waiting."

"You'll not have to wait long."

"And you're not to give in to those bad dreams."

He kissed her. "No more bad dreams, Trilby."

"I hope not, Joseph. They've got wicked claws."

"I'll remember." Gently, her concern had moved him beyond the pleasure of her bed. They kissed. He took his seat and she went to stand beneath the shade of a tree. A sliver of wind stirred her hair, rippled her skirt into the curvature of her thighs. His hunger was building as the carriage lurched forward, and his eyes stayed on her until the conveyance reached a bend in the road. She watched until he disappeared into the glare of sun. Its heat was shimmering the cliffs when he turned for a final look. She was back there in the tranquil expanse, and suddenly he was damning himself for not spending one more night. "Trilby Redd?" He spoke her name as though it was a question mark. Indeed she posed a question. So deftly she had removed that veil of anonymity that he'd brought with him to Dover; so quickly destroyed the meaning of that sailor's outfit he had purposely left behind.

Joseph reached home knowing, more than ever, that Sarah Danby was gone from his life. Trilby Redd had made that more bearable. Inwardly he acknowledged the vast difference that lay between Trilby's earthiness and Sarah's womanly manners. Yet the difference made little difference. Trilby meant freedom. Departing the carriage he stepped out into a downpour and entered the door soaked to the skin.

William helped pull off his coat. "Ah, Billy, you're wet as a trout."

"And smelling like one. The Empire's to be praised for its rain. I'm in need of some hot suds." He kicked off his boots and tossed them against the wall. "How does life go with you, Daddy?"

"Fit as can be. How was Dover?"

"'Twas fine. Better than I expected." After shedding everything except his long underwear he went to the kitchen to brew tea. He shoveled coal into the stove. The flames darkened, sputtered and blazed upward. Smoke and fire erupted. Something catastrophic had touched his imagination. William broke the trance. "I'll be in the gallery. Rehangin' a few paintin's."

Joseph found a letter from Farington on the table, a reminder that the Academy was preparing the catalogue for the spring showings and it hinted at his lateness in posting his entries. "Sheep dung!"

After putting on dry clothes he went to his gallery and, after four hours, finished the painting he had started before leaving for Dover. The canvas had been transformed into a snowstorm that thrashed the mountains. Plundering natives fought over a captive woman. War booty was piled high in the foreground. Hannibal's army was caught up in the hostility of the mountain and its people. "It's like Carthage before it fell to pieces. Could have been Britain," he mumbled. The decision was made. *Hannibal Crossing the Alps* would be one entry.

William nodded his approval. "I'm hoping you'll show *Frosty Morning* as well."

"Why so?"

"It's most worthy. What's more, it'll take a whack at that Fuseli fellow. Maybe he'll stop callin' landscape painters map-makers."

Joseph chuckled. "It's his right to think as he likes. He's no worry to me. But I'm to consider your suggestion." He then went to take a hard look at *Frosty Morning*. It depicted a bitter Yorkshire winter day with hedgers and ditchers working the frosted fields. Mud thawed. Weeds and naked trees were coated with rime. Behind a rose-colored mist the sun was rising. A small girl stood beside a man in a frock coat. A few yards away were two horses hitched to a cart.

He went back to William. "Okay, Daddy, I'm to agree with you. Your choice is a good one. Why do you like it so much?"

"The mood strikes me, and that little girl standing there shivering touches my heart so."

Joseph blanched. He wanted so much to say, "She's your little grand-daughter, Daddy. And her name's Evelina." That was the truth of *Frosty Morning*, but a truth he couldn't bring himself to divulge.

CHAPTER TWENTY-SEVEN

The following day he took his entries to the Academy. A letter awaited him there and he ripped it open:

> Dear Joseph,
> You'll be surprised to hear from me.
> It's such a long time since we saw
> each other. I tried writing you at
> the address you gave me but got no
> answer. So I'm trying the Academy.
> I'm in a snare I'd like talking to
> you about it. Can't say much, and
> you'll know why once we're together.
> Hope that's possible. Like to see you
> for old time's sake. Living at the
> bottom of Dock Street on the second
> floor. The number's 23. Rap three
> times, wait, then rap three more times.
> That's about all since I'm not sure
> of this getting to you. Hope you're
> fine and that we'll meet as soon
> as possible.
> Your friend, G.C.

"Gully Cooke!" In London and in trouble. The business with Thomas Lawrence would have to wait. He hurried out, got into a fly and headed toward Dock Street.

The area he came to had seen better times; Gully wasn't living in paradise. The number 23 was hardly discernible under layers of coal dust, and the street and sidewalk swarmed with downtrodden people, litter and garbage. The wooden stairs creaked as Joseph climbed to the second

landing. He knocked three times, waited, knocked three more times. Silence. He started down the stairs then turned back and repeated the code.

"Yeh—who's there?"

"It's me, Joseph."

The door creaked open. Gully, with a thick red beard was smiling broadly. "Joseph!"

"Gully! I'd never known you with that bush on your face?"

"Had it a bit over four years now."

"Well, I wouldn't lie and say it's becomin'."

"Don't fancy it myself, but I've come to feel it's necessary." With his nub he motioned toward two wooden boxes. "Have a seat. Not much to sit on, but they're sturdy."

"Good a'nough." As they sat down Joseph glanced around the small windowless room. There was a mattress on the floor, a battered chest, a small stove and an old table, that was all.

"Well, Gully, fill me in. You still a tar in that miserable navy?"

Gully's eyes dropped. "Nope, Joseph. I'm a deserter."

"A deserter?"

"Yep, that's why I'm in hidin'. Surely they're lookin' for me, and I no longer answer to the name of Gully Cooke. Around here they call me Glover Cotman."

"Ah, it's a rotten mess you're in." He was silent for a few moments, thinking. 'I've friends in high places now, Gully, and I'll try to get them to help. You're not to worry."

"'Twould be a blessing if you could."

"I will. How long ago did you desert?"

"About six months after we met on the *Victory*."

"Why not come to live with Daddy and me, Gully? It's terrible seein' you holed up here by yourself."

"That's good of you, Joseph, but I've a young lady who keeps me company. A fine one she is, and I'd like to make her my wife, but there's my name to clear first. She's to have the name of Cooke, not a fake one like Cotman."

"Where's she now?"

"Out selling flowers."

"And you, how are you makin' a livin'?"

"Selling sketches and drawings when I can. Little of that to do in these parts." He paused. "Allison and me have a six-year-old we named for you. Can't afford to keep him right now, but we aim to get him back when we get married."

"It's a real honor, havin' him named for me. Where's he now?"

"In an orphanage outside London. Allison's folks made her give him up until we're married."

They sat in silence for several minutes, their thoughts swimming in uncertainty. The reunion was suddenly all anguish. Gully finally broke the silence. "You've got so much fame now, Joseph. Tell me—how does it feel?"

"Wouldn't call it fame, Gully. More'n often its trouble with the bloody critics taking picks on me." He sighed. "Glad you're back workin' at sketchin' and watercolors."

"Hardly afford the materials. But you still haven't told me how it feels."

"Don't know, Gully. Never think about it."

"Well, it's a long way from Covent Garden. Lots of old memories from then."

"Good and bad. Sometimes I wonder which outweighs the other." Footsteps were on the stairs. Joseph stiffened.

Gully got up. "It's Allison." The misshapen black dress, uncomely as it was, failed to alter her attractiveness. Her face was sharply chiseled, and her blue eyes sparkled like jewels, a mop of reddish-brown hair fell to her shoulders, and the color in her cheeks matched the roses she carried. Joseph stood smiling.

"Allison, this is my best friend, Joseph."

"Happy to meet you, Allison."

"Ah, yes, Glover's talked so much about you. Seems I already know you."

Gully chuckled. "You see, even with you she's calling me Glover."

Allison flushed with embarrassment. "Oh, I'm sorry."

"No need to explain, Allison. Gully's told me everything."

She sat the bucket on the floor. "You'll have to excuse the place. We're to fix it up as soon as possible."

"Looks fine to me." He picked up his hat. "I've an appointment, but I'm to see you both very soon." He turned to Gully. "And I'm lookin' to see my namesake."

"To be sure we'll arrange that, Joseph."

"I'm not to let you forget." He left, being careful not to linger at the threshold. That door, opened too long, meant terror to Gully.

Farington! He had close ties with the highest office of the Royal Navy. Joseph hurried to his office and spilled out the situation. Farington responded rather coldly. "We've got to face it, Joseph. The fellow's an outright deserter, and he's due punishment."

"My God, don't you understand? He was press-ganged by a bunch of cutthroats. Are you to pass up the fact that he's already served Britain to his fullest—even lost his hand for it. He's my best friend and he's shed his blood and I'm askin' your help to keep him from sheddin' more. I've never asked such a favor of you before, Farington, and it's not time to let me down. I've come for your help. Are you givin' it to me? My friend's suffered a'nough!"

Slowly, Farington lit his pipe and blew smoke into the air. "I'll do what I can, but I make no promises. You're to remember, Joseph, men in power are quite adept at making deserters pay dearly."

"I know, I know, but truth should move them to understandin'." Joseph eased off. "For sure your efforts will be appreciated. I'm most thankful to you."

At the week's end, he arrived at Dock Street with enough paintbrushes, canvases and other supplies to keep Gully Cooke at work for a year. The following Tuesday, he brought good news. Gully was to be honorably discharged from the navy—and with a medal for valiant service to the Crown. His years of living underground were over.

By June, Allison and Gully had become man and wife, then with the help of Joseph, taken three rooms just off Harley Street. The pounds Joseph presented as a wedding gift outnumbered those Gully had possessed during his lifetime.

On a Sabbath morning, with all the arrangements made, the Cookes were en route to the orphanage to fetch their child. Joseph rode with them.

As they approached the tree-lined drive leading to the main building, Allison spoke of the woman who shouldered her son's welfare for the past six years. "Kind and good she is, and full of understanding."

"Sounds as though he's been in good hands."

"Very good indeed," Allison replied.

As the carriage moved up the drive Joseph's eyes roamed over the stately mansion and the green lawns. "A handsome piece of property."

They left the carriage at the front entrance and were greeted by a small, kindly woman with gray hair. "We have been expecting you, Mrs. Cooke. Do come in."

"Thank you, Mrs. Lindsay. You met my husband, Gully. This is Mr. Turner, our son's godfather."

"You have a fine godchild, Mr. Turner."

Joseph replied with a polite bow.

Mrs. Lindsay took them to an anteroom just outside the main parlor. "The children are at lunch, but they should be finished shortly. You can either remain here or accompany me to Joseph's quarters. His belongings are all packed and he will return there for them."

Anxiety was taking over Allison. "We will go with you."

Sensing the intimacy and the importance of the approaching event, Joseph declined. "I'd best wait here and look around, if you've no objections."

"Oh, you're welcome to do so, Mr. Turner. We're rather proud of our home."

Joseph drifted into the parlor. It was cozily furnished and handsomely carpeted. A highly polished banister circled upward along a staircase. Several paintings hung on the walls, and he moved closer to observe them. They were relatively small, and by artists he'd never heard of. The largest of them hung over the fireplace. Nicely framed and bold in color it pulled him forward. He glanced up at it and gasped. His own unsigned oil painting of Margate's Harbor looked down at him. His thoughts rushed back to Georgianna's abduction.

"Pardon me. May I be of some help?" Softly the offer had come from a woman descending the stairwell.

Turning he glanced up to her, and she so resembled Katherine Forsyth that he was tempted to call out her name. "No thank you. I'm just waiting' for someone."

She came closer. "Joseph—Joseph?"

Quickly he swung about. The voice, the smile sent tremors through him, canceling all doubt. "Katherine!"

"Joseph, this is indeed a surprise. What on earth brings you here?" While his insides tossed and turned she appeared not to suffer one moment of anxiety. "I've come with Mr. and Mrs. Cooke for their child. They're good friends of mine. And might I ask what brings you here?"

"Why, I'm here every day of my life. I founded this home shortly after my husband's passing."

He forced calmness into his voice. "And how have you been, Katherine?"

"Oh, I have had my ups and downs, but I'm happy, healthy and attempting to age gracefully."

"I see no sign of agin'."

She laughed softly. "Then, Joseph, I fear for your eyesight."

"You're not to. It's quite fine."

A stillness fell between them for a few moments. Their thoughts had come together, flowing with the same unmentionable memories. Glancing up at the painting she broke the silence. "You seemed so absorbed in that picture a few moments ago. I hope you admire it as much as we do here at the shelter. Of course, the subject matter must be familiar to you."

"Yes—yes. It is indeed."

"Oh, so much I wish I knew the artist, but he prefers to remain anonymous. It was a gift to us, and quite a generous one."

"It's a very worthwhile thing you're doing here."

"I'm pleased that you think so. Homeless children are society's worst evil."

"Yes, of course." He was remembering Margate now, and all that went with it; realizing, too, that it must have been through her intervention that Georgianna had been rescued.

"So you have come with the Cookes to take little Joseph from us. Such a dear boy. We will miss him."

"I've yet to meet him, and I'm lookin' forward to it."

"You have a treat in store." A short silence fell between them. "You have reached such heights, Joseph, and you are to be congratulated. I attended one of your showings at the Academy, and like so many others I find myself overwhelmed by your accomplishments."

"Thank you, but it wasn't my luck to see you there."

She laughed softly. "You passed right by me, appearing to be in quite a huff about something. You just gave me a quick glance and stormed off in another direction."

His brow wrinkled. "It's so, I'm sure, but hard to believe. Do you remember the year?"

"Not exactly, but I remember *The Holy Family* and *Calais*. I loved both of them."

"So strange that I didn't see you."

His thoughts were moving even deeper into that cove above Margate's harbor; into the broken promise; into those unread letters, and the pain of her rejection.

"Your brother, Reginald. He's still at Margate?"

"Oh yes, and he mentioned having dined with you once up in Yorkshire."

"He told me about your mother's passin', and I was sorry to hear of it." He wanted to cut away the nice words; to cry out his hurt. Did she know Reginald had made him aware of her mother's deception. It mattered little now. Surely she wouldn't know that the man who lied to save her from the gallows was standing before her. These thoughts and others were rubbing against one another in his memory.

Youthful laughter suddenly erupted from a hallway. Lunch was over and Joseph turned to the children streaming through the front entrance to the lawn.

"There goes my wonderful family, Joseph."

"Is the Cooke child amongst them?"

"No. He was sent to meet his parents. The dear boy has been packed and ready since sunup. Now, if you will pardon me, I must go to him before he leaves." She started off, then turned back. "It has been wonderful seeing you

after so long. There are so many things I would like to say, Joseph, but . . . " She was silent for a moment. "But perhaps we'll meet again." What she said seemed like a faint promise.

Ten minutes later, Joseph's namesake came into the room with his parents, Mrs. Lindsay and Katherine. At six, he was a delightful mixture of his mother and father: Gully's plumpness, Allison's blue eyes and red hair. Joseph stepped forward to speak to him, but he was beaten to the punch. "Aha, you're my uncle Joseph and you look the same as I'm told you'd look." He took Joseph's hand and shook it vigorously.

"And you, Master Joseph, look as I expected."

"And how would that be?"

"Why, the handsomest lad in all of England."

"Thank you, sir. I'm happy not to disappoint you."

Katherine's entire "family" was gathered outside, waiting. And one by one, each stepped forward to say farewell. Katherine and Mrs. Lindsay wiped away tears. The younger Joseph seemed to be intermixed with wistfulness and anxiety. Katherine embraced him as they were about to step into the carriage. "You are to be sure and visit us when you have the chance, Joseph. Is that a promise?"

"It's a promise, ma'am." The chorus of goodbyes rained on him, drowning out the gentler one that Katherine spoke to Joseph.

The interior of the carriage carrying them toward London was full of joy. But a moment arrived when Gully turned to look at Joseph closely. "Criminy, what's eatin' at you? You look like you've seen a ghost."

Joseph smiled pensively. "A ghost, yes—and one I once held in my arms."

"I don't understand."

"Better we forget it, Gully."

"As you wish." He patted Joseph's knee. "Thanks, my friend."

Joseph accepted the gesture for what it was meant. Gully and his family looked toward the tranquility of home.

They had been settled in for less than a week when two men came to their door. "You're Gullison Cooke?" the taller one asked.

"Yes, I'm known as Gully. What is it you want?" Allison stepped to his side.

"Was your mother's name Rachel Cooke?"

"That's right."

The other man took a sheaf of papers from his pocket. "We have some important business with you. Could we come in for a talk?"

They entered and the four of them sat down. "What's all this about?" Gully asked.

The taller one spoke again. "According to the Crown's records of wills and properties, your mother left a house to you near the waterfront, and it's of interest to my firm. I'm Mr. Glasgow and this is Mr. Hunt, and we represent Hartford's Pickle Works. They're extending their factory. Your house would lend itself to that purpose and they would like to purchase it."

Both Gully and Allison churned with surprise. She spoke up. "Oh, we've known of your needs, but we've no plans for selling it."

"But it's been empty for years, Mr. Cooke. It's just sitting there going to rot."

"My husband's making his own plans for it."

"We're making a handsome offer."

Gully spoke, "Put your offer in writing so our lawyer can study it."

"Fine, Mr. Cooke. The papers will be in your hands before the week's out."

Gully stood pleasantly shocked after the two men left. "I just can't believe all this."

"Never did you tell me you owned property, Gully."

"Never did I know it myself."

The written offer came two days later. The lawyer Gully consulted handled the matter with astute shrewdness and signed his name—J.M.W. Turner. The price the Pickle Works offered had been doubled, but it was accepted.

Shortly after, Allison's Flower Shop on Maiden Lane opened in Covent Garden. One flight up, Gully bolstered his family's upkeep by selling drawings and watercolors. Rachel Cooke, long since under her tombstone, had left him a most welcome gift.

The shop opened at nine on a beautiful spring morning. Two hours later a gentleman came and bought two huge baskets of roses. Allison helped him

into his carriage and after he had settled into his seat, the hansom began its long journey to Margate's Shelter For Homeless Children.

Katherine entered the parlor as Mrs. Lindsay was arranging the flowers. "My, how lovely they are. And who are we to thank for them?"

Mrs. Lindsay shook her head. "I don't know. The man who brought them would only say that they were sent by a friend. Probably just an act of charity."

Katherine stood in puzzlement for a few moments. Then, feeling Mrs. Lindsay was right, she asked no more questions and retired to her bedroom.

CHAPTER TWENTY-EIGHT

In mid-July Joseph was working his way toward Fawkes at Farnley Hall. This time he traveled by horse over the hills into upper Wharfedale and on to Richmond. Miserably wet from a heavy downpour, he was crossing the soaked heaths and peat bogs outside of Appleby when his animal suddenly sank in up to its haunches. As it thrashed about, Joseph flung his belongings to the high point of the bog. Jumping, he fell short of its mark and landed in a hole of muck. A thunderbolt struck. Lightning flashed. Joseph grasped a firm section of the heath and pulled himself out of the hole, then grabbed the animal's reins and began coaxing it forward. Twice it seemed to regain its footing only to fall back into the mire. The rain came harder. Another thundering flash filled the animal with such terror it leapt out of the muddy slough. An hour passed before the rain stopped and the wind quieted. It took Joseph thirty minutes to gather his belongings, and then nine hours to reach Appleby, only eleven miles away.

The wildness surrounding Wensleydale, Swaledale, Aysgarth, Askrigg and Hardrow filled his sketchbooks when he reached Fawkes' place in mid-August. Shooting on the moors had just begun, and among the guests was Fawkes's youngest brother Britt. Thirty-five, quiet of nature, he, too, secretly hated the family's sport of slaughtering birds. With concealed anguish he participated in order not to upset things. He was an inveterate sleepwalker. One night in mountainous country he had walked to the edge of a steep cliff before the groundskeeper turned him back. Another ten feet and he might have plunged to his death. Curiously, Britt didn't remember one step of that walk. Now his room held a key to be found before he could leave it.

As guns sounded in the distance, Joseph and Britt fished in a small boat at a nearby lake. "Lots of boomin' goin' on out there," Joseph said.

"They never tire of it." Britt laughed softly. "The family's a bit sour on me for being such a poor shot."

"Looks like your curse and mine's the same."

The wind blew hot as the moors filled with hunters the next morning. Joseph was munching on a hunk of bread. Britt, with his gun hanging loosely in his hand, moved toward the shooting area. "Sketch well, Joseph."

"Good hunting, Britt."

Britt grinned. "Poor hunting, you mean. Remember our curse?"

Two hours passed. Joseph had planted himself on the ragged edge of the moor. Within the great expanse before him the hunters were reduced to the size of insects—aiming skyward with smoke-puffs mushrooming above their gun barrels. Then, abruptly, the firing stopped and they were closing in on one spot. "Somethin's happened." He hurried toward the confusion with a sense of dread dominating his thoughts. Reaching the outer tent he found his fears justified. Britt Fawkes lay motionless with blood streaming from his head.

"Good Lord! What's happened?"

"It was an accident," someone answered.

Two days later, Britt died. Whenever the cause was questioned the answer was consistent. "An accident—just an accident." The answer was never to Joseph's satisfaction. He was inclined to suspect suicide. For the first time, shooting on the moors at Farnley Hall ended early. Joseph returned to London in despair. That night, death visited his dreams, sat on his bed, dressed for hunting with a gun in its hand. Little by little the eyes of Britt looked out of its hostile eyes and circled the room like slow turning wheels.

He found the letter that came two weeks later to the point and offensively short.

> September 20, 1816
> Joseph, I thought you should know that Evelina is now
> married to Mr. Joseph Dupuis who is in service of the consular.
> Sarah Danby

"Ah, so my child has grown up." It struck him that now Georgianna was also approaching young womanhood, and that he was being left out of

their upbringing because of their mother's hostility. "The money I've sent for them leaves her cold." He was right; her feeling for him had hardened even more. She had written of Evelina's marriage out of courtesy. He admitted to fatherly neglect, but only to himself. "Should have kept in touch with them in spite of her stubbornness. Anybody sayin' I don't love my children can be hanged. No need to shout it to the entire bloody universe. Should I have fouled up my life for a woman who refused to understand me?" This question to himself lingered long after he had gone to bed.

A dinner invitation from Farington brought him to the Academy two evenings later. When they met at the entrance, Joseph sensed a mild anxiety stirring inside his host. "A friend of mine will be joining us." Thin conversation, mostly about the weather, carried them to a table set for three. "And who's your other guest?" Joseph asked as they took their seats.

Without answering, Farington stood up. The other guest had arrived and was approaching the table. "Don't think the two of you have met."

"No we haven't," Joseph replied as he stood to shake John Constable's hand.

"I've looked forward to this meeting, Turner."

"With pleasure, I hope."

"Indeed so."

"It's my pleasure as well. Farington's always good for a little surprise."

Constable smiled. "Yes, I'm to agree with you."

Farington, having achieved his goal, smiled as well. "Am I to assume the role of a saint or sinner?"

"You're suited for the latter without doubt." Joseph's reply, given with a touch of humor, held a sting nevertheless.

"In any case, I have established a coup."

"Acknowledged," Joseph quipped.

Two of Britain's most prominent rivals sat within inches of each other for the first time. Aesthetically, they couldn't have been further apart. One, all voluptuous flowers, handsome trees and fine shrubbery—the other all storms, avalanches, battering seas and hypnotic suns. Farington, keenly

aware of the vast gulf, and their culinary tastes, had ordered oyster bisque, Dover sole and a good French wine.

After a spoonful of soup, Joseph put a rather malicious inquiry to Constable. "How's your friend, Beaumont?"

Constable, with deliberation, swallowed two spoons of his soup. "Quite well, as far as I know. Haven't seen him lately."

Joseph smiled. "Probably off buildin' more fire for my arse."

Constable countered with a weak smile. "A fine man."

"You've reason for thinkin' so. He's all praise for you."

Sir George Beaumont was suddenly endangering the sociability of the evening. Farington twisted the conversation to the talents of Claude and Poussin—for whom both artists expressed admiration. Over the sole, Rembrandt was mentioned by Farington. Constable was all praise.

"The man can't be denied his genius," Joseph remarked, "but I found several things at the Louvre lackin'." A moment of silence came to the table. "Yet, I give him praise."

After plum pudding, coffee and cognac and a few observations about England's war aims, the three parted. The meeting might have been less pleasant. Beaumont, Constable's foremost admirer, had mounted another vicious attack on Joseph two months before. With sales at his gallery declining, he wasn't in a mood for criticism. Nevertheless, the two rivals had parted without signs of animosity. Constable's former remarks about Joseph's style had been completely ignored.

In a letter to his Maria Bicknell, his betrothed, Constable wrote: "Sat next to Turner at dinner. I was a good deal entertained with him. I always expected to find in him what I did—he is uncouth, but has a wonderful range of mind."

The fire Farington might have expected to erupt had failed to take flame. Meanwhile, Joseph had spoken his thoughts about Beaumont. "More and more I very much like what he finds to dislike about me." For the moment *Hannibal Crossing the Alps* held Sir George at bay. Praise for it had been unanimous.

CHAPTER TWENTY-NINE

Months passed. Trilby Redd finally had their place in order. "And I'm hoping you'll like your space to work," she wrote. "It faces the sea, and with plenty of light. The bedroom's cozy and full of wild flowers." No doubt it was her one complaint that hurried him off to book passage for Dover. "Without you, the bed's too wide and cold."

He reached there on a chilly Sabbath morning in October a little after ten. It was Trilby's day off and she had been waiting since dawn. The door opened to a reunion, and very shortly her complaints about the bed were meaningless. Later she showed off the parlor that would also be used as a kitchen. Before the hearth was a settee and two comfortable chairs. She motioned toward a table beneath the window. "I've two chairs for it, but they're late in coming." The walls had been left bare—except for a cluster of nude drawings of her by Joseph. He didn't like the red frames, but he said he did.

"And what do you make of the carpet. It's secondhand, but the man who sold it to me claims it's from Persia. I've no trust in him."

Joseph gave it a quick glance. "Pretty a'nough I'd say. Not to worry. It's only meant for walking on." Trilby's big moment arrived when she opened the door to the workshop. She had made it extravagantly simple. Her present for him, an ancient easel made in Sicily, stood in the center of the room. There was an ornate chest for his materials, a lounge, a tall stool and two chairs beside an oak table. In the window facing the sea was a large copper vessel overflowing with wildflowers.

He smiled broadly. "It's just right, Trilby."

"Hope you're not joshing me."

He kissed her cheek. "I'm pleased to the gills. You'd know if I wasn't. There's nothin' I'd change. Not one stick." She fell into his arms and they returned to the bedroom. When night fell she was still in his arms.

With Trilby at the Red Cock, the days belonged to work. The white cliffs were at their best, changing moods with every shift of the sun. The sea roared. Waves pounding the rocks were music to his ears, and with the evenings came Trilby. Dover was serenity to the sea's edge. Plans for returning to London by the month's end were pushed aside. He worked on—and loved on.

With the success of *Hannibal,* he was again searching out historical themes. Strangely, in the quiet days of meditation, ruin and disaster roamed his thoughts, even though he was ensconced in the most peaceful of villages. He experimented by painting with crudely whittled sticks and the wrong ends of paintbrushes. Even his thumbnails were put to work. He avoided reading the newspapers and Trilby's return each day brought pleasure. Devoted to his needs in both the kitchen and the bedroom, she kept him well fed and well loved. He was at peace with himself for the first time in years.

When, after two months, it was time for him to depart, he left as he had come, on a Sabbath morning with his blood running warm. The arrangement was a good one, one he could manage on his own terms. Its beginning, which seemed to have come from nowhere, now seemed endless.

All that Sarah Danby left unsaid in her curt letter would not have pleased him. It did, however, encourage him to ask for a visit with Georgianna. Their meeting was reluctantly arranged by Sarah at her home. Awkwardly, Georgianna embraced him at the door where she met him alone, smiling, grown nearly to his height—a dimpled, attractive girl. They went to sit on a couch in the parlor.

Ineptly, he began: "I'm sorry not to have seen you for so long, Georgianna."

She smiled. "I love you no less for that, Father."

He relaxed. She had remained faithful in spite of his errantry. "And how have you been?"

"Fine, Father, and you?"

"Oh, very well. And are you findin' school more to your likin'?"

"I'm doing well in what I like best."

"And what's that?"

"Art and music. Those are the studies I like best and I'm not to fool myself. I know what I want."

"You come by all both things in a natural way, Georgianna. And your friends. Do you have many?"

"A few. Not a lot, but those I have are nice—although they say I annoy them, sometime."

"And why, might I ask?"

She laughed. "Oh silly things, like my not liking things they like. But when I tell them that sometimes I don't like myself, they look at me as if I've gone daft. They can't understand how I can find fault with myself."

Touching her shoulder he said, "Your father's more pleased than you'll ever know."

"Mother will be glad to know that."

"And how is your mother?"

"Fine. She sang at a concert last week, and such a beautiful voice she has."

"You're right—and your mother is a beautiful person."

"I think so." She paused, gazing at the floor. "Why are the two of you not together anymore?"

He gave her question several moments of thought, then bowed to the truth. "Because, Georgianna, your father behaved badly." Her next question spared him of further explanation. "Would you like some tea and cookies, Father?"

"Ah, I surely would." It was a superior moment. His thirteen-year-old daughter was about to make tea for him.

Before leaving for the kitchen, she picked up a large red leather-bound book and placed it on his lap. "Mother helped me put this together. I hope you like it."

He opened it, and the title page left him speechless.

MY FATHER, JOSEPH TURNER,
ENGLAND'S FAMOUS PAINTER

On the next page, his self-portrait, done years before at Margate, stared at him. He stared back, remembering. Slowly his fingers turned the pages to

newspaper reproductions of his work. Clippings, speaking both glory and dissent, were all there. He was profoundly struck, and suddenly awash with guilt. This lovely child whom he was hiding from the world, was proudly celebrating his existence.

With tea and ginger cookies Georgianna returned to a father filled with pride and remorse who, with a burst of enthusiasm, got to his feet and put his arms around her. "This is a remarkable scrapbook, Georgianna."

"Mother calls it your history book."

"It matters little. Tell her I'm touched to the depths by it."

"I'm so glad you like it, Father." After filling his cup she went to the kitchen and came back with a large dill pickle and a glass of hot chocolate.

He glanced at the shocking combination and smiled. "So your sister is married."

"And with a new baby."

He stiffened. "A baby?"

"Yes. Didn't you know?"

"First I've heard of it. Boy or girl?"

"A girl named for mother." She bit into the pickle. "Sorry to say, but I don't like Evelina's husband."

"Oh? And why not?'

"He's bossy to her and keeps a frown on his face. I don't think you'd like him either."

"Too bad. And how does your mother feel about him?"

"I don't know, but she has little to say to him. They're to live in some foreign place where they're going by boat."

"We must hope for the best."

During their final hour together he raptured over the virtues of his daughter's sketches, and especially the poetry she had written. "You're to keep up your excellent work, Georgianna." He kissed her cheek. "Now your father must be on his way, but we're to have another visit very soon."

"I do hope so, Father."

He met Sarah several yards from her front doorway just as he was leaving. Politely she said, "Good afternoon, Joseph. I hope you enjoyed your visit with Georgianna."

"Indeed I did. She's a wonderful child and I'm most thankful to you for seeing. . . ." She managed a quick smile then, without another word, moved toward the doorway. He had wanted to say much more, but she had not allowed that. The disappointments he had fostered were lodged too deeply in her memory.

Evening had fallen, and he went to bed with his daughters uppermost in his thoughts. Georgianna's drawings had shown promise, but her poetry, he thought was "bloody well good." It was a gift providence had denied him. A poem of his published by the Academy drew the Athenaeum's ridicule. "He must have written it during a strong fit of insanity." Now, poetry seemed to be boiling in Georgianna's blood.

Evelina's face floated through his solitude. "Sarah might have told me I was a grandfather. Don't even know the whereabouts of her and the child."

The foreign place Georgianna had mentioned was Kumasi, the capital of Ashanti in western Africa, where Joseph Dupuis had been appointed a consul. The boat was the H.M.S. *Yorktown*, and at the moment it was riding out a storm off the coast of Madeira. Both Evelina and the baby were seriously ill. Meanwhile Dupuis was having a glass of port with the boat's captain. The wine, it seemed, had given him supernatural resistance to the rough sea.

The twenty-third of April was wet and overcast, much the same as it had been forty-four years before when Joseph was born. In the noise and smoke of Nolan's Ale House, he sat alone in a dark corner, his thoughts diverted to the truth of middle age. The instincts of youth were fading. He gazed at his stovepipe hat on the table. It sat before him with a need of brushing, adding to the gloom that hovered around him like a scarf of darkness. His thoughts were drifting back through the shadowy distance: to his mother in that icy room at Bethlehem; to Gully and his murdered father at the charnel house; to Tom Girtin's final moments. After two more grogs he left the alehouse and walked slowly through the drizzle toward Queen Anne Street, feeling that he had sounded the depths.

"Happy birthday, Billy." William greeted him with a wide smile.

"Thanks, Daddy. What's waiting for supper?"

"Goose. And a nice one it is for the occasion. You won't celebrate forty-five anymore."

"You're a year ahead, Daddy. The number's forty-four."

"Ah, to be sure I'm mistaken."

"Matters little. Just a few moons' difference."

"Don't want to rob you of any time. We need all we can put our hands on."

The goose turned out to be much better than Joseph expected. Finished, he was clearing the table and William was preparing the dishwater. "Your Mum's to be praised for showin' me how to cook."

"You learned well, Daddy. I'm dead tired. Have to turn in early."

"Have a good night's sleep, son."

By midnight, Joseph had fallen into a deep sleep. (It was one o'clock, maybe two, or possibly even three when the soft knock came upon his door. He tumbled out of bed—or at least he thought he had—to see a shaft of light striking the door as he opened it. He expected William but instead there appeared the figure of a small woman veiled in black from the top of her head to her feet.

"Yes?" he muttered in amazement. "What do you want?"

A tiny wrinkled hand emerged from under the veil handed a small box to him. "It is for your birthday. The master has passed on and he wanted this left in your keeping."

He took the box then watched her walk away, not into the hallway. All beyond her was a blue sky arrayed with the brightest of stars.

"Who are you? What's in the box?"

No answer came. She had suddenly dissolved, melted into the blue sky. Puzzled, he went to light a candle, then lifted the lid to stare at skeletal bones of a hand lying neatly in place. He blew out the candle and went back to bed after placing the box on his night table. A voice jerked him up from the sheets. "Go as you choose to go, Joseph! Don't turn back!" He looked about the room. There was no one. After going back to sleep he

awoke—at least he thought he did—and looked to where he had placed the box. It was gone. He looked toward the door. There were no stars, no sky. Only the door stared at him. Suddenly he felt like a fool standing in his flannel nightshirt with an unlit candle in his hand. A dream within a dream.)

He was beginning to feel that his dreams had meaning. None came. He did think of Hikkon; of Orion's sword hanging out there somewhere in the sky, and of that star at the bottom of the blade that was suppose to spread his presence.

He thoughts were still with the dream as he entered the Academy the next morning. George Jones walked over to him and handed him a page from a letter. "Thought you'd find this interesting, Joseph. It's from Thomas Lawrence in Rome."

A smile crept across Joseph's face as he read: "The subtle harmony of this atmosphere wraps everything in its own sweetness. It can only be rendered, according to my belief, by the beauty of Turner's tones. He should come to Rome. Looking at this country I always think of his paintings, less often of Claude, still less of Poussin."

Joseph handed the page back. "Thank you, George. Sir Thomas lends me some mighty kind words."

Italy, suddenly the uppermost thing on his mind, stayed with him throughout the day; went to bed with him and was still there when he awoke. William could only stare at him for a few seconds when he abruptly announced, "Daddy, I'm thinkin' about a trip to Italy."

"Italy? Why so sudden, Billy?"

"Not so sudden. Had an itch to go for years. There's a whiteness in its light that I've got to bring myself to understand."

"If you're feelin' so strong about it then you should go. Nothin' here to keep you from it."

Trilby Redd suddenly crossed his mind. Months had passed and a longing had set in. The choices were his and he weighed them against each other. It took Rome only a few moments to emerge victorious. Trilby would have to wait.

CHAPTER THIRTY

Thickly fielded with olive groves, Italy unfolded before Joseph during August's punishing heat. By coach he had taken the malle-post road to Chambéry, gone over Mont Cenis to Turin, Milan, Verona and Lake Como. He came at last to Venice, a sprawling complex of stone edifices built within a lagoon laced together by sparkling canals. The sun stopped him. Here, more than ever before, it toyed with his imagination, intrigued him, dazzled him with the light and color that had resisted his palette for so long. The Giudecca, the Dogana, the Church of Santa Maria della Salute, the Campanile of San Marco, the gondolas plying the Grand Canal, all seemed to float in the misty beauty of a rare jewel.

He awoke in a euphoric state each morning, then hurried off to work. Soon the magnificence of the city was entering his sketchbooks, but the sun remained silent; it never divulged its secrets, just burned down and said nothing. Still he lingered in Venice for several weeks, searching for those baffling things that nourished its brilliance. They were as illusory as shadows on water. Eventually he went on, working his way through Bologna, Rimini and then, finally, to Rome. October had arrived and the heat had fled.

Francis Chantrey, a fellow academician, had set up quarters for him in the Via Margutta, the artist's colony where he worked. After looking over the place he offered Chantrey his thanks. "You've done well by me."

Chantrey smiled. "Now I can glance over your shoulder."

A most sensitive spot had been touched. "Not much to see, I'm afraid."

He spent the first day gazing into the wonders of the Sistine Chapel, then the Holy City opened up to him—every nook, cranny, street, piazza, church and moldering ruin. Vesuvius erupted for him, and he hurried to Pompeii to acknowledge its generosity. Great art treasures that Napoleon's long wars had deprived him of were awaiting him. Notes about the drawings of Dürer, and paintings by Titian, Correggio and Claude filled the pockets

of his coat. A trip to Carrara brought the only disappointment. "All I got out of it was a miserable sketch and a bottle of sour wine."

His final week was spent sketching statues in the Vatican Museum. "My journeys here are not over," he told Chantrey before leaving. "You're to hold on to these quarters for me. I'll come again and soon. My time here's been too short."

"And when are you taking off?"

"Tomorrow. I've business in London that's urgent."

"Traveling should be nice now. No heat."

"Should be. Taking the Mont Cenis route back."

"But it's January. Deep snow's sure to be clogging the pass."

"All the better for good sketchin' I'd say."

Chantry gave it a final try. "Forget Mont Cenis, Joseph. It's suicidal this time of year."

"You've been a great help, Chantrey."

Chantrey sighed. "Indeed you're a stubborn one."

The pass was choked with snow and the regular coach service refused to attempt it. Despite warnings, Joseph and three other travelers with urgent business hired another coach, drawn by two horses. If danger was ahead, it concealed itself. At the bottom of the mountain from where they set out only a few white clouds drifted the blue sky. Sun baked the countryside, streaked through trees rising in the distance; it appeared that they couldn't have chosen a better day for the journey.

They were an unlikely mixture. Penelope Collis, small, stern, pinch-faced, sharp-tongued and fully gray, ran the Horticulture Society in London. She climbed aboard wrapped in a wool coat, wearing riding boots and carry-ing a large fur muff. Vladimir Chesnokov, a short, chubby Russian, was a poet. Bedford Wallingford, an impressive looking man who introduced himself with a "Sir" attached to his name, was well over six feet, with an athletic bounce, a ruddy complexion and a voice as sharply clipped as his moustache. Once they were settled in he spoke to Joseph. "Marvelous day for our trip."

After a moment of silence Joseph replied, "Looks that way."

"Are you making a visit to London?"

"Live in London. And you?"

"You might call me a citizen of the universe who resides wherever he happens to land. I'm in the wild game business. Just back from a hunt in Africa and Persia."

"Rather risky business."

"Not really. If one's a good shot and stays alert danger is relative—even enjoyable at times."

"What sort of animals do you go after?"

"The whole lot—elephants, lions, tigers, whatever appears in my gun sight. They're all fair game."

Penelope Collis spoke up. "I'm one to believe that animals have a right to live peacefully and should not be destroyed."

Wallingford glanced at her lap. "Your fur muff hardly bears out your belief, madam."

"I didn't shoot it. My husband bought it. And I might say that he is very aware of my feelings."

Wallingford smiled and stroked his moustache. "But you're wearing it, madam. Wouldn't that amount to aiding and abetting the situation?"

"You have made your point, sir, and I stand partially guilty—but with the same conviction."

Wallingford eyed the Russian. "Mr. Chesnokov do you have any views on the subject in question?"

"I'm afraid they would be of little consequence. My immediate concern is Cenis pass." He pointed upward. "Storm clouds are gathering ahead of us."

Wallingford patted Chesnokov's knee. "Not to worry. I can assure you we will make it safely. I've traveled this route more times than I can remember." He turned to Penelope. "Madam, does pipe smoke offend you?"

"Not at all. Go right ahead."

The sky was darkening and Joseph took out a pad and began sketching.

"Ah," Wallingford quipped, "I see you dabble in art."

"A bit," Joseph replied and kept on working.

When pipe smoke began filling the coach Mrs. Collis lowered her

window and allowed it to escape. In the hour of silence that followed, she dropped off to sleep. Wallingford's thoughts seemed to be with wild beasts. Chesnokov was scribbling at poetry and Joseph was filling a sketch pad with storm clouds. Suddenly, the coach rumbled to a stop. They were at a way station where a man stood with two horses; they were less than an hour's ride from the top of the pass. The driver jumped down and the two men hitched the two fresh horses to the coach's tongue and ahead of the other two.

Wallingford stuck his head out of the window. "How do things look up there?"

"We'll see when we reach there," the driver answered.

"Not much of an answer," Wallingford hollered back.

"It's the best I can give you, sir." He snapped the whip and the coach moved upward.

A mile farther, on the sky darkened even more, and several minutes later snow whirled in behind a powerful gust of wind. Wallingford, having stopped smoking, sniffed at the air. "Seems to be getting a bit colder," he said with a half smile. Chesnokov's eyes, along with Joseph's were glued to the fury that began sweeping down toward them.

"A real turn for the worse," Wallingford remarked.

"A glorious sight," Joseph answered as he sketched.

Wallingford frowned "Glorious?" He had failed to see anything glorious about the storm blowing in.

Mrs. Collis awoke just as the stagecoach approached the summit. "My, my, we seem to be in a blizzard," she said quite calmly.

"Considerably worse." Wallingford had become annoyed with the sudden change of weather. The horses were straining now toward the last upward pull with ice forming on their backs and vapor rushing from their nostrils. Suddenly they were at the top and all beneath them was a valley of hard blowing snow. Even worse weather awaited their descent, and cautiously the driver reigned the horses to a slow walk as they started downward.

Joseph scanned the turbulence, eagerly sketching. Chesnokov, alert and apprehensive, sat forward in his seat. Penelope Collis seemed to be enjoying the spectacle. Wallingford was oppressively quiet.

Then real trouble came. The two lead horses slipped and fell to their knees and quickly the other two fell behind them. The coach slid forward, twisted sideways then flipped over onto its side. Penelope and Chesnokov landed atop Joseph and Wallingford. "God, what a bloody mess!" Wallingford shouted. "What a bloody mess!"

Soon the distraught driver came to their aid, and with great difficulty helped them disentangle themselves, then one by one they managed to climb through the window of the overturned coach. Their baggage, which had been roped to the rear, was strewn all over the pass. The horses were in a hopeless struggle to get to their feet; one would almost make it up only to be pulled back down by the weight of the others.

"What a bloody mess!"

"Could have been worse," Joseph said.

"I fail to see how!" Wallingford's fury heightened.

"We'll make it down. Nobody seems any worse off except the poor animals," Joseph said.

"Best they be shot!" Wallingford shouted.

"Penelope raised her voice at him. "You seem to be for shooting every animal on earth. Is there no sense of pity in you?"

Refusing her an answer, Wallingford turned on the driver. "Well, what's to happen now? Are we to stand here and freeze to death?"

"Nothin' to do but walk the rest of the way. The horses are done for, I'm afraid."

"Best we start down," Joseph suggested. "Madam, are you up to it?"

"There's hardly a choice. Come on, gentlemen. Let's get going!"

Joseph turned to Chesnokov. "Are you alright?"

"Astoundingly cold, but alright nevertheless!"

Wallingford, hanging back, seemed to be in a state of bewilderment. Joseph glanced at him. "You comin' with us?"

"No, I'm not. I'm to take shelter in that bloody coach until this wretched storm blows out." He then hurried toward it as the driver went off for help. Looking back, Joseph saw Wallingford's huge frame sinking through the coach window, while the horses lay kicking up snow. "Come on. Let's go. The great white hunter's seekin' safety."

On the way down, Penelope pulled a flask of brandy from her fur muff. "Have a swallow, gentlemen," she said after taking a large one herself. They did as she suggested. By the time they reached Lanslebourg an hour later the flask was empty. There, Joseph bargained with a young man to go up and retrieve their luggage, then they sat down in an inn to have coffee. Penelope suddenly began laughing.

"Well," Joseph asked, "what strikes your funny bone?"

She laughed even harder before stopping. "It's that windbag, Sir Bedford Wallingford, cringing up there like a trapped animal." She laughed again. "Well, the tigers and lions can roam safely tonight." She laughed then until tears ran from her eyes. Atop Mont Cenis, Sir Bedford lay shivering, listening to the snarling wind. Joseph smiled at Penelope gently. "Madam, you should have left him your fur muff." Even Chesnokov managed a slight smile. They had relaxed into a moment of silence when Penelope's saw the headline on the newspaper a man was reading. "Good Lord," she said, "the King is dead."

Joseph had grown weary of his absence from Trilby Redd. Shortly after his
return he set out for Dover. His letter to her, giving the time of his arrival,
never reached her. The coach that bore it had been hijacked by two gunmen
who robbed the passengers and then left them stranded in the countryside.
Trilby, just in from work, opened the door to his knock then stood for a
moment staring at him as though he were a ghost.

"Well," he said, "it's me. Am I not to be welcomed?"

The smile that came to her face was labored and late; the embrace more
like an obligation. "Oh, it's just that I'm so surprised. I didn't know you
were coming."

"Sent a letter. You never got it?"

"No. I got nothing." They devoted a few seconds to kissing. "You're to
be awful hungry after such a long trip."

"I'm starved."

She pulled away quickly. "Then I'm to hurry off and get something before
everything shuts up. There's hardly a thing for supper. Now you're to sit and
rest yourself till I get back." Before he could say anything she was out the door.

He had kicked off his boots and sat down with a mug of grog when he
saw the page of a letter staring at him from a shelf to his right. He stared
back at it, turned away, looked back to it then picked it up. The first line
sent his thoughts raging: "Dear Trilby, I long for you and your bed." The
rest of it shot him over the edge. "It's been more than three months now
and Wales is wet and lonely. I buried the wife and finally settled things here
and I'll be in Dover on August 13th around eight o'clock. I've my room at
the Red Cock, but I'll just place my bags and hurry off to you. Can't wait to
hold you in my arms. With love, your Pilk."

It was August 13 and close to six o'clock.

"Well, I'll be a pig's arse. The wench. The bitch. The ungrateful
whore!" He flung the page to the floor and began walking aimlessly

about the room. Anger rose even higher. He picked the letter up and went to tack it on the door. She could face it when she returned. Then he stormed into the kitchen to find that she had lied. The larder was crammed with food. "The wench's gone to head him off—this Pilk, or ever who he is."

He was right. Trilby was, at that moment, scribbling a note to her lover, telling him that she couldn't possibly see him until she came to work the next day. "I'll explain everything to you then," the note said. She placed the note in an envelope, addressed it to Lance Pilkington, sealed it and had a boy deliver it to the Red Cock.

The taste of salt was in Joseph's mouth when he drifted into the bedroom and glanced at the bed—the bed this fellow Pilk was missing so much—this very bed he himself had paid for. He grabbed a vase of wild-flowers and hurled it against the wall, breaking it into a myriad of pieces. The contents in his workroom seemed undisturbed, but two of the intruder's pipes lay on a dish by the hearth, and they hit a wall as well. He was a man betrayed. "The wench. The filthy bloody wench!" He was kicking her out, and right away. The burden of any explanation awaited her on the door. He jerked open a closet door. A frame he had carved by hand was still there waiting to be polished.

A half hour had passed when he heard the sound of her key in the lock—a long silence; a mournful cry; groceries dropping; and then terrible sobbing. He remained seated, calmly waiting in his workroom for her to enter. She never came. Instead she ran to the bedroom and flung herself across the bed, sobbing even more.

After a few minutes he went to find her there, lying face down in a pillow wet with tears. "You're a bitch. I'm a fool for lettin' you take me in. Your blubberin's no good to my ear. And I'm forever done with you. Now you can go screw your Pilk. Spend the rest of your days with him. I'm off to London tomorrow and when I get back here I'm expectin' to see you and your belongin's gone. Do you hear? Gone!" He turned to leave.

"Joseph." The softness of her voice stopped him. "I've no excuse to offer. It's, it's, well—it's that you stayed away so long and I found myself so lonely at times. I'm sorry, truly sorry."

Her tears only increased his anger. "I want you out of here when I get back."

"Won't you let me make supper for you?"

"Nope. I'm to eat supper where I can enjoy it. Good night." With sorrow streaming through her, she lay sobbing as the door slammed and departed.

He chose the Red Cock to abate his hunger. Frank Bishop greeted him cheerfully. "Didn't know you was back, Mr. Twyne."

"Just passin' through and stopped in for supper."

"Sorry Trilby's not here to greet you. She's gone for the night. Sure she'd like to have seen you."

So he wasn't aware of their relationship. At least she'd kept her mouth shut about that. "How's business?"

"A good season for me. Lots of people comin' in." He motioned for a waitress. "This is Bessie. She'll take good care of you." He winked. "The sole's at its best right now. Know it's your favorite." A tall man entered the dining room and Frank turned way to greet him. "Ah, It's good to have you back, Mr. Pilkington."

Pilkington! Joseph's head snapped around at the sound of the name.

Reading a note, he frowned as he answered. "Glad to be back."

Pilk—Pilk—Pilkington. This was him and indeed he looked familiar. Somewhere, someplace he had seen him before. Suddenly it struck like a thunderbolt—the big shaggy-eyed Flintshireman and his mad wife during that stormy trip through Wales between Merthr and Aberdare. Twenty-odd years had gone by. It was him for sure, sitting only a few feet away, and probably reading a message from Trilby Redd. So he was the man who had been warming her bed. He had an urge to let him feel the rage boiling inside him; to curse him for his intrusion, then just as quickly he decided against that. Keeping his back to him he finished supper and left.

He spent the night on a pallet in his workroom. Sleep came hard. Just yards away the voluptuous patron of his carnal pleasure lay weeping, but any such feeling for her had vanished. He got up early the next morning. She was still asleep when he left, at least he assumed she was. The groceries were still there where she had dropped them. He kicked a loaf of bread then slammed the door, shutting it to her forever.

The weather had grown bad as he approached the carriage station. He raised his umbrella as rain swept in. Soon Pilkington would be lying with her—an ungainly epilogue to the tryst he had contrived for himself. "Just another wench—another blasted wench." The fisherman he was passing looked toward him. "Speakin' to me, sir?" Joseph hurried on without answering. It was a bottomless morning.

By summer, he had buried Trilby Redd in his past. Rarely did she enter his thoughts now. With the help of a carpenter and a mason he was rebuilding his gallery. Social functions at the Academy had heightened; foremost of these was the King's annual birthday dinner. Perhaps it was pure happenstance that he found himself seated next to Constable for the feast, but Joseph held Farington in suspect. Together they stood to toast the new sovereign, George IV.

Later, as they were leaving the building, Joseph made an observation. "Afraid His Highness is in for some serious trouble. Seems Caroline's back from kickin' up her heels. Now she's claimin' her place as Queen."

Constable smiled. "She is his rightful wife. Hard to ignore that."

"Well, royalty's about to take a peep into its sacred closets. Should be interestin'."

Joseph was right. Having dragged himself downward, George wasn't exactly awash in popularity. Caroline, on the other hand, was flouncing about London in garish clothes and outlandish makeup, gathering appeal. Charm clung to her. Her admirers cheered and encouraged her wherever she appeared. In a show of support, some demanded that Londoners light up their houses in her cause. Windows left dark were smashed.

George's ministers had prepared a bill that would deprive her of all pretensions as Queen Consort. The trial became a spectacle. Somber, long-faced peers sat in judgment. The defendant, wearing a black wig, sat most of the time fingering her ringlets, appearing bored by the bizarre testimony aimed toward her. Questions and answers let the Empire in on some juicy repartee:

"Her Highness appeared at the ball in Geneva as Venus."

"Can you describe her attire?"

"She was naked from the waist up."

"You, sir, were present at another reception in question at Baden. Was there any exceptional thing about her Royal Highness's actions there?"

"Nothing extraordinary. She did, for some reason or another, wear a pumpkin on her head."

"Could the defense offer reason for this?"

"Very simply, sir, her Highness was trying to keep cool."

"Now, you say you were present on this pilgrimage to the Holy Land. Can you describe her Royal Highness's entrance?"

"She entered astride a bony ass."

On and on it went, splitting England into Kingites and Queenites, even with hints of a revolution. But grounds for divorce lay in her intimacy with a Mr. Bartolomo Bergami. The handsome gentleman had quickly risen from courier to chamberlain in Caroline's entourage, and the two had shared a tent on the deck of the vessel that took them to the Holy Land.

Clever questioning became the rapier for the Queen's counselors. They befuddled the witnesses and made their testimony appear unreliable. And though most of the Lords held no doubt about the truth of their words, they bowed to the gravity that attended a royal divorce. The bill was dropped and Caroline was vindicated, but she was in for sad music. On coronation day, her charms evaporated as public opinion sweetened for the King. Uninvited to the ceremony, she demanded entry, but was barred. Her supporters suddenly turned on her. "Go back to Como!" they shouted as she rode away.

Those voices were still snarling inside her when death took her three weeks later. George IV, aboard the royal yacht when he got the word, sighed and downed a glass of port. "He seemed affected but not afflicted," was the way one courtier put it.

The fears of those who thought that cultural advancement under George would suffer went unfounded. Soon after claiming the throne, he presented his father's library of sixty-five thousand volumes to the British Museum for the use of scholars. He then goaded Parliament into voting sixty thousand

pounds to purchase thirty-eight paintings from the collection of John Julius Angerstein, the prominent London connoisseur. "The King's put his words on the altar," Joseph commented to George Jones.

"We shall see. For the moment he's given some merit to his blustering."

The King's actions left Constable cold. The Angerstein collection especially galled him. "It contains mostly Europeans and favors old art. This tends to suffocate all original feeling at its birth."

Evelina had returned to London with her husband after a year in Ashanti, and Georgianna arranged for she and Joseph to lunch together. Evelina had emerged a full-blown woman—not as tall as Joseph might have expected, but endowed with good looks and a sparkling personality. After initial pleasantries, he began bombarding her with questions about her husband.

"He's a good enough person, but with faults that I can't ignore."

"Well, come, come. Tell me about his faults."

"It's not that simple, Father. He wouldn't consider himself to be at fault." She paused. "I admire his intelligence but I find him terribly self-centered. I've tried tolerating it, but it's hard, very hard."

"Well, give me an example, child, something more definite."

"If you don't mind, Father, I would like to eat first."

"If you say. If you say." They ate boiled beef, potatoes and cabbage. Only the plum pudding had escaped boiling. "And how's your child? Must be pretty big by now."

She dropped her fork. "Sarah is dead, Father. Didn't you know?"

"Dead! No, I didn't know, child, and so sorry I am to hear of it. How'd that come about?"

"We were in Cape Coast during those dreadful rains and the three of us came down with a malaria fever. Hospitals were filled and there were hardly any doctors. The woman who worked for us took sick and died. Sarah and I were left alone. She died on the sixth day."

"Did you say that you and the child were alone?"

"Yes."

"Where was this husband of yours?"

"He had taken to sea on a boat, where he hoped to recover."

"Out to sea? Out to sea, and left the two of you alone? What sort of a beast is this husband of yours?"

"He thought he was doing what was best, Father."

"The best? Yes, for himself the best. Decency keeps me from calling him what I think he is."

She spoke quietly, calmly. "Father there are other people here. You should lower your voice."

"I'm sorry child, but I'm all afire." His face had gone red, and hard as stone. "Out to sea to recover, leavin' a sick wife and child to look out for themselves. He is a beast."

"He is my husband, Father. You must remember that."

"Husband or no husband, he's a beast.

"And me, thinking all along I was a grandfather."

"Not to worry, Father. You will be soon. I'm expecting again. Haven't you noticed?"

"Just figured you looked a little healthy." He shook his head. "Ah, another child with that man. Sorry but your father's not altogether happy about it."

They had finished eating when she asked, "Would you like to hear more about Joseph?"

"His name's the same as mine?" Defiantly he bit into his lip. "No, there's no need to talk of him. What I know already is a'nough."

They stood on the corner for a moment before parting. "And when are you expecting?"

"In November, if the doctor is right."

"Do you have a name for her picked out?"

"It might be a boy, Father. If so would you like to suggest a name?"

"Not offhand. Call him Nicodemus, Henry, Horse Fly—anything but Joseph."

They laughed. She presented her cheek and he kissed it. Then quickly they said goodbye. He had only taken a few steps when she called out to him. "Father."

He turned back. "Yes, my dear."

"Please. You are not to judge my husband too harshly. Promise?"

He looked at her for a few seconds, thinking. What was he to do, congratulate him? Absolve him? Never. "I promise," he answered. His thoughts shouted, "Kill the scoundrel!" Joseph Dupuis would be kept at arm's length.

A year had gone by. With Trilby gone, the house in Dover stood empty. Done with it and its bad memories, Joseph had decided to return and put it up for sale. It was half past three on a December afternoon when he arrived by stagecoach. Dover was cloudy, cold and without charm for him anymore. He would put the place in the hands of an agent and get out as quickly as possible.

In the dreariness, his house appeared forlorn as he approached it. It needed paint, especially that green door. Three windowpanes were broken and grass was growing tall. He stood for several moments, regretting having bought it, regretting having ever known Trilby Redd. A stray dog trotting by stopped, lifted a leg and urinated on a dead tree in the yard. He watched it trot off, feeling as though he himself had been treated as the tree had been. He took a key from his pocket, thrust it into the rusty lock and opened the door.

The odor of disuse struck him as his eyes slowly adjusted to the darkness. When he tried rolling up a window shade it showered him with dust and fell to the floor. He walked to the center of the room and gazed through the dimness. Dust blanketed the furniture, walls and floor. It looked as though a hundred years had gone by since anyone had inhabited the place. He went first to the bedroom. It too was dark, and he pushed back a dusty drape for more light. That bed they had so passionately warmed was missing two legs and slumped to the floor with a crumpled sheet at its foot. Dry stems of wildflowers lay strewn about. Suddenly a purr spun him about. He turned to see two eyes staring at him. It was a huge black cat with four kittens at its side. Three more cats darted into the shadows as he approached his workroom. He entered and astonishment seized him. The odor of burning wood hovered in the air. Quickly he turned to see a small flame flickering in the fireplace; then he heard a groan. Someone lay on the floor in the darkness. He reached for a poker and held it ready. "Who are you?"

Another groan answered him. As the wood flamed brighter he saw a body move beneath a blanket. Cautiously he touched a leg with his foot. "Who are you? Answer. Who are you?" He stood awestruck as a balding head with wisps of hair slowly rose from beneath the blanket. Then a pale, toothless face with sunken eyes lifted toward him. The intruder appeared helpless and he dropped the poker. "Who are you? This is my house and I want to know."

The eyes widened with tears leaking from them. "Joseph, it's me, Trilby."

For several terrible moments he stood staring at her. "Trilby! Trilby. My God, what's happened to you?"

"I'm awfully sick—awfully sick."

"What are you doin' here? Why aren't you in a hospital?"

"No longer could I pay for my bed and keep . . . nor could they do any more for me. I came back here . . . it was the only place left to me."

Very slowly, the anger he felt toward her began slipping away. "Well—I suppose you did what was right. Anybody helpin' you, feedin' you?"

"Mrs. Bradford . . . lives down the block. She looks in on me and brings a bite to eat."

"What's causin' your illness?"

"Nobody knows . . . just started falling apart all of a sudden . . . losing weight . . . hair and teeth all gone."

"Well—I'm sendin' you back to the hospital where you'll get food and care. I'll pay for everything."

"It's good of you, Joseph. But I'm not asking for that."

"You're to go to the hospital."

The fire flared. The flames were consuming the picture frame he had made. She looked toward the flames. "Sorry I am for that, Joseph. It was cold and there was nothin' left to burn."

"Just a frame." He rubbed at his nose. "Maybe a good doctor from London can find what's ailin' you."

"No use for that, Joseph. I've not long to live . . . I don't want to live."

She was resigned and he knew it. They took her away three hours later. He stayed on to sleep in his workroom on a mattress.

Four days later she died. He gave her a decent burial but only Mrs. Bradford stood with him at the grave.

What, he wondered, had happened to Pilkington? Frank Bishop told him over coffee at the Red Cock. "The dog laid up with Trilby until she got sick. Then he steals my wife and runs off to Wales."

"Ah, the blackguard. I'm sorry for you, Frank."

"It's him to be pitied. 'Twas riddance of rubbish."

After putting the place up for sale Joseph packed up and left. His checkered days at Dover, so fruitful with pleasure and disaster, were finished. He was leaving them behind now, and to him it was like plunging into clean air.

Book Three

CHAPTER THIRTY-TWO

Nine years had elapsed, and Joseph's pencils and brushes kept busy. Hundreds of sketches, watercolors and oils stood for his efforts. Paris, Rouen, Dieppe, Holland, the Rhine and Belgium, the coasts of England, the Meuse, the Moselle, Brittany and the Loire had all been recorded; and his rightful place in the Empire's most important exhibitions had been assured.

Six years earlier he had painted *The Battle of Trafalgar*. Gully's painful account of the fury was infused into every brushstroke. George IV had commissioned it, but two years had passed without its having been paid for. With all due respect for the royal neglect, he had demanded his fee. Another three years went by before he received 500 guineas and the last installment of 25 pounds.

Meanwhile, Fawkes had died, and Joseph had been so deeply grieved that he never visited Farnley Hall again.

Rome was beckoning once more. He had hoped to be there by mid-July, but William became ill a week before he was to depart. He waited ten more days until color returned to William's face. Still feeble, he urged Joseph on. "You're not to git into a stew about me, Billy. Be on your way. I'm fit as can be."

"No hurry, Daddy. Charlie Eastlake's still putting together a place for me to work."

"Sounds good to—" A coughing spell stopped him and he put a rag to his mouth. It was flecked with blood. Hastily, he thrust it into his pocket, walked sprightly to the kitchen and drank a cup of water.

That night Joseph packed for Italy.

Eastlake greeted him in the Piazza Mignanelli on the second Sunday of October. "Welcome to Rome, Joseph. It's been waiting for your return."

"Thank ya, Charles. 'twas a long journey. My bones need restin' and I'm feelin' like a dried turnip."

They climbed to the second landing, where Charles had arranged for Joseph's studio, and entered a spacious room with a high ceiling and two large windows. An oversized easel, a comfortable chair, two wooden stools, a maple table, a cypress chest and a comfortable bed. Joseph smiled. "Couldn't have done better myself. Only thing missin' is a good woman."

"You were just complaining about being tired."

"The right woman can make you forget that."

"Settle for a good Italian meal?"

"I'd go to sleep at the table. Eatin'll have to wait." Five minutes later, with his bags unpacked, he fell across the bed.

In the weeks to follow, Rome became a Utopia nudging him to a boldness he had never experienced. The color there seemed more than ordinary color. Mediterranean light still awed him, and lent his watercolors a shimmering brilliance akin to that of his oils. Within two months he had begun ten paintings and finished three, which he exhibited in the Piazza Mignanelli. Romans came in droves to see *Regulus*, *Orvieto* and *The Visions of Medea*.

His second visit to the Holy City so overwhelmed him that he loathed leaving. "Nobody's pushing you out," Eastlake told him. "Give it another month or two. Why rush back to London's turmoil?"

"I've somethin' there that's worryin' me."

"Then go have a talk with your problem, but come back. Rome will be waiting."

"I'll do that," Joseph promised as they parted.

His return to London was once again by Mont Cenis—and once again during the month of January. Again his coach foundered in a snowdrift, but after his last experience, Mont Cenis this time seemed just a trifling hill. It was William's health that was worrying him.

He found his father in fair shape. He wanted to hang his Rome paintings in the Academy's spring showing, but time prevented that. Immediately, he finished *Ulysses Deriding Polyphemus*. William studied it for a few minutes. "It'll be hard to beat that one, Billy. So far it's your best, take my word for it."

"Glad you like it, Daddy."

"Not sure I know all the history behind it."

"I'll explain it later. I've an appointment at the Academy."

William took a more discerning look when he was alone. Polyphemus was stretched out on the top of a mountain crag. Ulysses sailed forth on a boat. Having assumed the tragic posture of Prometheus, he looked to be defying his tormentor, Ulysses, rather than being derided by him. It made little difference. As far as William was concerned, Billy had completed his most imaginative painting. The *London Times* confirmed his opinion after the Academy opening. "Without doubt *Ulysses* is the most outstanding work of his entire career."

Joseph had returned in time to vote on Constable's full membership in the Academy. A rumor had floated about that he opposed it, but it was his deciding vote that gave his rival the honor. When they met at Constable's induction, Joseph shook his hand warmly, "Welcome, Constable. You're now a full-fledged R.A."

"Thank you, Turner. I'm most appreciative, and I hope to live up to the Academy's fine tradition." Nothing more was said. If any hostility existed between them it seemed to have vanished.

The contentment that came in Rome quickly vanished when William took to his bed again. Dr. Monro's report was bad. "Your father's not responding to treatment and he's growing steadily worse. I'm sorry to say I've small hopes for his recovery." He gave Joseph a pat on the shoulder. "He's eighty-five, you know. Lived a good long life."

In the glow of a single candle, William lay wasting away. At his bedside Joseph watched him in his labored sleep. Memories flooded back—boating on the Thames; strolls through Covent Garden; the first drawings on the wig shop walls—those terrible moments when his mother's insanity plagued him. Life without him was hard to imagine. He was turning to leave, when William opened his eyes. "Ah, it's you, Billy."

"How're you feelin', Daddy?"

"Not good as I'd like. Stomach's burnin' like fire."

"Take your medicine?"

"Does no good."

"How about some barley soup?"

"Appetite's gone. I've no taste for anything."

"It'll give you strength."

"Not now, Billy—not now." He howled suddenly, bolted upward. Pain had knifed his chest and snapped his eyes shut. The shrunken cheeks, sallow skin and beak nose gave him the look of a stricken bird. Joseph stood helpless.

"Wish I could ease the pain, Daddy."

William spoke feebly. "We've had some good years together, Billy. You've been a fine son. I'm rewarded by livin' long a'nough to see you so successful." He smiled weakly. "Keep after that sun, Billy. You'll catch up to it. I'll—" A spasm of coughing stopped him.

A tear rolled down Joseph's cheek. "Whatever I've done came through your faith in me, Daddy. Nobody could have wished for a better father. I'm blessed to be your son."

William's eyes closed. "Billy . . . I'm . . . tired . . . awful tired." He was drifting into sleep. Joseph had heard death in his voice, seen it in his eyes. For the second time in his life he offered a prayer.

He slept very little that night. When he went to William the following morning he found him frightfully still. The mouth was agape and one eye was open. "Daddy?" He touched him. The flesh was cold.

> In the vault
> beneath and near this place
> are deposited the remains of
> William Turner,
> many years an inhabitant of this parish,
> who died September 21st, 1830.
> To his memory and of his wife,
> Mary Ann,
> Their son, J.M.W. Turner, R.A.,
> has placed this tablet.

So read the epitaph. William and Mary lay now beside one another outside St. Paul's Church in Covent Garden.

Misery moved in with Joseph, met him in every room. Finally he bundled up William's belongings and stored them in the basement. Only his pair of steel-rimmed spectacles were left on a shelf in the parlor. Shortly after, his grief heightened when word came that Thomas Lawrence had died. The Academy was without a president. It was a bad time.

A letter arrived from Lord Egremont inviting him to his estate at Petworth. The estate, despite its Italian Renaissance treasures, old masters and statuary, was more like a sprawling inn than a home. But the invitation was like sunlight falling into Joseph's darkness. He admired Egremont. From past experience he knew Petworth would be swarming with aristocrats, fashionable ladies and confusion, but he was promised a studio on an upper floor that offered privacy. He could also look forward to sketching and fishing.

Four days later, after a fifty-mile journey, Joseph entered Petworth's spacious grandeur. Egremont was extremely large, extremely wealthy and a foremost patron of painting. But despite the differences in their upbringing he and Joseph shared some of the same traits; both were sloppy dressers, blunt and complex. Honesty and frankness between them seemed to have been driven in with a hammer. They felt safe with one another. Neither thought of the other as pest or gardener, and both were dedicated to art, and the exploration of womanhood. There was one slight deviation. Unlike Joseph, Egremont had once taken on a wife—but only after she had borne him six children.

Egremont's eccentricity was evident when he met Joseph with nine barking dogs at his heels. The late sun sent orange light playing through his shoulder-length hair. They embraced warmly. "Welcome to Petworth, Joseph."

"Thanks for the invitation, George."

Those few words were all that was necessary. Their embrace said everything. Two servants took Joseph's bags. Egremont motioned to a pile of luggage stacked against a wall. "About fifty guests this weekend, but they're not to bother you. You're to stay as long as you like and do what you like. Your studio's waiting and off limits to everybody. Dinner's at eight. If you'd rather eat in your quarters that will be arranged. Enjoy yourself. I intend to."

Joseph climbed two flights of stairs to his quarters, had his supper brought in and remained there for the rest of the evening. The studio was a comfortable refuge, large, well lit by huge windows and not easily accessible to other guests.

Dawn light poured in the following morning. He dressed and went downstairs. The great hallways and spacious galleries were silent but that would soon end. Alone he could view the finest collection in all of England, hung in carved rooms of white and gold and flooded with light. Fishing was on his mind. He limited his viewing to the north gallery. Reynolds, Gainsborough, Wilson, Van Dyck and Loutherbourg—all hung in grand silence. Alongside them his *Thames and Windsor Castle, The Thames at Weybridge, The Thames from Eaton College, The Thames Near Windsor, An Evening Scene, Tower in the Lake, Cattle Drinking, Men Stripping Osiers, A Sea View with a Man-of-War,* and *Echo and Narcissus.*

After a quick breakfast he went back for his fishing rod. Twenty minutes later he found a small lake and sat down to fish. The morning was all peace. Swans floated on the water. From the uplands a steep, heathered descent led to Stag Park where beyond stretched the precipitous crests of Farnhurst and Heyshott. Opposite were the south downs, with Chanctonbury Rings and wide ranges of woodlands. The heart of the enchanted Weald awaited his sketch pads.

He had just made a catch when a woman carrying a white cat stumbled up, then sat down beside him. Her body was thickset and her face was bagged and deathly pale. With a fish in his hand Joseph tipped his hat as she introduced herself. "I'm Lady Spenser. I see I'm not the only early riser in the household."

"Good morning, madam," he said dryly and continued fishing. "It looks to be a pleasant day ahead."

She squinted through bloodshot eyes. "I don't recall seeing you before. Are you a frequent visitor here?"

"It's my first visit in four years."

"Your name, might I ask?"

"Turner."

"Have you no first name?"

"Joseph—Joseph Turner."

"Joseph. I've a brother called Joseph. Haven't seen him in years, and feel no pain because of it. He's a bounder of the first order."

His hope for tranquility was dwindling. "It happens that way sometimes."

"And what may I ask is your relationship with the lord of the manor?"

"Egremont? He's both a friend and patron of mine. I happen to be a painter, of sorts."

"Well, you must be of a very good sort if he is collecting your works. He only purchases the best."

Joseph stood and cast out his line. "A very generous man."

"And without any sense of shame, I'd say."

"I'm not to comment one way or another on that. He seems happy a'nough. That's what counts."

She laughed. "He should try counting his children living under the roof with him. There are no less than forty-three, I'd guess—and none with the same mother."

"I've seen nothing of that nor do I know anything about it."

"You wouldn't. They're all kept in the background." She waggled a finger. "Oh, you'll see, if you're here long enough. Few days pass without quarrels amongst them. The scenes they make are worthy of a madhouse."

"All I've seen is happiness here, madam."

"Even the animals are happier here than in any other spot on earth." When Joseph kept his silence she got to her feet and moved off, admitting to having too much champagne at dinner the night before. He last saw her stumbling down a narrow lane toward the manor.

Lady Spenser had demeaned her host while bulging with his food and drink. "Ungrateful wench," Joseph muttered, and turned back to fishing.

Curiosity caused him to attend the gala evening dinner. He descended the stairs at eight. The spacious, candlelit dining hall was filled with flower-bedecked tables and the mirthful guests were gathering. Joseph was hungry. He was about to sit at a table near the entrance when Egremont hailed him. "You're to dine at my table, Joseph. Come this way." The table he was ushered to sat at the dead center of the others. His eyes lifted with surprise.

Lady Spenser was seated to his right. She lifted a rose from a bouquet, put it to her nose and inhaled deeply. The white cat, partly obscured by her bosom, lay peacefully on her lap.

"Good evening, madam. We meet again."

Joseph received a puzzled look.

"I don't remember meeting you, sir."

"You are Lady Spenser?"

"I am indeed, but I can't recall having met you. What is your name and where do you think we met?"

"Turner is the name, and we met while I fished at the lake this morning."

Her eyes widened and she looked at him deeply. "Ah, so it is you, the writer?"

"The painter."

"Oh yes, yes the painter. It's all coming back to me now." She took a hefty swallow of wine. "The Lord's a patron of yours."

"That is so."

"Then you must have work hanging here. Where is one to look for it?"

"In the north gallery, but don't put yourself out. My pictures are just a few of many."

"The Lord's a generous human being—and a good one I might say. A savior he's been to artists and sculptors. He tells me now of plans to purchase more work of contemporary Englishmen. What's more he's to build a special gallery for them."

"Yes, he told me about such plans." Joseph was failing to understand Lady Spenser's contradictory appraisal of her host. That same morning he had been an adulterous bastard. Tonight he was a saint. "Obviously you are close to him."

Her smile seemed to hold a hidden meaning. "There was a time when we were very, very close." The implication was enough. Joseph turned the conversation in another direction. "I don't know the others at the table. Friends of yours?"

"Not a one. The pretty one at the Lordship's side is Consuela. She arrived out of nowhere two days ago. It isn't his custom to introduce his

guests to one another. He finds it too taxing. I sometimes wonder if he knows all of them himself." She emptied her wineglass.

"Perhaps he likes people gettin' to know one another in their own way."

"Perhaps. In any case, no one seems to care." She motioned for a servant to replenish her wine, then lifted it above her head. "To his Lordship. Long may he live—and love!" Seven other glasses lifted quickly.

How plentiful the feast. Roasted grouse, pheasant, venison, lamb, even slices of whale were piled high on silver platters to satisfy the most eccentric appetites. Wine and brandy from across the Channel. Soufflés aflame with brandy finished off the orgy. Egremont and Conseula abruptly withdrew to privacy. Then, without restraint, the night turned into one befitting that of hot-bloodied Romans. Joseph observed the chaos for a while, then left for his retreat. Near the bottom of the stairwell he heard unrestrained sounds from a bedroom that brought Trilby Redd to his mind.

He kept to his quarters until late morning, hoping that everyone had recovered and surrendered to the day. At eleven o'clock he looked from his window. Far below in the distance women strolled beneath parasols. Children ran about. Dogs chased one another. Beneath a copse of elms men played at cricket. Deer grazed in the hills. He descended into the world beneath his studio to observe the carnage of the previous evening.

From a partially opened door came the sound of someone snoring. He stole a quick glance. Lady Spenser lay naked with her cat next to her breast. He went on. Drawing rooms and their occupants began entering his sketch-book. A woman lay on a couch. A man sat on the floor with his head against her thighs. In the music chamber a black-gowned woman fingered Mozart on a piano. A couple listened, or perhaps slept. Obviously none of them had gone to their beds. In the north gallery a young man at an easel painted a naked woman. In the unrestricted spirit of Petworth, guests lay on rumpled beds throughout the manor.

He came at last to a large gallery filled with the soft glow of morning. He was viewing the paintings when a shaft of sunlight suddenly blazed through the large windows. He stepped into it, feeling its warmth. Slowly, the haunting mixture of color and light was overwhelming everything it touched. Mysteriously, form was becoming secondary, unimportant. Then

the entire room was ablaze. The luminous glow of Venice was entering Petworth.

The sun, that invincible power, was speaking its language of whiteness. The sun! The unconquerable sun! He stood unmoving for an eternity, drowning in it as it charred land and sea. With a semblance of calm its challenge was still perched on his shoulders, and he trembled under its weight. Now, more than ever, he felt an eagerness to search for the mystery of its deity. From that morning on, while Petworth's guests indulged in the sweetness of living, he roamed the hills, lakes and woodlands drenched in the music of his discovery—color and light in its charring totality.

It was midday. He stopped to gaze up into the sun's core. Waves of parching heat burned into his eyes—and he shuddered in its radiance. His God was up there waiting: nothing more.

The moment had seduced him. Blind to any possible failure, he sat down on a mound of grass and began preparing his palette. White upon the palest of white slowly blended into a delicacy that mystified him. At last, with dabs of rainbow colors melted into the whiteness, his brushes went straight to the heart of the mystery, attacking the canvas with a furious rhythm. After two hours, his sun was emerging like fathoms of shimmering corridors. He worked on in the blaze of light. And as he worked, Petworth's interior drifted into his thoughts. After a blending of warmer colors he sent his sun into the room's mysterious silence. Pools of light streamed in filled with paler light. The sun had dropped beneath the horizon when he fell back, exhausted. If the miracle was born he was powerless to measure its worth. On the back of the canvas he scribbled the word "Sunburst" and put it aside.

He worked on for another month. Before leaving, he presented Egremont with a portrait of a woman—and a mischievous smile. "Her name's Jessica. She's Shylock's daughter."

"Joseph," said the Lord of Petworth, "I want a picture when you have time, but not this one."

Joseph chuckled. "Make it a gift to Lady Spenser's cat, George. It'll be delighted."

"I think better of the animal than that." Neither one liked goodbyes. With a quick handshake they ended it right there.

CHAPTER THIRTY-THREE

Had the Academy's most illustrious artist been chosen to fill the president's chair after Lawrence's death, Joseph would have been the obvious choice. His rough-hewn bearing and manner of speech, however, shoved him out of the running. Martin Shee was chosen.

"He made it with combinations and concatenations," Joseph quipped to Farington as they left the Academy. He was bitter to the core. Farington shrugged, wondering where he had dug up such a word as "concatenations." Joseph went on. "I'm to be better off because of the time and worry it takes."

"It does indeed take up one's time, and a special kind of talent is needed."

Joseph frowned. "Talent?" Seems to me that's what was considered least of all."

"Hope your disappointment has no bearing on your entries to the showing this year."

"Disappointment's your word, not mine."

"Edwin Landseer spoke at a meeting the other day and said that without exception, you're the best teacher our young artists could ever have."

The ploy worked. Joseph smiled. "I'm not to banter with him about that. I throw out honest opinions for whatever they're worth. I'm stubborn as a mule, but mules are right sometimes."

"You're not one to dip your words in honey, Joseph."

"Nope. Find it useless."

An extremely large carriage with three horses pulled up and stopped in front of them and three people left it. "Good Lord—what's that contraption?" Joseph asked.

"The new omnibus. Your first time for seeing it?"

"Afraid so."

"Carries about twenty and travels to Paddington and Islington."

"Looks like a funeral wagon."

"Progress, Joseph."

"Still looks like somethin' for haulin' the dead." They parted and Joseph headed for the law firm of Parkinson and Leach. Since William's passing, the making of a will had obsessed him. He was only fifty-five and devoting himself to staying alive, but death was on his mind. This would be his second attempt at making a will. Georgianna, Evelina, Hannah—his housekeeper—and a few others had been named. He had even put down Sarah Danby for a few pounds a year. There was also a provision to provide charity for decayed English painters, and to ensure that two of his works would be hung in the National Gallery beside the paintings of Claude. The nation was to get all of his paintings and sketches, and he was buying back important works of his that showed up on the market. English law was making it hard to leave property to charitable purposes, and he spent the afternoon with the lawyers searching for loopholes. When none could be found he proposed making his entire Queen Anne Street house into a permanent museum—the only favorable possibility left to him.

"Legalities, legalities and more legalities," he snarled as he left Parkinson's office. A street-seller in a stovepipe hat and a ragged frock coat stood at the entrance as he left the building. Covered with dog collars attached to chains, the man approached Joseph. "A collar for your best friend, mate?"

"You're in the wrong biz'ness. I've twelve cats and hate collars." He then stepped into the path of an oncoming dray. Desperately, the driver reined the horses to a stop. "Watch where you're headin', daff. You lookin' to be tromped?" Without bothering to look up Joseph lifted his finger into an obscene gesture and walked on.

Sir Walter Scott found no improvement in Joseph's mood when Joseph arrived in Scotland to deliver drawings for his book of collected poems. But then Scott could hardly feel that his attitude was entirely unjustified. In a published statement he had written: "Turner's palm is as itchy as his fingers are ingenious. He will do nothing without cash and anything for it." But knowing Joseph's drawings would puff up the sale of his books, Scott had plunged into a generous arrangement with him. The poet's remarks had poi-

soned the air and Joseph talked to him through glares and stares—and in the hard terms of pounds.

Scott was pleased with the drawings and Joseph was more than pleased with the price he had put on them. From Abbotsford he went to Glasgow, the falls of the Clyde and on to Oban and Skye. Bad weather met the steamer as it was en route to Staffa. Strong winds, a head sea and giant waves brought concern to the captain of the vessel, and he gathered the passengers into the center of the ship. "I'll leave it to the majority as to whether we attempt to make shore or wait it out."

"I'm sick as can be from this sloshing about," a woman complained. "Just how dangerous would a landing be?"

"I'd like to know that myself, madam," replied the captain.

Joseph cut in. "What's to happen otherwise?"

"We just steam around the island until it blows over." The captain scanned his twenty-five passengers. "I'd like to have you raise hands for a vote. How many want to try for land?" Only two hands went up, and both belonged to a man standing to Joseph's right. "That about settles it. We wait it out." The unhappy situation turned into a blessing for Joseph when he took out a sketch pad. Within an hour, the sun burst through an angry cloud and lit up the stormy horizon. It was midnight before the vessel made a rough entry into Tobermorey. Beneath the sketch in Joseph's pocket was scribbled "Staffa."

Reaching London late in the evening, he was weary and longing for sleep. His coach had just entered Trafalgar Square when he heard the roar of voices. He lowered his window and stuck his head out. Thousands of people were gathering. Children ran through the square brandishing flaming torches. Signs jostled the air:

KILL THE POOR LAW! UNIONIZE BRITONS! OUR CHILDREN
BEG FOR BREAD AND EDUCATION! BURN THE SWEATSHOPS!
UP WAGES FOR THE POOR!

The crowd was growing larger, surging forward. Joseph's coach was forced to a stop. A hefty middle-aged woman with hair streaming to her

shoulders mounted a ladder waving a red flag. The crowd cheered. "Annie. Annie. Annie!" When the buxom protestor tried to speak, fifty bobbies moved in and attempted to carry her away. The crowd attacked them, shouting, "Out with the coppers! Bash the lobsters! Tromp the crushers!"

The bobbies were taking a beating when soldiers streamed into the square. A burly man with a club felled one, and then ran. Two soldiers ran after him. Evading them, he disappeared into the crowd. Suddenly, Joseph's coach door was opening. He turned quickly. The hunted man fell to the floor and pulled the door shut. "Sorry, guv'nor. Those bully boys are out to do me in."

Joseph rankled with indecision. "But you're going to get me in trouble and—"

"Come on, guv'nor—I've a wife and three kids waitin' for me. Just a few minutes and I'm off."

Suddenly, the coach was moving forward. The wife and three kids could have been a lie, but then maybe not. After a few blocks the man got up, wiped blood from his nose and took a seat. "I'm grateful to you, guv'nor. You spared my life."

"I had nothin' to do with it. What's all this fuss about anyway?"

"We're fightin' the Poor Law. Starvin' to death. Can't put a decent meal on our tables. I'm happy to work, but none's to be had. It's bad, guv'nor. My eight- and ten-year-olds are out beggin' and stealin'. My heart's shamed for that, but what's to do about it?"

"Can't you ask the city officials for help?"

"'Twas only this mornin' when I did that. They handed me a hammer and took me to a stone and ordered me to break it. I did and they said, 'You don't need help.' Then they threw me out." They were a safe distance from Trafalgar Square and the coach had stopped to let pedestrians pass. "I'll be leavin' you here, guv'nor. Thank ya for the lift."

Joseph pulled a pound note from his pocket. "Here—this is for your boys."

The stranger waved him off. "Thank ya, guv'nor but I can't. You've done a'nough already." Then he was out the door and gone.

Joseph went to bed with the ferocity of the crowd still ringing in his ears, and with the fear that its fists were raised in vain. The Empire's Poor Law and its evils seemed unbreakable.

The following night, he attended the opening of the Academy showing with the painter George Jones. Of the six pictures he entered, *Bridge of Sighs* was viewed with the most enthusiasm, but the others were praised as well. He had thought of entering *Sunburst* but decided against it; doubt was now gripping him like a claw. "Insanity, insanity!" He could hear the blasted critics screaming the accusation throughout the Empire. Later, he and Jones went to Nolan's Ale House for grog. Jones lifted his mug.

"Here's to you, Joseph. You deserved your laurels tonight."

"No reasons to complain."

"Took a squint at the prices. See yours have jumped sky high."

"If they want important pictures they must pay for them."

"A lot of us should take that into account."

"Most painters work their butts off only to find their pockets filled with air. I'm done with givin' my efforts away."

"Back to more work now?"

"Nope. I'm deservin' a rest. Off to Margate tomorrow mornin' for a couple of months. No harbor's better for good air and fishin'. "

"The light in your latest work is indeed exceptional."

"I owe it to Italy and Petworth. They're bringin' me a whole new feelin' for light and color."

"An important breakthrough, and others are bound to take notice and follow."

"In that case, they'll need some courage—and a deaf ear for the critics." Sleep was beckoning and he was ready for it. He motioned to the barkeep for their bill.

"Nope. The grog's on me."

"Thank you, George. Had I known you were payin' I'd of ordered cognac."

"Well, good night, Joseph. Enjoy your trip."

"It never occurred to me that I wouldn't. Good night, George."

He was getting into bed in his flannel nightshirt when the painting of that sun over Petworth entered his thoughts. He couldn't have explained why, but he lit a candle, went to the gallery and pulled it from the rack. Untouched, it had been there since his return from the estate. He placed it against the wall, stepped back and looked hard into it. Again, it was besieging him with doubts. Perhaps, caught up in the spell of that wondrous moment, he had allowed his imagination to sail too freely. Uncertainty piled on, ravishing those moments when the sun had so gloriously devoured that Petworth sky. Now his thoughts about it were flowing differently. Its meaning still escaped him. He grunted and pushed *Sunburst* back into the darkness of its slot. For the time being, it would be left in peace, away from those hostile voices that enjoyed nailing him to the cross.

Margate was abloom with spring when Joseph reached there, but a sense of foreboding struck with his first step upon land. Katherine Forsyth's presence still hung in the air. The waterfront, the trees and the sky said "Katherine." Hoping that old Maude might still be around, he headed for her cottage. His hopes faded as he approached the sight. The place was in a state of decay. Windows were boarded and weeds grew tall over the property. He knocked, nevertheless. An aged man leaning on a cane opened the door. The veil of gray over his pupils told Joseph that he was blind. Feebly his head lifted. "Yes? Who is it?"

"I'm Joseph Turner. Lookin' for Maude. Is she still around?"

"Lord, no. She's gone to her grave years ago."

"Too bad. Sorry to have bothered you."

"She was my wife. Can I be of any help?"

"Afraid not. Just passin' by. A good day to you."

"You sure 'Twas nothin' important?"

"Nope. Just an old friend. Thank you." The door creaked shut as he started down the path. Old Maude was gone, and her "old jackleg" had come home to roost.

A couple of hundred yards down the lane he came to another cottage overlooking the harbor. A sign, "Lodgers Accepted," was in the window. He knocked. A portly and rather attractive woman opened the door. "Yes?"

"I see you're takin' in lodgers."

"We do—along with meals, if they like. How long are you wanting to stay?"

"Two months, but I'll be eatin' out."

She gave him and his baggage a hard look. "You're a stranger to these parts?"

"Not altogether. Spent time here years ago makin' paintings of the place."

"So that's your trade?"

"It is."

"My name's Booth. Mrs. Booth. We've a room facing the sea you might find to your liking. If you want you can come in and look it over. Your name?"

"Turner. Joseph Turner."

He found the room to his liking. He found as well a striking resemblance between Mrs. Booth and Sarah Danby. "I'll take it."

"Fine."

While he was unpacking, a man came to his door. He was tall, haggard and ashen and introduced himself as Mr. Booth, while placing towels on a table. "Hope you find things comfortable." He left as quietly as he had come.

Joseph saw very little of the Booths during the next two weeks. He arose early to walk along harbor front, fished and relaxed in the park where he had first met Katherine. One Sabbath morning he climbed to their place of rendezvous to stand for several moments looking down on the spot. Overgrown with weeds, it was meaningless now. He had turned away, renouncing himself for having gone there in a moment of weakness. Twice he had deliberately walked by the Forsyth homestead. A "For Sale" sign was on the door and all the shades were drawn. He took his meals at a pub that watermen and sailors frequented. The grog drinking and boisterousness sent his memory back to the banks of the Thames; to Gully and himself watching the ships moving toward the sea.

It was a morning well into the second month when he found Mrs. Booth in the parlor in her nightgown, barefoot and sobbing. "Somethin' wrong?" he asked. Her sobbing increased. "Can I be of any help, Mrs. Booth?"

"Only God can help, I'm afraid." She wiped at tears. "It's my husband. He's dying from some disease at the hospital where I took him yesterday. They tell me he's little time left." She began sobbing again, got up and went to her bedroom. Joseph went off to start his day. He saw nothing of her for nearly a week. Only her cat shared his presence.

He arrived one afternoon to find a wreath on the door and Mrs. Booth dressed in black. Mr. Booth had died. "I'm awful sorry for you. If I can help in any way, let me know." She thanked him with a shake of her head.

A wake was held the night before the funeral, but Joseph kept to his room and paid his respects with flowers.

His time at Margate had grown short when Mrs. Booth asked him to share supper with her, and, respecting her loneliness, he accepted her invitation. Acceptable, too, was the soft candlelight and the tight-fitting dress she appeared in. It reaffirmed her likeness to Sarah Danby. Mrs. Booth turned out to be a fine cook. The wine could have been better, but certainly not the roast duck, potato dumplings and plum pudding. He had bought a bottle of cognac for the occasion, and he poured her some while offering his compliments. "A fine supper, Mrs. Booth."

"Thank you, Mr. Turner." After taking a swallow of cognac she smiled. "I've nothing against your calling me Caroline. We've known one another for nearly two months now."

"True a'nough—and 'Joseph' would sound more friendly comin' from your lips."

They touched glasses. "Then from now on, it's Joseph and Caroline." The shyness in her voice didn't fit her age.

The cognac began to take effect and hastily she brought the evening to a close. "Well, good night, Joseph."

"Well—a good night to you, Caroline."

She stood in the doorway of Joseph's room as he packed to leave two days later. "I'm going to miss you. Seems like we've known each other for years."

"And surely I'm to miss you, Caroline. Do you ever get to London?"

"Well, it seems to me that I'm free to go wherever I want now."

"Well—in case you find yourself comin' my way, just send a note ahead.

He tore paper from a sketch pad, scribbled his address and handed it to her. "I'd like makin' you comfortable."

"I've a strong notion to sell this place. Nothing to pin me down to it anymore."

"Might be best for you. And I'd think the sooner the better."

The shaking of hands during their parting was cordial, but without finality. His eyes said things he felt better not saying during her moments of mourning.

CHAPTER THIRTY-FOUR

For the next twelve months Joseph dedicated himself to harassing engravers—and justifiably so, he thought. Their inferior translations of his earlier work into black-and-white had left him angry and full of distrust. He became a lion roaring demands. They became bewildered lambs, suffering his presence and his orders.

John Le Keux, whom he had entrusted with his *Pope's Villa*, was a gentle human being. Sitting in his shop, he patiently listened to Joseph's railings. "Depth, clearness and well-laid lines are what I'm after. And I'll settle for no less!"

"Do my best for you, Turner."

"Then let your best be your very best."

Two months later, the engraving appeared. Joseph was ecstatic. He went to Le Keux and slapped him on the back. "Ah, had I known there was a man livin' who could have done that I'd have had it done long before now."

Softly Le Keux replied, "Without your watching over the plates the results would have been inferior." Joseph was hardly out the door when Le Keux turned to an assistant. "A man of great talent," he moaned, "but what an enormous pain in the arse."

An hour later, W.B. Cooke found himself in a quandary after showing him a proof for retouching. Joseph eyed it for a few moments then picked up a piece of white chalk and a piece of black chalk. "Which one am I to retouch it with?"

"I feel the white's better."

"Fine," Joseph said, then hurled the black chalk across the room. Working deftly he finished the retouching then held it up. "That to your liking?"

"Splendid," Cooke replied, handing him another proof. "Now I suggest you retouch this one with black."

"Nope. You had your choice and you'll haf'ta abide by it." Cooke had been baptized in the fire of Turnerism. The *Liber Studiorum* having proved unprofitable, had been abandoned, but his transactions with publishers, engravers and real estate dealings were making him a man of considerable wealth.

Nevertheless, his attitude toward money was growing complex. Envious artists were making him out to be a miser. Certain dealers were irritated by his 'guinea watching," and he enjoyed tormenting those particular dealers the most. He was becoming genuinely frugal, but he shunned extravagance to save himself for work. During a conversation with George Jones he expressed his feelings about money. "I hate wastin' it."

With Walter gone the Fawkeses were running into money problems. He rushed to their aid. On his return from Margate, Jenny Wilkerson, a neighbor's widow who had borrowed from him, arrived with her debt in hand. "I'm 'appy ta 'ave the means to pay you back, sir."

"A good lady you are for that, but you're to keep it for sendin' your young ones to school." Repulsed at the sight of worn seats in the Royal Academy meeting rooms, he bought new cloth for them. And he had refused to allow distraint on tenants two years in arrears in a house he owned on Harley Street. During a visit with Gully Cooke, his friend groused about not having more money to put into Allison's flower business. "Don't wish for money, Gully. You can have money from me whenever you want."

Secrecy about his working habits had become a complaint at the Academy, but covertness was his privilege. It was Farington who pumped up enough gall to mention it. "Our younger associates are feeling cheated, Joseph."

"Cheated? How so? Who's cheatin' them?"

"The one whom they revere most—you. They want to learn, and from you."

"They're not knockin' me down with questions." His feathers were slowly ruffling. "I've no obligation to let every meddlebutt in town gawk over my shoulder, makin' gossip about how I do things. They're to think what they want."

"No offense, I hope. Just thought I'd pass the word along."

"You did just that. Hope my answer's plainly understood."

"Understood, Mr. Turner, understood."

To everyone's astonishment Joseph showed up early one morning a week later, and began work on a canvas in full view of anybody who chose to watch. For three mornings he did this, arriving after his breakfast and going on until daylight faded.

Constable was suspicious. "Turner's up to something, and it's not without motives."

George Jones laughed. "For sure he's not doing it to show goodness in his heart."

Neither rival was altogether right or wrong. Joseph had taken the younger associates into consideration. Partly out of rancor, partly out of obstinacy, he intended showing his older associates that he could outwork them. They could accept the challenge or duck it. A good number of them accepted, including Constable and Jones, and soon Joseph was to recognize an advantage he hadn't bargained for. He could now keep a keen eye on his closest rivals.

Two incidents to that point occurred a month later as Constable treated his *Waterloo Bridge* with strong reds and greens. He was, Joseph suspected, trying to outdo the brilliance of a gray seascape he was working at in the same room. After viewing his rival's picture for a few minutes he went back to his own and added a daub of red to his sea. Suddenly Constable's lake appeared weak in comparison.

When Constable and Jones reentered the room, Constable smiled. "I see Turner was here and fired a gun." Jones was nodding in agreement when he suddenly blanched. A coal from his own picture had bounced across the room and set fire to Joseph's seascape. Surely Constable had the incident in mind when at a lecture that night he said, "In art, as in literature, there are modes by which men aim at distinction, by careful application to what others have accomplished by imitating their works."

The next morning, Augustus Callcott and Samuel Cooper were both puzzled by a lumpy substance Joseph was spreading over his painting of Yarmouth Harbor. Callcott nudged Cooper. "Good Lord, what's that goo he's putting onto it?"

"I should be sorry for the man who asked him," Cooper replied. Daniel Maclise joined them as Joseph finished, silently gathered his tools and left without even a glance at the canvas.

"Now that's masterly," Maclise remarked. "He didn't even linger to look at what he'd done. He knew it was to his liking and he was off."

Having completed a hard day of work, Joseph's desires had turned to a good supper, and a good woman to warm his bed. The supper was no problem; the woman was. Of late he had been unable to find one. Caroline Booth suddenly entered his thoughts. Nearly a year had gone by with only a postcard from her saying she was still trying to sell her cottage. He'd all but given up on her.

He was about to leave the building when he saw Richard Redgrave, a young associate he liked, sitting in a corner with a hangdog look on his face. He stepped over to him. "You look to have swallowed a sour lemon. Some lass give you the gate?"

Redgrave looked up with hurt in his eyes. "I'm at my lowest."

"What's the problem?"

"You'd find it with little meaning, I'm afraid."

"Come on, lad, give me a try at it."

He handed Joseph a small painting and sighed. "It's about this."

Joseph looked at the watercolor of a young woman. "It's a fine piece of work. Why's it got you in such a mood?"

"Hoped to get it in the exhibition, but the secretary's come out against it. Too much bosom, he says. Thinks she looks like a trollop."

Joseph studied the picture for several minutes. "You've no serious problem, lad. Just add a little white over the chemise, but keep it thin. The flesh'll still show."

"You think it will work?"

"For sure it will. He'll think you put a blanket over her." He smiled. "You're to take my word."

Redgrave's hopes lifted. "Thank you, Mr. Turner. I'll give it a try."

Joseph gave him a pat on the head and walked out into the twilight. He approached his womanless house with advice from Farington on his mind, that of obtaining an agent. He distrusted agents. "Thieves, leeches," he

mumbled. A number of names began rolling though his mind and halted at Thomas Griffith—the only one he could consider without any disfavor. He decided to sleep on it.

His boots seemed to complain from the corner where he had tossed them the night before. The soles had thinned; the heels slanted in precarious directions. They were in bad need of repair. After breakfast he went to the Griffith's office, and, with reservations, took him on as his agent. Then he headed for Remsen's Shoe Shop to have his boots looked after.

The afternoon was bright and clear when he passed the Houses of Parliament. Sun blazed through the spires. He took out a sketch pad, made a few notes and went on. If at that moment his vision could have penetrated the wall of the House of Lords, it would have also noted a Mrs. Wright, its plump housekeeper, complaining to a workman about the odor of burning wood.

"Nothing to worry about. Just burning some tallies in the furnace." Mrs. Wright, not so easily convinced, renewed her complaint a few minutes later, only to be given another brush-off. Shortly after six, the House of Lords was burning furiously. The battle to save Westminster had begun. The Parliament building was enveloped in flames when Joseph reached there around seven. Great columns of smoke fanned by the wind drifted in every direction. Fire was offering itself to him in a most dramatic way. Throngs of onlookers had gathered on the riverbanks and in boats. Working calmly, he began sketching and locking the flames and billowing smoke into his memory.

Around eight o'clock, the roof of the Commons crashed downward, emitting even more sparks, smoke and flames. It appeared to him now that Westminster Hall was doomed. The tragic grandeur of the moment hung between his anguish at the destruction and his impulse to capture its drama. Billows of fire and smoke raged upward. Westminster Hall was now threatened with fiery death, along with records of dramatic trials played out inside its walls—Charles for treason, the Duchess of Kingston for bigamy, Lord Melville for corruption, condemnations to death of Guy Fawkes and the Earl of Stafford. All of this history, and more, was being crowned with ashes.

The roar of crumbling walls sounded far into the night. Bystanders, yielding to their personal emotions, puzzled him. Astonishment, awe, even

joy shone on their faces. A spindly man grasping a mug of grog glanced at his sketch pad. "A sight to behold, eh guv'nor?" He was answered with silence. Another roof crashed into a bed of fire. The intruder chuckled. "Hope that bloody Poor Law got its due with that one. Hope it burns to ashes." He couldn't be ignored; his breath was too foul and uncomfortably close. He shoved the mug close to Joseph's face. "Like a swig, guv'nor?"

Joseph stopped work, eyed him for a moment then took a small crockery bowl from his coat pocket. "Put a small snip of it in this."

The man obliged him then stumbled off. Joseph soaked a brush in the grog and dabbed it in black paint, added some red then stroked the combination into the sketch pad.

Dawn rimmed the clouds with gold when he finally left. By then the Houses of Parliament were just ghostly spires of ruin with smoke curling above them. After reaching home he fell across the bed fully clothed, and evening found him still there.

("Billy." Joseph stirred in his sleep and buried his head deeper into a pillow. "Billy."

"Yes, yes. I'm comin'."

Annoyed at being awakened during the middle of the night he wiped sleep from his eyes and descended the stairs to the kitchen. His mother and father sat at the kitchen table. A boy sitting between them was an absolute stranger. Joseph watched as his mother placed a necklace about the boy's neck. "It's for your birthday." The boy didn't answer. "You see William? I told you he wouldn't like it—and after all the trouble I went through."

"But I told you he wouldn't like it, Mary."

The boy jerked off the chain and threw it to the center of the table, then, horrified, he watched the chain take on a head and curl into a purple snake.)

He sat up in the bed shaking his head. "Sixty-one and still havin' senseless dreams."

CHAPTER THIRTY-FIVE

Fireworks and all, *Juliet and Her Nurse* was Joseph's most admired and most condemned entry at the fall showings. He had stretched his imagination and transported Juliet from Verona to Venice. With her nurse, the girl stood on a rooftop gazing down into a brilliant carnival scene in the Piazza di San Marco. Thomas Griffith, Joseph's new agent, was smiling when they met at the entrance to the gallery. "*Juliet* no longer belongs to you, Joseph."

"It's sold? Who got it?"

"Munro of Novar."

"And the figure?"

"We're still working on that, but he'll come around. You're not to worry."

Joseph tried avoiding Munro until the price had been firmly set, but Munro sought him out. "No doubt Griffith has informed you of my intentions for acquiring *Juliet*."

Joseph feigned surprise. "Oh? Well you've a bit of competition, I'm afraid. I'm already givin' thought to the interest of another client."

"Griffith is aware of that?"

"I've not informed him."

"I would think the highest bid would clear up any confusion."

"I'd say you're right about that."

"Could you give me the name of my competitor?"

"That would be a bit awkward." Shrewdly Joseph shifted the conversation. "What's your overall opinion about this year's showin'?"

Munro's eyes were searching the crowd. "Griffith still around?"

"Think he's gone by now, but I'm to see him tomorrow morning."

"Then tell him I'd like dinner with him tomorrow evening."

"I will."

Griffith was again all smiles when Joseph arrived at his office the following afternoon. "Munro left a little while ago. Not only did meet my terms, he's buying your *Rome from Mount Aventine*."

"I'm pleased, Griffith—highly pleased."

He was much less pleased with an article carried by *Blackwood's Magazine* a few days later. The Reverend John Eagles, a dangerous critic, had made a virulent attack on *Juliet*. "It's thrown together higgledy-piggledy, streaked blue and pink and thrown into a flour tub. It has no place on the Academy walls." Joseph grunted, and threw the magazine into the rubbish.

Two weeks later, a letter came to him written in defense of *Juliet* and in condemnation of Eagles. In small cryptic penmanship it concluded, "Out of respect for you, sir, I send this for your approval before having it published. John Ruskin."

Unhesitatingly, Joseph wrote back: "I beg to thank you for the kindness and trouble you have taken in my behalf; but I never move in these matters—they are of no import save mischief and the flour tub Eagles fears I have invaded." He then sent Ruskin's letter to Munro to keep with the painting and shortly used the purchase money to help buy a cottage in Chelsea near Cheyne Walk, a stone's throw from the Thames.

Caroline Booth, had been unable to sell her cottage. A few prospects had shown up, looked the place over, then left, never to be heard from again. A year had gone by when a caller came, expressed his admiration for the cottage and left enough pounds to back up his enthusiasm. Before the month was out the "For Sale" sign came down and Caroline found herself free. She wrote Joseph, giving him the date of her arrival; anxiety was rumbling inside him before he finished reading her letter.

She arrived at Queen Anne Street the following month. His appraisal was swiftly drawn. Widowhood had not done Caroline Booth one ounce of harm. As evening approached, he suggested supper but, to his pleasure, she answered, "Later...perhaps?" The glint in her eye said frankly that eating, for the moment, was time wasted.

He reached for the bottle of cognac, pulled the cork and filled two glasses to their brims. Thirty minutes later, many months of waiting was passionately crossed out. He found no reason for Caroline Booth to take a back seat to Sarah Danby in the bedroom. His promise to make things com-

fortable for her had been kept, and she accepted his offer to take quarters in the little house he had just bought on Cheyne Walk. It was, after all, womanless and in need of a warmth he felt she could bring to it. Most importantly, he liked her.

Two days later, she moved in. Hannah Danby, his housekeeper and Sarah's niece, was put in full charge at the Queen Anne Street gallery. Joseph and Caroline then took residence at Cheyne Walk, alongside the Thames; the house faced south, on a bend of the river. Shortly after they moved in, he built a studio-gallery on the roof from where he could view the river.

Had Joseph written a memoir about the falling away of the months ahead, death would have been its overleaf. W.F. Wells and Lord Egremont died. On a cold blustery November day, he went to Petworth and led the procession of artists who followed the coffin to the burial ground. Death persisted in coming. Suddenly, without any signs of serious illness, Constable, too, met his end.

At the Academy memorial service, Joseph eulogized his rival: "From his first start he made preparation to render himself worthy of notice; a point from which, with his own eyes, he always seemed to be recedin'. He underrated his own genius. His work aimed toward breadth, tone, moral sentiment and originality—and in all those he was successful. His work'll live forever and I'll always hold him in high respect."

Since Egremont's funeral, Joseph had suffered a hacking cough. Forced to his bed, he was suffering chills, high fever and long intervals of delirium. He lay stricken for nearly a month. Having taken death seriously, he felt it hanging around his own house—and without his welcome. Caroline put him back on his feet with nourishment and tender care. Just before Christmas he announced his resignation as professor of perspective at the Academy. Approaching sixty-three, he felt old age creeping in, suggesting his withdrawal from the world.

Bundled against the cold, he went for a walk along the Thames. A boy stood near him, watching a huge ship being towed down the river. It was an old warship, the *Téméraire*. The rusted ninety-eight-gunner was being towed by tugs to Deptford to be broken up. "Another death," he mumbled.

"What do you mean by that?" the boy asked.

"Just what I said, lad, another death." He was silent for a moment. "That rusty old lady you see there helped rout Napoleon at Trafalgar." Then, with sadness, he sketched the scene as she floated on to her final destination. Suddenly he was feeling a kinship to it. He, too, was growing old and rusty.

Several years earlier, George IV had felt even worse as the end of his reign – and life—approached. At Windsor Castle, gout and dropsy hed kept him in his bed, drugged against pain. With legs no longer able to support him and suffering his laced corsets, he had shunned all public appearances. After planning his funeral he had grasped his doctor's hand and mumbled, "My boy, this is death." Londoners had not been wrapped in grief. Those socialites that mourned did so less for him than for the sparkling style he had granted them.

William IV mounted the throne clinging to one ambition—that of seeing his niece, eleven-year-old Princess Victoria, who was his heir, come of age. If she were eighteen years old when she became Queen, her mother, the Duchess of Kent—whom the King loathed—would not become Regent when he died. At sixty-five, he felt he had cause to worry. But luck was with him; his death would not come until three weeks after Princess Victoria's eighteenth birthday.

William had proved disastrous to the world of art. Blunt and crude, he sourly denounced pictures of sacred subjects. "They are improper and should be destroyed."

Blasphemous rot," had been Joseph's remark to Farington during the dilemma. "He deserves to be struck by lightnin'."

Farington smiled. "Careful, Joseph. Men feel the garrote around their necks for saying less."

"My sentiment remains."

"Certainly he's to be given credit for supporting the working man."

"A virtue he's not to be denied. But senseless jabberin's about art and moanin's about reform are not the same thing."

"Art will survive the King, to be sure, Joseph."

"Nevertheless, I would find his absence from the throne to be quite bearable. The reform bill's not to give everybody everything."

William was like a man split in half—a saintly Satan might have been an apt description for him. His cry for reform resounded throughout England, while England's painters suffered his scorn. The Academy was not intimidated. Secure in its eminence, it patiently waited for death to take him. Constable, before his own death, had eyed reform with gloom. "The government's about to fall into the hands of the devil's agents."

But reform eventually did come, and through the least likely of monarchs—Victoria. Now the oppressed in the Empire's rotting boroughs could rejoice. The opposition had not fully understood that William truly enjoyed rubbing shoulders with the common herd.

The reform bill, with its innovations, left the past looking like a buffoon. With the building of the new railroad lines, life for travelers became easier, including Joseph, whose backside had suffered many uncomfortable stagecoach rides. On one of his return trips to London on the railway's new Exeter Express, he was sharing a compartment with an elderly woman who was reading a book. Suddenly, a downpour of rain struck the window and suddenly the woman was a problem—sitting by the window where he longed to be. "Madam, it would please me mightily if you would change seats with me. I'd like to make sketches of the rainstorm."

"It's quite alright with me."

"I'm most thankful."

She didn't appear so agreeable when he opened the window and stuck his head out into the downpour. Rain was splashing in. She complained. "It's getting awfully wet in here." Her mild reproach went unheeded. Twenty minutes passed before he withdrew his head. She ventured a question as they left the compartment in London. "Well, sir, did you get what you wanted?"

"I did, madam. I did indeed."

Months later at the Academy show, Lady Simon gasped with delight at the appearance of *Rain, Steam and Speed*. "I was right there beside him when he conceived it." She rushed to him. "Mr. Turner, do you remember me?"

He looked at her closely, remembering the prominent nose and the deep lines in her face. "I do, madam, and I'm forever grateful for your giving your train seat to me."

"And I feel grateful for having done it."

Lady Simon had made a small contribution to that world of light and atmosphere that Joseph was constantly pursuing. He took a closer glance at the painting, grunted and smiled.

Joseph, along with the world of art, felt reassured when the young Queen presented a knighthood to the Academician Edwin Landseer; but Joseph himself was conspicuously absent from her honor list. "Doesn't bother me one crumb," he grumbled. Caroline Booth did not believe one word of it. He had not withdrawn completely from the Academy; he still attended meetings and offered advice to its younger fledglings.

Joseph's cottage at Cheyne Walk had been a well-kept secret, but suspicions that he was living someplace other than Queen Anne Street had taken root. David Wilkie, an associate, appointed himself to get to the bottom of the question. He stepped to Joseph's side after a meeting. "Mind my walking home with you, Joseph?"

"I've an engagement elsewhere."

"Oh? Then some other time perhaps."

"Perhaps." A month later, Wilkie made another attempt. "Alright, David, come along." As they walked, a beautiful young woman passed them. Her voluptuousness brought their thoughts to attention. A block further on they passed another young woman who was equally attractive, but miserably crippled. Supported by two canes she seemed to propel herself along with sheer willpower. With a sigh Wilkie said, "They're times when providence seems terribly unjust."

"David, providence seldom grants full justice to any of us." Wilkie was somewhat baffled when they wound up at the gallery on Queen Anne Street. "Come in for a few minutes if you like, David."

Wilkie had been outwitted, but he wasn't giving up. "Thanks. I'd like that." He was astonished when he entered. The place was in shambles. Hannah's

talents as a housekeeper had deserted her. Dust covered everything. Most shocking was the sight of two paintings streaked by rain that had leaked through cracks in the ceiling.

They had just sat down when Hannah, bent and mantled with a mobcap on her head, appeared carrying a broom and dustpan.

"How do you do, sir," she said. Then she took an envelope from a shelf and handed it to Joseph. "It's for you. A boy brung it about a week ago." She then went toward the kitchen.

He recognized Sarah Danby's handwriting on the envelope. He tore it open and as he read he paled: "Dear Joseph, Georgianna is seriously ill. I would advise your coming as quickly as possible. Sincerely, Sarah."

"Some very bad news, David. Sorry but I'll have to be off."

"I understand."

They were parting outside as a fat man with red muttonchops passed. He raised his hand to Joseph. "Admiral Booth. A good evenin' to you," the man said.

Hesitantly, Joseph replied, "And a good evenin' to you, Fred." Then he hurried off toward Sarah's house.

Wilkie was further puzzled—certainly by Joseph's answering to the name of Admiral Booth. His curiosity urged him to overtake the man. "Pardon, sir. Do you happen to be an acquaintance of the admiral's?"

"Nothin' close. We're neighbors of sort and take a grog together now and then."

"Then you live in this neighborhood."

"Nope. In Chelsea near the river."

"An interesting man, the admiral."

"Yep, I find him so."

"Well—sorry to have bothered you."

"No bother a'tall."

Approaching Sarah's house, Joseph took one glance, gasped and stopped. A death wreath hung upon the door. His thoughts had collapsed into anguish

when he knocked. After what seemed like an eternity Sarah appeared, and they stood for a long moment staring at one another. At last she said softly, "You have come too late."

Slowly he strung her words together. "I've come too late?"

"The funeral was this morning." Tears filled her eyes.

"May I come in, Sarah?"

"Of course."

They went to sit on the divan they had so often shared. Alone with her now in the flowered redolence that had pervaded his daughter's coffin, Joseph searched for words. "Sarah, never have I felt such sorrow. I loved Georgianna. She was a part of us and she still lives in both of us. I cannot think of her as dead." A watercolor of their daughter stared at them from the wall. She had been four when he painted it. Sarah sat now with hands clasped, staring at it as she wiped away tears. "Fate can be ruthless, Sarah. It's showing its worst right now. Georgianna was all goodness and that came from inside you." He wanted to put his arms around her, to console her, but this wasn't the moment. What then could he do here—where he had come too late; where sorrow now consumed this woman he had mistreated so badly? He could only enjoin her sorrow with his sorrow.

"Why didn't you come earlier? Didn't you receive my note?"

"Yes, but less than an hour ago. I've been away."

"She kept asking for you near the end."

His eyes snapped shut. "The dear child. How long was she ill?"

"For less than six weeks." A long silence ensued before she went on. "It was all so sudden—a mysterious malady of some sort. The doctors are still puzzled."

"And Evelina. Was she here with you?"

"Yes, and constantly at her sister's bedside during the final hours. Just this afternoon she left to join her husband in Ashanti."

"And her children?"

"Both boys are fine."

"Sarah, I will send money for whatever funeral and doctor's expenses you incurred."

"That won't be necessary, Joseph. I can manage."

"Nevertheless, I insist." Night was falling before he rose to leave. "And how are things going for you in general, Sarah?"

"At this time it is difficult to say. But I'm to be married soon."

"Oh? Then in that case I wish you happiness."

"Thank you, Joseph. I wish you the same."

"Ah, Georgianna, dear Georgianna." Quietly he spoke her name as they moved toward the door. Never had either of them known such pain. "She was a flower, Sarah."

"A beautiful flower. "Well . . . goodbye, Joseph."

"Goodbye, Sarah. Goodbye."

He felt alone as he walked homeward, and the sorrow was mantled with guilt, against which he had no defense. His thoughts, thick now with things he might have done but didn't do, abandoned him to misery. Besides Sarah, there was no one with whom he could share that misery, and even that connection was wrapped in secrecy. Her mention of marriage had jolted him. Was this dejection simply due to his loss of her? The question taken hold of his conscience. He found he was somewhat curious about this husband in her future. She had not named him, nor could he bring himself to ask her to. Nevertheless, his wish for her happiness had been honest.

Fate's unpitying flag was still waving in the silence of the room when he at last fell asleep.

"Goodbye, Georgianna," he thought.

Caroline awoke to touch his side. "Joseph, you're talking in your sleep." She touched him again. "Who's this Georgianna you're dreaming about?" Secrecy, his old enemy, was still alive. "It's just a name, Caroline. Let me sleep." He had awakened with his sorrow still stretching through the darkness, still wandering with no end. Georgianna, whom he had given nothing, had left him with so much. And what she left was still flowing through him like a river, giving him no peace, even in his sleep.

Ill luck stayed on. Soon after, he found his source of income on the wane. His most popular drawings, made from engravings on copper, were being replaced by cheaper ones by other painters processed on steel.

Marketplaces, swamped with the inferior works, were pushing his publishers to the edge. "Picturesque Views in England," his most celebrated portfolio, had met an abrupt end. Adversity struck again when two of his publishers went broke. Matters worsened as public taste for art gradually shifted to the sweet domestic leanings of the young Queen, but he worked harder than ever. Caroline finally complained. "You've done plenty for a lifetime, Joseph. You should slow up."

"My heart tell's me to work, Caroline, and I'm to obey it."

The years they had lived together had been well spent. A casual observer might have concluded their life together amounted to flat-out boredom; complacency would have been more accurate. They needed each other. She was no longer a bird of spring and he was twenty years her elder. Their relationship had become their easement. They were stuck with no place to go beyond where happenstance had brought them. The small time left to him offered very little choice. The passion of his youth had dwindled. She, having had her share of sensual pleasure, felt comfortably resigned.

His lofty position in the world of art drew her awe, but she kept her silence about that. Had he been an outstanding bricklayer, her attitude would have been the same. Joseph, not one to be fondled with praise, found this attitude easy to live with. He made no mention of it; to have done so would have tainted its purity. But Caroline possessed one serious fault—that of criticizing his work with a frankness that drove him to fury. Such a thorny moment disrupted what had been a peaceful Sabbath afternoon. He had pulled out *Sunburst* for another look. She pointed to it. "Now I like that one very much, but the colors you're using on that landscape you're working at don't seem right."

"You've stepped out of line again, Caroline. You've not painted a stroke in your life."

"I know what I like and don't like. Right now I don't like what I'm seeing."

"Then, Mrs. Booth, you can bloody well look the other way and stop badgering me."

"Yes sir, Mr. Turner, yes sir."

Gradually, his teeth were deserting him and he seldom dined out. Locally, he had become known as Puggy Booth. To his associates, Caroline remained a secret. On his seventieth birthday she presented him with a birthday cake. "Why ten candles?" he asked.

"They stand for the years you've got left—providin' you stop working day and night."

"Then you might add another ten. I'm to be around for a while."

She then clipped some gaiety off the occasion. "Why are you buying back pictures that have been already bought?"

"Because there's more work to be done on them. Never felt they were finished when I sold them."

"I, for one, think it strange, and awful expensive."

"I've no objection to what you think, Caroline—long as you don't try addin' your thinkin' to mine." He paused. "And I'm not headin' for the poorhouse."

"Sorry." She touched her glass of wine to his. "A happy birthday to you, Joseph, and to twenty more."

He sighed. "Who knows, Caroline? Who knows?" The number twenty hung in the air staring at him. He stared back at it, knowing that it was highly unlikely.

Airily, Caroline suggested another rest at Margate. He gave it thought for several seconds then shook his head. "No, I'd not like that." His last trip there had been too wedded with things he would have rather forgotten, and he was firmly against reawakening them. To her, the refusal was just another show of stubbornness.

CHAPTER THIRTY-SIX

Thomas Griffith lived well. His nicely appointed flat had become the gathering place for art patrons and lions of the literary world. Joseph had come to like him more than he thought possible, but with mild reservations. "A good agent, but a bit too priggish." Griffith had arranged a dinner party. Along with Joseph were George Jones and six other guests. The parlor buzzed with small talk. Joseph, worn from the day's work, had taken a comfortable chair. He had just relaxed into it when a tall, rather handsome young man with long sandy hair, leaned over and offered his hand. "Mr. Turner. It is at last my pleasure to meet you."

"And your name?"

"Ruskin. John Ruskin."

Joseph's brows knitted. "Ruskin...Ruskin. Ah, yes, it was you who sent the letter about *Blackwood*'s needling my *Juliet*."

Ruskin smiled. "I am the same, sir. And I feel that my remarks were well founded. With all due respect to the Reverend Eagles, I find him unqualified for serious criticism."

"I'm most grateful to you, young man, but as I said in my answer to you, I don't bother with things like that. Otherwise, I'd suffer nails in my scalp, and I've no wish for that."

"Certainly, I respect your position."

"Please, sit down."

"Thank you, sir." Ruskin pulled up a chair.

"Now tell me, what are you up to?"

"You deserve a better answer than I can probably give. Briefly, I travel a good deal, study works of art, collect geological specimens—he rubbed nervously at his chin—and paint a bit." But my foremost aim is to gather in as much knowledge as possible and then pass that knowledge on to the public. That's about as much clarity as I can bring to my answer."

Joseph chuckled. "Clear a'nough, I'd say. You know what you want and you seem to be goin' after it. And are you gatherin' sufficient knowledge?"

"Not so much from the general society, and I expect that is my fault. I do find great comfort in poetry lately and I am at work on some of my own."

"You're on the right road. Good poetry's akin to good paintin' and I'm never without it. How old would you be, lad?"

"Twenty-one, sir."

"Ah, to be twenty-one again. You've got so much livin' still ahead. Hope you're to make the most of it."

"Certainly that is my intention."

Boisterous laughter suddenly filled the room. Something amusing George Jones said had obviously provoked it. The room softened to a buzz when Griffith called his guests to the feast of grouse and cuckoo birds. Seated together, Joseph and Ruskin talked at length about the virtues of Aosta and Courmayeur. After dessert, Joseph gave Ruskin a quick hand-shake, thanked his host and left.

Ruskin recorded their meeting in his journal the next day: "Met JMW Turner last night. Everybody had described him as boorish and vulgar. I know this now to be impossible. I found in him somewhat eccentric, but keen-mannered and good natured—hating humbug of all sorts. Perhaps a bit selfish, but highly intellectual, with powers that flash out occasionally in a word or a look."

Joseph's words for Ruskin to Caroline were delivered with brevity: "I like him. He's a young colt with his feet on the ground and some good thoughts in his brains. Just twenty-one, with all the virtues of youth." He shook his head. "And me with my bones achin', my sight goin' and my mouth missing three more teeth." He forced a smile. "Ah, Caroline, age is wrappin' its arms around me."

The eve of the New Year was being acknowledged throughout London. Champagne flowed for those who could afford it, cheap grog for those who couldn't. Joseph had chosen the solitude of home and a cup of tea. Caroline, weary from housecleaning, slept. William, Georgianna, Egremont and Fawkes—all gone. Loneliness roamed the house. He spent the following

day working at a watercolor. Evening was approaching when he finally finished it. "Caroline," he called out, "could you fetch me a cup of tea?"

"Fine, Joseph."

By the time she came to his worktable with the tea he had nodded off. She was placing it before him when he jumped awake and knocked the cup from her hand, splashing the liquid over his watercolor. "Caroline. look at what you've done!"

"I've done? You did it yourself. Not me."

Devastated, he stood up, shaking tea from the painting. His day's effort was in ruin. "Just look at it. The whole thing's a bloody mess."

"Well, Mr. Turner, your slave's sorry as all get out about that."

"Now you've the nerve to turn uppity about it."

"Good day, Mr. Turner." Abruptly she turned then went to the bedroom and slammed the door shut.

"How about supper?" he shouted.

"You're to get your own supper," came the muffled reply.

"You've an apology to make, Joseph," were the first words spoken over breakfast the following morning.

"Well, 'twas my fault, I suppose."

"That's no apology."

"Is it your shoes you want licked?"

"I've asked for an apology and you've yet to give me one." "Alright, Lady Booth, I'm to offer my apology." He took a sip of coffee. "Now that should suit you?"

"If it's the best you can come up with."

"It's my best, Caroline. Now I'd like a big helpin' of those pancakes. Only goat's milk for supper last night. No way to start out the year."

"I'm to agree. Sorry we got off on the wrong foot." She eyed him in her quizzical way. "You best slow down this year and take your time."

"Time's not to be patient, Caroline. It gives less than a hoot about how I use it. It'll be here long after the two of us are gone."

Work—hard meaningful work. That's what it was all about now, and for the

next nine months he gave little time to anything else. In late January, he sailed to Harwich for a lecture. It was a thoroughbred winter day when he started back. Even to the toughened crew of the steamboat *Ariel* the weather was proving extremely rough. Wind was blowing strong from the northeast. Menacing waves assaulted the boat and thick snow swirled in, leaving the deck wet and slippery. Joseph had wrapped a wool scarf about his head. Only space for his eyes was left so that he could keep sketching. The gale heightened, shifted, sending the deckhands sliding toward the leeward side. "You'd better git yourself inside, mate, else you'll find yourself overboard." The captain's warning was directed at Joseph.

"I'm to be alright. No need to worry."

"You're to take orders and git inside. My men can't even keep to their feet!"

"Then do the favor of ropin' me to the mast there. I've work to do and this storm's my work."

Reluctantly, the captain gave in. "You're no longer my responsibility, mate. You'll be on your own!" Within a few moments, Joseph found himself lashed to the mainmast. And there he sat, wet, cold and blanketed with snow, recording the wildness that surrounded him. A giant wave suddenly struck. The *Ariel* tilted for a frightful moment, then swept down into a huge swell. Another wave struck with a force that caused the boat to shudder. Everyone aboard shuddered with it. A resounding thunderclap split the air. Lightning streaked the snow with eerie brightness. For a few moments, Joseph felt himself at the midpoint of hell. The deckhands had deserted their stations and he sat alone on a box, soaking wet and shivering uncontrollably. Death seemed to be looking him in the eye.

The buffeting went on for another hour until the *Ariel* limped into calmer waters. The snow was being carried into another direction by a southwesterly. The wind died, and Joseph was grateful for the hands that unknotted the ropes about his waist and helped him to his feet. The boat reached port three hours late. Leaving it, he dropped a remark for the captain to digest. "I lost my hat over the side of your bloody boat." The captain didn't answer. Quite possibly he didn't even hear the complaint.

Two months later death caught up with David Wilkie on a ship returning from the Near East. Joseph stopped everything and began preparing a canvas to commemorate him. A drawing by George Jones showed the body being committed to the sea from the ship's deck. Joseph thought differently. "I will do it as it must have appeared off the coast." His painting, *Burial at Sea*, showed the coffin lowering into dark water between torchlight and the blackness of the ship's silhouette. In response to a complaint about the darkness of the ship's sails, he replied, "I only wish I had a color to make them blacker." It was hung at the Academy several months later beside his *Snowstorm*, depicting the *Ariel*'s turbulent voyage. Upon viewing it, the Reverend Kingsley confided to Joseph, "My mother suffered a similar experience, Mr. Turner, and she certainly understands that painting."

Joseph's face puckered into a scowl. "I didn't paint it to be understood. I only wished to show what such a scene was like." There were those who failed to understand. The *Times* critic dubbed it "Soapsuds and whitewash."

Over supper with Ruskin, Joseph grumbled, "Tell me, what would he have? I wish he'd been there, then maybe he could have seen what a rough sea's really like."

"I find the criticism unjust," Ruskin replied, "and I intend to do something about it."

"You're not to bother. He's a clunkhead."

"Can I give you a lift home, Mr. Turner?"

"Thank you, but no." Soapsuds were on his mind.

En route to his home at Herne Hill, Ruskin took a pad from his pocket and scribbled: "Consider a pamphlet to answer the criticism most effectively." He was more bothered than Joseph might have expected.

Wounds for his soul kept knifing in. One afternoon he stood in a crowd watching a pantomime in the window of a London bookshop. A portrayal of him gaudily clad in crimson, gold and white was taking place. In it, he works at a large painting. A baker boy enters with a tray of confections, trips and falls headfirst through it. A dealer rushes out, sees the ruined canvas jumbled with red and yellow jam tarts. He smiles, sprinkles flour over the mess, frames it, then calls in a connoisseur and sells the mess for one thousand pounds. Through it all, Joseph had remained calm and smiling.

"I'm to ignore those who wish me ill," he said to Caroline later. "I was there, and I'm not kowtowin' to nincompoops whose arses were in their comfortable beds at the time."

The coming of spring brought Allison Cooke's flower shop to his mind. Time had separated both Allison and Gully from him for too long. Their son, named for him, seemed lost to the past. Joseph headed for Covent Garden. Alarm replaced his peaceful thoughts when he reached the corner where the flower shop had been. The building was now vacant, the door and windows boarded up and the upper story had been ravaged by fire. He stood observing the ruins, considering the worst. Two doors away was a boot shop. He went in and spoke to its owner. "Could you tell me how long ago the flower shop burned?"

"Only about a week ago."

"The couple and their son, did they make it out safely?"

"Oh, they'd moved from there months ago. They've a new place two blocks from here on the corner."

"Thank you. Thank you." Joy swirled within him when he reached Allison's new shop. It was twice as large as the old one, and the entire front was banked with fresh flowers. Quickly he entered. There were several customers. Allison was giving attention to one of them when she turned to see him. "Joseph. Joseph!"

"Allison. How good to see you."

"Oh, Gully will be so happy. Wait, I'll go get him. Look around." She had, he quickly noticed, matured into the handsome woman he might have expected, but noticeably on the heavy side. Flowers also banked the interior, but one wall was given to framed paintings with a "For Sale" sign beneath them. Gully was still at his watercolors. He stepped closer and observed them. "They're bloody well good." The style had changed. That airy freeness, similar to his own, had struck him with delight.

A rumbling hit the stairs. Gully, with Allison, was arriving with a big grin. "Joseph!"

Warmly they embraced. He glanced at Gully's enormous stomach. "I see Allison's not feedin' you well."

"She's starvin' me. Feeds me nothin' but daisies and roses."

Allison returned to her customers.

"See you're still at watercolors, Gully, and they're mighty good."

"Oh? You really like them?"

"They're your very best."

Gully's smile broadened. "I've news for you. They're not mine. They're your namesake's. How's that find you?"

"Little Joseph's?"

"Little? He's bigger than me now."

Joseph stood flabbergasted. "I'm indeed pleased. When did he get started?"

"When he was only fifteen. Loves everything of yours he lays eyes on."

"Why haven't you sent him to me? He should be considered for a probationer at the Academy."

"He'd be pleased to hear that, but the lad's thirty now and livin' in Wales with a wife and child."

"Ah, it's hard to believe." He observed Gully closely. The eyes were a bit watery and dimmed, but he was aging well. His hair had gone white but, except for the girth, there was no fault to find. Gully had observed Joseph just as closely, but he made no comment. What he saw disturbed him. His old friend was aging badly.

Joseph stayed on for supper and he and Gully relived the years as Allison knitted and listened. Gully's recounting of the Nile and Trafalgar sea battles stopped her knitting at times. She was hearing things she had never heard before. At one point Joseph turned to her. "A pretty piece you're knittin' there, Allison."

Gully cut in. "Forgot to tell you—we're expectin' another grandchild. That's what keeps her fingers busy."

"We're looking to it with great joy," Allison added.

"And indeed you should."

Gully slapped Joseph's knee. "Havin' a child is one big joy you've missed, mate."

The thought pierced his heart. He had not been denied that joy; his secrecy had demeaned it. Evelina and Georgianna had been there—and yet

not there. Now, two grandchildren he had never seen were out there some-where. "Right, Gully, I guess you're right." His words had been like salt on his tongue.

Their conversation had immersed Joseph in memories. None escaped. Joseph observed the two of them with gratitude. Once shaken by so much fear, they were now gathered into the honeyed years of family life. And they expressed their thanks. His help had fallen on them like rose petals. But his time for coming and going was about over, and he doubted that they would share a table again. Gully Cooke had survived the terror that conspired to destroy him. Now, having made peace with the past, he had put his life in order. They parted with only good things falling in their memory. Not the blood.

Joseph had become John Ruskin's patriarch during the intimacy that blossomed between them. Ruskin had been given the run of the gallery on Queen Anne Street. Joseph was receiving fresh vegetables and fruit from Ruskin's Herne Hill estate and being entertained there as an honored guest. Any new attack upon him heightened his admirer's defense. The pamphlet he had proposed for that purpose had grown into a full-blown book about modern painters, and Joseph emerged the hero of its pages. Murray, the publisher, showed no interest in it whatsoever. "The public cares little about Turner anymore," he said. Smith & Elder thought differently and published the book. By autumn *Modern Painters* was eliciting considerable attention.

Ruskin called on Joseph at Queen Ann Street, hoping to get his reaction. Instead he was only offered a glass of wine.

"No, thank you, Mr. Turner. A bit too early in the day for me."

"Come, now. Never too early for a swig of good wine."

"No, thank you."

"Tea and biscuits then?"

"Sorry, afraid not."

"I've nothin' more to offer."

"Offer an opinion on my book," Ruskin wanted to suggest, but he was beginning to think that none was in store. "Are you at work on another painting?"

"Yep. Fling myself at it every mornin'."

"And the subject matter?"

Joseph smiled mischievously. "The elements—what else?"

The answer was no more evasive than Ruskin expected, and he knew better than to press. "Well, you're probably anxious to work and I'm to meet my fiancée very shortly. So I'll take leave of you, Mr. Turner."

"You're to give her my good wishes." Joseph smiled. "And when's the weddin' day set for?"

"Not sure of that yet."

They were at the door when finally Ruskin got what he had come for. "Thought your book neglected my earlier works. It did in fact seem to have a lowly opinion of them. That so?"

"In retrospect I do admit to being somewhat confused about their relationship to your love of nature."

"That, my friend, is quite in evidence. You sure gave Claude a shin-kickin' he doesn't deserve."

"Frankly, I wanted to go after Stanfield, Creswick, Martin, Lee and Harding. But I couldn't attack the living. Claude, I could attack. He is dead."

Joseph grunted. "Maybe my comments are triflin' ones, lad. You're to make no apologies for your efforts—or for what you believe. Good day, and my love to Effie."

"Thank you, sir, and good day." Ruskin had his answer. The patriarch was less than impressed.

Wearily Joseph returned to a canvas he was working on. An hour had gone by when a Mr. Thomas Gleason arrived. Worry was in his face and voice. "I'm trying very hard to buy your *Red Rigi*, Mr. Turner, but I'm having no luck. I've come with hope that you might be of some help."

He had caught Joseph during a bad time. The past, and the future, was taking a critical look at his life's work. Now, more than ever, he was determined to retrieve as much of it as possible—especially from money spiders who locked it in drawing rooms to be unseen. *Sunburst*, he had decided, would stay in the darkness of the rack forever. Why, at this point, should he open himself to more idiotic criticism? He rubbed at his ear for a few seconds pondering Gleason's question. "What's your reason for wantin' it so badly?"

"Why I find it beautiful and a good companion piece for two others of yours I own."

"And which ones are they?"

"*High Street* and the *Ehrenbreitstein*."

"Ah, all watercolors." Gleason's chin lifted at Joseph's next question. "Would you consider sellin' them to me?"

"To you? Why would you want them back?"

"To keep them together. Otherwise what's the use of them?"

"Well, it's my intention as well to keep them together."

"Then I'm inclined to help you, if I can. Want to look around?"

"I would indeed."

"Hannah!" Joseph called out. She came slowly through a door with a skillet in her hand, and Joseph saw that her eyes were terribly bloodshot.

"Yes? What's the matter?" she asked.

"Nothin's the matter. Show this gentleman around the gallery. I must be off to the Academy. And be sure to get the gentleman's address."

Like Wilkie, Gleason was shocked at what he saw. A number of the paintings were cracked, some fading. Others were mere ghosts of what they had been. The once magnificent sky of *Bligh Sands* had lost its beauty, and the white fluffy clouds had gone a rusty brown. Turning to Hannah as he left his address he politely spoke his concern. "They're incredible pictures, but so badly injured. Is there nothing to do about them?"

Scratching her stomach, Hannah looked at him as though he were daft. "What'd you have him do? They're ta'gather, sire, and that's what he's carin' most about."

Gleason spoke to himself as he walked from the gallery. "What a shame—buying his works back only to let them rot."

Midsummer found Joseph with most of his teeth gone and gorging himself on rum and milk. Caroline sat at his side as he read: "'There on the lonely shore the bold brave lover stands . . . on the lone beach . . . the pale strand, the lamp, the instant shore, death, the lover's toil . . . on the lone beach beyond the hour stand, and on the horizons rim the waves, it seems, rise and fall, replacing one another.'"

"That's a beautiful poem, Joseph, but it's got some awfully sad words. What's the name of it?"

"'Hero and Leander.' 'Twould make a fine paintin'."

"A mighty sad painting, I'd say."

"I've no grudge against sad paintings. They're part of life."

The tone of his answer sent Caroline in another direction. "How many paintings will you be showing this year?"

"Seven at the Academy. One at the British Institution."

"Why only one at the Institution?"

"Only one's allowed. It's a competition for the Empire's best painters. The very best's to be bought for the palace."

"And which one will you be sending?"

"I've not the slightest idea, Caroline."

Venice was still crowding his thoughts, and he was eager to go back. Time was saying, "the sooner the better." He began packing.

"I'd see the doctor before you take off," Caroline advised. "Won't hurt to have him look you over."

Reluctantly her advice was accepted and off he went the following evening.

Dr. Gordon Stafford had a bump of humor left despite his own crumbling age. "So, Joseph, you've come to see if you're still alive?"

"That's it in a nutshell. My whole body tells me it's wearing out."

"You've a lot of rambling to do yet. Wouldn't be so anxious to start picking out a gravesite. Take off your things and I'll examine what's left of you."

Groans came throughout the examination, whether they were justified or not. "Well, what do you think?" He asked when it was over.

"You're to buy dancing shoes and some fancy new duds."

"For what? To be buried in?"

"No need to worry. You'll outlive the ones you're wearing now."

"That's no comfort. I've already done that."

Joseph went off feeling lifted. Stafford's final analysis had been, "Just a bad case of nerves." Actually no such diagnosis lingered in the good doctor's head. Over dinner he said to his wife, "I'm afraid old Turner's on his last legs."

Joseph stopped off at his gallery to pick up some paintbrushes. The place was slowly falling apart, as was Hannah, who had consumed several grogs too many. She was stretched out on a bed asleep with several cats beside her. Without disturbing her, he chose materials for Venice and left.

Night had fallen as he came out. A couple had just passed walking arm in arm. They stopped and the man put his arms around her shoulders. "Dear, you sang wonderfully tonight. My dear wife's voice was never better."

She kissed him. "Thank you, Preston. I was singing for you." Joseph was flabbergasted. Her voice left no room for doubt; it belonged to Sarah Danby. He stood for a several moments watching them disappear into the dusk. So, Preston was the name of her husband. Suddenly, it struck him that this was Evelina's stepfather, and he could only hope that he was worthy of the honor.

"Well, what did the doctor say?" Caroline asked when he came in.

"Says I'm strong as a mule." And just as stubborn, was the thought Caroline's lips dared not express. She had prepared roast mutton for supper, but Joseph's gums were too sore for chewing. His stomach, growling from emptiness, had to find satisfaction in a hunk of bread soaked with milk and rum.

The British Institution, not having heard from Joseph, had become extremely anxious, and Ruskin was asked to inquire about his entry in the upcoming exhibition. Joseph's answer shocked the younger man. "John, I lack both the strength and will to hunt for a selection. They can do without me. I have to save myself for Venice."

"Oh, but Mr. Turner, that would indeed amount to a tragedy." He took a chance. "Please, would you allow me to help—to go through your work and make a choice? I'd be deeply honored—and certainly, I would understand if you refused."

Joseph gave thought to it for several moments then, to Ruskin's surprise, he answered, "Alright, John, the dirty task is yours."

Wayworn, Joseph went off to Venice with a purposeful eye. Sun-burnished and moon-glimmered, the Empress of the Adriatic still flooded his imagination. Time was the problem. Was there still enough left? Dark colors were banished from the palette. Canvases were undercoated with white paint. There was no place for chiaroscuro in the Venice he set out to capture. As at Petworth, white was laid upon white with the softness of pinks, blues and

yellows melted into its magic. In less than three weeks the Doges Palace, the Grand Canal and the Campanile emerged shimmering with his mastery.

He left Venice feeling that, at last, he was a complete artist; that he had rightfully claimed his gift from the Adriatic. Time, having misjudged his voracity, would have to wait. When he returned to London Caroline pierced him with a thorn. Ruskin had made his choice. *Sunburst* would no longer rest in peace. It was already hanging on the wall at the British Institution. Exasperated he said, "The minute they're not lookin' I should go in and haul it down." He shook his head in despair. "Afraid Ruskin's done me in—and it's of my own doin'."

"Are you to attend his wedding?"

"Afraid not. I'll send a present of some sort." He downed another concoction of rum and milk. "Drat this stuff. I've had too much. My only way to stay alive now is suckin' on meat."

"It's better than too much grog."

"Without it, I'm a useless animal."

CHAPTER THIRTY-EIGHT

Unexpectedly, death had claimed the Academy's president, Martin Shee. Joseph was at the council meeting to help select a successor. He cast a vote for Charles Eastlake, drank a glass of hot grog, complained of tiredness and then went home. Before taking to his bed he scribbled a note to Hawksworth at Farnley Hall thanking him for two braces of longtails and three hares. "Time has made sad work of me. I always dreaded it with horror; now I feel it acutely. Gout and nervousness have fallen into my marrow bone."

Illness kept him from Eastlake's election party, but he appeared at a private Academy dinner. The guests were preparing to leave when he touched Sidney Cooper's arm. "Sit down. Have a glass of wine with me."

"One, and then I'm off to Lord Rosse's place."

The wine was consumed and Cooper, aware of Joseph's feebleness, offered him his arm as they descended the stairs. Leaving with the prime minister, John Landseer quipped a bit too loudly, "Ah, Cooper's leading out the Nestor of the Royal Academy."

Cooper stiffened at the remark. Joseph smiled. "Never mind, Sidney. He shan't have the pleasure to lead me out."

"I'd like to see you home, Turner, but I'm expected at Rosse's."

"I can make it. You're not to worry one bit about me." The fly Cooper hailed for him rumbled off. When Cooper arrived at the soirée he was aghast to find Joseph already there comfortably seated and enjoying another glass of wine. "Thought you were home in bed by now, Turner."

"Home's tired of me bein' there every night. Thought I'd give it a few hours' rest."

He had taken his third glass and was about to depart when Fred Palgrave stepped to his side, a bit drunk. "Why's the white star blotted out of the *Fairy Queen* engravings of your *Liber Studiorum*, Turner?"

A deliberate long swallow of wine preceded the answer, "Stars and their ways are beyond my control, Fred."

Palgrave followed him to the door where Joseph pointed to the sky. "That North Star there, Fred, I might ask why it is so pleased to be shinin'." He then walked to Piccadilly and hailed another fly.

Anxiety struck the Academy when Joseph didn't appear at the annual showing. David Roberts immediately wrote to Queen Anne Street: "Please, if you're ill, let me come to see you." Roberts got no reply. He got instead a visit from Joseph a week later at his studio in Fitzroy Square; he had obviously been deeply touched by the letter. "David, I've come to thank you for your concern. You must not ask me, but whenever I'm in town I'll come to see you."

"My letter didn't upset you?"

Joseph put a hand over his heart. "No. There's somethin' in here that's all wrong." Breathing heavily he sat down. "What are you workin' at?"

"An oil—*The Battle of Hyderabad*, and its nearly finished. It's a flight up. Would you like to take a look at it?"

"I would indeed." He had reached the fourth step when he clutched his side, stopped, then slowly turned and went back to sit down. "Sorry. These old legs won't permit. Have to see it some other time."

"It's a bit large, but I could try hauling it down."

"No, never that. Right now your paintin' doesn't want my company." Several bottomless moments enveloped them. "Why not lie down for a while?"

"No, David. I must be off."

"Then allow me to take you home?"

"Nope. I can make it alone."

Caroline was at the kitchen table intently sorting out money when he reached Chelsea. "He watched her for a few seconds. "Plannin' to buy London Bridge?"

"Nope, just a patch of the river out there. Need a lot more water to do your wash. Suddenly she scraped up the money and dumped all of it into his hands. "There's a little over sixty pounds, and I'm asking you to invest it in the Public Funds for me. Could you do that tomorrow?"

"I'll attend to it." He pocketed the money and went to lie down.

A week had passed. She was hanging up his trousers when the money fell from a pocket. She shook him awake. "Joseph, you failed to invest my money. Why?"

He didn't bother to open his eyes. "Very simple, Caroline. I forgot it. Now leave me to my sleep."

He wasn't to get off so easy. "You know, Mr. Turner, you're in debt to me for nursing, washing, setting your pallet and cleaning this house and your brushes. You know that, don't you?'

"Can't go into accounts with you now, Caroline. Make claims against my estate."

"Your estate?'

"Yep, my estate. Then you'll be dealin' with gentlemen who'll do you justice." He pulled the sheet over his head. "Get out, Caroline, and let me sleep." The complaints went on but they were left with silence.

Exasperated, she shut his door and stood for a moment—thinking. Somehow she would have to keep him at that easel if he was to stay alive. She went off to clean his brushes. "Ah, what a stubborn man." Joseph lay quiet, storing up strength to fight off death in case it tried sneaking into his room. He feared now that it might even try laying claim to him during his sleep.

John and Effie's marriage had taken its time coming. After he finally took her to the altar, fate marred the very first night of their honeymoon by bringing on the early arrival of Effie's menstrual period. For John, a gentleman of extreme delicacy, that night would for long be epitomized by a crimsoned bed sheet. The remembrance stayed on, nudging them toward a troubled relationship. Joseph, seeming to have been intuitive about their unhappiness, wrote a short note: "My dear Ruskin. Do be happy. Truly and sincerely yours, JMW Turner."

At the end of November, John and Effie dropped by the gallery to ask him to a dinner party. He accepted and served them cold biscuits and tea. After their departure, he was sure there was truth in the rumors about their problems. Well, it was their responsibility now to play man and wife. So many times he had wondered why he had avoided marriage. And so often he

had accepted his loss of Katherine Forsyth as the reason. He had watched his father suffer the pains of marriage. Then Sarah Danby's sermons about the responsibility of fatherhood had helped frighten him off.

En route to the Ruskin's for dinner, he was rethinking the matter. Had bachelorhood, despite its lonely moments, granted him a better existence? "Ah, afraid wedlock would have just dumped misery on my shoulders." He had spoken his conclusion with a hardness of stone—but deep inside him doubt was spreading its presence. He sighed. "Oh well, no sense thinkin' about it one way or the other. Yesterday's gone."

Snow was falling when he arrived. Ruskin took him around and introduced him to the guests. He was finally brought to a tall, distinguished man with a ruddy complexion. "Joseph—Godfrey Crowell." He greeted Joseph with a pleasant smile and shook his hand. "Turner, what a pleasure to meet you at last. My wife speaks so highly of you and your work. She will be so pleased to see you."

"Delighted to meet you. And is your wife here?"

"She should be arriving any moment. I came directly from my office."

If indeed she knew him, Joseph hoped he would recognize her. "Are you in the literary profession?"

"No. I am a barrister."

"In the law business?"

Crowell smiled. "That's accurate enough, I'd say. For relief I occasionally turn to poetry. Don't allow myself to become too seriously involved. Just a doodler who tries his hand at it now and then. My wife's written some very fine verse."

"Have you any favorites?"

Again Crowell smiled. "Beyond my wife, Milton and Aikenside appeal most to me."

"Not bad choices."

"And there's Scott, but—" He had stopped abruptly. "Pardon me." Mrs. Crowell had arrived and he had gone to her.

Curious, Joseph strained for a glimpse of the face but it was obscured by her husband's shoulder, and he waited to greet her. A few moments later he did. "Katherine—how good it is to see you."

Smiling, she gave him her hand. "I'm so delighted to see you again Joseph—and to have you meet my husband."

She was completely gray now, beautifully gray, and gracefully settled into her age. He was folding into a frailness that she couldn't help but notice. Thirty-five years had gone by since he had last seen her. But instantly he was looking beyond the years, far beyond to that cove above Margate Harbor, and to that poem she had once written for him. Their conversation escaped those memories. Her orphanage was still open. His work was going well. There looked to be more snow later that evening. Just ordinary, meaningless words.

Ten guests sat for dinner. Katherine and Joseph were seated directly across from one another—trading glances now and then, both remembering what neither of them could forget. Ruskin, lording over the conversation, appeared somewhat uneasy. Effie had lingered in her room—where John would have preferred that she stay, but his mother had insisted that she join the company. She came finally to sit at the end of the table opposite her husband, and spoke only when she was spoken to. Her attitude bore out the rumors of their unhappiness.

During dessert, Ruskin lifted his champagne glass. "Friends, there is something of extreme importance to announce. I have just left the British Institution where a final vote was taken on the nation's most prestigious award for art. Joseph, your painting *Sunburst* was unanimously selected as the finest entry throughout the Empire. Congratulations."

Joseph sat silently as the room became thick with praise and applause. With his thoughts swimming in a sea of gratitude, he managed a slight smile. His eyes watered when at last he spoke. "Thank you, John. Thank you so much." He paused, shook his head and went on. "To me the award will be more than an award. It's to lift me out of a kind of darkness that would take a long time to tell you about it. I will say only that what I once thought was dead has proven to be alive. Now, perhaps for those who have wished me ill, there is reason to forget. So very long I've belonged to the sun, and now the sun has blessed me. I'll remember your faith, John." He smiled again. "I've nothin' more to add."

Later, Katherine took him aside. Her eyes were directed at the floor. "Joseph, I must tell you something."

"Yes."

"John Ruskin came to the orphanage a few months ago. He saw the painting above the hearth and greatly admired it. Then he asked why it was without a signature. I told him that the artist, for reasons of his own, had refused to let himself be known. John spent nearly an hour examining it. Would you care to hear what he told me?"

He was silent for a few moments as she stood waiting. "I would."

"He said something that I had come to feel."

"Yes."

"He said that it could only be the work of Joseph Turner."

"Well, Katherine..."

Her eyes lifted to meet his. "Tell me, please tell me. Joseph, is he right?"

His silence, and the twinkle in his eye, gave her the answer. Unabashedly she gave him a warm kiss on the cheek. Thank you, Joseph . . . thank you so very much. It will mean even more to me now." Taking her husband's arm she smiled. "We are leaving now, so I must wish you good night."

The touch of her lips lingered. "Good night, Katherine." The wistfulness in his voice bore a last farewell.

The question Joseph asked as he departed brought a curious smile to Ruskin's face. "Mrs. Crowell tells me you made judgment of a certain paintin' at her orphanage. That so?"

"Yes, that is so." His eyes searched Joseph's for the truth. "Was my judgment well founded?"

"It was."

"You must have reasons for not affixing your name to it."

"Some things are best forgotten, John. It was a fine party."

Ruskin let the matter drop. "Thank you for coming, Joseph. And again, congratulations." Ruskin's carriage for Joseph had pulled up and he stood waving as his guest rode away.

As Joseph journeyed homeward, his thoughts lingered on Katherine. She had paid dearly for happiness, and his love for her was still there for him to forget. That, he knew, was a feeble uncertainty; forgetting could be so

involving and so terrifying. Surely it would all come entirely clear to her now. She would know that Georgianna, whose safe return had been the reason for the gift, belonged to him. No longer would she have to guess at that secret. He thought of the award he was to receive; of the price it had cost, and the sorrow. But sorrowing had become his nature for a number of reasons—reasons to be either honored or mourned.

During the following week his will took over his thoughts again. Georgianna was gone, and he was sorry to have outlived her. Evelina and her family seemed to have disappeared from the face of the earth, but he still felt himself responsible to her. In one codicil he limited the time for the National Gallery to receive his works to ten years after his death.

In November he wrote to Hawksworth at Farnley Hall: "I cannot bear the same fatigue, or have the same bearing against it I formerly had. Time and tide stop not—so I must work on." He worked on at what he feared would be his last painting, *Dido and Aeneas*—the betrayal of love by Aeneas in order to achieve his goals. During the years of social struggle, he had devoted himself to storms at sea, fire, wind and deluge. Venice had given truth to the purity of light and color. The scissure between watercolor and oil had been closed. *Rain, Steam and Speed* had grasped the changing of the universe. *The Fighting Téméraire* had explored the irreversibility of it. *War*, with Napoleon contemplating his losses, had supplemented peace. He had been faithful to his artistic responsibility.

CHAPTER THIRTY-NINE

On the first Friday of December, Caroline went to the Cheap Market to buy fish.

Joseph, painting at Queen Anne Street, heard a rapping on the door. Wearily, he got up to answer it. A postman greeted him. "A package for Mr. Turner. You happen to be him?"

"What's left of him." He took the package and abruptly shut the door. "Hannah!"

"I hear ya. No need to holler."

"I'm off. Be shore and give the brushes a good cleanin'."

"You've no reason to think I won't."

"Just tellin' you."

Slowly, he pulled on his greatcoat, put on his hat, and with the package under his arm, he left. He knew what it contained by its shape. It always arrived in time for Christmas. At Cheyne Walk he placed it on a table and shed his coat. Still wearing his hat, he started work on an unfinished oil painting. He was still at work when Caroline came in and noticed the package. "Ah, you've got your usual game pie from Farnley Hall I see."

"It's a bit ahead of time this year. Have to write young Fawkes before I forget. Memory's short these days." He sat back and observed the painting. Then with a delicate flourish of his brush he highlighted a somber area. "Better, much better. I'd call it about finished."

She stepped closer for a more discerning look. "What's the name of it? Seems to me you finished it sometime ago."

"If I'd finished it, Caroline, I wouldn't be workin' at it. It's called *Visit to the Tomb*."

Picking up the package she gave the painting a final look. "If you was to ask me, I'd say you paint too much about death lately."

"I'm not askin' you, Mrs. Booth."

"Just speaking what I feel, Mr. Turner."

Her remarks had thrown him into deeper depression. They were not altogether unjust. She was, after all, living under the same roof with *Hero of a Hundred Fights* (which she thought resembled a skull) and *Skeleton Falling Off a Dead Horse*. To her way of thinking, both were allegories of death.

Suddenly, his body became one big miserable ache. He got up to leave the room, deliberately avoiding the mirror. It had grown unbearably unkind. Only rarely did he accommodate it with a swift sidelong glance. His thoughts were far more agile than his legs as he climbed the stairs. He thought, "Paintin' too much about death? Me with every tooth gone, jaws saggin' into my gums, eyes losin' sight, bones stiff as oak, and tremblin' like a leaf. I'm not to fool myself. I've good reason to think about death." He undressed and got into bed, but before sleep overtook him he scribbled his thanks to Hawksworth. It was short and to the point. "Surely I'm to enjoy the pie. Thank you, and bless all of you. A most happy holiday."

Joseph never fully awakened from the deep sleep he fell into. It had been a struggle just to get into his nightshirt. A few minutes later the bedroom filled with snoring—so grievous and fitful Caroline came quickly to shut his door. Never did he gain an appetite for the game pie, or even think about it. His mind, floating in and out now, was more sublimely connected with the spiritual world. Only during brief intervals did it regain reality. Except for the doctor who was called for him, he was entirely in Caroline's care.

On the fourteenth night of delirium his head turned toward a slight rustling. (An aged man in a hooded monk's robe stood at his beside.

"Ah, it's you," Joseph mumbled. "Thought you'd show up. So you've come to see me off."

"I've come to welcome you to peace."

"Dread would be a better word for it, with me straddled here thinkin' about not bein' alive anymore, alone, flat on my back in a cold grave with my eyes closed forever, my body left to the worms while things still sprout above me. I've not brought myself to accept it."

The old man smiled as he had so long ago outside Tintern Abbey in Wales. "We are born to expire, Joseph. We start dying after our first breath.

No dread is to be attached to that. It happens to all of us. Before that moment we roamed the shores of nowhere; knowing nothing and in need of everything. You were fortunate. You were granted passage into the realm of dying—without dying. So honor your existence; your absence will still glow with your name. Come along, Joseph. You have basked in a radiance far brighter than the darkness of a tomb. You laid bare the mystery of the sun. For that alone, you can smile at all those who frowned at you. Leave your sorrow to the snarlers who smeared their lips with your blood. The time you were granted is used up and your secrets have been made clear. Come peacefully, Joseph. Come peacefully." He pulled the hood over his face and turned toward the door.

"Wait. Wait. Just a minute. Just a minute."

The old man was gone.)

"Hikkon. Hikkon!"

His cry brought Caroline hurrying to his side. "What's the matter, Joseph, more pain?"

Reality had returned for a moment. "Nothin'. 'Twas nothin'. Just a dream."

She leaned closer, wiping sweat from his brow with her apron, whispering, "I'm taken care of in your will? You're not to forget the cooking, washing and cleaning I've done for you."

"You're not to worry, Caroline."

She stood fingering the wedding band she had found in his coat earlier that morning. She had intended asking him about it, but now he had gone off again. For the third time she read the inscription: "To Katherine from Joseph." She felt somewhat deceived. "Not in all these years did you say one thing about being married to somebody." She had spoken softly. He wouldn't have heard her in any case.

The dawn of December 19, 1851, moved in with mist, fog and black rolling clouds. Cold wind ruffled the water flowing between the shores. These beloved extensions of Joseph's vision had, it seemed, come together on this morning to pay him homage. Only the sun, that phenomenon he most revered, was absent, withholding its final blessing. But at exactly nine o'clock the clouds parted for it to burst through and emblazon his bed. His

God had not forsaken him. Bright shadows cut across Cheyne Walk and over the Thames. His eyes opened to gaze into the shimmering fathoms, held steady for a moment then snapped shut. Death entered the room and grasped Joseph's hand; then together, they quietly departed.

EPILOGUE

It was half past nine in the morning when the funeral took place at the gallery on Queen Anne Street. The coffin had been placed in the downstairs parlor. All the furniture had been removed. Other than his Academy associates, who filled the bare room, there were Caroline, Hannah, Ruskin, Gully and Allison. Later, Gully went upstairs to look at the pictures hanging in the second floor gallery. Most of what he saw saddened him. Once a gay amber, some were now dirt-streaked, yellowed and stained from rain that had leaked through the skylight. Slowly, Gully's eyes watered. A woman with a boy of about twelve was also there. The boy's question held a trace of awe as it broke the quietness. "And my grandfather painted all these pictures, Mother?"

"Yes he did, Joseph, and many more."

Gully could only stare at the two of them. Evelina Dupuis had revealed the golden secret. For a moment he was tempted to speak to her—to find out her name. Then he thought better of it.

Slowly he descended the stairs to take a final look before the coffin lid was closed. Joseph's lips, forever sealed now, had left a lot untold. Certainly the woman and child were part of it. But that was his business—and he was carrying it to his grave.

For three hours, through Regent Street and Trafalgar Square, the procession flowed to St. Paul's Cathedral. It entered to the surging voices of the great organ and a boys' choir. There, Joseph was placed in a crypt beside Sir Joshua Reynolds and Sir Thomas Lawrence.

No immediate peace would surround the 140,000-pound fortune he left. His next of kin, most of whom he had never seen, were enraged at the contents of his will. Promptly they accused him of being of unsound mind and incapable of making a legal decision. Failing to move his executors, they turned to the Court of Chancery. After a long, stormy battle, they came to a satisfactory arrangement with the executors—making no claim to the

multitude of paintings, drawings and sketchbooks. Those became the property of the nation—which failed to build the gallery the will had provided for, and, for years, neglected his paintings much the same as he had. Later, John Ruskin toiled endlessly to have most of what had fallen into disrepair restored to its original splendor.

Eventually, Evelina's 100-pound annuity was vindicated and put into an account for her personal use. Hannah Danby, who was left a tidy sum, died three years later. Sarah and John Danby's three children were awarded her share, and Caroline was left enough to ease her worrying. Joseph must have anticipated the storm that was to erupt among the relatives he had never even spoken to. But then, there was nothing Billy Turner enjoyed more than the turbulence of a good storm.

His wish for all of his work to hang beneath one roof was not abandoned. But 136 years passed before Her Majesty, Queen Elizabeth II, opened the door to the Clore Gallery, in a wing of the Tate Gallery in London, wherein that wish was at last fulfilled. There, on April 1, 1987, Joseph's hopes were rescued from the edge of the abyss. On those walls hang secrets of things he searched for—shores of green shade, the fury of the sea, and that trembling light wreathing the unconquerable sun.